GOTHIC ART IN BOHEMIA

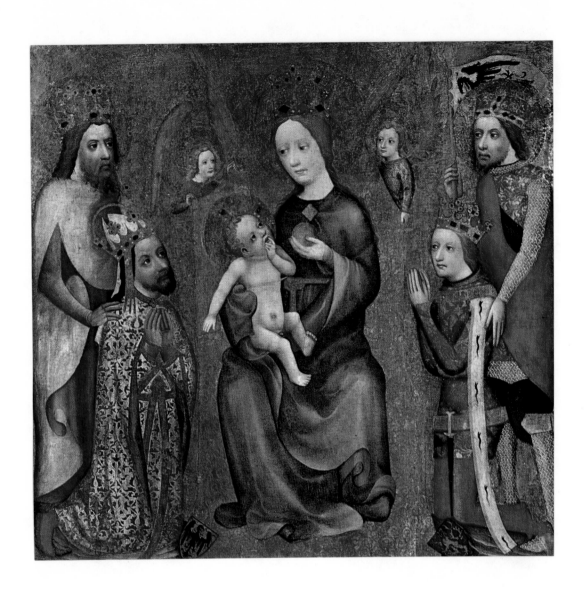

GOTHIC ART IN BOHEMIA

Architecture, Sculpture and Painting

Ferdinand Seibt, Erich Bachmann, Hilde Bachmann,

Gerhard Schmidt, Götz Fehr, Christian Salm

Edited by Erich Bachmann

Praeger Publishers
New York

Photographs by Werner Neumeister
Translated by Gerald Onn

Phaidon Press Limited
Littlegate House, St Ebbe's Street, Oxford

Published in the United States of America
in 1977 (abridged)
by Praeger Publishers, Inc.
200 Park Avenue, New York, N.Y. 10017
Originally published as *Gotik in Böhmen*
© 1969 by Prestel-Verlag, Munich
Translation © 1977 by Phaidon Press Limited

Library of Congress Card Number: 75-111067
ISBN 0-275-36590-5

Printed in West Germany

CONTENTS

about 900	The Slav peoples in Bohemia make themselves independent of the sovereignty of the Moravian empire, which is conquered by the Magyars in 907. Unification under the Czech dynasty of the Přemyslides. The name of the Czechs is extended to the smaller tribes and to the country.
935	The Přemyslide duke Wenceslas killed by his brother; subsequently he is venerated by the Church as a martyr, and today, in secular forms, patron of the country. Relations with the German kings are broken off.
950	Renewed dependence on the German kingdom in various forms and almost without interruption. During the following three hundred years Bohemia rises from a tributary dukedom to the principal Electorate of the Empire.
973	Bohemia detaches itself from the missionary bishopric of Regensburg (Ratisbon); Prague becomes the seat of the new diocese.
995	The Přemyslides exterminate the Slavnikids, the last independent rulers in Bohemia. Forcible unification of the country.
1029	Moravia joints the Bohemian domain.
1085	The Přemyslide duke Vladislav raised to royal rank by Emperor Henry.
1212	Bohemia raised to a hereditary kingdom.
1253–1278	King Otakar II reigns for twenty-five years over Bohemia and Austria: first unification of the 'Danube region'.
1278–1305	Wenceslas II, also King of Poland.
1306	Wenceslas III murdered: Extinction of the male line of Přemyslides.
1310–1346	Among various candidates the West German count John of Luxembourg, son of Emperor Henry VII and husband of the Přemyslide princess Elizabeth, gains the throne of Bohemia. Resumption of the expansionist policy of the Přemyslides.
1327	Acquisition of Silesia.
1344	Bohemia and Moravia become independent of the archbishopric of Mainz. Prague becomes the seat of the new Metropolitan: the first archbishop is Ernst of Pardubice.
1346–1378	Charles IV King of Germany and of Bohemia (as Charles I). Economic and cultural prosperity: 'Caroline period'.
1348	Foundation of the University of Prague, the first in central Europe east of the Rhine.
1355	Charles IV crowned as Emperor in Rome.
1356	Issue of the Golden Bull, Bohemia confirmed as Electorate.
1378–1419	Wenceslas IV, from 1376 also King of Germany, but there deposed by the Electors because of his inactivity; opposition of the nobles in Bohemia.
1409	Wenceslas changes the university statutes and deprives the non-Bohemian professors and students of the majority of votes (Decree of Kuttenberg). Departure of the non-Bohemians, mainly Germans.
1415	Jan Hus burnt at the stake in Constance.
1419	First defenestration from the Neustadt Town Hall in Prague.
1419–1436	Hussite Revolution against the ecclesiastical, social and political conditions. The throne remains vacant, the country is governed by Hussite Diets. Žižka of Trocnov (died 1424) and Procop the Great (died 1434) are leaders in the Hussite wars.
1436	By agreement with the Council of Basle the basic demands of the Hussites are conceded. The royal house of the Luxembourgers returns.
1436–1437	Sigismund of Luxembourg, German king since 1410.
1438–1439	Albrecht of Habsburg King of Bohemia, since 1423 margrave of Moravia, from 1438 also German king.
1439–1452	The throne is vacant; it is claimed by Albrecht's son Ladislas Postumus (1440–57).
1453–1457	George of Podiebrad becomes Governor for Ladislas, who dies in 1457 without leaving children.
1458–1471	George of Podiebrad, elected King of Bohemia. Attempts to reunite the Utraquist (Hussite) kingdom with the Latin Church.
1466	Renewed papal Hussite crusade against George of Podiebrad, led by King Matthias Corvinus of Hungary.
1471–1516	Vladislav II, of the house of the Jagellones, a nephew of Ladislas and brother of the King of Poland, reigns as King of Bohemia.
1490	After the death of Matthias Corvinus, Vladislav II also becomes King of Hungary.
1516–1526	Vladislav's son Ludwig King of Bohemia and Hungary. He is killed in the battle of Mohács against the Turks, and leaves no children.
1526	Ferdinand I of Habsburg elected king; in 1531 he becomes also King of Germany and in 1556 Emperor.

Until 1918 the Habsburg rulers are also Kings of Bohemia, the line being interrupted only by Frederick of the Palatinate, 1619–1620, and Charles VII of Bavaria 1741–2.

1. Social developments in Bohemia during the Gothic period

Bohemian art made rapid progress during the Gothic period. But there were also great social changes, as a result of which the Bohemians were drawn more and more into the European community. In the twelfth century their country, which then covered some twenty thousand square miles and was nearly as big as Belgium and the Netherlands, was still effectively cut off from the western world by the thick forests and high mountains which formed its borders. And yet by the mid fourteenth century this isolated and backward territory was able to compete successfully, in both the cultural and economic spheres, with its western neighbours. Owing to the expansionist policies by the Luxembourg dynasty, the kingdom of Bohemia and the neighbouring margravate of Moravia became the heartland of a new territorial bloc embracing Silesia and Brandenburg in the north and east, and numerous feoffs and pledges in the west, including properties within the Duchy of Luxembourg. By the end of the fourteenth century even the vast kingdom of Hungary, which was then the foremost power in south-east Europe, had been drawn into the Bohemian bloc by dynastic marriages.

The settlement of the Bohemian countryside was a very slow process, owing to the extremely difficult nature of the terrain. In the twelfth century the rural settlement areas were grouped around the rivers and plains, and this was still largely the case some two hundred years later; for although by 1400 there were stretches of land, primarily in the north and east, that were ready for colonization, these were not very extensive and were more than offset by the overcrowding that was found in the southern territories at that time. It was, of course, the urban settlements which eventually determined the character of Bohemia. Even in the twelfth century, when they had been few and far between, these settlements had acquired a certain significance from their association with the old feudal establishments. Subsequently, they grew in number until, by the fourteenth century, there were no less than one hundred towns and market-places in Bohemia, a third of which received royal protection and privileges. Prague, which had benefited from both river and road communica-

tions since the beginning of the millennium, was the largest urban centre north of the Alps, with one of the largest populations. It is hardly surprising that the first revolution in the history of the new nationalist Europe, a revolution which, although conceived largely in 'medieval' terms, was prompted by the same kind of considerations as the 'modern' revolutions of our own period, should have been staged in this political, economic and intellectual centre.

The Emergence of a Pluralistic Society

Although there was a certain amount of social mobility in the early period of Bohemian history, there were only two social classes: the masters—i.e. the duke and the great nobles—and the vassals. With the advent of Christianity in the ninth and tenth centuries this social order underwent a considerable transformation, partly because the Church consciously sought to reduce class divisions, but more especially because it created a new and independent social group, namely the clergy. However, unlike the Catholic Churches established in the former Roman colonies of western Europe, the Bohemian Church was neither economically nor legally independent of the state. Right up to the end of the twelfth century the Bishop of Prague was officially designated as Court Chaplain, and was treated accordingly. Moreover, during the early years of Bohemian catholicism the church tithe was collected by the nobles and distributed by them to the bishops and priests.

The thirteenth century brought about a fundamental change in the social order. The steady growth of the Bohemian population had increased the demand for food, and this had led to the expansion of the old settlement areas, and the introduction of the new intensive farming methods developed in western Europe. At the same time Bohemia had gone over from a barter to a money economy. As a result of these innovations there was a growing division of work between farmers on the one hand and craftsmen on the other, until eventually specialization became the order of the day. Meanwhile, the ancient trade route

from Vienna via Regensburg and Passau to Prague, Cracow and Kiev was revived, and numerous small trading posts were established in Bohemia. Inevitably, these developments had far-reaching effects on virtually every aspect of social life: the composition of the ruling class, the administration of the church, the cultural standards and the economic prospects of the population were all affected. In fact, the highly dynamic process in which Bohemia and the other eastern territories of Central Europe were caught up at that time was not unlike the industrial revolution of our own period. It created the same mass movement of people in search of work, and it created entirely new social structures.

With these new structures, a new type of man gradually emerged, *homo economicus*, a member of a social group whose fortunes depended in large measure on its mobility. Civic freedoms and rights of autonomy, which previously had been conferred only on small groups, on merchants, and on occasional settlers from abroad, were now granted quite freely to all foreign migrants. These migrants, from north and south Germany, also brought their own system of law with them—so-called *deutsches Recht*—and used it in the administration of their self-governed rural and urban communities. Thus, the bourgeois freedoms, which had been acquired over a long period in western Europe, were established in Bohemia virtually overnight.

At the same time the Bohemian Church, whose position had been greatly strengthened by the foundation of a large number of Cistercian and Praemonstratensian colonizing monasteries, continued its dispute with the nobility and met with considerable success in its quest for temporal power. In the middle of the thirteenth century a special status was granted to the bishops of Prague, with the result that very soon they were accepted as second only to the king in the temporal hierarchy, a far cry from their original position as Court Chaplains.

Meanwhile, the nobles had also contrived to consolidate their position, both economically and constitutionally. Clearly, the dukes of Bohemia had never been absolute masters in their own house. On the contrary, they had always depended on the collaboration of the *primates terrae* who, although not their equals, none the less wielded great political influence. Many of these nobles amassed considerable fortunes from land clearance and development, and with their new-found wealth began to compete with their rulers as builders. In the process, they carefully dissociated themselves from the knights and the lesser gentry, who had been their natural allies in poorer days.

By this time, of course, the power of the ruling house had also increased, for in 1189 the duchy of Bohemia had been raised to a kingdom, and in 1212 its new status was confirmed under the terms of an imperial charter granted by Frederick II. And so the comparative freedom acquired by the nobles, especially the high-ranking barons, was held in check by the special rights and privileges granted to the monarch. These conferred great economic advantages. For example, only the crown was allowed to prospect for minerals or to mint money; and Bohemia had very large silver deposits at that time. Between them, the Bohemian and Silesian mines accounted for about half of Europe's total output of silver in the fourteenth century. In addition, the king benefited—in exactly the same way as his barons—from land development, and also from the economic and trading concessions granted to the royal towns, whose importance as taxpayers had not escaped the Bohemian rulers of the mid thirteenth century. And so we find an extremely vital and competitive social order developing in Bohemia at this time. On the face of it, admittedly, the king would appear to have held all the trump cards. But as in England, Hungary and Poland, the estates were pressing their demands for political representation with great vigour, and it was quite evident that limitations would soon be imposed on the authority of the crown.

The Peak and the Crisis

By now the pluralistic society was an accomplished fact. The heavy investments made in the country—the crash programme of land development, the settlement in Bohemia of German nationals, the founding of hundreds of new villages and dozens of towns—had paid off. Although our statistical knowledge of the period is patchy, it is quite clear from the development of Bohemian art that the economy had prospered. Numerous architects, sculptors and painters were engaged on major projects, not only for the court, but also for the great nobles, the high church dignitaries and the wealthy burghers.

With its treasury full, the Bohemian crown was not slow to adopt expansionist policies. The first ruler to think along these lines was Přemysl Otakar II—the 'man of gold' but also the 'man of iron'—who set his sights on the territories of the Austrian dukes. For a quarter of a century Otakar II actually controlled the areas that were later to become the heartland of the Danubian district, and he

sought to link the Baltic with the Adriatic by political agreements. But he underestimated both Rudolph of Habsburg, who was his principal opponent, and the passive resistance of his own great nobles. In the end he was defeated and killed on the *Marchfeld*. The last two Přemyslide rulers, Wenceslas II and III, did not continue Otakar's policies. Instead, they sought to expand eastwards. Subsequently, during the brief reign of the younger Rudolph, Bohemia pursued a pro-Habsburg policy in the east. But then, in 1310, the Luxembourgers established their dynasty, and after reaching a realistic compromise with the Bohemian nobles, John of Luxembourg embarked on a two-pronged campaign in the north and south which, although costly, was by no means unintelligent, for it brought Silesia into the Bohemian fold, thus doubling the size of the kingdom at a stroke, and increasing still further its economic power. What John acquired by militancy, his son Charles sought to preserve by cool diplomacy. The thirty-two years of Charles IV's reign—from 1346 to 1378—were one of the 'golden' periods of Bohemian history.

During the Hundred Years War, when France and England were tearing each other to pieces, when the papacy was stripped of much of its political power, and when the King of the Romans withdrew north of the Alps, the countries of eastern Europe suddenly found themselves thrust into the political limelight. In the second half of the fourteenth century the princes who ruled over the eastern territories of Central Europe were, without exception, men of ability and calibre. They included Casimir the Great of Poland, Louis the Great of Hungary, Rudolph the Founder of Austria, Stephen the Great of Serbia, Waldemar Atterdag of Denmark, and Winrich von Kniprode of the Prussian Order State. Some of these princes were related by marriage, some were linked by bonds of friendship, and some merely corresponded with one another. But whatever their personal relations, they all pursued the same political objectives. Both in the day to day administration of their states, and in their long term policies, they sought to strengthen the power of central government in order to bring their nobles to heel; they also sought to increase the financial viability of their states by planning their economies and to extend their spheres of influence by diplomacy rather than war. In this last connection they engaged the services of writers, architects and artists, they expanded their capital cities, founded universities, and tried to gain the support of the Church for the furtherance of their own state cults. This sudden upsurge of political vitality followed hard on the heels of the economic boom produced by the land clearance and development programme. Thus, after more than a century of economic and political evolution, these peripheral states at last caught up with the more advanced territories of Central Europe, which had passed through a similar phase of development during the High Gothic period.

The policies pursued by Charles IV of Bohemia, who received his initial training in kingship at the French court, were typical of the new style of government. After being elected King of the Romans in 1346, and Holy Roman Emperor nine years later, Charles sought to add to the splendour of his reign by having new residences built, not only in his own capital city, but also in a number of towns in neighbouring imperial territories. Meanwhile, in 1344, he had persuaded the Vatican to raise the Bishopric of Prague to an archbishopric, and in 1348 he founded the first university in Central Europe. In the grandiose Latin of the Prague chancellery he argued the merits of his new conception of government, hoping in this way to gain the loyal support of the great nobles, still one of the most powerful factions in the country and the traditional rivals of the crown.

Social conditions in Bohemia during the second half of the fourteenth century are not easy to assess. The plague was ravaging the country, albeit perhaps not quite as perniciously as in south Germany. By and large, the urban population appears to have prospered, although this new-found affluence was accompanied, especially in the capital city of Prague, by growing social divisions and the emergence of a large underprivileged class living at subsistence level. In the rural areas social conditions varied greatly from region to region. In some places there was a shortage of agricultural lands, in others the tenant farmers were harassed by oppressive landlords. Wheat prices fell during this period, and there was unemployment in certain localities.

During the closing years of Charles IV's reign, and subsequently—and much more forcibly—under his son and heir, Wenceslas IV, the existing social order in Bohemia was undermined by a crisis, which had many strange facets. It was triggered by the struggle for power between those striving to maintain the *status quo* and those seeking to disrupt it, and was then reinforced by the 'national' disputes within the clergy, the serving nobility and the municipalities, about a third of which had lost their original German ruling class by the turn of the century. The young university was convulsed by similar disputes, which

were conducted even more fiercely by the professors than by the students. Meanwhile, a number of preachers whom Charles IV had either invited to, or promoted within, Bohemia launched a campaign of social criticism from the pulpit. Konrad Waldhauser from Upper Austria, Milíč von Kremsier, and their many disciples found adherents amongst rich and poor alike; they started reform movements similar to the contemporary Dutch *Devotio moderna*; and again and again they drew attention to the social abuses of the times, and to the terrible day of judgement that would surely come if these were not remedied.

In about 1400 a group of young Bohemian masters discovered the radical theses of John Wyclif, the English reformer who had been condemned posthumously as a heretic, and were themselves then duly suspected of heretical leanings by their conformist colleagues. The spokesman for this group was, of course, John Huss.

The Hussite Revolution

Meanwhile, in 1409, the last remnants of unity were destroyed at Prague University, with the majority of the German professors and students leaving the country, and the Bohemian Wyclifites becoming the dominant force on the campus. After Huss's death at the stake in 1415 a revolutionary movement was launched under the leadership of the Hussite masters and deacons, which toppled the monarchy in 1419 and set up a republic which was governed by successive groupings of the estates. Over a twelve-year period five crusades were mounted against the new republic, but to no avail. And in 1426 the Hussites went over to the offensive. Their armies advanced to the Baltic, into Hungary and the Palatinate, Silesia and Austria. They seemed invincible. But then, in 1434, the Hussite movement simply disintegrated, owing to internal tensions. Art historians are inclined to write off the years of Hussite rule as a barbaric period. This is a mistaken view. Admittedly, the visual arts, which had flourished under the *ancien régime* of pre-Hussite days, went into a total decline. But they were replaced by the literary art of the revolutionary writers.

Although the Bohemian monarchy was restored in 1436, the members of the estates, especially the great nobles and the burghers, continued to press their demands for representation. The 'Hussite King', Georg of Podiebrad (1448–71), made a last attempt to implement the policy of centralization initiated by his predecessors, but was forced to relax his efforts when he became embroiled in a conflict with the Catholic counter-reformation. Subsequently, when the Polish Jagellones inherited the throne, it seemed as if the great nobles had won the day. But their victory was short-lived, for in 1526 Bohemia was taken over by the powerful Habsburg dynasty. The essentially agrarian social structure promoted by the Jagellones, and so favourable to the great nobles, was abandoned, and after a second revolution had been consequently suppressed in 1620, Bohemia entered upon a period of absolute monarchy.

2. Gothic architecture in the period before the Hussite Wars

The Early Phase during the Přemyslide Dynasty

The only country on the continent that can lay claim to an autochthonous school of Early Gothic architecture is, of course, France; every other country, including Bohemia, adopted the Gothic as a ready-made style. Initially, these countries not unnaturally sought to avoid the complex problems posed by the highly differentiated systems of the allied work of cathedral art, and instead of building cathedrals they concentrated on the greatly simplified structures evolved by the Cistercians and the mendicant orders. In Bohemia the assimilation of the Gothic took place in several stages. Unfortunately, the vast majority of the surviving records and monuments relate to the final, Caroline epoch, which brought the Gothic proper to an end and ushered in the Late Gothic of the fifteenth century, so that when we try to trace the earlier development of the Gothic style we are forced to rely to a great extent on conjecture. Consequently, the history of Gothic architecture in Bohemia during, and even after, the Přemyslide dynasty is extremely patchy, and our knowledge of large sections of this period is restricted to just a few salient facts. The principal reason why we have been unable to acquire a clearer view of the main body of thirteenth-century Bohemian architecture – above all the architecture of the Cistercian and mendicant orders–is that the primary sources, namely the surviving architectural monuments, are in such a bad state of repair. The ecclesiastical buildings erected in Bohemia in the thirteenth and fourteenth centuries suffered far more due to religious fanaticism than in any other part of Central Europe; in many Bohemian districts the extent of the damage was positively catastrophic. Apart from those in the southern territories controlled by the powerful von Rosenberg family, nearly all of the great Cistercian churches, and very many of the churches built by the mendicant orders, were razed to the ground in the early fifteenth century by the Czech heretic Hussites. Of the great ecclesiastical buildings erected in Prague during the Gothic period the only one to survive in its original form was St. Vitus's Cathedral, which, however, remained unfinished, largely owing to Hussite fanaticism. During the Baroque period an attempt was made to restore many of the Bohemian Early Gothic churches and monasteries, and it is quite evident from the anachronistic, pseudo-Gothic solutions adopted for this purpose that the architects of sixteenth-century Bohemia were sadly out of touch with the techniques and aspirations of their forebears. The buildings in Sedlec and Kladruby (Kladrau), Zd'ar (Saar) and Roudnice nad Labem clearly demonstrate this lack of continuity.

The initial phase of Bohemian Gothic saw the emergence of the half Romanesque, half Gothic forms of the so-called Transitional Style. In the northern parts of Bohemia, as in Saxony and Silesia, the individual forms evolved by the classical cathedral architects of northern France found widespread acceptance, whilst in the southern districts, as in Austria, the Burgundian Early Gothic of the Cistercians was dominant. But the Late Romanesque or Norman decorative style, which was carried from Regensburg and Bamberg via the Danubian School as far afield as Hungary, and was subsequently established in southern Moravia and Slovakia, made little or no impact in Bohemia. This explains why, unlike their Moravian counterparts, the architects of thirteenth-century Bohemia created none of the ostentatious Late Romanesque portals that were so common in the south-east parts of Central Europe. What is not so easy to explain is the fact that Bohemia appears to have produced no thirteenth-century Gothic portals with decorative statues. The only exception is the Tišnov (Tischnowitz) portal in Moravia which was based on the Golden Gate (Goldene Pforte) in Freiberg, Saxony, and was nearly ruined by subsequent reworking. And yet Bohemia none the less evolved an original form of Transitional Style, in which collective polygonal shafts surmounted by mushroom shaped capitals provided the principal structural element for whole buildings. In fact, apart from France, which furnished the original impetus for this development, Bohemia and the countries within its immediate sphere of influence–namely, Austria and Slovakia–seem to have been the only places where an attempt was made to build hall

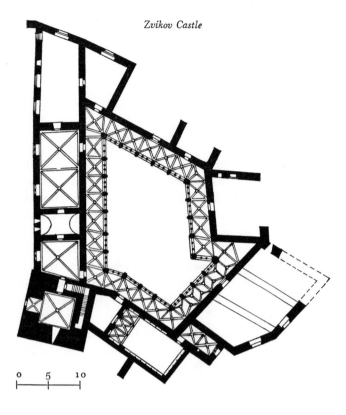

Zvikov Castle

0 5 10

churches, basilicas and barn churches, in which the structural systems were based exclusively on the use of collective polygonal shafts. Moreover, it was only in those countries that such simplified systems were methodically renewed and developed from the Late Romanesque to the Early Gothic of the Cistercians and subsequently–albeit in a fragmentary form in many cases–to the High Gothic of the fourteenth century. The successive phases of this development are best represented by the following sequence of buildings: the gigantic Late Romanesque hall church built by the Praemonstratensians in Tepl in 1231; the magnificently anachronistic Benedictine basilica in Třebíč (Trebitsch), southern Moravia, in which the domical vaults of Anjou are combined with architectural forms taken from the Transitional Style of the Bohemian and Danubian territories; the parish church in Písek, where the structural system used by the Cistercians in Eberbach was taken over and adapted to meet the needs of Bohemian architects; the churches in Oslavan, Milevsko (Mühlhausen) and Vysoký Ujezd (Hohenmauth); and, finally, the Cistercian churches in Zlatá Koruna (Goldenkron) and Vyšši Brod (Hohenfurth) in which the Bohemian system of collective polygonal shafts was developed in terms of the High Gothic.

In the first half of the thirteenth century the chief impetus for new architectural projects came from the nobility on the one hand and the religious leaders on the other. And so we find that the members of the royal house of the Přemyslides, the powerful Herren von Rosenberg (in southern Bohemia), the provincial bishops and the abbots of the great Cistercian monasteries were the foremost patrons of the day. It was only much later, in the second half of the century, that the burghers of the new towns, whose statutes were based largely on Magdeburg or Nuremberg law, began to take an active part in this respect. Like the Hohenstaufen, the late Přemyslide rulers were interested in secular rather than ecclesiastical architecture, and King Otakar II was often referred to as *Der Städtebauer* (the builder of towns). At a time when Bohemia's neighbours were building nothing but cathedrals, the court in Prague authorized the renovation of the castle on the Hradcany hill but refused to restore the Romanesque basilica of St. Vitus. In Bohemia ecclesiastical architecture was almost the exclusive province of the Cistercian and mendicant orders, although in fairness to the secular rulers it should be pointed out that they made generous donations to the monasteries to help them with their architectural projects. In the sphere of castle architecture the Přemyslides were, not unnaturally, far and away the most important patrons. The castles which they commissioned in the second half of the thirteenth century were the most advanced in Central Europe; between the closing years of Hohenstaufen rule and the early period of the Teutonic Order nothing comparable had been erected in any other country. And, of course, Bohemia also led the field for a whole generation during the final phase of this branch of architecture under Emperor Charles IV (see p. 22). It may seem surprising, but it is none the less true, that elements of the Gothic style were adopted by the Bohemian castle architects before making their appearance in the ecclesiastical buildings erected by the Cistercians. This early Gothic influence may be seen in the two-storeyed chapel in the former imperial castle at Cheb (Eger), an exclusively German variant of the feudal chapel, of which Zábori in Bohemia is another example. In its general structure, at least, the upper chapel in Cheb (Ill. 7) is quintessentially Gothic, and as such stands in marked and doubtless intentional contrast to the crypt-like lower chapel, which was built at the same time in a pure Romanesque style. This double chapel must have been completed by 1213 at the latest, for in that year Emperor Frederick II signed a document there bearing the inscription 'data in

capella in castro Egre'. The chapel at Cheb was probably built by craftsmen from Alsace and the Upper Rhine.

Unlike the castle at Cheb, which was an imperial fortress, the castle at Zvíkov (Klingenberg) was built for the Bohemian crown. This irregular, wedge-shaped installation–the main parts of which were completed in the thirteenth century during the reigns of Wenceslas I and Otakar II–was constructed around the keep, whose ancient blackened walls of curved freestone are reminiscent of Hohenstaufen castle architecture. The courtyard was transformed by two-storeyed arcades into a jousting arena, which foreshadowed the arcade courtyards of the Bohemian and Moravian Renaissance castles. The simple rectangular chapel embodies Early Gothic forms of immense vitality, and this castle reflects, probably more than any other in Central Europe, the youthful splendour of the Minnesang, and the lofty aspirations and ultimate decline of medieval chivalry (Ill. 8).

Pisek Castle

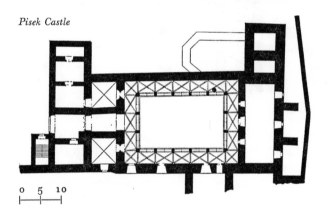

The same Cistercian-trained craftsmen who had worked in Zvíkov also built the royal castle in Pisek, which–like the royal castle in Brno (Brünn)–was based on a rectangular ground-plan. The only variation in Pisek from this regular design is to be found in the single-storey arcades which surround the courtyard.

The castle chapels in Horšův Týn (Bischofteinitz), built under Bishop John III of Dražič, 1258–78, and Bezděz (Bösig) were based on quite different designs. The first of these chapels has a kind of hall choir, and so broaches one of the central themes of the Late Gothic period. It seems likely that it was built by a group of craftsmen who were trained in France and the territories of the Lower Rhine and subsequently worked on St. Ulrich in Regensburg. As for the castle chapel in Bezděz, where Otakar II's widow lived under strict surveillance with the young Prince Wen-

ceslas following her husband's tragic death on the *March-feld*, this constituted a synthesis of Gothic elements taken from the palace chapels of France and the double chapels of Germany. A gallery with a latticed wall runs right round the building at clerestory level, thus creating a simplified two-storey chapel of a kind that was still encountered in the Lower Rhenish territories but that had almost completely disappeared from France. (Although there is no firm date for the Bezděz chapel, all the indications are that it was completed before the end of the thirteenth century.)

The initial phase of Gothic architecture in Central Europe was determined by the Burgundian style of Early Gothic introduced by the Cistercians. They made their influence felt in virtually every part of the territory, but nowhere as much as in Bohemia. By and large, the Bohemian Cistercians concentrated on hall churches whilst their Austrian counterparts were more concerned with hall choirs (Lilienfeld 1230; Heiligenkreuz 1295; Neuberg in Styria; and Zwettl). Unfortunately, it is by no means easy to assess the achievements of the Cistercians in Bohemia with any certainty since nearly all the order churches were sacked by the Hussites. The church in Zbraslav (Königssaal) was completely destroyed, whilst of other churches – for example, those in Osek (Ossegg), Nepomuk and Mnichovo Hradiště (Münchengrätz), only fragments have survived. Not that some of these fragments are without merit. In Osek there is a splendid Early Gothic chapter-house whilst in Mnichovo Hradiště there are two portals with beautifully wrought naturalistic leaf tympana and leaf capitals, which were executed in the northern French style

Prague, Altnai-Synagogue

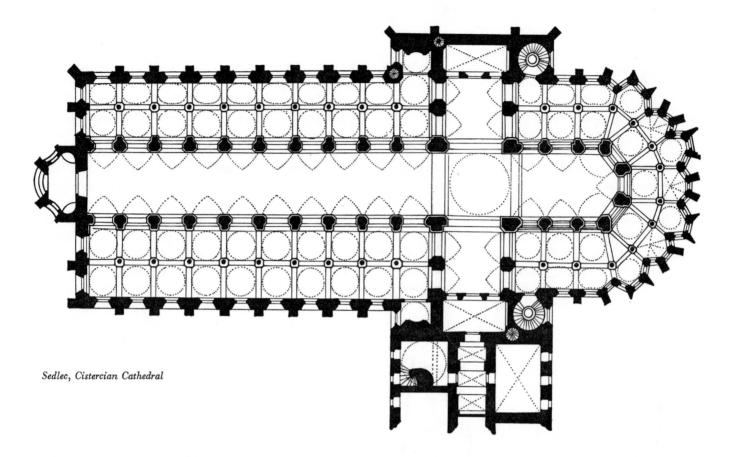

Sedlec, Cistercian Cathedral

of cathedral art. The choir on the other hand–of which only the foundations remain–faithfully followed the rectangular design of the Cistercian mother house at Ebrach in Franconia (although it none the less incorporated twin ambulatories). The precursors of Mnichovo Hradiště include: Walkenried (1219–38); a design by Villard de Honnecourt (who is known to have visited Hungary); and–probably–Lilienfeld (1230). But none of the buildings I have mentioned so far can compare in terms of historical significance with the Cistercian cathedral in Sedlec, which was burnt down by the Hussites and rebuilt in the Baroque style in the eighteenth century. Sedlec was not only the first cathedral in Bohemia, it was the first in the whole of the south-eastern part of Central Europe. True, the architectural system employed there was not on the grand scale of later cathedrals. None the less, it anticipated the Late Gothic cathedral choirs of the Parlers, for with its triangular bays this early multi-naved building reflected, for the first time in Central Europe, the progressive and anti-classical cathedral design based on the tripartite vault (the *Dreistrahl*, i.e. the triangular unit of vaulting from which the stellar vault was developed). In this respect it was very similar to the choirs in Châlons-sur-Marne, Le Mans, Toledo, Zwettl, Kaisheim, Kolin, Kutná Hora (Kuttenberg) and Nuremberg. In fact, Sedlec was even more advanced than Toledo, since all its chapels were polygonally terminated: those facing the trapezoid bays in the ambulatory octagonally, those facing the triangular bays hexagonally. Thus, for the first time ever, the new type of vaulting based on the tripartite vault achieved equality with cross vaulting. A generation later the ambulatories of the Parler choirs were, without exception, surmounted by tripartite vaults, which converged to form 'crazy vaults'. In all of these anti-classical vaults, which had their origins in the territories of the Lower Rhine, the rows of supporting pillars were staggered.

Unlike the Cistercians, who had their own monastic craftsmen, the mendicant orders commissioned lay architects, and hired craftsmen, in the nearby towns. Consequently, we find that whereas the Cistercian monastery architecture of the period is consistently aristocratic and austere in all parts of western Europe, the churches and monasteries built by the mendicant orders were subject to considerable regional variations. Thus, the German mendicant churches

were quite different, not only from the Italian, but also from the French and English, mendicant churches. In Central Europe, i.e. in Germany and Bohemia, we find—in both basilicas and hall churches—long and high choirs; naves with simple rectangular aisles but with no transept and no subsidiary choirs; and, more often than not, oblong and narrow bays. Initially, the mendicant orders concentrated almost exclusively on basilicas. It was only in districts such as Westphalia and Hesse, where hall churches were traditional, that they went over to this system. Later—due in no small measure to the example set in these northern districts—they also began to build hall churches in Austria and Bohemia. The architecture of Central Europe was not greatly influenced by the Italian mendicant orders, to whom hall churches and long and high choirs were virtually unknown. But by incorporating the twin naves first evolved for secular halls, refectories and chapter-houses into sacred buildings—in Paris, Toulouse and Agen—their French counterparts undoubtedly contributed to the development of the hall church in the different Central European territories, although it must be said that this particular kind of architectural system was nowhere near as popular in France as in many parts of the Austrian Alps, where it was virtually mandatory during the Late Gothic period. It was also used for numerous churches, both in the neighbouring territories of southern Bohemia and Moravia, and in Slovakia. As for long and high choirs, these were seldom used in conjunction with multiple nave installations in France, and never in a single-storey system. Yet the strangely expressive pathos of the high choirs would be inconceivable but for the extension of the single-storey system in the French palace chapels.

In England long choirs were built only from the late thirteenth century onwards, and most of these had flat roofs and rectangular terminations. (Of course, the predilection revealed by English architects for a bell tower between the nave and the choir tended to militate against this development.) Meanwhile, long choirs had been adopted in Central Europe at a much earlier date. The double choirs flanked by choir towers found in Naumburg Cathedral, and the principal choirs in the transeptless triapsidal churches, in which the subsidiary choirs were partitioned off, are, to all intents and purposes, Romanesque prototypes of the long and high choirs of the Gothic period. It seems likely that there is a genetic link between these pre-Gothic structures and the high and long choirs

introduced by the mendicant orders. The triapsidal ground-plan of the Dominican church in Regensburg, which contains elements of both styles in more or less equal measure, would certainly suggest that this was the case. The actual transition to the Gothic long choir—which preceded the high choir—was not effected, of course, until the subsidiary choirs were discarded, and the principal choir was both elongated and isolated. The earliest Gothic long choirs were built in the territories of the Upper Rhine, first with rectangular terminations and flat ceilings, and later—from the turn of the century onwards—with polygonal terminations and vaulted roofs. In Bohemia long choirs were often used in conjunction with short, box-like naves, although initially this practice was less common in Prague and the central areas of the country than in towns such as Jihlava (Iglau), Cheb, Olomouc (Olmütz) and Panenský Týnec (Jungferteinitz), which are situated in the border districts of the south and west. It is also interesting to note that the early long choirs had not narrow, but deep rectangular bays, frequently with sexpartite vaults: the Dominican Church in Jihlava (1260–70), the Minorite Church in Jindřichův Hradec (Neuhaus, early 1300s), the Church of St. Maurice in Kroměříž (Kremsier), and the Church of St. John in Brno are examples. Of course, the vast majority of Bohemian churches, including those built by the Cistercians, were burnt down by the Hussites, and the few that escaped were totally transformed by Baroque conversions in the seventeenth and eighteenth centuries.

One of the first Bohemian religious settlements, if not the first, was the Convent of the Poor Clares in the old town of Prague. Soon after its foundation, which may well go back to 1233, the settlement was extended to accommodate twin convents dedicated to St. Francis and St. Laurence. Princess Agnes, the sister of King Wenceslas I, was both the original founder and the first abbess. The cluster of buildings which made up the settlement was quite extensive, and eventually embraced at least two cloisters and three sacred buildings. The layout was organic rather than architectural. During the early phase of the construction programme the craftsmen were all members of the Přemyslide workshop and, as such, had received their training from the Cistercians. But later these native workers were joined by a group of Saxon craftsmen, most of whom had been employed in either Naumburg or Magdeburg. The Church of St. Francis, an asymmetrical vaulted basilica with twin naves but with no choir was probably completed by 1249. The sanctuary, which consists of two bays terminating in one octagonal, and the rectan-

gular structure attached to the north wall (the so-called chapter-house; Ill. 15), which consists of three oblong bays, were added in the following year, whilst the Salvator Chapel, which consists of two bays and a polygonal choir, was incorporated in 1285. This small but exquisite building, whose component forms still reflect the rich plasticity and the slender grace of classical Gothic art, is undoubtedly one of the most perfect examples of thirteenth-century ecclesiastical architecture in East-Central Europe (Ill. 16).

But despite its great beauty, the monastery founded by Princess Agnes exerted no influence on the subsequent development of Bohemian architecture. This was not the case with the churches built by the mendicant orders in the new urban centres and hill towns of the border districts, such as Cheb, Olomouc, Jihlava and Brno. The Minorite Church in the silver mining town of Jihlava contained a remarkably early rectangularly terminated long choir composed of three bays, and—doubtless a legacy from the Cistercians—a transept. This church is thought to have been consecrated in 1258. If so, it was the earliest vaulted

basilica erected by the mendicant orders in Central Europe, although at the time this will hardly have been regarded as a recommendation, for the mendicant orders, especially those in Italy, were very much opposed to vaulting. In the Dominican church in Jihlava, which was built in the 1260s, a short box-like nave was combined with an octagonally terminated long choir surmounted by two sexpartite vaults. In many ways this church served as a prototype for both the Bohemian parish churches and the later churches built by the Bohemian mendicant orders. In the Franciscan hall church at Cheb for example, a short nave containing four bays was used in conjunction with an octagonally terminated long choir containing three bays. This Franciscan church was destroyed by fire in 1270 and was replaced by a second church that was consecrated in 1285 in the presence of Emperor Rudolph of Habsburg, King Wenceslas and numerous dukes, margraves and bishops. The Minorite churches in Jindřichův Hradec and Brno also had polygonally terminated long choirs surmounted by sexpartite vaults. Of course, long choirs with sexpartite vaulting were a fairly common feature of east Central European architecture, although in some cases—notably, in the cathedrals at Wroclaw and Cracow—these choirs were only the long inner sections of triple choirs. Finally, we find long choirs with regular ribbed vaults in the Dominican church in České Budějovice (Budweis) and the Franciscan church in Plzeň (Pilsen). Strangely enough, the interior of this Franciscan building lacks the austerity that is the hallmark of so many of the churches built by the mendicant orders.

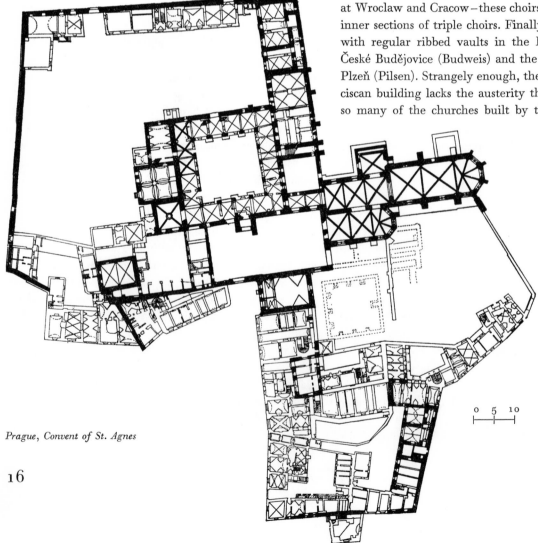

Prague, Convent of St. Agnes

0 5 10

16

The proportions in Plzeň suggest comfort rather than asceticism. The Dominicans were the first of the mendicant orders to adopt High Gothic forms, although it must be said in this connection that whereas the buttresses in their church at České Budějovice simply rested against the walls of the choir, those in the nearby Cistercian church at Zlatá Koruna rose triumphantly above the cornice. Between them, the stunted buttresses and the flattened window arches at České Budějovice create an air of deep pathos. Unfortunately, work on the Dominican church in České Budějovice, which was based on a remarkably bold design, proceeded very slowly, with the result that it exerted no influence on the further development of Bohemian architecture. This was not the case with the Dominican church in Jihlava, whose ground-plan—which incorporated a box-like nave and a long choir—was adopted and modified in the fourteenth and fifteenth centuries by the other mendicant orders, the working orders, and the burghers responsible for the erection of the parish churches in Žatec (Saaz), Ústí nad Labem (Aussig), Tabor, Prachatice, Kutná Hora, Vysoké Mýto, Šlany (Schlan), Rakonice, Melnik, Nepomuk and—last but not least—Prague (where the churches of St. Henry and St. Stephan were based on this plan).

The only variant on this basic type was the triapsidal ground-plan which had been established in the southeastern areas of Central Europe since the beginning of the Romanesque period and had been adapted at a very early stage by Gothic architects in Bohemia, who used it

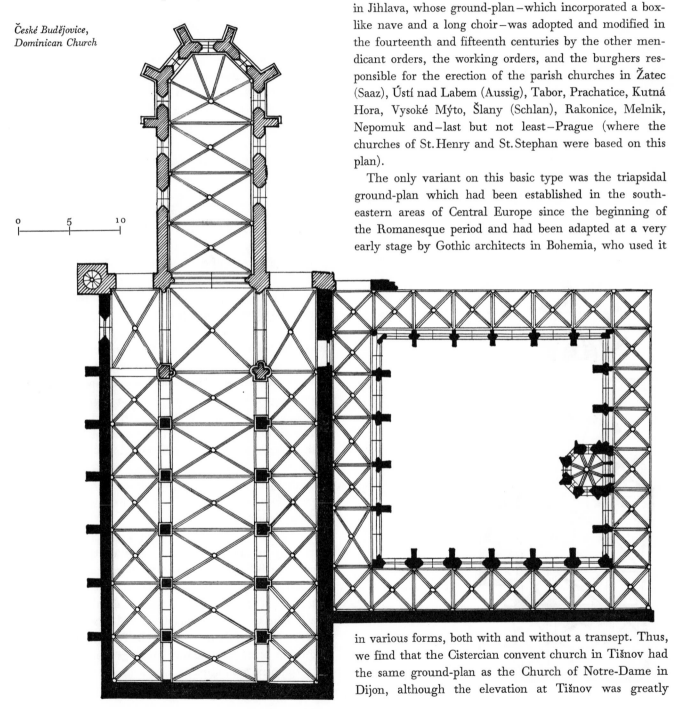

*České Budějovice,
Dominican Church*

0 5 10

in various forms, both with and without a transept. Thus, we find that the Cistercian convent church in Tišnov had the same ground-plan as the Church of Notre-Dame in Dijon, although the elevation at Tišnov was greatly

17

simplified in accordance with Cistercian practice. The church of St. Urbain in Troyes is also interesting in this respect, for the triapsidal ground-plan used there was subsequently introduced into a basilica in Kouřím and a hall church in Kolin (although the choir at Kolin was not built in the form of a hall choir). The first Bohemian triapsidal hall choir, which was executed after the manner of St. Stephan's Cathedral in Vienna and the Church of Our Lady on the Sand in Wroclaw, was the choir of the Emmaus church in Prague, which dates from the second half of the fourteenth century. In the Church of St. Bartholomew in Kolin, which was erected by the local burghers, we find an amalgam of the Early Gothic hall church design used by the Cistercians throughout Central Europe and the somewhat later hall church design evolved in Hesse and Westphalia. Of course, the squat console pillars in the Church of St. Stephan in Kouřím were also of Cistercian provenance, as was the vault of the octagonal crypt beneath the choir, in which eight tripartite vaults emanate from a central pillar to form a star-shaped pattern. This is one of the earliest umbrella stellar vaults on the continent (Ill. 14).

Kouřím, St. Stephan's with crypt

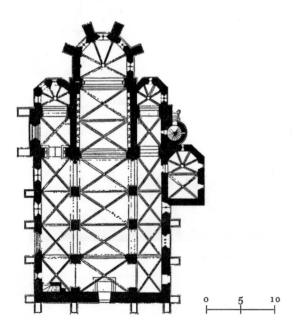

0 5 10

The Caroline Era

The advent of the Luxembourgers, under whose guidance Bohemia soon came to dominate the political and cultural life of Central Europe, was accompanied by the introduction into Bohemia of the High Gothic style of architecture. From then onwards it was the mendicant orders, and not the Cistercians, who exerted the major influence. A further innovation was the emergence of the burghers as architectural patrons, which meant that the king and the provincial bishops were no longer the only builders in Bohemia. In Prague alone three new churches were built in rapid succession, all of which featured the lofty choir that was characteristic of Central European High Gothic architecture. The expressive forms of these mighty structures towered above the town houses of the burghers, thus providing new focal points which changed the character of the urban scene. None of these three churches has survived in its original form. The Minorite Church of St. James, which was consecrated in 1374, was the only one to be spared by the Hussites (because it was needed as a storeroom by the local butchers). But then, having escaped the ravages of the iconoclasts, St. James was gutted by fire in 1689. The choir in this church, which was donated by the wealthy Prague burgher Konrad von Leitmeritz, was about 30 metres high and incorporated no less than five bays whilst the choir in the Church of the Augustine Order, which was completed five years after St. James's, had four bays and was twenty-seven metres high. But big as these choirs were, they could not compare with the marvellous structure in the Carmelite Church of Maria Schnee, which was three metres higher than the cathedral choir built for St. Vitus's. The interior design for this Carmelite church was quite breathtaking in its audacity. The whole of the vertical space between the buttresses was taken up by tracery windows, which made the church look like an enormous glasshouse, but a glasshouse executed in the most delicate filigree.

The ascetic character of these high choirs was, of course, by no means representative of the art forms favoured in Bohemia, or in Central Europe as a whole, in the mid fourteenth century. The reaction against the austerity and monotony of the highly simplified architectural system used by the mendicant orders was led by the Parlers and energetically promoted by Emperor Charles IV, who commissioned numerous buildings which had much more complex ground-plans, and achieved a much more sophisticated use of internal space. Under Charles IV the

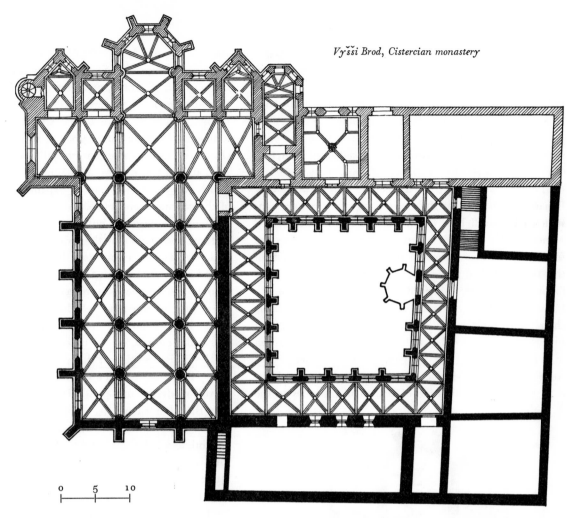

0 5 10

round church, which had all but disappeared from Bohemia since the Romanesque period, underwent what was virtually an anti-Gothic renaissance. As for the hall church, which had been almost completely banished from French ecclesiastical architecture by the new Gothic cathedral, this was only fully established in Central Europe with the introduction of Gothic architecture, which coincided with the rise of the burgher class. At the same time, the basilica, which remained very much in vogue in other parts of Europe, was virtually abandoned by the Late Gothic architects of Germany, and also lost a great deal of ground in Bohemia. Eventually, the hall choir and, with it, the round church were assimilated into the hall church system of architecture. The paradoxical situation whereby round churches and cathedrals were reorganized in this way—or, to be more precise, the paradox of the cathedral hall choir—was encountered only in Central Europe (for example, in Zwettl, Salzburg and Landshut). In Bohemia, however, only the first stage of this process— namely, the reorganization of the cathedral—made itself

felt. It was, of course, initiated by the Parlers when they introduced the Late Gothic phase of cathedral architecture. Although hall churches were built in the new towns of the Bohemian border territories at an early stage, it was not until the mid fourteenth century that they began to appear in Prague and the other more centrally situated towns. The naves and aisles in these churches are, for the most part, short and squat, and the pillars unjointed and either polygonal or prismatic in cross-section. Although relatively rare, jointed and clustered pillars do occur. For example, in the Church of St. James in Kutná Hora, which is the oldest of the four hall churches built in this wealthy silver-mining town, we find jointed pillars of rhomboidal cross-section, whose diagonally aligned faces open up a new visual plane, thus creating an extremely fluid system of spatial relationships (Ill. 22). The architectural system employed in Teplà (Tepl) during the Late Romanesque period, which was based on the use of collective polygonal shafts, was also retained, and in the Cistercian hall church in Vyšší Brod—where such shafts were used both for the

19

columns and on the walls—it was adapted to the require- ments of the Late Gothic. The result is a simple, but ex- tremely compact, barn-like structure, which found many imitators. Similar churches were built in Tabor, Jihlava, Käsmark and—above all—the Emmaus monastery in Pra- gue. In the monastery church, which—like the Benedictine monastery church in Sazawa—was donated by Emperor Charles IV as a centre for the Czech mass, there is a triap- sidal choir that differs from the earlier thirteenth-century Bohemian type in that the three polygonal apses are con- structed in parallel, as in Silesia, and not in a staggered sequence. The Parlers carried this development one stage further when they placed in the polygonal main choir of the Týn Church a pillar in the principal axis. They then followed this up by using this plan for all three choirs in Jaroměř and Louny (Laun). Eventually, of course, triple choirs were replaced by single hall choirs. The fact that smooth, heavy four-sided pillars occurred relatively often in Bohemia during the High Gothic period, although they were most unusual—in fact, almost unheard of—elsewhere, is in many ways indicative of Bohemian attitudes to the

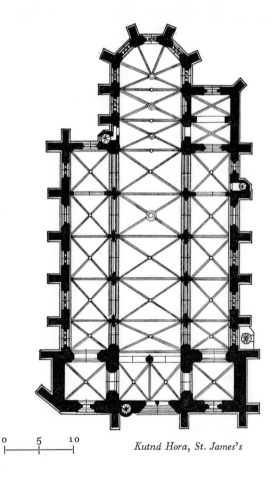

0 5 10

Kutná Hora, St. James's

Gothic. The first hall church built in Prague, the choirless Collegiate Church of St. Ägidien, which was donated by Bishop John of Dražič, and consecrated in the presence of the emperor in 1371, has extremely powerful, four-sided pillars, similar to those in the Church of St. Maurice in Kroměřiž, Moravia. St. Henry's, Prague was yet another church in which these massive pillars were used, but the spacious, almost comfortable, proportions of St. Henry's— which was built in the more expansive style of the turn of the century—tend to reduce their impact.

There is a persistent but erroneous belief amongst archi- tectural historians that the two antithetical types of short hall church—the central and the four-pillar church—orig- inated in the Bohemian territories. With the single-pillar church the emphasis is placed firmly on the pillar in the centre of the nave which, together with the vault, brings out the integral character of the interior. With the four-pillar church, on the other hand, attention is focused on the limited section of the interior circumscribed by the four pillars (the central area of the three sets of three bays in the model ground-plan). It is only logical, therefore, that the altar should be placed within this central area (whose four pillars surmounted by a vaulted ceiling are not unlike a baldachin) and, in point of fact, we find that this was usually done. Poitiers, Heiligenkreuz, Neuberg in Styria, Enns, Pöllauberg and Salzburg are all examples. But the prototype of the four-pillar church in south-east Central Europe was the Nuremberg Church of Our Lady, which was built as an imperial chapel between 1350 and 1352, possibly by Peter Parler (See p. 28). It comes as no surprise, therefore, to discover that the portal of the earliest four-pillar church built in Inner Bohemia—the Church of the Poor Clares in Panenský Týnec, which dates from 1382—was decorated with statues in the Parlerian manner, just like the Týn Church in Prague. Four-pillar churches also appeared in Kutná Hora and Dvůr Králové (Königin- hof) after the turn of the century. All had round pillars. But although the ribs emerged uniformly from the heads of these pillars, they did not determine the shape of the vault, because this type of interior was based on the medi- eval bay concept and the ribbed vault, just as the single- pillar interior was based on the umbrella vault. Conse- quently, we find that the four-pillar church was aban- doned with the passing of the High Gothic whereas the central pillar church continued to flourish during the Late Gothic period, when it was incorporated, together with the Late Gothic developments of the umbrella vault, into monumental architecture. It should be noted, however,

Jindřichův Hradec, Minorite Church, St. Nicholas's Chapel

rhomboidal crowns which extended from the calyx-shaped bases of the vaults like petals.

Although the Bohemian Gothic architects did not begin to build rectangular central pillar churches until the mid fourteenth century, they still used the traditional cross vault for these buildings, and continued to do so for the next hundred years, although they invariably incorporated one or more tripartite vaults between the central pillar and the arch of triumph. Examples include: the Chapel of St. Nicholas in Jindřichův Hradec, 1365-70; the Servite Church of St. Mary in Prague, 1378; St. James's in Větlá (Wettel), 1380; Loučím, *c.* 1400; and Polín. Incidentally, this rather crude solution, which was first used in Romanesque crypts (for example, in Maastricht and Brandenburg), is also found in numerous twin-naved hall churches built in southern Bohemia during the Late Gothic period. These churches – examples of which may be seen in Třeboň (Wittingau), Bavorov, Soběslav, Selčan, Miličín, Nemčiče and Milevsko – were inspired by the twin-naved hall churches

Vetlá, St James's

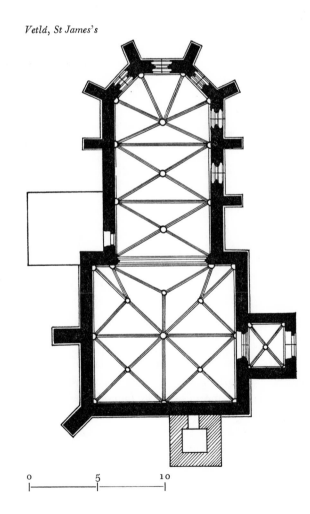

that this distinctly anti-classical type of interior was used for churches only in Central and Northern Europe (primarily in all those eastern Central European territories, from Scandinavia, where it had been especially popular in the Romanesque period, to Slovenia). No central pillar churches appeared in Italy, France or England, although these countries did produce a number of secular rooms based on this principle. The central pillar in this type of building – which sinned grievously against classical theory since it blocked the principal axis and also impeded the congregation's view of the altar – was, of course, the main feature, not only of the interior, but also of the vault. As fas as I can judge, the first umbrella vault appeared in the crypt of St. Michael's, Fulda, which is a Caroline building. In point of fact the Romanesque period produced various new methods of umbrella vaulting, but only the umbrella vault with tripartite vaults was adopted, and subsequently orchestrated, by the Gothic architects. This led to the development of the High Gothic umbrella stellar vault, in which four or more tripartite ribs are arranged around a central support in such a way as to produce a star-shaped pattern. Whilst the German architects of this period frequently eliminated the separating rib between the tripartite vaults, their English counterparts added more and more ribs – not always with beneficial results – until they eventually progressed to the fan vault. The corresponding development in Central Europe was effected by the Parlers, who advanced from the High Gothic umbrella stellar vault to the rhomboidal net vault, this being the nearest Continental equivalent of the English fan vault. The principal difference between the two types of umbrella vaults is that whereas the English architects attached more importance to the decorative ribs, the Parlers stressed the

of the Alpine territories. Rectangular central pillar churches with stellar umbrella vaults formed from between six and eight tripartite ribs are not found in Bohemia. But there are strong indications that large scale octagonal versions of this type of building were planned, and possibly executed, on one or two occasions. A case in point is the Karlshof Choristers' Church in Prague, an imperial foundation that is nearly twenty-two metres wide. Although the original vault was replaced in 1575 by a dome-like ribbed vault, which was presumably executed by Boniface Wolmuet, it seems more than likely, from an inspection of the present building and from other, more general, considerations, that in the first instance a stellar vault consisting of eight tripartite ribs and supported by a central pillar, was certainly envisaged, and very probably built. A second church where we may assume the existence of an original stellar vault with a central pillar is St.Mary's

It was erected between 1382 and 1393 to provide a suitable setting for the public display of the imperial crown jewels and holy relics, and was a four-pillar cruciform building with lofty polygonal side choirs placed at an angle between the polygonally terminated arms of the transept. What was new about this chapel was that, unlike the Church of Our Lady in Trier, it was built, not as a basilica, but as a hall church. Charles IV also commissioned various imperial castles, including Karlštejn Castle, which was built between 1348 and 1365 to provide a secure place in which to keep

Třebon, Church of St. Augustine

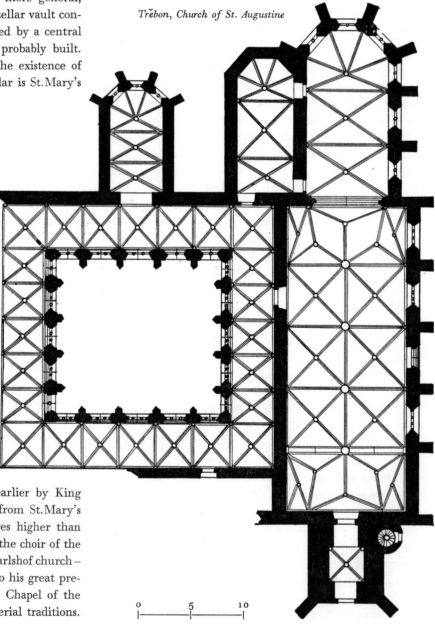

in Ettal, which was built a generation earlier by King Louis the Bavarian. The vault removed from St.Mary's during the Baroque period was four metres higher than the enormous stellar umbrella vault above the choir of the Dominican church in Toulouse. Like the Karlshof church – which was dedicated by Emperor Charles to his great predecessor and namesake, Charlemagne – the Chapel of the Blessed Sacrament in Prague renewed imperial traditions.

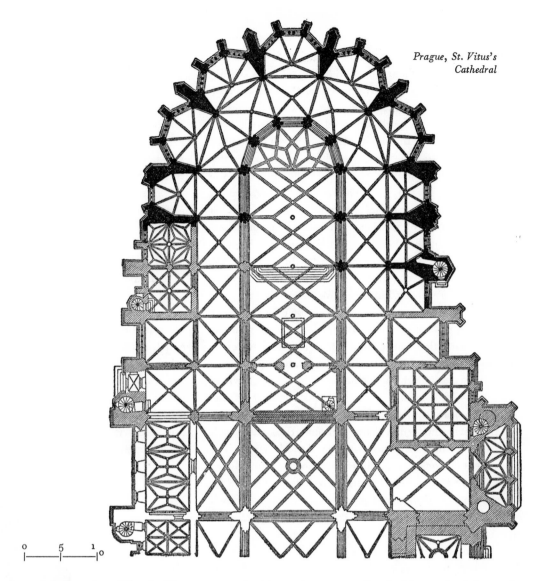

0 5 1
|———|———|———|0

the imperial crown jewels and holy relics (Ill. 11). The core of the defensive system at Karlštejn, which contained no less than five sacred rooms, was the second chapel tower. This massive structure, whose walls were between six and seven metres thick, housed the Chapel of the Holy Cross, which was consecrated in 1365 after being fitted out at immense cost. The plinth was decorated with more than two thousand semi-precious stones set in gold stucco, with the emperor's initial (K), the imperial crown and the imperial eagle superimposed as a continuous motif. This was surmounted, first by a ring of 1330 candles, and finally by a series of 137 life-size head and shoulders paintings of saints, martyrs and angels, many of whom are portrayed looking down into the chapel and pop their heads out of the frames, like emissaries from the other world. The windows were made from translucent semi-precious stones, the vault ribs were gilded, and the keystones silvered and de-

corated with precious stones. On the blue web of the vaulting there were hundreds of glittering stars, fashioned from gold leaf studded with crystals, and there was a silver moon and a golden sun. Only the archbishop was allowed to pass beyond the gilded tracery screen into the choir, for it was there—in a blue niche decorated with golden stars—that the imperial crown jewels were kept. In referring to the installations at Karlštejn Benesch von Weitmühl, the imperial chronicler, wrote in a style that would have done justice to the Castle of the Holy Grail: 'In the whole wide world there is no castle and no chapel so finely wrought; and rightly so, for it is here that the imperial crown jewels and all the treasures of the kingdom are kept'.

The most important architectural development in Bohemia in the fourteenth century was, without doubt, the rebuilding of St. Vitus's Cathedral. The foundation stone was laid in 1344, the year in which Prague was elevated to an

23

archbishopric, and work was then started under the supervision of the French architect Matthieu d'Arras. Unlike the Cistercians in Sedlec, Arras opted for the kind of classical design traditionally used for royal cathedrals, despite the fact that this was quite outmoded. By 1352, when Arras died, the chapels at the top of the choir, three of those on the south side, and one on the north, had been completed in orthodox High Gothic. The rest of the cathedral was then executed in the Late Gothic style introduced by Arras's successor Peter Parler, the most important member of the great family of Suabian architects, who erected Late Gothic buildings for the emerging burgher class in every territory of Central Europe. Incidentally, the life and work of this great architect and sculptor are well documented. We know more about him than we know about any of the other fourteenth-century artists, most of whom have remained quite anonymous. Peter Parler was well acquainted with the two antithetical styles of architecture used in his day for ecclesiastical buildings, having encountered the Late Gothic hall church in his home town of Schwäbish-Gmünd, and having worked on one of the great European cathedrals as an apprentice in Cologne. But this early knowledge of burgher and aristocratic architecture does not fully account for Parler's style. The monumentality of his sculptures, which were unparalleled in Germany at that time, and his absolute preference for Late Gothic vaulting, also presuppose first-hand knowledge of the cathedral art of north-west Europe, and more especially England, whose architects had gone over to the Late Gothic style before their French counterparts. When Peter Parler took over at St. Vitus's he made major alterations to Arras's conservative plan, extending the cathedral to the south so as to incorporate the burial place of St. Wenceslas, which had been held sacred since time immemorial. The St. Wenceslas Chapel, which commemorates the martyrdom of Bohemia's patron saint, is almost completely enclosed within the cathedral. As a result, the interior is dark and mysterious, almost forbidding. The ground-plan of the choir, and the earliest parts of the elevation, which were designed by Arras, were more or less orthodox. But the later parts of the elevation, for which Parler was responsible, were quite revolutionary.

The first section of the cathedral completed by Parler was the highly inventive south porch (Ill. 29). Then, in 1369, the aisles in the choir were vaulted, and in 1374 work was carried out on the triforium and the windows of the high choir, whose tracery screen produces a strange impression of undulating movement, like the screen in Wells

Cathedral (Ill. 26). In 1385 the choir was consecrated, and in 1392 the foundation-stone of the nave was laid, although before proceeding with the nave Parler first turned his attention to the south face of the transept with the Hostium Magnum and the great south tower. It was here that he really demonstrated his rich inventive talent. In doing so Parler virtually put the cathedral through a ninety degree turn, for this south face was so impressive that it displaced the principal façade as the visual centre of the external elevation. With a bravura piece of illusionism Parler gave the impression that the successive storeys of the filigree staircase turret of the transept deviated from the perpendicular axis, first to the left, and then to the right. Although the great south tower was evidently intended to offset the domestic townscape, it was not conceived simply as a scaffold, but rather as a steep and compact pyramid of immense power. Of course, the upper storeys were executed, not by Peter Parler, but by his sons Wenceslas and John, as were the decorative motifs on the south face of the transept, which are typical of the flowing linear art of the turn of the century. In the end, the tower remained a fragment, but a fragment which proved extremely influential: without it important features of the magnificent south tower of St. Stephan's Cathedral in Vienna would

Kolin, St. Bartholomew

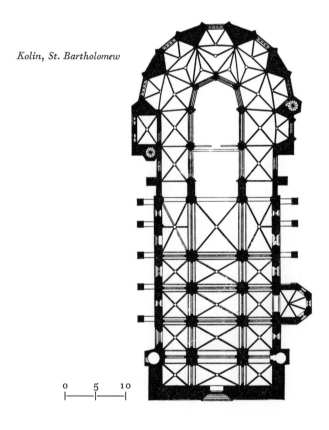

have been inconceivable. Peter Parler died in 1399. Twenty years later the Hussite wars broke out, and all work stopped on St. Vitus's.

The most important of Peter Parler's other buildings was the cathedral choir which he built for St. Bartholomew's, Kolin (Ill. 19). In Kolin, where he was able to plan the whole project from the start, Parler opted for the anti classical type of cathedral choir with tripartite vaults in the ambulatory that had been introduced into Central Europe by the Cistercians and elaborated by the burghers. Examples may be found in Sedlec (*c.* 1300), Zwettl (1343), Schwäbisch-Gmünd (1351), and Kaisheim (1352). But, of course, Parler went one step further than the burghers, for he covered all the bays in the ambulatory with tripartite vaults or–to be more precise–with 'crazy vaults'. This arrangement, whereby one pillar was moved into the principal axis, was anticipated by the triangular compartments of the ambulatory in Notre Dame de Paris and in the twin-naved Jacobean church in Toulouse, where a pillar surmounted by an umbrella vault was placed in the principal axis. As for Parler's third Bohemian cathedral project–St. Barbara's, Kutná Hora–this was little more than a variation on the cathedral choir in Kolin. Moreover, this choir remained a fragment, for work ground to a halt at Kutná Hora in 1401, just two years after Parler's death. But although he did not live to complete St. Barbara's, Peter Parler did witness the completion of the Prague Karlsbrücke, the new bridge commissioned by the emperor to replace the Romanesque Judithbrücke, which had been destroyed by floodwater. The Karlsbrücke, which was begun in 1357, was far larger than any other stone bridge in Bohemia. In structural terms, admittedly, it was not particularly advanced, although it is quite clear from the model in the tower on the old town side of the Karlsbrücke that Parler did, in fact, evolve a much improved method of bridge construction using braced segmental arches. What is quite certain, however, is that the Karlsbrücke is the most beautiful, and the most famous, bridge ever built in the old Holy Roman Empire.

Perhaps the most important development initiated by Peter Parler was the net vault. Although this was not a new invention–it was derived from Cistercian and, above all, English models–before Parler's day it had been quite unknown in Central Europe, where it subsequently exerted considerable influence on the development of Late Gothic cathedral architecture. Parler's vaults were strictly formal variations of either the ribbed cross vault or the tripartite vault, and although the first type was of no consequence

Prague, Tower of the old city bridge

for the further development of Gothic vaulting, the second most certainly was. The tripartite vault, which had first emerged in the territories of the Lower Rhine (where it was used for the Palace Chapel in Aachen), had appeared in quite complex structures even during the Romanesque period. Thus, in the chapter-house at Worcester, it formed the basis of a centrally supported stellar vault, and elsewhere it was incorporated into crazy vaults, whilst still retaining its irregular, anti-classical character. The only way of developing regular vaults from these structures was by eliminating the axial pillars. And so from the umbrella vault with tripartite ribs and a single central pillar the regular dome-shaped stellar vault was evolved, and from a combination of crazy vaults–either juxtaposed or built up one above the other–the net vault. In the choir of St. Vitus's Cathedral there is a net vault composed of two crazy vaults placed one above the other which, between them, form a rhomboidal pattern similar to that found in York Minster, the one difference being that Parler avoided the use of lierne ribs. Although the pattern of the vault above the gateway of the new bridge tower on the old town side of the river was also produced by a combination of two crazy vaults, these were juxtaposed, as in the twin-naved Cistercian chapter-houses. In the case of the tower, Parler simply eliminated the axial pillars and fashioned a regular dome-shaped vault. This whole development is clearly demonstrated by the south porch of St. Vitus's, which may be said to have been conceived in the spirit of the tripartite vault in so far as there are three outer arches in the porch and only two inner arches, with the result that the pillars form a triangular pattern. For technical reasons alone, this unusual interior could only be covered with a vault based on the tripartite vault, since in this system the symmetrical axis is always blocked by at least one pillar. In fact, the vault above the south porch in

St. Vitus's may be interpreted in three ways: if we consider the tripartite compartments across the whole width of the porch—and given the general shape of the interior, this is a perfectly natural thing to do—we find ourselves faced with a crazy vault; if we look at the crown of the vault we see a regular dome-shaped stellar vault; and, finally, if we have the pillars in view, then the chief emphasis appears to lie on the trumeau planted in the central axis, from whose head slender shafts emerge to link up with the vault ribs, thus forming the skeleton of an umbrella stellar vault. This highly inventive solution proved extremely influential. Quite apart from the porches of the Maltese Church in Prague and the churches in Chrudim and Vysoké Mýto, the ambulatories of the cathedrals in Kolin and Kutná Hora, which had crazy vaults with pillars in the principal axis, were derived from Parler's design, which means that Stethaimer's hall choirs, in which umbrella net vaults were constructed in the central section of the ambulatory, were influenced by it (the Hospital Church in Landshut, the Franciscan church in Salzburg, and the later churches in Merano, Fernitz and elsewhere are examples). Of course, the three and five-pillar churches of the Bavarian and Austrian border districts, examples of which may be found in Braunau, Eggelsberg, Rieth and

Prague, Bethlehem Chapel

0 5 10

Kreuzen, were lastly also derived from the south porch of St. Vitus. The pillars in these churches are arranged in a triangular formation, and so form diagonal passages, as in the crypt of the chapter-house of Wells Cathedral. In this kind of architectural system, which is unique in European ecclesiastic architecture, the basic structural unit was the umbrella vault and not the cross vault and the High Gothic bay. As for the net vault, which Peter Parler evolved from the crazy vault, this was used during Parler's lifetime for various hall churches, the first of these probably being the asymmetrical four-naved Bethlehem Chapel in Prague, which was donated by Hans von Mühlheim and consecrated in 1394. If the vault (recorded in a plan) – which reflects in more or less equal measure elements of the crazy and stellar vault of the south porch of St. Vitus and the net vault of the bridge tower – is original, then this chapel must have been the prototype both for the hall churches with umbrella or net vaults of the late fourteenth and early fifteenth centuries (examples of which may be found in Austria in Handenberg and Neukirchen on the Enknach) and also for the three-pillar churches of the Austro-Bavarian territories. The development of the rhomboidal umbrella net vault of the Late Gothic period from the High Gothic tripartite and crazy vaults was also accomplished by the members of the Prague Cathedral workshop or their associates, and the first stage in this process may well have been the vault in the Welsh Chapel in Kutná Hora which was built by Peter Parler's son John (Ill. 32). The fact that this innovation should have taken place in Kutná Hora, and not in Prague, is not really surprising, for the Parlerian style of vaulting spread throughout Central Europe with amazing speed, and at one time was adopted by virtually every Central European workshop. The so-called Junkers of Prague from the Prague Cathedral workshop acquired almost legendary fame. It is also probable that Peter Parler's son Wenceslas, who ran both the Prague and the Viennese cathedral workshop, was the *ingegnere Venceslao da Praga*, who was invited from Vienna to Milan in 1401 to work on the Milan Cathedral project.

But following the death of Emperor Charles IV in 1378 conditions in Bohemia had become progressively less propitious, and from the turn of the century onwards architecture, and the allied arts of sculpture and painting, had been forced to yield pride of place to the literary arts, which found expression primarily in the spoken word of the preachers. Then, in 1419, the Hussite storm erupted, thus bringing to an end an epoch which probably constituted the absolute peak of Bohemian history.

3. Bohemian sculpture up to the Hussite Wars

The first examples of High Gothic sculpture in the Bohemian territories date from *c.* 1340, which is rather late by comparison with western Europe. But although they can scarcely be classified as revolutionary works within the wider context of the international Gothic movement, these Bohemian statues none the less form a composite group of sculptures with characteristic and well-defined Gothic features. The central figure of the group is the Madonna from Michle (Ill. 37), whose thin, vertical drapery folds provide a very pure example of the unnaturalistic style evolved for the decoration of St. Catherine's Chapel in Strasbourg and subsequently carried, via Freiburg im Breisgau, to Suabia and Central Germany. The remaining works in the group consist of three further Madonnas, a small carving of an Apostle from Moravia (Ill. 38) and the Crucifixion from the Barnabite Monastery in Prague (Ill. 41). (Yet another work which bears an amazing resemblance to the Madonna from Michle is the figure of St. Florian from the church of the same name near Linz [Ill. 40]). In addition to this rather distinctive group, which was created by a single workshop probably located in southern Bohemia, a number of sculptures were produced in the course of the 1340s which reveal an indebtedness to Vienna and, above all, Regensburg. The Viennese stimulus was provided by the sculptures in the choir of St. Stephen's, which had been derived from thirteenth-century French models, whilst in Regensburg the principal influence came from the followers of an important Romanesque tradition and from the great Erminold master. The Madonna from Strakonice (Ill. 43), in which the Madonna's body is still fairly relaxed despite the use of a *contrapposto* technique, is an example of this older trend. So too is the Madonna from Rudolfov (Rudolfstadt) (Ill. 44), in which the *contrapposto* is much more rigid. Two further sculptures from southern Bohemia, which are now in Rychnov (Reichenau) and Domažlice (Taus) were clearly derived from Viennese models. But they are somewhat later works and were inspired by the effigies in the St. Eligius Chapel in St. Stephen's Cathedral. By contrast, the Madonna and the Apostle (Ills. 45 and 46) from the Church

of St. James in Brno (Brünn) – which presumably once formed part of a larger cycle – belong to the Suabian tradition. Although most of the Crucifixions from Bohemia and Moravia were also carved before 1350, none was a pure example of either of the two basic medieval types. In the first of these, which found its most perfect expression in the triumphant Crucifixions of the thirteenth century, the heroic figure of Christ, who is shown full face with arms outstretched upon the cross, seems to be soaring above the world of men rather than suffering on their account. The second type, which is in complete contrast, is exemplified, above all, by the mystical Crucifixions. In these the stunted and twisted body of Christ is nailed either to a cross made from rough branches or, in some cases, to a *Gabelkreuz* (a cross with Y-shaped arms), and is quite clearly in torment. In the early years of the fourteenth century the mystical Crucifixions, which were of Rhenish provenance, were introduced into the territories of western and, above all, southern Europe, where the excessive pathos of the original type was soon toned down. The Crucifixion in the Jesuit Church at Jihlava (Iglau) (Ill. 47) is one of a whole series of positively monumental Crucifixions created in different parts of south-eastern Bohemia (Stift Nonnberg in Salzburg, Friesach, Klosterneuburg and Wroclaw). The Crucifixion at the Barnabite Monastery in Prague, which I have already had occasion to mention, was conceived in the skeletal style of the 1240s. The Crucifixions at Krumlov (Krumau) (Ill. 42) and Strakonice, on the other hand, are much more moderate. Far from being stunted, the figure of Christ in these works is elongated, there is no sign of physical deformation, and no blood issues from the wounds.

In the second half of the fourteenth century interest began to focus on Silesia, where a new genre of sculptures was developed that have come to be known as the 'Lion Madonnas'. In the earliest examples of this genre the Mother of God is represented as an apocalyptic figure treading on the head of the devil, who appears in animal form. In later works she is shown in an extremely complex *contrapposto*, with one foot resting on a lion, and holding

a lively, kicking infant in an almost horizontal position in front of her breast. Other characteristic features of these Silesian Madonnas are the gentle modelling of the spindle-shaped figures, the relief-like composition, and the flowing line of the delicate drapery folds. From Lower Silesia and the districts flanking the southern reaches of the Weichsel these Madonnas were carried to the Baltic territories in the north, and to Bohemia and Austria—especially Salzburg—in the south. By comparison with the Lion Madonnas produced in Silesia, which became progressively more flat, those executed by the Bohemian sculptors of the period were much more fully modelled, and much more robust. The Madonnas from Broumov (Braunau) (Ill. 48), Cheb (Eger), Zahražany (Saras) (Ill. 51) and Konopiště (Ill. 50) are examples of the type. Of course, in Bohemia these Silesian Madonnas were often embellished by motifs taken from illuminated manuscripts. In the Madonnas from Běcov (Hochpetsch) and Hradek, for example, the playful hem-line of the flowing drapery incorporates fish-bladder motifs and decorative spirals. Although these delicate works were forced to yield pride of place to the monumental, realistic carvings of the Parlers—the first of which appeared in Prague in the early 1350s and which soon came to domi-nate the whole of Central European sculpture—they were still being produced as part of a secondary sculptural move-ment, right up to the end of the century, when they made an important contribution to the development of the Soft Style about 1400.

The Parler Period

The first works to be executed in the Parler style were the figures created in 1351 for the choir portals of the Church of the Holy Ghost in Schwäbisch-Gmünd. The ground-plan of the choir was designed by Heinrich von Gmünd—Peter Parler's father—and it is possible that he may also have decorated the twin portals. But whether it really was Hein-rich von Gmünd who was responsible for these two groups of sculptures or some other member of this extensive fam-ily, the fact remains that they incorporate many of the characteristic features of the new style: short, stocky figures, heavy drapery folds which stress the horizontal plane, life-like faces, and a rather more dramatic, rather more intense relationship between the component figures. The fact that some of the sacred figures in these groups were depicted in contemporary dress clearly demonstrates the new movement towards a realistic art form that was to

reach its peak in the portrait sculptures of St. Vitus's Cathedral. But although many of the component elements of the figures represented at Schwäbisch-Gmünd undoubt-edly anticipate the mature style of the Parlers, the type of prophet depicted on the north portal, which was soon to be adopted by sculptors in many other Central European cities (such as Augsburg, Nuremberg, Ulm and Cologne), cannot really be said to be 'Parlerian'. This type of figure still reflected the attitudes of the two workshops which paved the way for the emergence of the Parler style. The first of these workshops was attached to the Frauenkirche in Nuremberg, for which it created, within a period of a few years from 1352 onwards, a complete series of sculp-tural ornaments at the behest of Charles IV. The second was the workshop of St. Stephan's Cathedral in Vienna, which was revived by Archduke Rudolph, who sought to emulate his imperial grandfather by commissioning a vast programme of sculptural work for the decoration of the royal portals and the south tower, which was carried out between 1359 and 1365. Between them, these two work-shops afford an insight into the sculpture of the 1360s, a period from which none of the products of the cathedral workshop in Prague has survived (unless, as has been sug-gested, the St. Peter console at the entrance to the St. Wen-ceslas Chapel was created during that decade). Curiously enough, although the Frauenkirche in Nuremberg was an imperial foundation, the sculptures executed there—extre-mely vital figures engaged in positive actions—are dist-inctly bourgeois, and even the ribs in a number of the vaults have been decorated with Parlerian abandon. Some of the statues—ten in all—which are grouped around the pillars in the choir (and which date from 1360) are closely related, even in respect of detail, to certain sculp-tures produced in Prague. One of the ten—which most critics consider to be a representation of Charles IV—in-corporates exactly the same motifs as the statue of King Wenceslas in St. Vitus's Cathedral; it even shares the same lack of genuine plasticity. However, there is nothing lacking in the decorative reliefs carved on some of the keystones in the nave, which have been attributed—and rightly so—to the young Peter Parler on account of their extremely high quality. Parler, of course, was not called to Prague until 1353.

The similarities between the workshops in Vienna and Prague were of quite a different order. These cities were both residences, and the emperor and the archduke, who commissioned the sculptures with which we are at present concerned, not unnaturally attached considerable impor-

tance to the glorification of their respective dynasties, and so insisted on a particular kind of representative art with strong political overtones. In Vienna this resulted in a happy synthesis of vital modern design and a particular kind of workshop sculpture based on local traditions but refined and sophisticated by contact with the court. This synthetic art form, together with the monumentality of the thirteenth century, and the plasticity of the fourteenth, were the foundation of the mature Parler style as exemplified by the sculptures created by Peter Parler in Prague. Only a certain number of the works commissioned from Peter Parler, first for St. Vitus's Cathedral and, subsequently, for other buildings in Prague, are listed in the early iconographic records. But every one of them—from the statues and the architectural and funereal sculptures to the portrait busts and reliefs—was influenced by the emperor, whose personality and attitudes must never be disregarded in assessing Parler's oeuvre. Incidentally, Parler did not create a single devotional work in Prague.

The first item on Peter Parler's long agenda was the decoration of the St. Wenceslas Chapel, which was the heart of St. Vitus's. The statue of St. Wenceslas (Ill. 227) symbolizes the great reverence felt in Bohemia for this saint, not least by Charles IV, who always thought of himself as Wenceslas's successor. The sign of the Parlers—a runic square—is cut into the base of the statue, and we also know from the weekly accounts for the year 1373 that a certain Henricus (Parler) worked on this figure. However, it does not necessarily follow that he was responsible for the whole project. As leader of the workshop, Peter Parler probably produced the design. True, the imaginitive power and the depth of characterization that are the hallmark of Peter Parler's work are somewhat subdued in the St. Wenceslas statue, but this is readily explained by the fact that the subject was an historical figure. And although the character of St. Wenceslas is subdued, the underlying mood of resignation and almost pained sensitivity invested in the figure of this kindly warrior and patron saint is quite unmistakable.

The one work which can be attributed to Peter Parler with absolute certainty is the tomb of Otakar I (Ill. 56), which dates from 1377. When the Romanesque cathedral, in which the Přemyslide rulers had been interred, was pulled down to make way for a Gothic building, the emperor commissioned new tombs for six of his maternal ancestors. The siting of these tombs, which were executed in 1376–77, was determined by the historical importance of the deceased and not by the sculptural significance of their monuments. Consequently, we find that the tomb created by Peter Parler for Otakar I, which is the most impressive of the six, was tucked away in one of the side chapels. The contrast between the smooth base of this tomb and the rugged contours of the drapery which envelops the mighty figure of Otakar I is quite splendid. The highly symbolic motif of the hand concealed behind the drapery folds, and the anxiety and tension which mark the deeply furrowed face, reflect the historical achievements of this ruler, who established the hereditary principle in Bohemia. The tombs of both Otakar II and Spytihněv have also been attributed to Parler on stylistic grounds despite the fact that the drapery in the second of these was executed in a timeless, idealized style with gently flowing folds that are reminiscent of the more traditional products of ecclesiastical sculpture. Although the remaining three tombs in this series are less well preserved, it is quite evident that they were not designed with the same scrupulous care. Moreover, two of them are on a smaller scale.

At St. Vitus's the sculptural decorations were carefully integrated into the architectural design. Thus, the monumental figures on the tombs, which commemorated the dead, were accommodated in the dark area at the base of the choir; the portraits of the living, who had helped build the new cathedral, in the brighter area of the lower triforium; and the idealized statues of Bohemia's patron saints in the upper triforium, which is the brightest area of all. The sculptures in the lower triforium reflect an interesting sociological development, for we find there, on a par with the members of the imperial family and the first three archbishops of Prague, the two architects and the master masons placed in charge of the cathedral site. The last of the portrait busts executed for the cathedral was completed by 1385, the year in which the building was consecrated, the others having been produced between 1374 and 1379. It is possible to classify these busts in terms of the degree of realism which they possess, and in this connection the most important question would seem to be whether the subjects were known to their sculptors or not. In the first group (which embraces Emperor Charles IV, his son Wenceslas, his mother Elisabeth, and both his third and fourth wives, Anna von Schweidnitz [Ill. 54] and Elisabeth von Pommern), the personality of the subject was the all-important consideration. Consequently, physical features take precedence over formal factors with the result that these fully modelled and carefully proportioned heads are portraits in the precise sense of the word. This is not the case with the second group. These busts (of John and Wenceslas

of Luxembourg, Blanca of Valois, Anna von der Pfalz, and Matthias of Arras) have a distinctly academic quality which finds expression in the precise working of the texture and the much more idealized treatment of the facial features. As for Peter Parler's self-portrait (Ill. 53), this resembles the second group in purely formal terms, although it occupies a special position in so far as it was the first selfportrait to be produced in the medieval period. There is also a third group composed of the archbishops and the master masons, whose facial features are reproduced by means of a gentle modelling technique which is extremely realistic and has nothing to do with the Gothic style (Ills. 52 and 55).

In 1378 a series of decorative sculptures was also commissioned for the bridge tower of Peter Parler's Karlsbrücke on the old town bank. The figures on the old town side were executed in the style of the triforium sculptures in St. Vitus's. At the second floor level a triangular scheme was adopted – a standing St. Vitus flanked by the seated figures of Charles IV and Wenceslas IV (Ill. 57) – whilst at the third floor level we find a group of two – St. Adalbert and St. Sigismund. The tympanum on the north portal of the Týn Church in the old town, which was decorated between 1380 and 1390, was another work very much in the Parler mould. This was the kind of 'formal exercise' in which the powerful narrative folk art of the Suabian Parlers so often found expression. (Similar works may be found in Gmünd, Thann and Ulm). There is also a tenuous link between the art of the Prague cathedral workshop and the bronze equestrian statue of St. George, which was created by the Klausenburg brothers for installation in the third courtyard of Prague Castle in 1373 (Ill. 58). But the graceful and highly decorative figure of the saint, and his surprisingly naturalistic horse, have a great deal more in common with the sculptures produced by the ducal workshop in Vienna, of which the St. Paul relief in St. Stephan's Cathedral is an example.

Bohemian Art at the Turn of the Century

The Soft Style, which came to the fore in all parts of Europe at the end of the fourteenth century, was represented in Bohemian sculpture primarily by the 'Beautiful Madonnas', whose graceful postures and loving expressions were enhanced by the soft, flowing rhythms of their heavy drapery. Although the elegant courtly art of the cathedral workshop in Vienna and the highly progressive works of the Bohemian panel painters (especially their miraculous Madonnas) will

have made a major contribution to the development of this type of sculpture, the plasticity of the heavy drapery folds was probably derived from Flemish and Burgundian sources. South-west Bohemia – or, more specifically, the archdiocese of Salzburg – would seem to have been the heartland of the Beautiful Madonna. Certainly, most of the surviving specimens were produced there. By and large, the Beautiful Madonnas were based on one or another of three prototypes, which all date from c. 1400. These were the Madonna from the Church of St. John in Thorn (Ill. 62), the Madonna from the Church of St. Elisabeth in Wroclaw (Ill. 64) and the Madonna from Krumau (Ills. 66–7). With its harmonious balance of convex and concave shapes the Thorn Madonna was more in keeping with the classical taste of western Europe than either of the others. This statue – which is also remarkable for its enormous drapery folds, the lowest of which acts as a base for the figure – influenced sculptural developments in the north, the west and the south of Europe. Beautiful Madonnas based on the Thorn prototype were carved in Danzig and Stralsund, and at the Castle of Sternberg a Moravian variant was created which reproduced every single motif of the original (Ill. 63), but without achieving its remarkable combination of calm nobility and loving intimacy. The Madonna from Wroclaw (which was probably executed in Strasbourg) is quite a different work. The lower part of the body is heavier and more block-like, whilst the modelling of the drapery produces a series of ridges and hollows that impart a highly dynamic quality. One of these ridges, the most powerful, follows an almost diagonal course and virtually cuts the figure in two. A similar Bohemian work is the Madonna from Třeboň (Wittingau) (Ill. 65), in which the drapery folds are even more dynamic but in which the solid mass of the body is lightened by the introduction of a *contrapposto* structure. The third prototype – the Madonna from Krumau – is not unlike the Thorn Madonna. It is, however, technically more sophisticated in that the line of the body repeatedly changes direction, thus producing a highly complex three-dimensional structure which invites inspection from many different angles. With its heavy but by no means hard drapery folds, and its sweet, intimate expression, the Madonna from Krumau is a very powerful work with an almost erotic aura. In 1410 what purported to be a replica of this Madonna was made in Hallstatt (Ill. 68), and although it did not even begin to compare with the original, the replica none the less appears to have been the more popular of the two, for the vast majority of the variations on this particular Madonna were based

on the Hallstatt version. (The Vimperk [Winterberg] Madonna is an example; Ill. 71). In addition to these three prototypes there were, of course, many other Madonnas, which were less influential. Some of them were executed before the turn of the century; but although they predated the prototypes, these works did not prepare the ground for them. One of the most charming of these individual Bohemian Madonnas is the one from the Church of St. Bartholomew in Plzeň (Pilsen) (Ill. 69). This is an interesting work from the point of view of the art historian, for the large lateral drapery folds would seem to anticipate the symmetrical and frontal style of sculpture which was developed subsequently and which found widespread application in both Bohemia and Austria. There are two other statues that should perhaps be mentioned at this point, although neither of them is a Madonna. The first is the St. Catherine in the Church of St. James in Jihlava (Iglau) (Ill. 70), which is much more original and much more expressive than the Plzeň Madonna and is reminiscent of the work of the Master of Grosslobming; the second is the bust of a saint from Dolní Vltavice (Untermoldau) (Ill. 61), which was probably executed by a follower of the Parlers.

To all intents and purposes the Beautiful Madonna theme was a product of the turn of the century. This was not the case, however, with the second major theme of the period – the pietà – which was firmly rooted in an older iconographic tradition (although its greatly increased popularity towards the end of the fourteenth century was, of course, also due to the influence of Christian mysticism). The principal characteristics of the pietàs produced between 1200 and 1250 were the prominence of the vertical elements in the composition on the one hand and the figures of Christ on the other, whose bent bodies created complex linear structures on several different planes. After 1250 we find quite a different kind of pietà with much smaller Christ figures that barely extend beyond the contour of the Virgin's body. These two early types of pietà, both of which originated in west Germany, were followed in the 1380s by a new and much more monumental type. Two splendid examples of this third type have survived in eastern Europe, one in the Church of Mary Magdalen in Wroclaw and the other in the Church of St. Thomas in Brno (Ill. 72). The posture of the Virgin in the Brno pietà, which is the older of the two, is more vertical, and this Virgin also wears the copious headscarf that was a favourite

motif of earlier artists. In all other respects, however, these sculptures are very much alike. Both are imbued with the same deep sense of gravity and poignancy, and both show the body of Christ in the same rigidly horizontal position. In fact, these are the earliest known examples of the so-called 'horizontal' type, which became quite common by the turn of the century but which never again achieved the expressive power that is the hallmark of these early works. A third pietà – from Lutín (Luttein) (Ill. 73) – appears to have been compiled from the Wroclaw and Brno pietàs, although it is a very much smaller work and has a softer contour. Eventually, these traditional pietàs were replaced by a multiplicity of Lamentations (whose originality defies classification), but not before giving rise, in the first decade of the fifteenth century, to a series of more modern and quite splendid pietàs, in which the Virgin was very much younger, and quite as beautiful as any of the Beautiful Madonnas. Although the majority of these works were modelled on the pietà from Baden, near Vienna, a work of infinite grace and classical simplicity, they none the less followed two quite distinct trends. The first of these, which is exemplified by the pietà from Všeměřice (Schömersdorf) (Ill. 74), reveals a growing movement towards broader and heavier forms whilst the second, of which the pietà in the Church of St. Ignatius in Jihlava (Ill. 75) is typical, betrays what is virtually a Manneristic preoccupation with *contrapposto* techniques and an almost exclusively decorative use of drapery.

During the first two decades of the fifteenth century sculptural production in Bohemia tended to shift away from the capital to the provinces. But in the 1420s – shortly before the Hussite wars brought all sculptural activity to an end – a new and important artist appears to have made his début in Prague. His most impressive sculpture is the Crucifixion Group in the Týn Church (Ill. 76), which bears a certain resemblance to the work of the contemporaneous Silesian Dumlose Master, although the dark figures in the Crucifixion are much more threatening and the massive drapery folds much harder and more statuesque. The Prague master's opus also includes a further Crucifixion (from St. Vitus's Cathedral), two Men of Sorrows (Ill. 77) and a St. John, whose intentionally ugly forms create an impression of sombre and melancholy being that seems to reflect the gathering storm of confessional strife, and stands in marked contrast to the joyous products of the Soft Style.

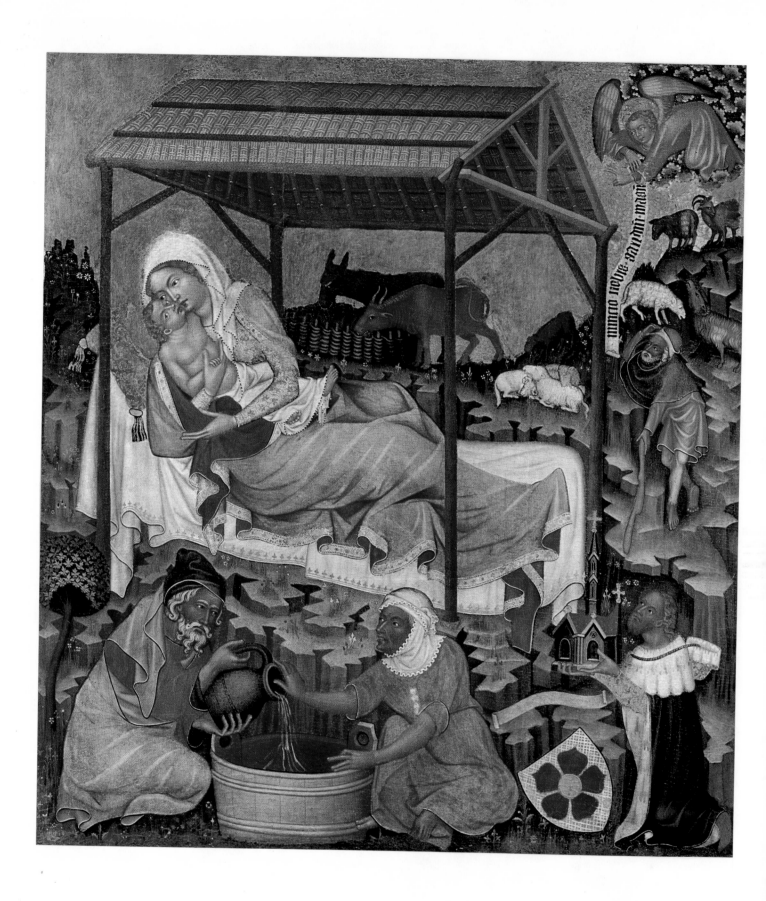

PLATE II *Death of the Virgin from Kośatky, c.1345. Boston, Museum of Fine Arts*
PLATE III *St. Jerome, c.1360–5. Prague, National Gallery*
PLATE IV *St. Matthew, c.1360–5. Prague, National Gallery*
PLATE V *Crucifixion from the Emmaus Monastery, c.1370. Prague, National Gallery*

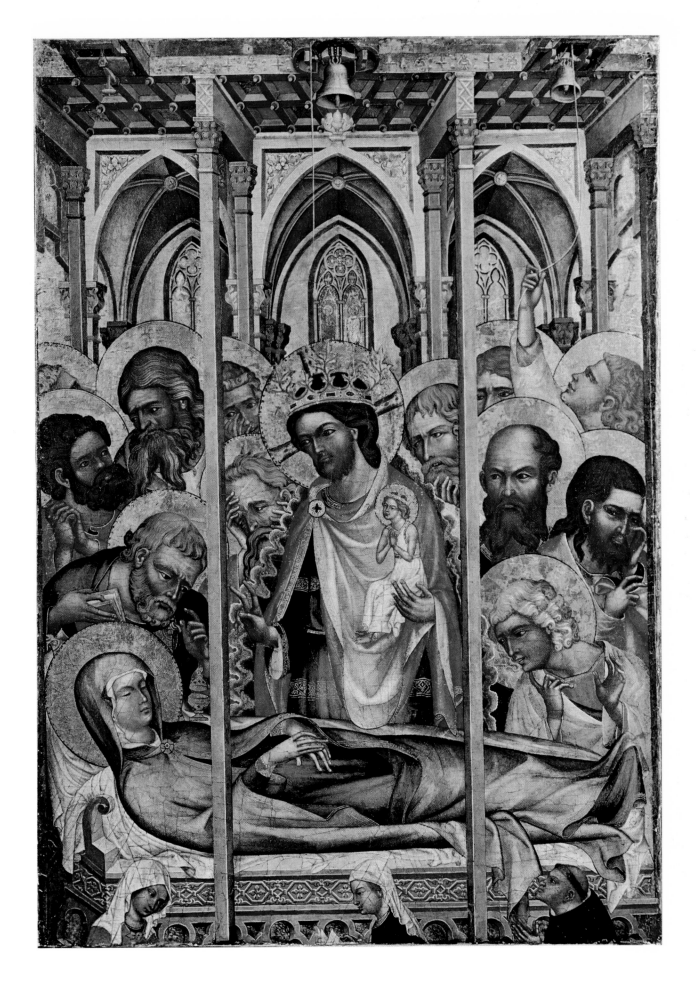

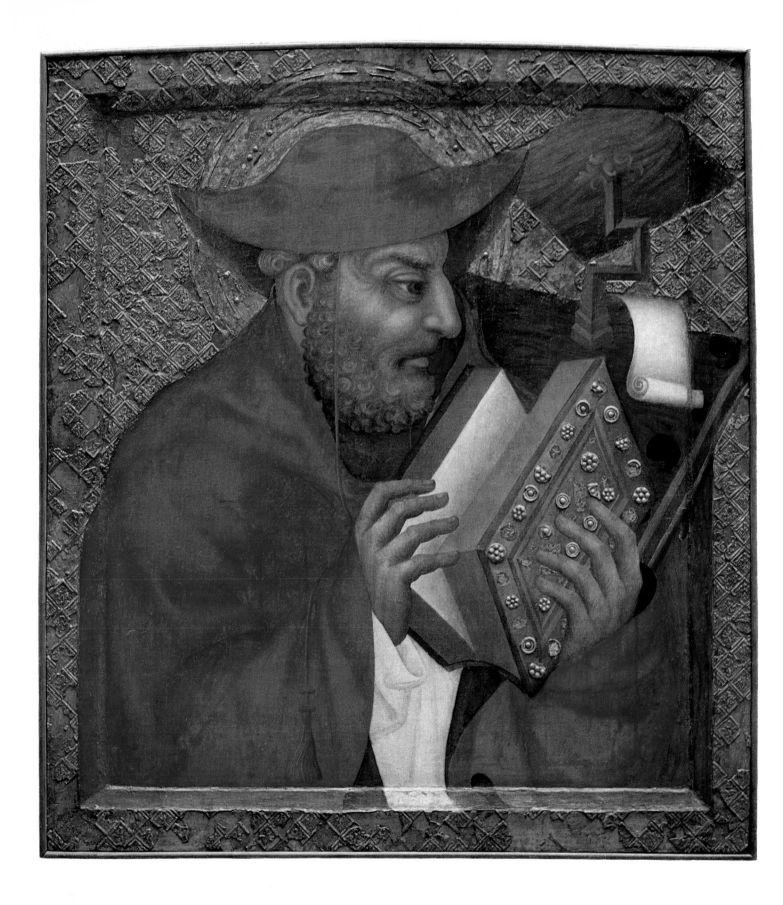

III

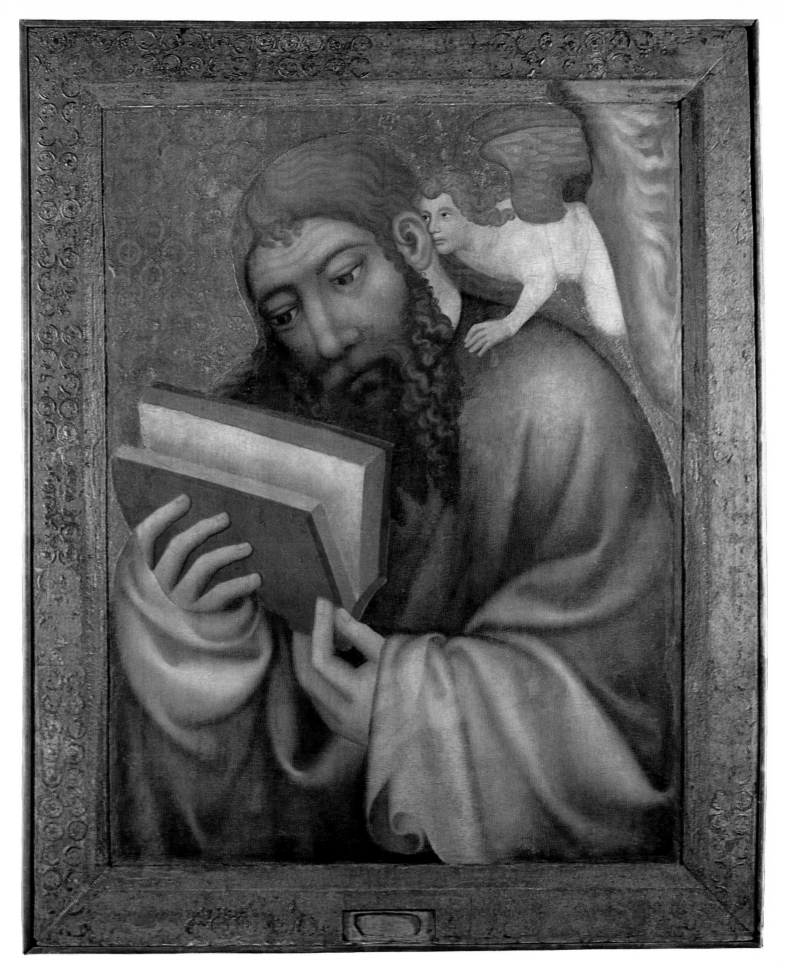

IV

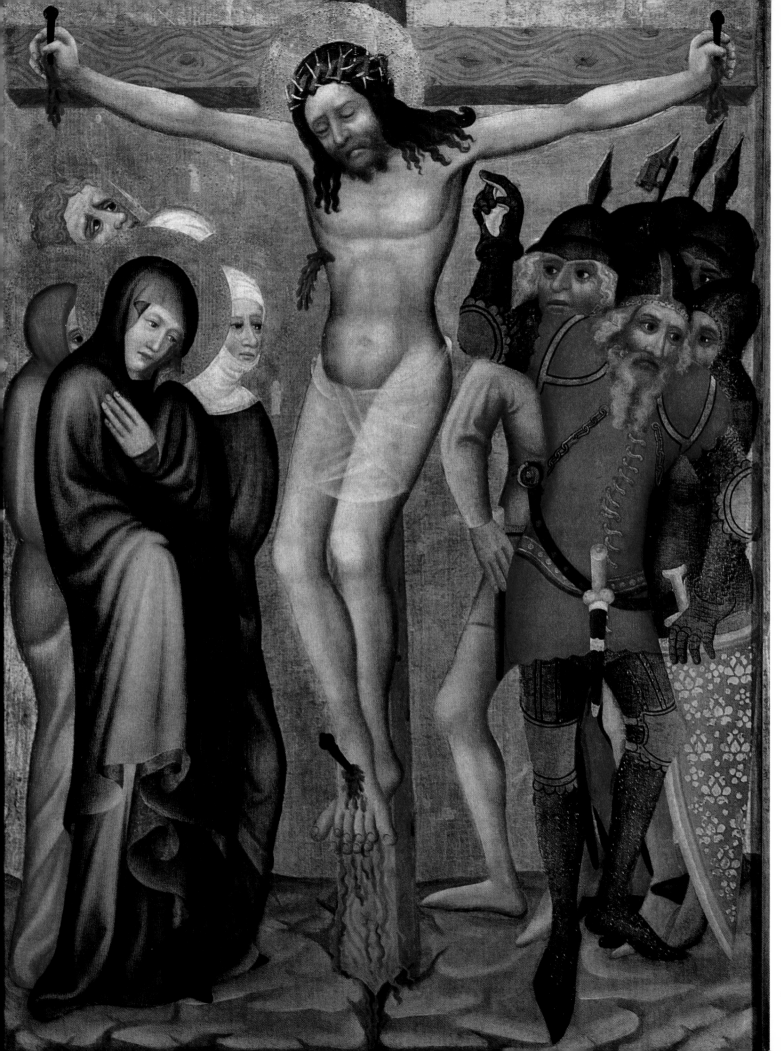

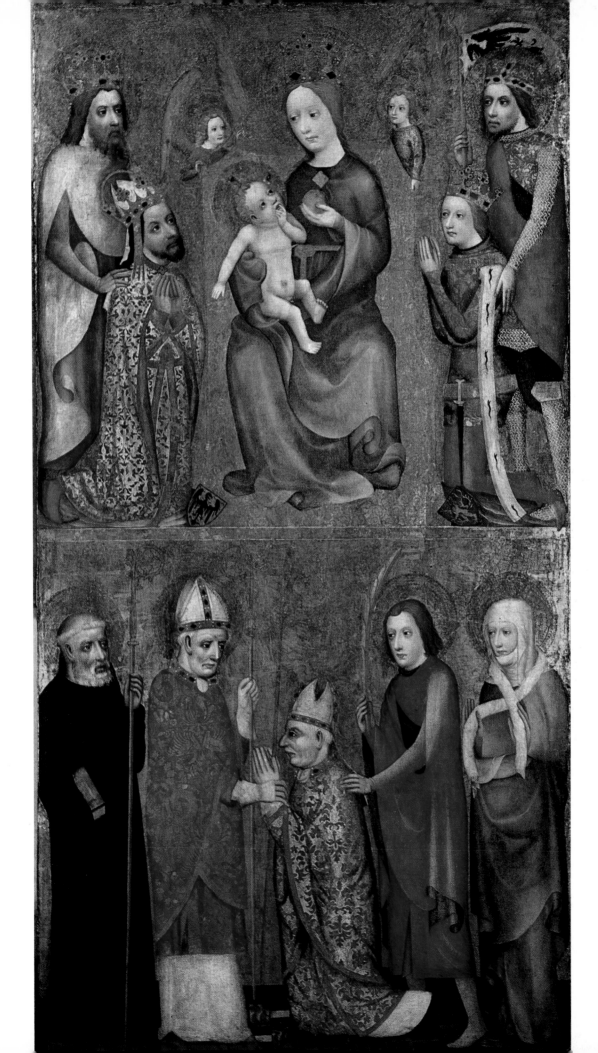

VI

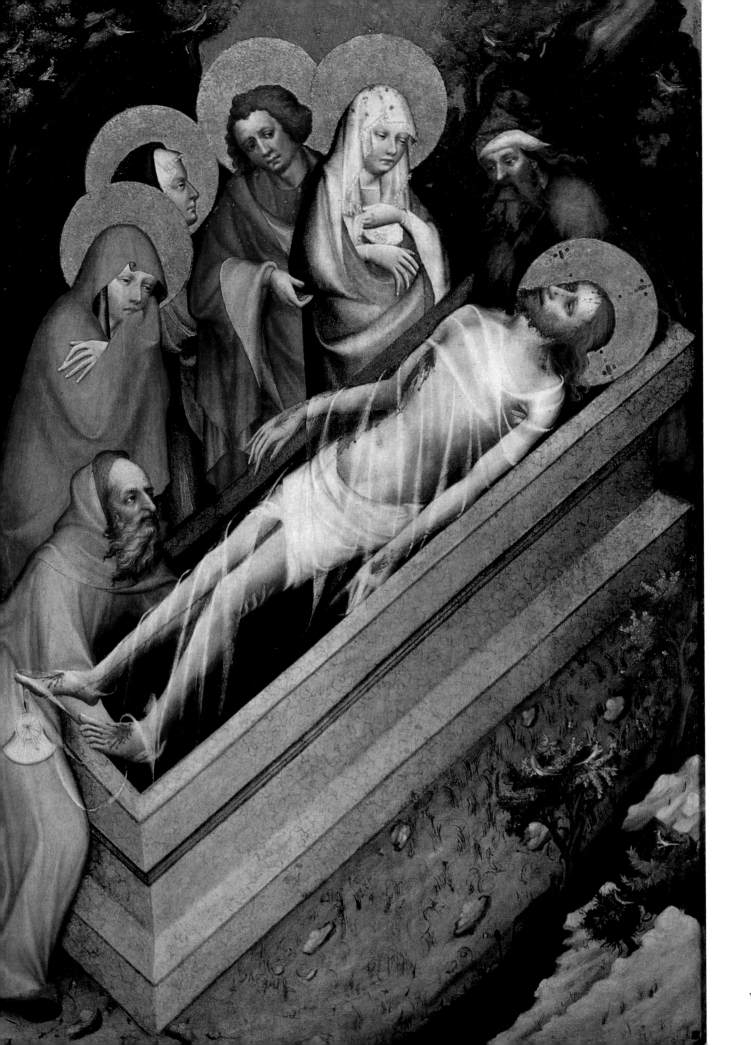

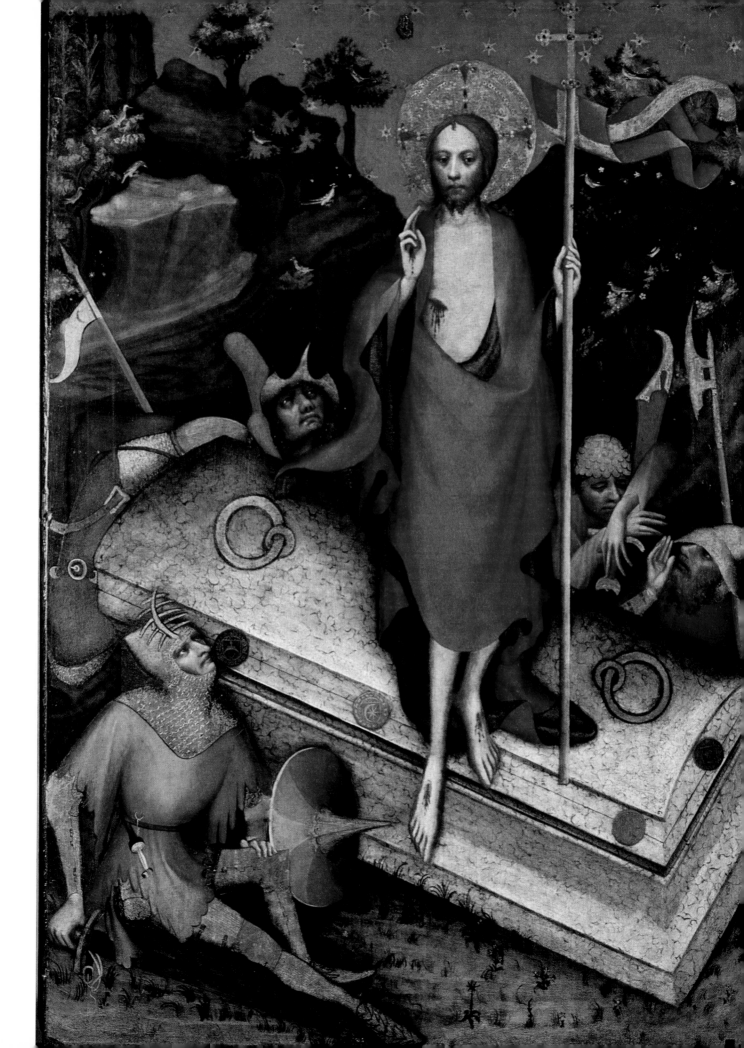

VIII

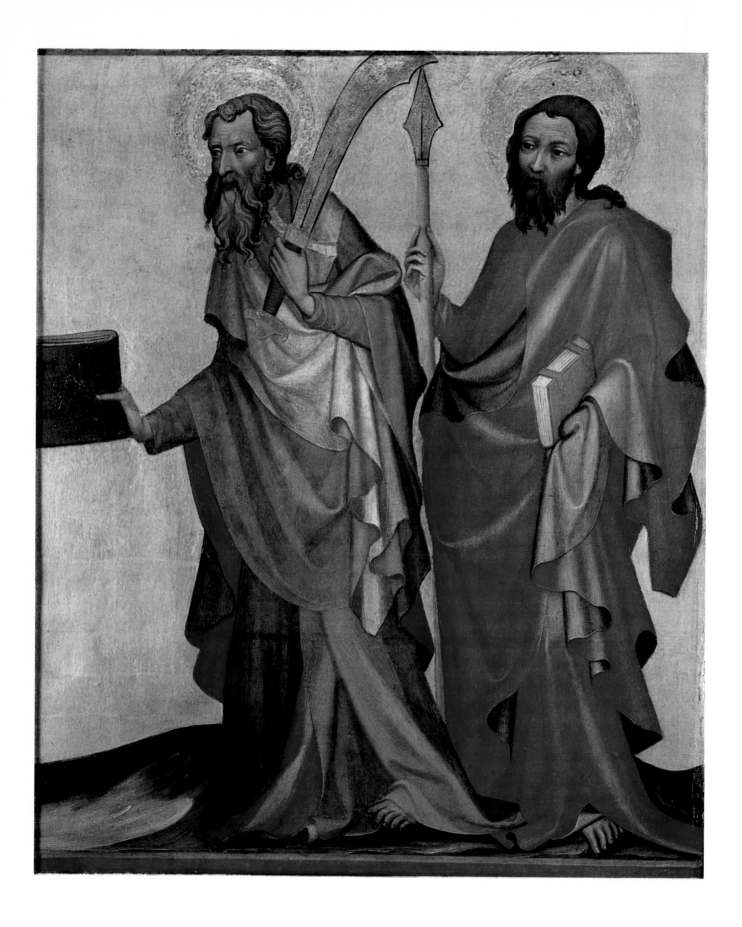

IX

4. Bohemian painting up to 1450

The panel paintings of the 'Bohemian Primitives' are among the most important products of fourteenth-century European art. Because of their high quality, and also because they have survived in rather larger numbers than the panel paintings of any other territory north of the Alps, they have long been an object of interest to scholars, and have been appreciated in numerous publications, the most important of which are listed in the bibliography.

Although Bohemian painters had already tried to come to terms with the new forms of west European Gothic art in the thirteenth century, their achievements at that time were of purely regional significance. The few surviving and, as often as not, stylistically uneven wall-paintings and illuminated manuscripts from the thirteenth century cannot begin to compare with the Early Gothic buildings erected during the closing years of Přemyslide rule. It was not until the fourteenth century that this imbalance was redressed, owing not least to the establishment of the new Luxembourg dynasty. The members of this house, who came from the western borders of the Holy Roman Empire, and especially Charles IV, who was brought up at the French court and was subsequently involved in his father John's North Italian campaigns, made a major contribution to the essentially cosmopolitan character of the new style developed in Prague in the middle years of the fourteenth century.

According to the records of the Prague Painters' Guild, several painters' workshops had been established in the Bohemian capital by the late 1340s. These workshops seem to have concentrated on two basic products: half-length pictures of the Virgin and polyptychs. The Madonnas, which were derived from Byzantine and Italian prototypes, became something of a Bohemian speciality, and were in great demand as devotional images for well over a century (Ills. 84, 91 and 159). As for the polyptychs, they were often an imitation of Italian *pale*, and many of them were unusually large. Without exception, the works produced during this phase were executed in a syncretistic style based on a combination of west European and Italian elements.

To my mind, the most telling of these works is the Death of the Virgin from Košátky (Plate II), by a painter who must surely have been trained in Venice. The group of figures which forms the focal point of this painting is virtually identical with the group in Paolo Veneziano's Death of the Virgin (Vicenza; 1333), which, for one, is nothing but a Venetian version of the Byzantine iconography of the *Koimesis*. The heads in the Košátky painting, and the flesh colour that he uses for them, are also reminiscent of Veneto-Byzantine works. But although the master's figures are relatively flat, they are set against a three-dimensional interior, which calls to mind some of Simone Martini's frescoes in the St. Martin Chapel in Assisi, and which certainly presupposes a knowledge of Tuscan developments. Moreover, some of the clean-shaven and fair-haired young apostles in the Košátky panel were probably derived from either Martini or the Lorenzetti brothers. The discrepancy, which is quite marked, between the master's flat figures and his perspective settings may well have appealed to the conservative taste of his Bohemian patrons in so far as it revealed the painter's awareness of the most up-to-date achievements of Italian art, and at the same time still gave pride of place to the ornamental and two-dimensional qualities of the Gothic tradition. Judging by the state of his knowledge of Italian developments, and the influence he exerted on native Bohemian artists, it seems likely that the Master of the Košátky panel settled in Prague in the mid 1340s. We have only to compare the figure of St. John in his Death of the Virgin (Ill. 94) with the St. John in the more recent Pentecost from Vyšší Brod (Ill. 95) to realize that the influence of Italian models on the Košátky work is far more immediate.

Like the Master of Košátky, the illuminator of the 'second' Book of Municipal Statutes in Brno (c. 1355; Ill. 136) had surely been trained in Venice. These observations lead us to assume that Bohemian painting of this period must have been greatly influenced by the Venetian school, which was responsible for the harmonious colouring and ornamental effects that distinguish the Prague panels from those produced in other parts of Central Europe. The fact that the Venetians regarded colour and light as artistic media in their own right, and considered them more important than

either the graphic elegance of the French school or the trenchant plasticity of Tuscan painting, made a strong appeal to the Bohemian painters of the mid fourteenth century, for whose artistic aims such an approach was ideally suited.

On the other hand, the workshop which produced the Glatz Madonna (Ill. 87) drew its principal inspiration from western sources that were already imbued with the latest achievements of contemporary Gothic art. This great painting once formed the central panel of a retable which Ernst of Pardubice, the Archbishop of Prague, presented to the church of the Augustinian monastery which he himself had founded in Klodzko (Glatz). This type of Madonna, enthroned and revered by angels placed one above the other, was Italian in origin, but must have been taken over, and modified, by Northern artists by the early 1320s. (A Northern example of the type is to be found in a Sermologium of the Diocese of Constance (Ill. 83).) The structural complexity of the throne in the Glatz Madonna is characteristic of the manner in which Northern artists tried to appropriate the perspective techniques of the trecento. Like the Master of Košátky, the Master of Glatz did not endeavour to create the illusion of homogeneous three-dimensional space. Instead, he concentrated on the throne, investing this essentially architectural motif with carefully controlled perspective features, whose overall effect—owing to the use of divergent pairs of parallel lines—is to reduce rather than increase the impression of depth. A number of individual features are indicative of Italian influence, which may of course have been acquired at second hand. The shot-gold robes worn by the infant Jesus and the archbishop, and the modelling and flesh colour of the faces (except those of the Madonna and Child, which underwent a considerable transformation at the hands of a restorer) are clearly of Italian provenance. So too are the shape and posture of the archbishop's head, which is virtually an amalgam of Siennese models (see Ills. 85 and 86).

The Glatz Madonna is also remarkable for the fact that it incorporates two quite distinct styles, which may be observed in isolation in two related works of the period. The harmonious composition, the luminous colouring, the loose folds of the drapery, and the emphasis placed on the vertical elements in the contour and shading of the two central figures are qualities which the Glatz Madonna has in common with the Madonna from Veveří (Ill. 91), whilst the small, gesticulating and extremely vital angels set in the wings of the throne belong to a stylistic trend that is dominant in the Madonna from the Strahov Monastery (Ill. 84).

The tight heads and limbs, the sharp folds of the thin drapery, and the expansive movement of the figures point to the participation of the same painter in both works. So too does the close correspondence between the colouring of the Strahov Madonna and the angels in the Glatz panel, in which the same rich brown is used for the shaded areas of the bodies and the same unusually bright range of colours for the drapery.

The tension that is set up in these works by the juxtaposition of new Italian elements and traditional Gothic patterns from north-west Europe is also manifested in the Passion cycle from the South Bohemian Cistercian Abbey of Višší Brod (Plate I; Ills. 88, 92 and 95), a work consisting of nine panels, which in their original form were joined together in a polyptych measuring about three metres square. In the Višší Brod cycle the antithesis between these disparate elements is very marked, even within individual panels. Whilst the Annunciation (Ill. 88) displays the same combination of qualities that distinguish, e. g., the Madonna from Veveří (Ill. 91), the Crucifixion and the Resurrection (Ill. 92) are much closer to the Wroclaw Throne of Mercy (Ill. 140), whose figures, colouring and ornamentation reveal an affinity with the Death of the Virgin from Košátky (Plate II). The survival in the Višší Brod workshop of facial types of pure Venetian descent is also demonstrated by the similarity between Christ rising from his Tomb (Ill. 92) and the apostle standing behind and to the right of St. John in the Death of the Virgin (Ill. 94). At the same time, the tense posture of the figures in most of the panels of the Višší Brod cycle (Ills. 88, 92) foreshadows the later style of the Madonna Enthroned Between St. Catherine and St. Margaret of c. 1360 (Hluboká; Ill. 108), which means that the cycle must be regarded as a more modern work than the Glatz Madonna, whose rhythmical movement and flowing drapery hark back to an older tradition. However, all these works belong in the main to the early syncretistic phase of Bohemian painting, whose principal characteristic is the—often quite disturbing—juxtaposition of flat and perspective composition. The Višší Brod Annunciation is a particularly good example of this trend (Ill. 88). The antependium from St. Mary's Church in Pirna (Saxony; Ill. 102), which is the oldest surviving specimen of Bohemian embroidery, also belongs to this early phase. Its composition and iconography are clearly derived from Italian prototypes, whilst some influence of the western style can be seen in the figures.

The first major work of Bohemian manuscript illumination is the Passional of the Abbess Kunigunde, which was

commissioned for one of the daughters of Přemysl Otakar II. It would seem that work on the illustrations started in 1314 and continued right up to the death of Kunigunde in 1321. In fact, the work was never completed, and the last few pages of the manuscript remained unillustrated. There are two distinct styles of illustration in the Passional: an early one (folios 1–9), which was based primarily on East Anglian illumination of *c.* 1300, and a later one (folio 10 onwards), of which the figure of the Mourning Virgin (Ill. 78) is a good example. In this illustration, which has something of the quality of a devotional image, the strong linear composition evolved by the Gothic artists of western Europe is integrated with the modelling technique which was developed in thirteenth-century Italy, thus rendering more realistic both the body and the mood of this solitary figure. It is because they combine such heterogeneous styles that the ink and wash drawings in the Passional foreshadow the syncretistic works of the ensuing decades.

After a period of rather uninspired illumination a second high quality work was produced. This was the 'Velislav Bible', so called after the person portrayed in the final illustration, whose name is given as 'Vellizslaus' and who is assumed to have commissioned this manuscript. The ink drawings made for this 'picture bible' illustrate passages from the Old and New Testaments and stories from the lives of the saints. They are based on a variety of models, doubtless of Romanesque origin, and were probably executed in Prague. The master who illustrated folios 1–47 of the Velislav Bible worked in a style which was cultivated in the area around Lake Constance during the 1330s and which subsequently spread to a number of eastern districts (Ills. 80 and 81). The second master, who was responsible for the illustrations from folio 48 onwards, followed his colleague fairly closely but was not quite so imbued with the spirit of Western Gothic (see Ill. 82). As a result, rather more of the Romanesque quality of the original models has survived in his illuminations, yet at the same time his figures, and more especially their faces, indicate the influence of the Italianizing Bohemian panel paintings executed in the 1340s.

In the miniatures and decorative motifs which appear in the breviary written for Provost Vitko of Rajhrad in 1342 the Italian element is entirely dominant. With his three-dimensional throne, constructed in strict accordance with the rules of thirteenth-century Italian perspective, King David (Ill. 89) anticipates one of the principal facets of both the Glatz Madonna (Ill. 87) and the Wroclaw Throne of Mercy (Ill. 140). But this was not the only Italian feature to grace the Rajhrad manuscript, which introduced into Bo-

hemia a system of decoration that was first developed in Bologna *c.* 1300 and was still to be used, with only slight modifications, by the Bohemian illuminators of the 1350s and 1360s. (The most important of the later works executed in this style is the Kreuzherren Breviary of 1356; Ill. 90.)

Prior to 1355 the influence of early fourteenth-century Italian art on Bohemian panel painting was sporadic. But with the return of Charles IV and his court from the imperial coronation in Rome the influx of Italian ideas assumed massive proportions. The miniatures and wall-paintings, which were produced in large numbers from the mid 1350s onwards, were based primarily on Italian models. Incidentally, the most important of these works were executed for specific individuals. The emperor, who was engaged on his own building project at Karlštejn and who was also an extremely generous patron of the Prague churches, commissioned the vast majority of the monumental wall-paintings, whilst the illuminated manuscripts were undertaken on behalf of a small group of high clerics, all of whom had close connections with the Imperial Chancery. The most important of these manuscripts was the *Liber viaticus domini Johannis Luthomuslensis episcopi imperialis cancellarii* (Plate XI; Ills. 79, 99, 129 and 145), which was commissioned by Charles IV's chancellor, Johann of Neumarkt (Středa), and was executed between 1353 and 1364, when Johann also held the office of Bishop of Litomyšl. The master who illustrated this manuscript was probably a panel painter as well as an illuminator. His intricate technique, his unusually rich palette, and his extremely subtle use of colour certainly suggest that this was the case, as do the numerous stylistic and iconographic features which he adopted from contemporary Bohemian panel painting. The form and posture of the Madonna, and the structure of the throne, in his Annunciation (Plate XI) were taken over, virtually as they stood, from the Vyšší Brod Annunciation (Ill. 88). (In this connection it is perhaps of interest to note that the small panel painting of the Madonna in the Boston Museum of Fine Arts, was undoubtedly executed by a close associate of this artist.)

The major influences to which the Viaticus Master was exposed were North Italian. His encounter with works by the Bolognese artists and, above all, by Tommaso da Modena and his followers was perhaps the really crucial factor in his development. But for Tommaso, who was himself highly regarded at the Prague court, the painterly qualities which distinguish the work of the Viaticus Master and the full—almost bloated—faces of many of his figures (Ills. 79, 129 and 145) would have been inconceivable. Niccolò di Giacomo,

who was the foremost Bolognese illuminator from the 1350s right through to the 1380s, also provided him with a number of motifs. If we compare Niccolò's Roman soldiers, in one of his later works (Ill. 98), with the Annunciation to the Shepherds from the Liber Viaticus (Ill. 99) we see that these agile figures, some of which are depicted in *profil perdu*, have many points of resemblance. But although he borrowed heavily from the artists of Northern Italy, the Master of the Liber Viaticus was none the less firmly ensconced within the Bohemian tradition. This is clearly demonstrated by the Madonna and Child which he painted on the margin of folio 47r (Ill. 79). The head of this Virgin has an obvious affinity with the type of head found in the Višší Brod cycle (Ills. 88 and 92) whilst a further link with a second essentially Bohemian work – the Passional of Abbess Kunigunde (Ill. 78) – is furnished by the curious lack of any real anatomical structure, which is replaced by a flowing rhythm that appears to emanate from some external source and to pass right through the figure of the Madonna. In fact, this structureless condition is a characteristic feature of a very large number of the figures in fourteenth-century Bohemian painting. It is particularly marked in the work of the Viaticus Master, due to his subtle modelling. Besides, rejecting the linear composition of the 1340s, this artist developed a style of painting based on an extensive use of shading which enabled him to evoke something akin to 'atmosphere'. This effect was, of course, further enhanced by the incorporation of landscape motifs (Ill. 79).

The decorative system used in the Liber Viaticus was particularly propitious. The borders, which consist of staffs embellished with knots (Plate XI), were derived from Italian illumination, and had, in fact, already been used for the Rajhrad Breviary. But another decorative device found in the Liber Viaticus – namely, the almost naturalistic acanthus leaves – was something entirely new to Bohemia. It was likewise of Italian provenance, for it had already featured in various Lombard manuscripts of the second quarter of the fourteenth century (Ill. 97). Besides it was to prove a most fruitful innovation, one which was clearly capable of further development. Other borders in the Liber Viaticus – those depicting tendrils rather than staffs – were derived from French models (Ill. 99); they correspond particularly well to the kind of borders produced during the 1350s by the Paris atelier of the so-called Maître aux Boquetaux (Ill. 96).

There are two further manuscripts which, although they were illuminated by different artists, bear a marked affinity to the Liber Viaticus and were doubtless produced in the same workshop. The Missal of Provost Nicholas was commissioned by Nicholas of Kremsier, who is portrayed on the first page of the manuscript under the title *Dominus Nicolaus prepositus Brunensis*. Nicholas was a prothonotary in the Imperial Chancery and, from 1357 onwards, Provost of St. Peter's in Brno. Whilst the posture of the figures in this Missal (Ill. 100), and especially the flow of their drapery (which is reminiscent of Niccolò) are based on the same North Italian models on which the Master of the Liber Viaticus so often drew, their heavy cheeks and their pursed, almost pouting, lips are clearly influenced by Tuscan painting (Ill. 101). The head of the prophet (Ill. 93) on folio 190r of the Missal is also derived from the same sources, namely the Lorenzetti and Lippo Memmi, and even the dominant colours in the miniatures – the stone greys, the greens and the rust reds – are reminiscent of the colouring in the works of these Siennese painters. Like the North Italian elements used by the Viaticus Master, the Central Italian elements which appear in the Missal were probably imported into Bohemia as a result of Charles IV's coronation journey, which would suggest that this manuscript was illuminated shortly after 1357. Incidentally, if we compare the bearded prophet in the Missal (Ill. 93) with the bearded figures in the Višší Brod Pentecost (Ill. 95) we see that both the panel painters and the illuminators of Bohemia had profited by the same Siennese lessons.

The illuminator of the *Laus Mariae*, a new text composed by Konrad of Hainburg in 1356, was both more advanced in style and more dependent on the models furnished by the Liber Viaticus. The two full-page illustrations in this manuscript – the Annunciation (Ill. 104) and the Presentation (Ill. 103) – try to copy the corresponding compositions in the Liber Viaticus, as is quite evident from the artist's misinterpretation of certain features of the figures and the architectural setting. At the same time, the illuminator of the Laus Mariae made his figures appear even more to have no bone structure, and used even more luminous colours, than the Master of the Liber Viaticus; thus, working within the latter's artistic heritage, his own style anticipated certain features of Bohemian art of the 1360s.

Taken all in all, the Bohemian illuminators of the 1340s and 1350s can only be described as the most up-to-date representatives of their craft in Central Europe. But their achievements were none the less surpassed by those of the early wall-painters of Charles IV, who developed a new style that was even more progressive and even more original. By 1360 they had completely abandoned the idealized

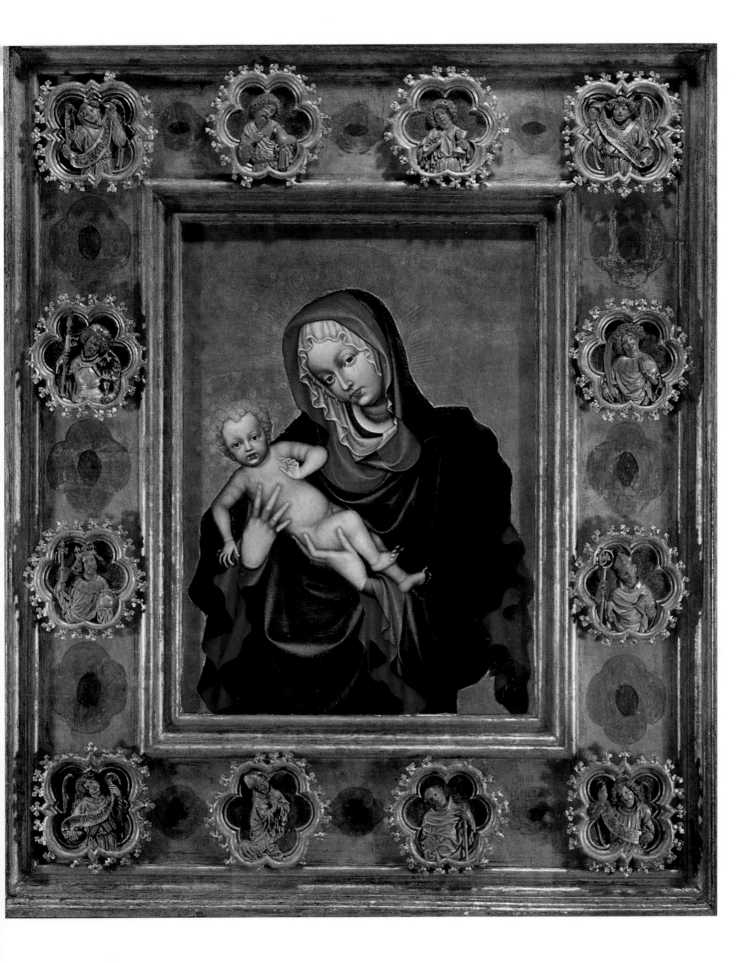

creatures of the early Gothic period and replaced them by uncouth, powerful figures with large and expressive heads. From then onwards the narrative of their paintings was determined, not by the elegant ceremonial of symbolic gestures, but by the violent, though pent-up emotions of the protagonists (Ills. 120–8). A constituent feature of this style is the new relationship of the figures to their surroundings, which are much more expansive and allow them to react with a surprising degree of freedom and, in some cases, even passion.

The surviving Caroline frescoes are concentrated in three sites: the cloisters of the Emmaus Monastery in Prague; the choir chapels of St. Vitus's Cathedral; and – the most richly endowed of the three – Karlštejn Castle. By applying rigorous methods of stylistic analysis it has been possible to establish that about six major painters were employed on these projects. We know the names of three of them: Nicholas Wurmser of Strasbourg and the royal painters Theoderic and Oswald. Unfortunately, their individual contributions have not been confirmed by historical sources in all cases. On the other hand, it has been possible to piece together – from contemporary records, building reports and consecration dates – the general order of events: the building work at Karlštejn started in 1348; by 1355 the castle was ready for occupation; and by 1367 at the latest the decorations must have been completed. The Emmaus Monastery was founded in 1347 and consecrated in 1372; Stockhausen and Krofta argue convincingly that the paintings in the cloisters were executed between 1355 and 1360.

In the late sixteenth century two copies were made of the 'Genealogy of the Luxembourgers', the sequence of painted figures which used to adorn the Great Hall on the second floor of the keep of the Karlštejn Castle and which was probably created in 1356–7. It seems reasonable to suppose that the watercolours of these copies reflect the style and iconography of the lost original fairly accurately. In any case, they justify the assumption that the frescoes in the cloisters of the Emmaus Monastery were created by the same workshop as well, and that its leader was the artist who has come to be known as the Master of the Genealogy. The differences of style that occur in the cloister paintings are quite easily reconciled with this view. The scenes represented in bays 4, 5, 6, and 7 appear relatively flat and largely symmetrical, and it would seem that they were painted by the master during his early phase. After completing these frescoes he must have interrupted his activities at the monastery and transferred to Karlštejn, where, in addition to painting the Genealogy, he started work on the first, tentative decoration of the Chapel of the Holy Cross. (A number of under-drawings by his hand have been discovered in this sanctuary: Ill. 135.) During the master's stay in Karlštejn it must be assumed that his style developed and that by the time he returned to the monastery he had already entered upon his mature phase, which is characterized by dramatic confrontations between massive individual figures and groups of figures in spacious settings. The change-over from the early to the late style is still visible in the fresco in the seventh bay on the south wall of the cloisters (Ill. 121), the upper half of which clearly belongs to the first period (1355–6), whilst the two lower scenes, and especially the kneeling figure of Moses (Ill. 131), are typical of the second (1358–60). The intermediate stages in this transition from relatively slender and graceful figures (Ill. 110) to monumental, block-like figures (Ill. 131) are demonstrated by the watercolour copies of the Genealogy. Although it may seem strange that paintings of such disparate character should have been conceived by the same artist, we need only compare the head of Adam (Ill. 110) with the heads in the Israelites eating manna (Ill. 126) to reassure ourselves that this was indeed the case.

Tracing the foreign influences in this master's work is no easy task. Both the programme and the composition of the Genealogical Cycle would indicate some contact with Franco-Flemish painting, and it seems likely that this work was based on a north-western, possibly a Brabantian, model. The almost barren landscapes of the Emmaus frescoes may well have been inspired by Italo-Flemish monumental paintings which – although none has survived – are thought to have served as models for the 'Boquetaux' manuscripts (Ill. 96). It is also possible that the Master of the Genealogy acquired some knowledge of Siennese works via Avignon. Certainly, two of his heads (Ills. 133 and 135) were conceived in accordance with a Siennese pattern (Ill. 134). The occasional presence in the master's paintings of North Italian motifs is explained by the ready availability in Bohemia of Bolognese manuscripts, especially those of Niccolò di Giacomo. The Bohemian painters of this period were particularly adept in their use of light, and the Master of the Genealogy was no exception. Many of his figures seem literally to glow (Ill. 131), and where the surface of his frescoes has been sufficiently well preserved, the skill with which he uses highlights to obtain genuinely painterly effects is immediately apparent (Ill. 133).

In Karlštejn a second workshop was engaged on the decorations for the chapels in the Lady Tower. The frescoes in St. Catherine's Chapel, which was intended for the

private devotions of the emperor, were probably completed by 1356, the year in which this tiny oratory was consecrated. These frescoes were executed by no less than six different artists. Although the first (Bohemian) master was responsible for the major part of the fresco in the altar niche–which depicts Charles IV and his third wife, Anna of Schweidnitz, praying to the virgin and flanked by two apostles–the face of the madonna (Ill. 119) was painted by an Italian artist, presumably from Sienna. The Crucifixion on the front of the altar (Ill. 113) was the work of a third master whilst the figure of St. Catherine on the southern side of the altar was executed by an assistant under his guidance. The frieze depicting the apostles and patron saints, of which only fragments of seven heads have survived on the north wall of the chapel, stems from a fifth hand and must have been completed before the consecration of the chapel in 1356 since the apostles are seen carrying the crosses used in this ceremony.

The reliquary cross which Charles IV had had made in 1357 in order to accommodate a number of newly acquired relics was provisionally installed in the St. Catherine's Chapel, and a superporte fresco was then executed depicting the emperor and empress with the new cross (Ill. 105). At the same time three related scenes were painted, presumably by the same (sixth) master, in the adjacent Church of our Lady. The first two of these show Charles IV receiving the sacred relics from the French dauphin and from King Peter of Cyprus whilst in the third the emperor is seen placing these treasures in the reliquary (Ill. 120). Although the relic frescoes have been falsified by successive restorers (Ills. 107 and 120), they none the less still reveal telling similarities with the superporte (Ill. 105). Despite their proximity, in both time and space, to the remaining frescoes in the St. Catherine's and Lady Chapels, the above-mentioned paintings have less in common with them than with the Morgan Diptych in New York (Ill. 106). The female heads on the panels of this diptych are closely related to the head of the empress on the superporte (Ill. 105), whilst the beardless apostles bear a distinct resemblance to Peter of Cyprus (Ill. 107). The modelling of the heads on the superporte, in which the artist's use of light is all important, has its closest analogies in the panel paintings and the illuminations executed in Prague in the late 1350s, of which the Morgan Diptych (Ill. 106) and the Laus Mariae (Ills. 103 and 104) are examples. The common factor was doubtless–yet again – the influence of Tommaso da Modena (Ill. 117).

Important though they are, the relic scenes on the south wall are not the principal decorations in the Church of our Lady, these being provided by a number of representations taken from the Apocalypse of St. John (Ills. 115, 116 and 118). Certain arrangements made at the time of the consecration of the Church of our Lady, plus the fact that these frescoes have been superimposed on the original consecration crosses (see Ill. 118), indicate that the Apocalypse cycle was painted only after 1357. There may even have been a certain time-lag between the execution of the frescoes on the east wall (Ill. 115) and the execution of those on the west wall (Ill. 116). It would seem that the former at least were painted by the Master of the Crucifixion (Ill. 114), who, during his mature period, was probably the dominant figure in this workshop.

Whether he can also be identified as Nicholas Wurmser of Strasbourg is a matter of conjecture. We know from the historical records that Wurmser contributed to the Caroline frescoes, but unfortunately these documents do not specify the paintings for which he was responsible; and although the Master of the Crucifixion and the Apocalypse might well have come from the Upper Rhine, so too might the Master of the Genealogy and the Emmaus frescoes. Neither can this problem be solved by comparisons with the few surviving Strasbourg paintings of the period around 1360. Both the posture and the features of the figures in an early illuminated manuscript of Heinrich Suso's 'Exemplar' (Ill. 109), or in an Alsatian Legenda Aurea of 1362 (Ill. 111), are reminiscent of the Crucifixion (Ill. 113) and the Apocalypse (Ill. 115). But then if we consider the works of the Master of the Genealogy we find that his figures contain elements of the Strasbourg style as well: the slender angels in the Exemplar (Ill. 109 bottom) and in his Expulsion from Paradise (Ill. 110) are very similar whilst the heads in the Legenda Aurea (Ill. 111) and in certain glass paintings from Colmar (Ill. 112) have the same powerful features as the heads in some of his in The Israelites eating manna (Ill. 126 top). The fact of the matter is that both of these masters use stylistic elements associated with Strasbourg, the only difference being that where the Master of the Crucifixion incorporated them as they stood, the Master of the Genealogy combined them with Flemish and French elements. Without further historical evidence there is no means of telling which of these two artists was Nicholas Wurmser.

Of course, the progressive painters who executed the court commissions were not the only artists working in Bohemia at this time. The Madonna Enthroned between St. Catherine and St. Margaret (Ill. 108), which was executed c. 1360, is comparatively traditional. The design of the throne and the rocky terrain is modelled on the Višší

Brod Annunciation of *c.* 1350–5 (Ill. 88), and so too are the faces. The only up-to-date features are the posture of the figures and the distaff-shape of their bodies, the movements of which seem no longer determined by their contours alone, but originate from within, and in this respect are reminiscent of the Crucifixion (Ill. 113).

But by this point of time the general line of development was quite clear. Between them, the frescoes in the Emmaus cloisters and those in the chapels at Karlštejn Castle, together with the early manuscripts produced by the Neumarkt illuminators, had created an artistic synthesis based on a variety of stylistic innovations culled from many parts of Europe, and this synthesis provided a basis for the emergence, from *c.* 1360 onwards, of a specifically 'Bohemian' style. The principal champions of this new development were the royal painters Theoderic and Oswald, and the younger illuminators from the Neumarkt group.

Unlike Nicholas Wurmser, Theoderic–who is known to have been active in Prague from the late 1350s to the late 1370s–is mentioned in contemporary records as the creator of a number of specific paintings. Unfortunately, these all date from the first half of the 1360s, which means that we are unable to identify any of his early or late works with absolute certainty. It seems highly probable, however, that the Crucifixion panel from the Emmaus monastery (Plate v) was one of the later products of his school. The design may well stem from the master himself, although the actual painting was executed by two of his workshop assistants. But it is in the Chapel of the Holy Cross at Karlštejn Castle that we are able to feel the full impact of Theoderic's art, and it is interesting to note that he was granted certain privileges in 1367 in recognition of his contribution to this favourite artistic enterprise of the emperor. At the time of the first (pre 1357) consecration of the chapel, which was intended to house the imperial crown jewels and insignia together with precious relics, the decorations must still have been at the planning stage. The preliminary drawings, mostly by the Master of the Genealogy (Ill. 135) for a series of frescoes, which was subsequently abandoned, were executed at this stage; it would seem that by then the programme of the decoration–half-length figures of various saints–had already been decided. In 1359–60 the lower part of the wall was inlaid with semi-precious stones, as in the St. Catherine's Chapel. At the same time, the vault was decorated with blended glass and crystal, and the frescoes were painted on the pointed vaults of the window niches. In the contemporary account of the second (1365) consecration ceremony there is a reference to the 'most precious

paintings in the chapel', and it would seem that the tempera panels–some 130 in all that cover the upper part of the wall–had already been installed by then. From this it follows that the works provided for the Chapel of the Holy Cross by Theoderic and his numerous assistants must have been executed in the first half of the 1360s. Theoderic's personal style is clearly manifested in his St. Matthew (Plate IV) or in his Adoration of the Magi (Ill. 125). Although the luminosity of Theoderic's colouring betrays a certain indebtedness to the Master of the Genealogy, his manifest indifference to spatial effects enables us to distinguish his work without any difficulty. In his scenic compositions the figures, and the various elements which make up the settings, are packed closely together to form extremely tight-knit reliefs, whilst in his paintings of the saints the figures are so huge that the panels appear to be, quite literally, full to overflowing. The decorative effect of these pictures in the chapel is, of course, greatly enhanced both by their two-dimensional quality and by the absolute priority given to painterly values. In Theoderic's work the specifically Bohemian style that was heralded by the flowing figures of the Liber Viaticus and the Laus Mariae, and the luminosity of the Emmaus frescoes, seems to have reached its apogee. Judging by the paintings in the Chapel of the Holy Cross, one could guess that Theoderic's early works would have been rather akin to the Morgan Diptych (Ill. 106).

But there is one panel in the chapel which is of a completely different order. This is the painting of St. Jerome (Plate III), who, incidentally, is also the only saint represented in full profile. In this work the head and hands are executed in a precise, linear technique, which makes them stand out in bold relief from the relatively unshaded and almost glaring red of the robes. All this is in marked contrast to the figure of St. Matthew (Plate IV), whose soft, painterly texture seems almost to absorb the light and colour. On the other hand, both the structure of the head in the painting of St. Jerome, and the vitality of the linear composition, have a great deal in common with the turbulent fresco in one of the window niches of the chapel: The twenty-four ancients adoring the Lamb (Ill. 128). Clearly, both of these works were executed by another rather important artist, who was probably trained in the workshop run by the Master of the Genealogy. Many of the heads in his paintings are reminiscent of this master's work, although both the ill-defined settings, and the squat proportions of the somewhat grotesque figures, constitute a new departure.

On the other hand, it was precisely the apt rendering of

vast landscapes by the Master of the Genealogy that inspired the fresco painter who executed the scenes from the St. Wenceslas and St. Ludmilla legend in the staircase of the Great Tower at Karlštejn Castle between 1360 and 1362. Not that these frescoes—many of which were disfigured by over-zealous nineteenth-century restorers (Ill. 122)—are by any means imitative. The graceful rhythm of the figures and the flowing, wreath-like designs are completely original features. There are also works in Prague that would appear to have been executed by this artist and his workshop. Definite similarities exist between the Adoration of the Magi in the Saxon Chapel of St. Vitus's Cathedral (Ill. 123) and the Baptism of St. Ludmilla (Ill. 124), which is one of the better preserved works in the staircase at Karlštejn. In both of these paintings we find the same slender figures with oval faces, vivacious eyes and 'tapir' noses, the same loose grouping of figures and objects, the same flowing drapery, and the same painterly use of highlights. It is also instructive to compare this Adoration with the Adoration (Ill. 125) executed by Theoderic for the Chapel of the Holy Cross at Karlštejn Castle. In Theoderic's work the figures and objects are packed closely together to form an essentially two-dimensional composition whereas in the Prague version of this theme the three-dimensional quality of the pictorial space is clearly indicated by the shady background. Incidentally, there would seem to be reasonable grounds for associating the workshop responsible for both the frescoes in the Karlštejn staircase and the Adoration in the Saxon Chapel—an important group of artists who will doubtless have worked mainly for the court—with Master Oswald, whose position as royal painter is authenticated by payments made to him in 1372 and 1373.

Only a half-dozen illuminated manuscripts of the 1360s bear witness to the equally high standard of Bohemian illumination at that time. This small body of work was produced by two workshops. The first of these, which enjoyed the patronage of Ernst of Pardubice, the Archbishop of Prague, numbered amongst its members a group of illuminators who still worked in the Italianate style of the Kreuzherren Breviary (1356; Ill. 90). In 1363 these illuminators were commissioned by the archbishop to execute a series of liturgical manuscripts for the cathedral in Prague, and some of them also contributed to the four volume Antiphonary from Vyšehrad, which is now in Vorau (Styria). The fact that the coat of arms of the bishopric of Minden appears several times in this manuscript would suggest that it was donated by Dietrich of Kugelweit, who was a relative of Ernst of Pardubice. From 1355 to 1361 Dietrich

was Bishop of Minden (Westphalia), and from 1360 onwards Chancellor of Bohemia and Provost of Vyšehrad. Several initials in this lavishly decorated manuscript (Ill. 137) are distinctly reminiscent of the 1350s style. Thus, the Throne of St. Peter (Ill. 141) is a variation on the Wroclaw Throne of Mercy (Ill. 140). But the major part of the Vyšehrad Antiphonary was decorated by another illuminator, who collaborated for only a relatively brief period with the workshop. Stylistically, he is much closer to the monumental art of the Master of the Genealogy. His impetuous figures with their powerful heads, and their rich drapery with its flowing borders and fluttering lappets (Ill. 130) are full of a dynamism comparable to that of the Emmaus frescoes (Ill. 131). Incidentally, the metropolitan chapter in Prague has a two volume bible illuminated by this 'second' Master of the Vyšehrad Antiphonary, in which the initials are also imbued with the same dramatic power (Ill. 127). Although few works by the highly original second master have survived—and all of these date from the same period in the early 1360s—he exerted a considerable influence on his contemporaries. Thus, the illuminator of one of the so-called Austro-Bavarian World Chronicles (Ill. 138) employed a scheme for his margin decorations that was clearly derived from the Antiphonary (Ill. 139): half-length figures emerging from the folds of acanthus leaves.

The other group of illuminators, which was closely associated with Johann of Neumarkt, continued to work in the tradition established by the Liber Viaticus. The first of the three surviving manuscripts illuminated by one of the members of this group is the Orationale Arnesti, a prayer book executed for Ernst of Pardubice in the early 1360s. In 1365 Johann of Neumarkt commissioned the same illuminator to produce a missal according to Olomouc use, presumably to mark the latter's appointment as bishop of this town. But although the motifs used for the initials in this manuscript were still derived from the Liber Viaticus, the painting style is more recent (Ill. 142). Many of the heads already reveal the influence of Master Theoderic, as does the flat composition, which is set out almost like a relief (Ill. 125). The third surviving manuscript from the Neumarkt workshop is a gospel book, which was written entirely in gold leaf and decorated by the calligrapher and illuminator Johann of Troppau (Opava) in 1368. Destined for Albrecht III, Duke of Austria, it too was probably commissioned by the chancellor. Like the Master of the Olomouc Missal, Johann of Troppau took the Liber Viaticus as the point of departure for his work (see Ills. 129 and 132) but also incorporated a number of the stylistic features

developed more recently by the Oswald workshop. Both the facial types and the postures of his figures are reminiscent of Oswald; and, like Oswald, he used three-dimensional objects (e.g. a sarcophagus) to enhance the effect of pictorial space (Ill. 143). He also adopted elements from foreign spheres, including the Neapolitan school of illumination, and–obviously in accordance with Duke Albrecht's antiquarian tastes–even harked back to modes of early Romanesque book decoration.

It was in the chancellor's scriptorium in Prague that fourteenth-century Bohemian illumination reached its first peak, and in the 1370s and 1380s the vast majority of native illuminators took their lead from this group. Even though none of their followers could equal the Master of the Liber Viaticus and Johann of Troppau, a few outstanding works were still originated; the Kuneš Bible is a case in point (1389; Ill. 144). But unless our conception of this period has been distorted by the necessarily random composition of what survives of Bohemia's artistic heritage, it would seem quite certain that not only Bohemian illumination, but every branch of Bohemian painting, became progressively more mediocre and provincial at the very time when Peter Parler was carrying Bohemian sculpture to its greatest heights. This process was not reversed until the Master of Třeboň made his début.

In 1370–7 a distinctly exotic work was produced in Prague at the direct instigation of the emperor. This was the great mosaic of the Last Judgement, which was executed above the south portal of St. Vitus's Cathedral by Italian artists, who were the only competent exponents of this particular technique. It is possible that they worked from cartoons prepared by the royal artists of Prague. But stylistically, they followed their native practices, and so had little influence on Bohemian painting.

By common consent, the major work of the 1370s is the votive picture commissioned by Jan Očko of Vlašim, the Archbishop of Prague, for installation in the episcopal castle in Roudnice, the chapel of which was consecrated in 1371 (Plate VI). In the upper half of this painting Charles IV and his son Wenceslas are seen praying to the Madonna whilst in the lower part the artist has portrayed the kneeling figure of Jan Očko flanked by Bohemian saints. Only Jan Očko, the donor, is shown in full profile. Most of the other figures appear in a stereotype half-profile; the Madonna alone is shown full face, but her head and the upper part of her body are inclined towards the infant in her lap, who appears to be kicking with his feet. All other movements have been reduced to frozen gestures. The complete lack of three-dimensional space, the rigid symmetry of the composition, the rich colours and, finally, the all-pervading glow of the golden ground imbue this work with a mystical quality, as if the figures were in a state of trance. The stylistic vocabulary used in this painting is reminiscent of the frescoes executed by the Oswald workshop, so the question remains whether it is another of Master Oswald's works. Unfortunately, the frescoes, which are earlier, are not sufficiently well preserved for a definitive judgement to be made in this respect. But the mere fact that the Jan Očko painting is comparatively flat, whilst the frescoes suggest so much depth, does not invalidate this hypothesis. As a votive painting, it may have been executed in a more hieratic style, and as a product of a later decade, it may also have been influenced by a new trend which appeared in the 1370s. Typical representatives of this trend were the illustrators responsible for the Liber Pontificalis (Ills. 146 and 147) of Albert of Sternberg, the Bishop of Litomyšl, which dates from 1376. The execution of the figures and drapery in this manuscript, the flat–almost static–composition, and the iridescent glow of the sophisticated colouring establish a close affinity between this work and Jan Očko's votive painting (Ill. 150). Many of the initials are also reminiscent of the various frescoes executed by the Oswald workshop in the chapels of St. Vitus's Cathedral, which are poorly preserved today, but appear to have been the dominant influence in Bohemian painting in the mid 1370s.

Other contemporary illustrations are in Thomas von Štítný's Six Books of Faith (also dated 1376), which is, by the way, one of the most important documents from this early period of Czech literature. But although he too was influenced by the Oswald workshop, the illuminator of this manuscript seems to have derived his strikingly slender figures (Ill. 148) primarily from contemporary French models. Incidentally, this master also worked for the young King Wenceslas. In 1373 he illuminated a Bohemian Chronicle–which is now in Cracow–for his royal patron.

During the 1380s various minor workshops were active in different parts of Bohemia, including the region of Olomouc, where, among other works, an important illuminated bible was produced in 1385. In this bible the figures in the initials (Ill. 149) betray a sense of anxiety and restlessness, which would suggest that their creators were well aware of the impending religious and political crises.

The altar panels from Třeboň (Wittingau) in southern Bohemia, which were executed between c. 1385 and c. 1390, are the work of one of the greatest of all fourteenth-century

50

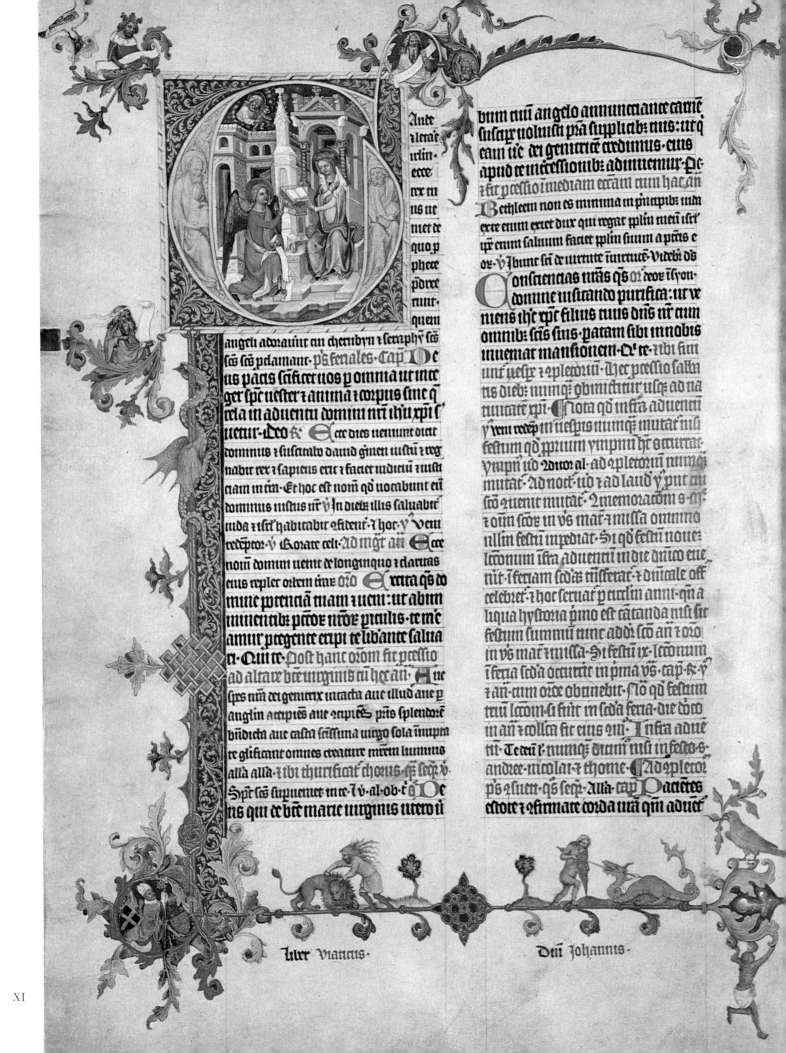

XII vnd sprechen zu mir Jch vms

les sein housvrow vnd seine X

XIV vorterben von achaben den

teile der rede ioas vnd alles X*

wassern. Und got sprache. Es
werde ein liecht. Und es wart ein
liecht. Und got sach das liecht
das es gut was und schid das
liecht von der vinsternusse. und
nante das liecht tack und die vi
sternusse nacht. Und wart ge
macht abent und morgen ein
tag. Und got sprach. Es werde
ein vestenunge in der mitte der
wasser und teilte die wasser vo
den wassern. Und got machte
ein firmament. und schied die
wasser die do waren unter dem
firmament von den die do wa
ren auf dem firmament. Und
es geschach also. Und got nan
te das firmament himel. und
wart gemacht abent und mor
gen der ander tag. Got unser
sprach. Die wasser die unter dem
himel sint sammen sich an ein
stat und erscheine die trucken
und es geschach also. Und got
nante die trucken erde und die
sammenunge der wasser nante
er die mer. und got sach das
es gut was. Und sprach. Ge
bere die erde grunende wurtze
und machende samen. Und
ein opfeltragendes holtz und

Incipit decimus octauus
liber moraliū beati Grego
rij pape: sup Job;

Rerūq̃ in sacro eloquio
sūt non nulla mistica descri
bunt: ut tamē iuxta nar
racōm hystoricā platā
videant⁹ Sz sepe dicta tali
a in eadem hystoria narra
cōe priuxta sūt: p̄ que sup
ficies hystorie cūcta casset⁹
que dum nichil hystoricū
resonant: aliud ī eis mũce
lectorem cogunt. His em̄
dictis que apta credimus·
cum interiecta aliqua obscurius
inuenimus: q̃ quibusdam scrutu
lis pungim̄⁹ ut ad alia aliq̃ alcius
intelligenda vigilemus: z obscurius
plata seruiamus ea etiā que apte dic
ta putabamus. Cum g̃ beatus Job
de sermone dm̃ z magnitudine tou
trū loq̃ret⁹ eisdē vbis ptc⁹ sub iusert⁹

Addidit quoq; Job assumēs pa
bolā suā z Quo p̄ferto vsu os
tendit hur castmū viri dicta qñ
mystice sunt plata⁹ dū pabola· idest

loco pabolam· illud musī
nū semamus; Nec em̄ fac
q̃ in afflicōne penax inu
tet: cū p scripturā suā vi
musica in luctu in portuna
est; Notamā g̃ pabolam
ipo loqture iam dicimus:
tertiū trūmodo eius vba pe
Ad eam itaq; silitudinē d
heuda sunt· qua figurate
sigt⁹ z in ipo quidē loco co
dio dicta apte plata sunt
uctis ob scurioribz iplīcaī
plena ut solet locucōne incho
sua p mysticos sensus grau
racōne z sūmat. Itaq; ait:

Iurut deus qui abstulit
mcū: z oīpc qui ad a
diuē addurit aiam meam;
nuncie vbis vtis Job z sua
z sce ecce tpa afflicte sigui t
quibz apta infideliū puica
t: z ipsecucōis amaritudīe
Duobz uaq; modis teptari
adūsarijs solet: ut videlz
aut vbis paciat· aut glad
uō etiā summope saptam z
ille studet: Sz ecce eius sap
tat ubis· ecce eius pacia cū
gladijs Nūc vo de ea psecue
ingz uo gladijs sz falsis allo
lacessit· a; ultos aūt uouini
cū in hac vita aliq adūsa p
deū esse uo credūt· no alli⁹
estimāt: sz res hūanas ur̃m
De illis q̃ p p dauid dr̃· dī
in corde suo uo est deus: isti
se dicūt· Quō scit deus? z si
excelso· Et curs9; Et dicerem

painters: the Master of the Třeboň Retable. It now seems fairly certain–in this connection see the article by J. Cibulka in *Umení* 15, 1967–that originally these panels formed the whole of the left-hand wing and half of the right-hand wing of a retable commissioned for the main altar of the Church of St. Aegidius in the Augustinian monastery at Třeboň. The insides of these panels are decorated with scenes from the Passion (Plates VII and VIII), the outsides with standing figures of saints–three on each panel–representing the orders of the apostles, the confessors, and the virgins (Ills. 151 and 160). The centrepiece of the retable was doubtless a Crucifixion.

Since his style was not reflected in Bohemian manuscript illumination until the late 1380s, the Master of Třeboň can hardly have embarked on his career in this country much before 1385. In all essential respects the new style was the creation of a single individual, although–like most medieval masters–he will no doubt have enlisted the aid of workshop assistants and pupils. The Třeboň panels may well have been executed in Southern Bohemia, but judging by what we know about the provenances of the master's later works and by the influence these exerted on the artists of Prague it would appear that subsequently he made the Bohemian capital the centre of his activities.

The principal characteristics of this master's style were already fully present in his early works: the Třeboň fragments and the closely related Crucifixion from St. Barbara's (Ill. 156). These paintings were so advanced in their day that it seems quite impossible that they should have been evolved from the Bohemian tradition alone. Consequently, many critics have tried to discover connections with the Franco-Flemish school of the 1370s and 1380s. Unfortunately, they have met with little success, for of the few fourteenth-century panel paintings to have survived in France and the Netherlands, the only ones that bear a resemblance to the Třeboň Altar-piece were executed, almost without exception, in the 1390s. All we can do, therefore, is compare these, and postulate the existence of similar Franco-Flemish works dating from an earlier period. An instructive comparison may be made between the Třeboň panels and the altar wings painted in Ypres by Melchior Broederlamm between 1393 and 1399 for the Carthusians of Champmol, near Dijon. The structural analogies between the temple architecture in the Dijon panel (Ill. 153) and the baldachins sheltering the groups of the saints at Třeboň are unmistakable (Ills. 151 and 160). Moreover, there is a distinct similarity between the figure of Mary Magdalen in Třeboň (Ill. 151 centre) and the female attendant in the Dijon Presentation (Ill. 153). Landscape motifs also provide a link between the Passion scenes at Třeboň, Broederlamm's second panel at Dijon (which depicts the Flight into Egypt) and a Netherlandish polyptych (which is now partly in Antwerp and partly in Baltimore). Finally, we find a very close iconographic parallel between the Crucifixion from St. Barbara's (Ill. 156) and the Passion polyptych in Norwich Cathedral (Ill. 154), which was probably based on Netherlandish models of *c.* 1380. Further analogies exist between this English work and the Resurrection panel of the Třeboň Altar-piece, where the posture of the foremost guard in the fourth Norwich panel is repeated almost to the letter (Ills. 154 and 155). Moreover, there is a close similarity between the oblique alignment of the coffins in these two panels. Incidentally, comparable West European influences may be observed in a roughly contemporary embroidered chasuble in Brno (Ill. 152), whose figures are reminiscent of the Parement de Narbonne and similar Franco-Flemish paintings.

It seems highly probable, in view of his obvious affinity with Franco-Flemish art, that the Master of Třeboň received part of his training in North-Western Europe. And yet his work remains quintessentially Bohemian. Although the master must have become familiar, during his apprenticeship, with the painterly technique of the Franco-Flemish school and with its clear, gleaming colours (the polyptych panels in Baltimore and Antwerp are a good example of this style), the particular expressiveness of his own palette can only have been developed in Bohemia (Plates VII and VIII). The visionary radiance of the master's figures, which seem almost to glow from within, is quite unknown in the Franco-Flemish works of the period, but it is by no means alien to the Bohemian painters of the 1350s and 1360s. The Master of the Genealogy, and Master Oswald and his associates, were certainly acquainted with this technique (Plate VI, Ills. 123 and 131). Thus, although the Master of Třeboň would no doubt have enriched his palette as a result of his travels, his conception of painting as being fundamentally dependent on colour and light is entirely Bohemian. And it is to this conception that he owes his position as one of the foremost artists of fourteenth-century Europe. Where Giotto considered the interaction between solid objects and the surrounding space as the dominant factor in painting, the Master of Třeboň insisted on the primacy of colour and light.

The master's later works include his Madonna from Roudnice nad Labem (Ill. 157). The lovely, youthful face of this Madonna is very similar, both in its physical features

and in its handling, to the figure of St. Catherine in the Třeboň Retable (Ill. 158). The Roudnice Madonna is representative of a new type of the miraculous image (Gnadenbild) of the Holy Virgin which had been developed from the Zbraslav Madonna of c. 1355–60 (Ill. 159) and which was to persist in Bohemian art until well into the fifteenth century. There is, of course, a great difference between the highly stylized figure in Zbraslav, which is reminiscent of the icon paintings of the East, and the figure in Roudnice, which is chiefly remarkable for its individuality and its feminine grace. The natural behaviour and the nakedness of the infant are also new features, and so too is the significance attached to the drapery within the general composition. Instead of representing the drapery in the form of a low-relief and using bold outlines to pick out the seams as in the Zbraslav Madonna, the Master of Třeboň introduced large, looping folds of carefully modelled material, which constitute an essential part of the import of his painting. It was by introducing such features that this master contributed, during his mature period, to the birth of the 'Beautiful Style' in Bohemia.

The last surviving work by the Master of Třeboň – the Pietà in Církvice, near Kutná Hora – is a fragment (the upper half of an altar-wing) now bearing a life-size half-length portrait of the Mother of Sorrows on one side and of St. Christopher on the other. If we compare the Církvice St. Christopher (Ill. 162) with the Třeboň St. Philip (Ill. 163) it is immediately apparent that the art of the Master of Třeboň underwent a considerable change between c. 1385 and c. 1395. During that ten-year period he progressed from nervous spontaneity to technical mastery, from flickering highlights to a soft, diffuse glow, and from highly individual to much more stereotyped heads. Although the master's painting was still of the same high quality, it lacked the tense energy of his early work.

King Wenceslas IV, who reigned from 1378 to 1419, may not have gone down in history as a great ruler, but to this day he is still highly thought of by art historians. Like Jean de Berry and Gian Galeazzo Visconti, Wenceslas IV was one of the great bibliophiles of the late fourteenth and early fifteenth centuries, and it was during his reign that Bohemian illumination reached its apogee. Only seven manuscripts have survived which we know to have been executed for Wenceslas. All of these were decorated in a manner evolved partly from the work of the Neumarkt illuminators (Ills. 99 and 142) and partly from the manuscripts of the 1370s and 1380s (Ills. 144 and 146), which means that the lobular and dentate acanthus motifs of the

Liber Viaticus continued to dominate Bohemian illumination right through to the end of the century. In the Wenceslas manuscripts, which were all created between 1385 and 1400, these vegetal borders intermingle with numerous emblems and allegorical figures reflecting both the symbolism of the secret fraternities of chivalry, which were particularly widespread at that time, and the religious and astrological ideas of the age. Although they were undoubtedly the major achievement of Bohemian illumination during the late 1380s and the 1390s, and despite a marked similarity existing between them in respect of their general composition, the seven Wenceslas manuscripts do not appear to have been created by a homogeneous and centrally controlled workshop. The quality of the illuminations varies greatly, which would suggest that they were executed by artists of unequal talent and of different training – who in ever-changing combinations – collaborated almost haphazardly in their vast assignments. The manuscripts were produced in the following order: the 'Willehalm' Romance, which was dedicated to the king in 1387 and was probably illuminated by that date (Ills. 170, 172 and 174); the six volume Wenceslas Bible (Ills. 173, 175, 176, 177 and 180; Plates XII–XVI); the Astronomical Tables in Vienna (Ill. 171); Nicholas von Lyra's Commentary on the Psalms (Salzburg University Library, cod. M III 20); the de luxe copy of the Golden Bull, dated 1400 (Ill. 183); the Ptolemy Manuscript (Plate XIX) and the Astrological Codex in Munich (Bavarian National Library, Clm. 826).

As a rule, the illuminators working in medieval scriptoria divided their manuscripts up into sections or 'gatherings', a procedure that is particularly well documented by the Wenceslas Bible, where some of the gatherings are actually signed. The anonymous artists in the workshop, however, have been mostly named by reference to their particular contribution.

The general style of the 'Willehalm' Romance, which is chiefly remarkable for its slender figures and its delicate but elaborate canopies, appears to have been fixed by the master who illuminated the first few pages. His illuminations are based partly on the Štitný Codex of 1376 (Ill. 148), and partly on the monumental paintings of the 1350s. (Thus, some of his figures and drapery arrangements were borrowed from the Genealogy of the Luxembourgers.)

Apparently, the Genesis Master – so-called because he created the great Genesis initial in the first volume of the Wenceslas Bible (Plate XVI) – was invited to contribute to the 'Willehalm' Romance only when it was decided to change to a more lavish type of decoration (from folio 185

onwards; see ills. 170 and 172). It would also seem that before long this master came to dominate the illumination of this manuscript, just as he was to dominate the entire Wenceslas workshop up to about 1395. Although the Genesis Master's style appears to be typically Bohemian, his earliest known work (Ill. 168) is to be found in a manuscript illuminated in Nuremberg in 1380. (Of course, it does not follow from this that he was of German origin, for he may simply have been visiting Nuremberg at the time.) The first Bohemian work to which he contributed was a miscellaneous manuscript, now in the Monastery of Stams in the Tyrol, which was executed for one of the Bishops of Litomyšl. The most ornate part of this manuscript is the opening section (folios 1–44), in which both the title-page and the small initials on folios 24 to 30 (Ill. 169) were clearly executed by the Genesis Master. The title-page was already based on the same decorative scheme that was subsequently used by the Wenceslas workshop, and even features one of the Wenceslas emblems, namely the love knot. The principal influence in this master's work came from the wall-paintings executed by the royal artists of the late 1350s and early 1360s. Both his figures and his conception of pictorial space were evolved from Theoderic and the Master of the Genealogy.

Of the illuminators who contributed to the Wenceslas Bible only two belonged to the older generation of artists. One of these was the Genesis Master, the other was the Balaam Master, whose work also reveals the influence of the late 1350s (compare Plate XII and Ill. 145). The Balaam Master undoubtedly studied the bleak landscapes in the Emmaus frescoes with their characteristic *boquetaux*, and the gentle modelling and soft glowing highlights of the hands and faces in panel paintings such as the Morgan Diptych (Ill. 106) or manuscripts such as the Laus Mariae (Ills. 103 and 104). In some cases, however, his figures and interiors are so immediately reminiscent of the late North Italian followers of Giotto—artists like Altichiero and Giusto di Menabuoi—that one feels inclined to think he must have known their principal works at first hand.

Not surprisingly, the other—younger—masters who worked on the Wenceslas Bible were more interested in the new style of painting developed by the Master of Třeboň, and many of them even came to adopt the fully-fledged Beautiful Style. Thus, in the Viennese Bible (Plate XIII) the Exodus Master, who had made his début in the Stams and the 'Willehalm' manuscripts alongside the Genesis Master, produced numerous variations on the type of rocky landscape used by the Master of Třeboň for his Mount of Olives panel. Unlike the Genesis Master, who invariably opted for subdued and lustreless colours which make his paintings look as if they are covered with a layer of dust, the Exodus Master adopted the gleaming palette developed by the Master of Třeboň and, with it, the latter's predilection for dark shadows and flickering highlights. Apart from his Exodus illuminations in the Wenceslas Bible, this master produced decorations for the Salzburg Commentary on the Psalms and—during his late period—created the title-page for the Golden Bull.

Another illuminator who had contributed to the 'Willehalm' Romance before working on the Wenceslas Bible is the Solomon Master. He was responsible for part of the decoration of the third volume. Incidentally, he acquired his sobriquet from the fact that the tall and elegant figure of King Solomon appears in so many of his illustrations. The principal features of his work are the deep furrows and the patches of dark green shading, which give his figures such impressive faces.

The Esra Master had also contributed to the 'Willehalm' Romance (Ill. 174). His indebtedness, in respect of both his figures and his palette, to the Master of Třeboň is immediately apparent (compare ills. 151, 156 and 160). He took from the repertoire of the great panel painter not only his facial types—the men with their bearded and impressive heads, and the women with their round, youthful faces, their small mouths and narrow, vivacious eyes—but also his drapery motifs, which were conceived in terms of the early Beautiful Style. His picture of Queen Jezebel being torn to pieces by dogs in the Wenceslas Bible (Plate XIV) shows his remarkable capacity for setting the mood of a scene by the use of bold combinations of magically gleaming colours.

The Ruth Master was probably a pupil of the Esra Master. But although their styles are obviously related, the Ruth Master's figures are far more powerful and have much coarser faces. Incidentally, it is quite easy to identify this master's work from his use of regular cross-hatching to indicate shadow. In his use of colour the Ruth Master is clearly inferior to the Esra Master, but in their expressiveness many of his miniatures—especially his picture of Ruth and Boaz asleep in the field (Ill. 177)—are even more thrilling than those of his teacher.

The Samson Master is a particularly engaging narrator. In his illustrations the protagonists are arranged in lively and often extremely dense groupings (Ill. 175). The characteristic features of his work are the spindle waists and the relatively small heads of his slender figures. Apart from

Ill-assorted pair, 1300. Brunswick sketchbook

contributing to the Wenceslas Bible the Samson Master was responsible for the miniature glued to the title-page of Cosmas's Bohemian Chronicle (Ill. 167), and also for part of the Morgan Bible. The initials in the first part of this manuscript, which is dated 1391 in the colophon, were illuminated by the Samson Master, those in the second part by the Master of the Morgan Bible (Ill. 179).

In the Wenceslas Bible, however, the latter did not illuminate a single gathering on his own. In this undertaking he was working exclusively as an associate of the Samson and Exodus Masters, and in a number of cases he executed illustrations based on their preliminary drawings (Ill. 180). The principal characteristics of this master's work are his extremely delicate brush strokes, his use of pale colours blended with white lead, and his rhythmical figures with their gnome-like faces and intricately folded drapery. The curling seams in the drapery of his early period, and certain pseudo-perspective articles of furniture, are reminiscent of the style of illumination developed in Prague in the late 1370s and 1380s in the wake of the Sternberg Liber Pontificalis (Ills. 146 and 147). Later, when he joined the Wenceslas workshop, the Master of the Morgan Bible modified his style. Following the lead of the Samson and, more particularly, the Exodus Master, he submitted to the influence of the Master of Třeboň, as is quite evident from the initials which he executed for the Miscellaneous Manuscript of Archbishop Johann of Jenzenstein (Ill. 181). But the Master of the Morgan Bible's most significant achievement was the series of illustrations which he created for the two volume manuscript of the Moralia in Job, now in the monastery

library at Herzogenburg in Lower Austria. Although four other artists from the Wenceslas workshop had cooperated in the illustration of the first volume, the second was illuminated in its entirety by the Master of the Morgan Bible. The large initial showing Job flanked by his wife and Satan (Plate XVII) is exceptionally fine, and is probably his most mature work. Later, this master headed the group of artists responsible for the illumination of the Bible of Konrad of Vechta. However, apart from the large Genesis initial, he himself painted only one miniature in the first gathering, and although some of the other miniatures may have been designed by him, their execution was entrusted to an assistant. But even in the best of his illustrations in this Bible (Ill. 182) he did not get beyond his earlier achievements in the Moralia. And in spite of the fact that his latest works date from the early years of the fifteenth century, he never accommodated himself to the Beautiful Style as most of his colleagues had done by that time.

Finally, I must deal with the illuminator who signed several gatherings of the Wenceslas Bible as 'N. Kutner', and who also worked on a number of other manuscripts, including some of Silesian provenance. This artist was remarkable for the precision with which he executed the background detail of his pictures—his flowers (Plate XV) are drawn as regularly as if they were ornaments—and for the merely decorative and quite unrealistic division of his landscapes into light and dark zones (Ill. 176). These are interesting features, for they have their closest analogies, not in Bohemia, but in certain of the French manuscripts of the 1380s (Ill. 178). This would suggest that Kutner—who

Three prophets (?) c. 1300. Brunswick sketchbook

59

was probably of Silesian origin – trained in France for a considerable period. So too would his figures and his repertoire of gestures, which are clearly based on French models.

Some members of the workshop did not contribute to the Wenceslas Bible. One such was the Oracle Master, whose work we first encounter in the Vienna Astrological Miscellany and who subsequently illuminated the first page of the Vienna Ptolemy (Plate XIX). After an early period, in which he worked rather in the style of the Balaam Master, this artist was influenced by both Kutner and the Samson Master. The Master of the Astronomical Tables, who illuminated the Alphonsinian Table in the Astrological Miscellany, should also be mentioned. His greatest achievement was the title-page, dated 1392, of this text (Ill. 171). Although this master's work reveals certain analogies with that of the Genesis Master, his most striking affinity is with the principal artist who contributed to the Bohemian Sketchbook at Brunswick (see illustrations on previous page). Incidentally the drawings in this sketchbook yield good information about the stylistic exchanges that took place between different branches of art; they hold an intermediate position between the Master of Třeboň, the early Wenceslas manuscripts and the Prague sculptors of about 1390.

Most of the illustrations in the Golden Bull were created by a single artist, who takes his name from this manuscript (Ill. 183), but who also contributed to the Bible of Konrad of Vechta (Ill. 185).

There is a further small group of manuscripts which are thought, but cannot be proved, to have belonged to the library of Wenceslas IV, and from these I should like to mention the Epistles of St. Paul (Vienna National Library, cod. 2789), because they were illuminated by a painter who also contributed several minor initials to the Golden Bull. Moreover the St. Paul Master participated in the decoration of the Moralia in Job and a Latin Bible in Agram (Library of the Metropolitan Church, MR 156). Besides these he illuminated a dozen other codices, the most interesting of which is a Sanctorale (Prague National Museum, XV A 12). Both the style and the handling of the St. Paul Master (Ill. 166) are in many ways reminiscent of the second Master of the Vyšehrad Antiphonary (Ills. 127 and 139).

In applying the term Beautiful Style to the major works produced in Bohemia in the late 1390s and early 1400s I have followed the practice of Czech scholars, who distinguish in this way between the International Style, which was common to all European schools at this time, and its specifically Bohemian variation. The Beautiful Style was first introduced by the Master of Třeboň in his late period (Ills. 157 and 162) when he started to use richer, more precise pictorial forms, and much harder textures. At the same time he abandoned the highly luminous palette and chiaroscuro effects of his earlier period in favour of soft, pure colours and a gentle, all-pervading light. A younger generation of Bohemian artists then carried this progressive development – which, paradoxically, incorporated a number of archaic features – to its logical conclusion. The epitaph for Johann of Jeřeň, a member of the chapter of Prague Cathedral who died in 1395 (Plate IX), is a paradigm of the Beautiful Style in its mature form. Not surprisingly, this – on the whole idealizing – development made greater progress in the solemnly composed works of the panel painters than in the narrative pictures of the illuminators. But neither were the panel painters the first artists in fourteenth-century Bohemia to adopt the formal and thematic programme of the International Gothic movement. They had only to follow the lead of the sculptors, whose Beautiful Madonnas (Ill. 69) were doubtless the earliest examples of the new style.

In the Jeřeň Epitaph the figures of the apostles appear within a pictorial setting that is almost completely abstract, for the golden ground is so dominant that it is all too easy to overlook its one objective feature, namely the narrow strip of brown earth. There are no dark shadows in this picture, the two figures are enveloped in a diffuse glow, and only a few highlights are set in narrow bands along the bulging folds of the drapery. All this is reminiscent of the early period of Bohemian Gothic painting (Ills. 87, 88 and 92), as is the clear preference revealed by the Master of the Jeřeň Epitaph for *disegno* rather than for the *sfumato* adopted by the Master of Třeboň (Ills. 162, 163 and 165). The only novel feature is the artificial arrangement of the rich drapery, which creates the kind of rhythmically interwoven movement that is the foremost characteristic of the Beautiful Style. Of course, it was not only in Bohemia that there was a reaction against the realism of the 1360s and 1370s. On the contrary, the new trend – which probably originated in Paris – was taken up throughout the continent. In the late 1370s Parisian artists had already started to introduce decorative motifs and structures based on the use of elaborately curved outlines, and subsequently these were combined with the rich and voluminous drapery style that was developed in Flanders during the last quarter of the century.

The St. Vitus Madonna (Plate X), which is the finest of the devotional images ever produced in Bohemia, gives

PLATE XIX *Title page of Ptolemy's Commentary, c. 1400 Vienna, National Library*
PLATE XX *The Creation, c. 1415–20. Boskovic Bible, Olomouc, University Library*

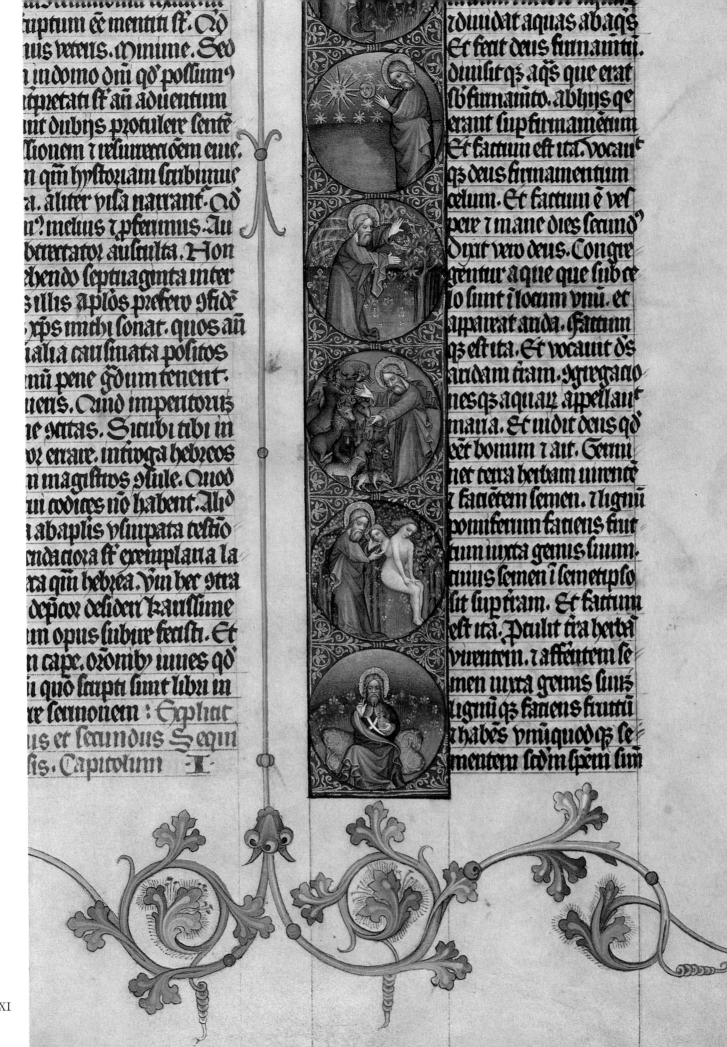

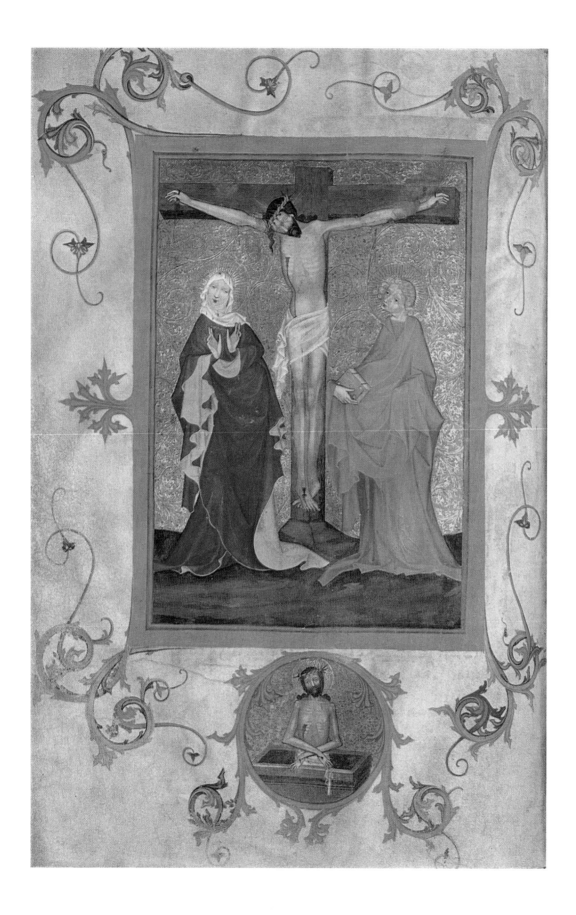

XXII

some idea of the artistic trends leading up to the Beautiful Style. On the one hand, the enamel-like texture and the plasticity of the figures are reminiscent of certain polychrome statues (whose original colouring has survived) just as the child's movements, the position of the madonna's hand, and the way the flesh gives way under the pressure of her fingers call to mind a number of Bohemian sculptures (such as the Madonna from Český Krumlov (Krumau) [Ill. 67]). On the other hand, a comparable type of half-length picture of the Virgin was also evolved in western Europe by the artists in the circle of Jean Malouel and the Limburg brothers, who revealed the same preference for combining harmonious reds and blues in the drapery. In panel paintings like the St. Vitus Madonna influences from both these spheres seem to have merged. However, we are not as yet in a position to establish the precise year in which the Beautiful Style first appeared as a specifically Bohemian variation of International Gothic, or to identify the artist responsible for this innovation, because with the single exception of the Jeřeň Epitaph none of the major early works has been reliably dated.

The retable from Dubeček near Prague, whose four panels show representations of eight saints together with a portrait of the donor, is a slightly more recent work than the Jeřeň Epitaph. With their childlike proportions, their scrupulously stylized faces and their schematized drapery, these fragile figures (Ill. 161) reflect a stylistic development that is not encountered in the work of the Bohemian illuminators until the early 1400s (Ill. 183).

The fourteen head and shoulders portraits of Christ, the Virgin, John the Baptist and the Apostles from the Capuchin Monastery in Prague cannot be linked up with any other Bohemian paintings of the period. This difference becomes apparent if we compare one of the Apostles from this series (Ill. 164) with the portrait of St. Thomas from the Jeřeň Epitaph (Ill. 165). In the Capuchin panel, which was executed well after 1400, there is no longer any hint of the immense vitality that is the dominant feature of the St. Thomas. Instead we find cool precision and a sophisticated grasp of the optical effects produced by light and texture. Apart from the iconography of some of the heads and their hypothetical arrangement in the form of a huge retable there is nothing specifically Bohemian about the Capuchin cycle. The most immediate antecedents of these paintings would seem to be the apostles and prophets painted by Franco-Flemish artists such as André Beauneveu and Jacquemart de Hesdin. (Compare, for example, the series of full-page miniatures in the Psalter of the Duc de Berry

and the 'first' dedication picture in the Très Belles Heures in Brussels.)

Shortly after the turn of the century two important groups of illuminators emerged as successors to the Wenceslas workshop. But although they maintained occasional contacts, their aims and their methods were entirely different. One of these two groups–the one led by the Master of the Hasenburg Missal–was closely connected with the panel painting of the period (Ills. 186 and 187). The Madonna from Jindřichův Hradec reveals the same decorative cascades of drapery, which extend across the entire width of the picture, the same brilliant colouring, the same grace and the same dainty fragility. Six manuscripts illuminated by the Hasenburg Master have survived, and three of these have been dated in their colophons: the two volume Bible copied by Martin Korczek in 1400 (which, however, was not decorated until several years later); the Missal of Sbinko of Hasenburg, Archbishop of Prague, which was copied by Laurin of Klattau in 1409; and the Bible in the Cathedral Library in Gniezno (Gnesen), which was copied in 1414 (and which disappeared in 1945). The Hasenburg Master was active from the turn of the century to c. 1415–20. Although his stereotyped figures, which were derived from the initial phase of the Beautiful Style (Plate IX), did not lend themselves to further development, he is none the less an important artist, chiefly on account of the many splendid pictorial compositions which he apparently reproduced from contemporary panel paintings that have failed to survive. Thus, the Crucifixion scene in the Hasenburg Missal (Ill. 186) was quite clearly derived from a model conceived on a much more monumental scale, and the same holds true for many of the smaller scenes he used to insert into initials and marginal scrolls (Plate XVIII).

The second trend in Bohemian illumination after 1400 found expression in two major works: the Bible of Konrad of Vechta (Antwerp; Plantin-Moretus Museum) and the so-called Dietrichstein Martyrology (Gerona; Diocesan Museum). Both the coats of arms and the notes of ownership which appear in the Bible show that it was commissioned by Konrad of Vechta, a close confidant of King Wenceslas who was comptroller of the royal mint in Prague from c. 1401 to 1403, and subsequently became Chancellor of Bohemia and, finally, Bishop of Olomouc. Konrad must have commissioned the Bible in 1401–2, for according to the colophon the first two volumes had been copied by 1403. Doubtless, they were immediately handed to the illuminators, but work on the decoration must have been inter-

PLATE XXI *Genesis initial, c. 1403–5. Korczek Bible, Vienna, National Library*
PLATE XXII *The Crucifixion, c. 1413. Missal from St. Vitus's Altar, Brno, State archive*

65

rupted shortly afterwards since the major part of the illustrations were never finished. The first gatherings in the Bible were illuminated by the Master of the Morgan Bible (Ills. 179–82) and by a group of minor artists who had been trained in the Wenceslas workshop. Only one of them – the Noah Master (Ill. 184) – was somewhat exceptional, for although he cooperated closely with the Master of the Morgan Bible, his work is already firmly rooted in the Beautiful Style. Then this first group of illuminators suddenly disappeared. From the seventeenth gathering onwards a new leading artist, the Joshua Master, and the Master of the Golden Bull shared work on the illuminations. The latter's contributions to the Bible were stylistically much more advanced than the illustrations which he had executed for the Golden Bull in 1400 (Ills. 183 and 185). In the meantime, he appears to have been influenced by both the Noah Master and – particularly with regard to his elaborate rendering of buildings – the Joshua Master.

This second phase of the work on the Vechta Bible was dominated by the Joshua Master – a very superior artist who, during his years of travel, had evidently been exposed to a variety of influences, some of which have yet to be clearly identified. But although this problem – which has equal importance for the history of Bohemian as well as of European art – is still far removed from a definitive solution, certain facts have none the less emerged. Thus, it seems fairly certain that the Joshua Master's predilection for a ridgy terrain and his use of bright foliage set against a dark ground were inspired by the Master of Třeboň (Ill. 189). However, in the unfinished miniature depicting the meeting between Jonathan and David (Ill. 190) he went far beyond these local antecedents. The convincing perspective of the landscape, the realistic townscape in the background, and the naturalistic tones of blue used for the sky, call to mind the most progressive Parisian manuscripts of the period. Moreover, some of this master's heads, and many elements of his decorative system, are clearly derived from North Italian, and more especially Paduan, models. This creative synthesis of alien and indigenous elements shows the Joshua Master to have been a quite outstanding personality with an extensive appreciation of artistic problems that raised him far above the Bohemian panel painters of his day.

True, the Joshua Master's *œuvre* is relatively small, and very much smaller than that of the Master of the Martyrology, who probably started out as one of his pupils, but soon emerged as a master in his own right, and ultimately exerted a more lasting influence on the subsequent development of Bohemian painting. But this in no way detracts from the Joshua Master's importance as the pioneer of a new cosmopolitan style in the early years of the fifteenth century.

Like the Bible of Konrad of Vechta, the Martyrologium Usuardi, which was kept in the Dietrichstein Library at Mikulov in Moravia in *c.* 1600 and is now in Gerona, was only partly decorated. This manuscript was entrusted to four illuminators, who worked in two teams. Although their miniatures differ greatly in quality, these teams must have worked side by side, as can be deduced from the completely random way in which the gatherings were distributed between them. The first team worked in a style which was chiefly based on the earlier manuscripts of the Wenceslas workshops, yet also incorporated the flowing drapery of the Beautiful Style. The style of the second team, which was composed of the Joshua Master and the Master of the Martyrology proper, was determined in the first instance by the former. Initially, the Master of the Martyrology even painted over sketches provided by the Joshua Master. Subsequently, however, he executed the major part of the illuminations entrusted to this team without any guidance at all, although he still took care to approximate his own compositions to those of his older colleague.

The difference in style between these two masters is most clearly demonstrated by their treatment of vegetal decoration. The medallions painted by the Joshua Master (Ill. 195) are surrounded by curling tendrils which branch to form dynamic spirals terminating in either blossom or dragon motifs. These bold, complex designs, which provide a firm framework for the miniatures, are in marked contrast to the sapless creepers painted by the Master of the Martyrology which fill at random, and almost without touching the medallions, the empty space between them (Ill. 183). Morphologically, this latter type of leaf scrolls goes back to a much earlier phase of Bohemian illustration. Foliage of this kind was first used in manuscripts of the 1350s and 1360 (Ills. 136 and 142) and remained in vogue – alongside the acanthus ornament adopted by the Wenceslas workshop – until the early 1390s.

There is an equally marked difference between the figures painted by these two masters, and in this respect it is the Joshua Master whose style appears to be the more delicate. This is due partly to the unusually thin faces and slender hands of his figures, and partly to their drapery, which falls for the most part in light, concave folds that cling to the limbs and so establish firm and restrictive contours. In many instances the outline of the falling drapery and the outline of the flowing train are joined by a single

curve (Ill. 195). The Master of the Martyrology treated his figures quite differently. He tended to stress both their volume and the volume of the individual drapery folds (Ill. 193), with the result that his outlines are dominated by convex curves whilst the transition from the falling drapery to the train is marked by sharp folds and creases. As a general rule, the Master of the Martyrology painted round, heavy faces which correspond in large measure to the kind of faces depicted in the Apostle series from the Capuchin Monastery in Prague (Ill. 164), a source on which the Joshua Master was far less dependent. On the other hand, the Master of the Martyrology never used the kind of beadles' heads with receding chins and protruding Roman noses which were a feature of the Joshua Master's work and which he may well have derived from North Italian models.

The unframed medallions painted by the Master of the Martyrology are almost like peep-holes which afford the observer a view of facets of another world behind the vellum. In most of these miniatures we find either a hillside, or a townscape, or a gently curving horizon, which serves as a backcloth, and so enhances the three-dimensional character of the foreground scene. The Joshua Master, on the other hand, used a very low, almost subsiding horizon, or he tended to fill the whole of his background with tiny trees or delicate architectural motifs. But in neither case did he attempt to create the illusion of three-dimensional space. For this he was still far too attached to the aesthetic rules of the Beautiful Style, and accordingly his pictorial forms are spread out like tapestry motifs. Moreover, since the Joshua Master's medallions are firmly framed by the spiralling tendrils they do not look like peep-holes, but rather like autonomous paintings which were subsequently applied to the vellum. Their relatively flat compositions stand in a reciprocal relationship to the relatively three-dimensional interlacing scrolls, and whilst this relationship sets up a vibrant spatial effect it does not produce any appreciable impression of depth.

In this manuscript the Master of the Martyrology incorporated artistic elements which first appeared in Paris as late as 1405–10, namely the voluminous figures of the Limburg brothers, and the spacious and atmospheric landscape backgrounds of the Boucicaut Master. The clear implication is that the Master of the Martyrology must have visited France during this period. Prior to that he probably worked as an associate of the Joshua Master on the Vechta Bible, where the stylization of both the foliage of the trees and the herbs on the ground in a number of the miniatures (Ill. 190) is reminiscent of his later illuminations (Plate XX).

Shortly afterwards the Master of the Martyrology painted the first three miniatures in the Korczek Bible, all the rest being executed by the Hasenburg Master. Both the figures and the tendrils in these three miniatures (Ill. 192 and Plate XXI) anticipate the master's work on the Martyrology; at the same time they are likely to give his artistic background away. Thus, his margin decorations, and his voluminous figures, go back to the late phase of Caroline painting (which ultimately may also have prompted him to advance beyond the Beautiful Style as represented in the work of the Joshua Master). Finally, in his mature period, the Master of the Martyrology provided a Bohemian pendant to the achievements of the Limburg brothers and the Boucicaut Master. He was, in fact, the first Bohemian artist to paint in a style that is completely and unmistakably fifteenth century. Apart from the Dietrichstein Martyrology, his mature works include the group of single miniatures in the Museum of Fine Arts in Budapest (Ill. 194), and the miniature of the Trinity in the Rosenwald Collection, all of which probably formed part of an Antiphonary from Sedlec Monastery (Brno; State Library, cod. No. 25; dated 1414), and a closely related Gradual (Brno; State Archives, cod. G 11/2).

Autograph miniatures by the Joshua Master are also to be found in a number of other manuscripts, the earliest being the tiny and extraordinarily delicate Calendar pictures which he painted—presumably soon after the completion of the Vechta Bible—for a Prague Missal, now in the Austrian National Library in Vienna (Ills. 191 and 196). But the major work of his mature period was the splendid full page Genesis miniature (Plate XXI) in the Boskovic Bible, his only other contribution to this manuscript being a Nativity (Ill. 197). Although by then he had started to use perspective landscapes for his backgrounds after the manner of the Master of the Martyrology, he still retained the tondo form as the basis of his compositions. Equally significant are his slender figures, and his cool but intense colours. Not least had the jet black of the background (as in the first Genesis medallion) been a regular feature of his work ever since the Vechta Bible, just as the almost Impressionist dotting technique by means of which he executed the trees in the Creation of Eve, and the rising horizon, which tends to merge with the top of the picture frame, are reminiscent of his early miniatures (Ills. 189 and 195).

Shortly after completing the Genesis scenes and the Nativity for the Boskovic Bible the Joshua Master painted his last surviving miniature: a Madonna with Angels and Saints (Ill. 198). The landscape that forms the background

to this work is even flatter than the corresponding land-scapes in the Genesis medallions, and is distinctly reminiscent of tapestry design. The sky, which is studded with a pattern of gold ornaments, looks much like a heavy and ornate curtain with God the Father appearing immediately above it amidst a host of angels. The similarity between the female saints in this miniature and the Beautiful Madonnas of the Bohemian sculptors reminds us that although the Joshua Master was one of the foremost exponents of International Gothic, his art was none the less firmly rooted in local traditions.

Unlike the members of the Wenceslas workshop, both the Master of the Martyrology and the Joshua Master exerted a considerable influence on their contemporaries, especially in Moravia, where they inspired a whole series of manuscripts. The most important of these was the Missal of St. James (No. 8/10) in Brno, which probably dates from 1413, the year in which the corresponding altar was endowed. The historiated initials, the scroll ornament, and above all the canon miniature in this manuscript (Plate XXII) were clearly based on the illuminations created by the Joshua Master for the Martyrology (Ill. 195). His style was not only assimilated, but also manneristically distorted by his Moravian follower. Although no demonstrable links exist between the illuminations in another Missal of St. James (No. 15 in the Brno Municipal Archives) and the illuminations produced by known Prague artists of the period, there is none the less a certain affinity between the sketch of a bearded head in the margin of folio 120 v and the preliminary sketches executed by the Joshua Master for the Vechta Bible.

I have already indicated that the trend towards harder textures that had first appeared in the Dubeček panel and the Capuchin cycle (Ills. 161 and 164) reached its apogee, within the sphere of manuscript illumination, in the miniatures executed for the Martyrology by the Joshua Master (Ill. 195). Within the sphere of panel painting, this development reached its peak towards 1410, which is demonstrated by many of the replicas of the St. Vitus Madonna – for example, that from Zlatá Koruna – and by the even later Crucifixion panel that is now in Berlin (Ill. 194a). Although the figures in this Crucifixion bear a certain resemblance to the modelled forms developed by the Master of the Martyrology, the setting is completely different. Instead of a carefully ordered perspective world we find a total void. Moreover, if we compare this painting with earlier examples of the Beautiful Style, it becomes readily apparent that the eurhythmical tension between the figures had greatly diminished. The square-built figures in the Crucifixion and the narrow setting allotted to them, are almost reminiscent of Master Theoderic and his school (Plate V). But then it is hardly surprising that the painters working in this final phase of the Beautiful Style should have harked back to the works of the Caroline epoch, which had so much in common with the powerful realism that was to be developed in Bohemian painting of the 1420s and 1430s.

With its perpendicular drapery folds the Roudnice Retable – which dates from the same years as the Berlin Crucifixion – anticipates the much heavier and more realistic drapery of the late 1410s, even though many features of its central panel, depicting the Death of the Virgin (Ill. 188), were still derived from the early work of the Joshua Master.

The new trend away from the idealism of the Beautiful Style and towards a more realistic art, which had been heralded by the Berlin Crucifixion, was fully developed between 1415 and 1420 by a group of painters working in Moravia and southern Bohemia, who are commonly subsumed under the name of the Master of the Rajhrad Retable. True, there was nothing revolutionary about the types of figures depicted by this master and his associates. As in the panels from Rajhrad (Ill. 199), they were generally derived from the Master of the Martyrology (Ills. 193 and 194). But the way in which the Rajhrad Master focused attention on his figures was decidedly new. In his Procession to Cavalry there is no hint of spatial depth: individual figures alternate with compact groups in a dramatic sequence, thus creating a densely packed frieze of fully modelled human forms, in which the few ill-defined landscape elements are used simply as additional volumes.

During the Hussite disturbances, Moravia and southern Bohemia, both of which had largely remained loyal to the Roman Catholic Church, were spared the worst excesses of the iconoclasts, and consequently we find that the vast majority of the works of art to have survived from that period originated in those territories. A good specimen is the fragment from Náměšt near Olomouc, on whose two sides are depicted the martyrdoms of St. Catherine (Ill. 199a) and St. Apollonia. In this panel the style established by the Rajhrad workshop – which remained the dominant force in Bohemian painting until the 1440s – was enriched by elements of a crude realism, whilst the composition became even more complex, with the figures merging together to form a cluster of huddled up bodies that gives perfect expression to the religious fanaticism and the violence of the times.

(Abridged from the original text by Maria Schmidt-Dengler)

5. Late Gothic architecture

In none of the great territories of Europe were the decline of the medieval world and the emergence of the new era as dramatic as they were in Bohemia. Charles IV had tried to make Prague the political and cultural centre of a state capable of mediating between East and West. In his cultural aim, at least, he was eminently successful, for within a few years of his accession the Bohemian capital had become the focal point of Central European art. The splendid achievements of this period have already been described in the preceding chapters of this book.

But Charles IV's grand design for Bohemia soon crumbled in the hands of his weak successor. Although the sculpture of the period gives little or no hint of the mood prevailing in the country at the time, the sense of hopelessness and impending doom that oppressed Bohemian society on the eve of the Hussite insurrection may be inferred from Johannes von Saaz's epic poem *Der Ackermann aus Böhmen*. Of course, social discontent was widespread and led to disturbances in many parts of Europe. But the social revolutionaries of the times elsewhere in Europe were neither as violent nor as remorseless as the Bohemian zealots. The Bohemian uprising, which was pervaded by feuds, hatred and despair, shook the feudal order to the core.

The Hussite wars were followed by a period of almost total exhaustion and disruption, during which Bohemia became more and more isolated. For over fifty years, the country was racked by disputes between the Utraquists and the Catholics on the one hand and between the burghers and the nobles on the other. Faced with this constant strife, the Bohemian estates finally decided to elect a new monarch in the hope that this would provide greater stability. And so a Polish prince from the house of the Jagellones became King Vladislav II of Bohemia in 1471. At the same time, the estates sought to prevent the new king from acquiring any real power, and initially they succeeded in this aim. But in the end Vladislav was forced to assert himself in the interests of self preservation. Accordingly, he strengthened the castle in Prague, and to this end brought foreign craftsmen and artists to his capital, thus initiating a new phase of creative activity

after a lapse of more than half a century. During Vladislav's reign Prague again became a great architectural centre, whose great achievement was a uniquely successful integration of the new representational art of the Renaissance with the style of the Late Gothic.

In the immediate aftermath of the Hussite wars restoration work was carried out on various buildings damaged in the fighting, and a number of unfinished buildings were completed, but no new projects were undertaken. Not surprisingly, therefore, we find that the Týn Church in Prague – which was the metropolitan church of the Utraquist movement from 1348 onwards – was completed in a conservative style. Although the great golden goblet in the west gable and the statue of King George of Podiebrad had been removed in the course of the counter-reformation, this perpendicular building still reflected something of the spirit of the Hussite movement (Ill. 200). The powerful, the stark, deliberately accentuated verticality of this building and its fortress-like character still reflect the uncompromising, combative spirit of the Hussite movement (Ill. 200). The powerful, almost defiant proportions of the church, shown particularly in the corner turrets of the twin towers, were clearly derived from the Parlers, who frequently used fortification elements in their churches.

One of the principal characteristics of the post-Parlerian period was the overriding importance attached to decorative detail, and it is quite evident that the architects and masons of fifteenth-century Bohemia took great pride in their virtuoso carving techniques. The œuvre of Matthias Rajsek (1445–1506), a native Bohemian master, is particularly relevant in this connection, for much of his decorative work was clearly inspired by a specifically Czech sense of architectural design. In Prague Rajsek covered the whole of the Powder Tower (on which work first started in 1375) with an intricate decorative design, whose interlacing forms completely obscure the underlying structure. With its graceful insubstantial pillars, which are surmounted by a rich and highly organized canopy composed of ogee arches and tracery balustrades, his stone baldachin in the Týn Church (Ill. 202) is also delightfully 'unstruc-

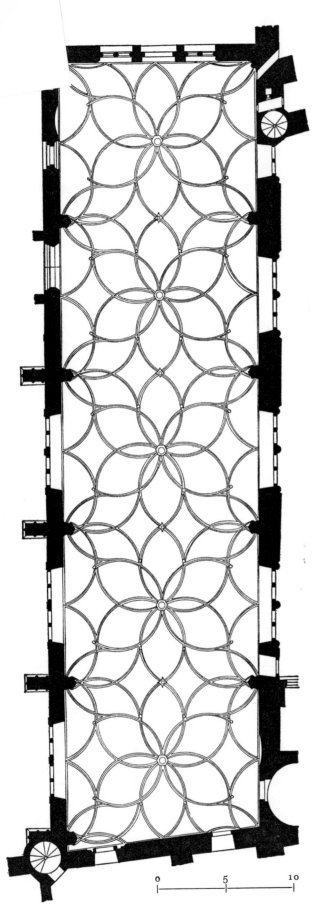

tured'. In the vaulting of the choir of St. Barbara's, Kutná Hora (Ill. 201), Rajsek again revealed his predilection for intricate and highly decorative effects, for the ribs in this vault are more like willow branches than structural members of a weightbearing system. The domestic architecture of the period – for example, the town hall in Prague with its astronomical clock, and the town houses built for the burghers of Kutná Hora – are also remarkable for their rich ornamentation.

The widespread popularity of this decorative style – which was based primarily on the use of plant motifs – may be gauged from the fact that visiting foreign artists, such as Hans Spiess of Frankfurt and Master Gauschke of Wroclaw, also sought to impress their Bohemian patrons with their virtuoso skill in the mason's art. Hans Spiess, who must have come to Prague in 1477, created the tower of the Priory Church in Melnik; he almost certainly worked on the new castle in Křivoklát; and he probably also converted Vladislav's rooms in the palace of Prague Castle, including the audience room. But perhaps the clearest indication of the way in which the architects of this period sought to emulate the masters of the Parler workshop is provided by the carved wooden pendant in the castle chapel at Křivoklát.

The fact that shortly before the dissolution of the medieval workshops Prague once again became the focal point of Central European architecture was due, above all, to Benedict Ried (c. 1454–1534). Ried, a native of Piesting, was a man of enormous talent, whose achievements in the architectural sphere place him on a par with the great painters and sculptors of his day: Dürer, Altdorfer, Cranach, Veit Stoss and Holbein. The Prague court made it possible for him to work with a degree of freedom that was not to be found at that time in any of the German territories. As a royal architect, Ried could safely ignore the restrictions to which the lesser members of the workshops were subject, and so was able to advance to new and bolder conceptions.

Ried came to Prague between 1487 and 1489 as a fortifications expert to restore the castle on the Hradčany hill, which had not been used since the reign of Wenceslav IV. He built a new outer wall nearly one thousand metres long, and strengthened it with bastions and artillery towers. This system was inspired by recent advances in fortification technique based on the use of artillery as the main defensive weapon, and it depended for its effectiveness primarily on the Daliborka Tower, which was positioned in front of the outer wall. In evolving this defensive system

0 5 10

Prague, Vladislav Hall

Ried drew heavily on the ideas used shortly before in the fortress of Burghausen on the Salzach. Incidentally, the owner of Burghausen, Duke George of Landshut, was Vladislav's brother-in-law and he probably arranged Ried's assignment in Prague.

In 1490, soon after becoming the leader of the Prague castle workshop, Ried started work on the oratory in the southern arm of the transept of St. Vitus's Cathedral. Although he certainly made concessions to popular taste in decoration in executing this project, the oratory – which projects sharply from the wall of the transept – remains an architectural masterpiece of the first order. By creating this remarkable oratory Ried proved his ability beyond any shadow of doubt, and when King Vladislav decided that the whole of the third floor of the castle palace was to be used for a combined throne room and jousting hall, it was only natural that the commission for this structurally extremely daring undertaking should have gone to Ried. The palace project was prompted by Vladislav's election to the Hungarian throne in the summer of 1490. The fact of the matter was that his election was made conditional on his moving his residence to Budapest, which meant that he had to devise some means of assuring the Bohemian nobles that he would continue to take their interests to heart and maintain his connections with Bohemia. And so Vladislav decided to modify the castle, which he hoped would eventually rival the magnificent Renaissance residence of Matthias Corvinus in Buda.

The combined throne room and jousting hall – the so-called Vladislav Hall (Ill. 205) – was built between 1493 and 1502, and was 14 metres high, 16 wide and 62 deep. To have enclosed such a vast area without breaking up its free space with supporting columns or pillars was a remarkable achievement. Ried did it in a way which not only preserves the unity of the enclosed space, but makes it mobile and living.

Ried preserved the unity of the enclosed space through concentrating the weight of the seemingly unsubstantial but actually heavy ceiling on ribbing which is gathered together in six bunches on each side of the hall. Without interruption of any kind, without capital or cornice, the ribs swing from the peak of the lofty ceiling to the floor of the great chamber, creating a single, combined wall and ceiling fabric. But it is not only the unbroken expanse of this vast area which is impressive. Even more impressive is the unique lightness and movement of the ceiling fabric. It has an insubstantial, floating quality, based on the fact that it is a seemingly never ending series of moving, swirling, interlocking gentle curves.

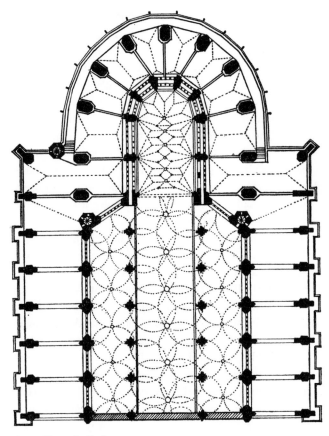

Kutná Hora, St. Barbara

Ried's work is readily distinguishable from the English fan vaulting of a somewhat earlier period because the curves of his vaulting are not interrupted through grouping into clearly discernable sub-designs, as is the case with fan vaulting, but blend continually into one another, giving the impression of endlessness. The continuous intertwining of the curved, floating vaulting seems to hint at the existence of an infinite and ever expanding universe which it symbolizes.

The rhythmical forms of the interior harmonize with the contrasting forms of the exterior, whose southern face was designed in the style of a Renaissance palace. The monumental structures of this façade – which, incidentally, were derived from the Renaissance windows and portals that Ried had seen in Budapest – were, of course, introduced into the interior of the hall, in the form of a *facciata interna*, by the great East window. Between 1502 and 1509 Ried built the King Ludwig wing of Hradčany Castle in a pure Renaissance style. In fact, the only part of this building that reminds us of Ried's earlier work is the vault of the Bohemian Chancellery with its almost

arbitrary assortment of ribs. As in the vault surmounting the Horseman's Staircase of *c.*1500 (Ill. 203), the ribs in the Chancellery vault spring from an imaginary point, and create a jagged, staccato pattern with mutiple overlaps that impresses itself on the viewer with great force. In both vaults the design is immensely vital, and in the case of the Chancellery vault this vitality is reinforced by the fact that the ribs are set out in the form of a spiral and possess a kind of torque that gives them a thrusting, dynamic quality: moving along the surface of the vault, they shine momentarily before disappearing from sight. Thus, the architectural structure provides a symbolic representation of the invisible universe.

The design used by Ried for the nave of St. Barbara's, Kutná Hora, which was built from 1512 onwards, was equally dynamic. By placing the clerestory windows on the outer wall (Ill. 207) he transformed what was essentially a basilical installation into a brightly lit gallery church. As in the Vladislav Hall, so too in St. Barbara's, the dominant feature is the sexpartite vaulting of the roof, which is remarkable for its immensely vital interlacing rib patterns. True, the rhythm set up by the vault design is more restrained in St. Barbara's than in the Vladislav Hall, but this merely serves to strengthen the impression of weightlessness produced by this apparently free floating structure. For the outside of the nave—which, incidentally, was merely designed and supervised by Ried, and was not completed until 1548—flying buttresses were used in conjunction with High Gothic tracery forms, which would suggest that on this occasion Ried was consciously seeking to perpetuate the traditional cathedral style of architecture. In one important respect, however, his exterior was quintessentially Late Gothic: by designing a roof composed of three tent-shaped structures Ried established the flamboyant or ogee form as the leitmotiv of his elevation. As a result of this ascending form the church seems almost to hover over its hilltop site high above the river valley (Ill. 206).

But the roof of St. Barbara's was not only an aesthetic triumph. Technically, it also constituted a considerable advance over the heavier saddleback roof since it was less vulnerable to the effects of wind and snow. Not surprisingly, therefore, we find Ried using the same design for the parish church of St. Nicholas in Louny, whose reconstruction he supervised from 1517 onwards. The interior at Louny bears the unmistakable imprint of Ried's mature period; the slender pillars rise up like so many stalagmites whilst the interlacing vault ribs seem to cleave

to the surface as if by magic (Ill. 225). Although the vault in the Church of the Assumption at Ustí nad Labem has not been definitively attributed to Ried, we find there the same arrangement of interweaving ribs, the only difference being that at Ustí nad Labem the pattern is so fluid that the whole structure looks as if it might break down at any moment, like a house of cards (Ill. 223).

The leading part played by Ried at the workshop assembly at Annaberg, Saxony in 1518 shows quite clearly that he was the leader of a group of masons who were concerned primarily with the introduction of new vaulting techniques, and who had ensured the survival of the medieval workshop tradition in Saxony during the difficult transition from the Gothic to the Renaissance. Ried also demonstrated his technical skill in further fortification projects, including the massive castle installations at Svihov and Rábí in Western Bohemia (Ill. 208). In his conversion of the Castle of Blatná in southern Bohemia, which he started in 1515, and the Castle of Frankenstein in Silesia, which followed ten years later, Ried used representational elements on a much wider scale than any of his predecessors in the sphere of castle architecture. In Blatná the triangular oriel windows formed part of a sophisticated lighting system for the hexagonal inner rooms. Meanwhile, in 1503, Ried had completed the hunting lodge in the Prague royal animal preserve gardens, which was to serve as a model for the Belvedere. Unfortunately, this building, which was evidently based on the lodge at Nyég near Budapest, was converted in the nineteenth century.

Ried died in 1534 at the age of eighty, by which time peace had returned to Bohemia. His life spanned the whole of the Late Gothic period, and in his work he established direct links between the workshops of Hungary, Saxony, southern Bohemia, Silesia and southern Poland. Thanks to him, the Bohemian masons of the Late Gothic period were able to put their sophisticated skills to the most exquisite use.

Whilst Benedict Ried was creating the Vladislav Hall in Prague, a second architectural centre was developing in the territories ruled over by the Rosenbergs in southern Bohemia. As the leader of the Bohemian Catholic Party, Peter von Rosenberg was intent on stemming the Hussite tide, and it was owing to the counter-reformationary movement launched by him and promoted, above all, by the Franciscans that so many churches were built in southern Bohemia at that time. Most of the masons engaged on these projects were former members of either

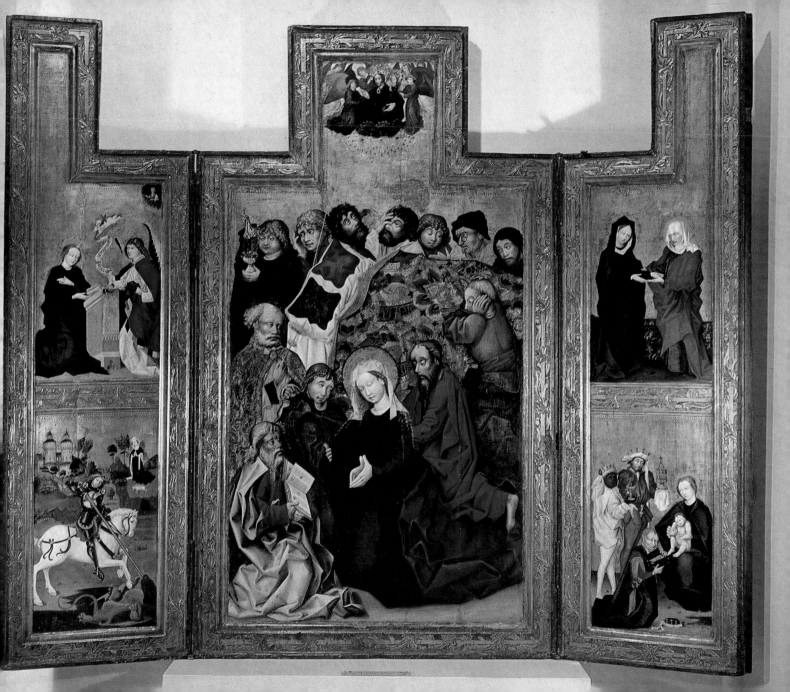

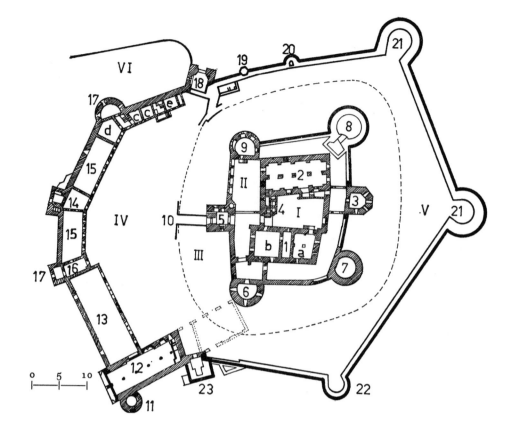

SVIHOV CASTLE
I Inner Courtyard
II Keep
III Moat
IV Outer courtyard
V Outer courtyard
VI Pond
1 South
2 North
3 Chapel with bastion
4 Open staircase
5 Gate-house
6 White tower
7 Green tower
8 Golden tower
9 Red tower
10 Bridge
11 Caspar's tower
12-15 Stores
17 Round Tower
18 Outer tower
21-22 Bastions built by Ried
23 Gate-house

the Upper Austrian or the Passau workshops. It is hardly surprising, therefore, that when Peter von Rosenberg came to found his own workshop in 1497, he took the Passau workshop as his model.

The first building undertaken by the new workshop was probably the Church of St.James in Prachatice, whose impressive exterior dominates the whole town (Ill. 212). Incidentally, the structure of the pillars on the north side of this hall church would suggest that the original design incorporated a gallery above the north aisle (Ill. 213). One of the most beautiful interiors created by the South Bohemian school was that of the village church of St.Giles in Dolní Dvořiště (Ill. 219) where the hall church style established in southern Bohemia during the period of the Soft Style was adapted to meet the needs of the Late Gothic. The choir vault in the parish church in Rosenberg was created by a master from the important workshop in Freistadt, Upper Austria. The vault of St.Magdalen's Church in Chvalšiny (Ills. 215 and 216), which is remarkable for the precision of its sculptural detail, was probably executed by the same master. The base of the vault is particularly fine, and so too are the intersections of the vault ribs (Ill. 214).

The influence of the Prague Castle workshop is clearly manifested in the Deanery at Český Krumlov. If we compare the highly decorative oriel window in Český Krumlov Castle (Ill. 218 [1513]) with the much simpler window in the Deanery (Ill. 217 [1514–20]) we see just how quickly the new style evolved by Benedict Ried was taken up by his contemporaries.

In Bechyné the Prague and Český Krumlov schools of architecture came up against the Saxon school, which had made considerable headway in Bohemia from 1500 onwards with its cellular, or net, vaults. These cellular vaults, which were both technically and artistically the logical outcome of the Late Gothic trend, were made possible by the discovery of a new technique, which enabled the sixteenth-century mason to dispense with the traditional weightbearing stone ribs and construct vaults composed entirely of cellular units, whose irregular structure provided sufficient cohesion for them to be self-supporting. This new kind of vault was, of course, much more economical, and it was also an extremely effective artistic medium, for the interlocking cells produce a curious, undulating effect, which transforms the whole of the roof area into a sea of light and shade (Ill. 215). Such

vaults appear quite insubstantial; they look like sails billowing in the wind. There are examples in Soběslav, Nezemyslice, Kaaden, Konopiště and Karlštejn. But the most beautiful is probably the vault of the Franciscan church in Bechyné. Although Benedict Ried's achievements were certainly recognized in southern Bohemia, his influence was greatest in the northern districts of the country and amongst the workshops of the Erzgebirge. In the Church of the Assumption at Most decorative motifs derived from Ried's Prague workshop combine with a gallery church design of Franconian provenance to form a particularly happy synthesis. The foundation stone of this church was laid in 1517, and work was started shortly afterwards under the direction of Jacob Heilmann, who had produced the design. Later, Georg von Maulbronn took charge, and the church was completed by him in 1544. There is a close affinity between this church and the Church of St. Anne in Annenberg. Both have the same smooth exterior, due to the adoption of internal buttresses, and both have galleries running round all four walls. But although this arrangement ensures a clear and virtually panoramic view of the two interiors, these are none the less complex in their architectural organization, for both were fitted out with chapels beneath their galleries. They are, of course, also dominated by the masterly design of their multipartite vaults, whose intricate ribs emerge from slender polygonal pillars. The effortless virtuosity of the masons in Most is demonstrated again and again by the sculptural detail; amongst other things, by the twisting pendants (Ill. 220), by the spiralling branches which disappear into the wall only to re-emerge a moment later, by the curved stairs, and by the delicate tracery balustrades on the galleries. But the architectural design in Most aimed at more than virtuosity. By comparison with the ribbed vaults in the Vladislav Hall or, for that matter, in the Church of St. Anne in Annaberg, which link up with one another to form a smooth rhythmical sequence, those in Most are quite disjointed, owing to the consistent termination of the component ribs at their intersections. This has the effect of stressing still further the sense of weightless floating induced by these vaults. In the Church of the Assumption at Most the knowledge and skill of the medieval workshops were harnessed in a last magnificent attempt to frame time, space and movement within an architectural structure.

As the above indicates, Ried was the great innovative figure of the Late Gothic in Bohemia. His pioneering genius was responsible for the revolutionary vaulting techniques which exploited and expressed to the last degree the architectural concepts of the waning Middle Ages. At the same time, his work, on which so many of his contemporaries relied for inspiration, formed an unbroken transition between the art of the Gothic and that of the Renaissance. The long, gently curving vaulting of the Vladislav Hall and of the Saint Barbara Church seem to express in terms of art a concept which Copernicus was to formulate in more scientific terms half a century later: the vision of a cosmos slowly circling into ordered infinity, driven on mysterious orbits.

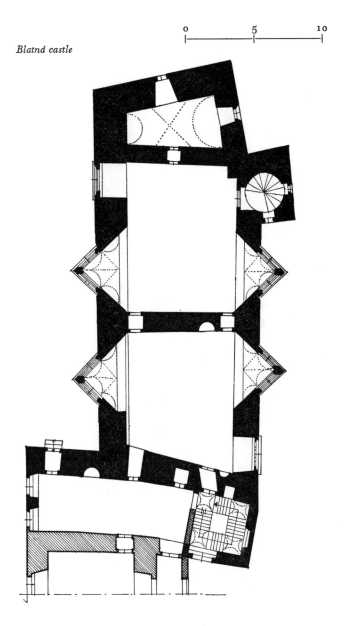

Blatnd castle

75

6. Late Gothic painting and sculpture

The major work of Late Gothic painting in Bohemia was the decorative cycle on the walls of the St. Wenceslas Chapel in St. Vitus's Cathedral in Prague (Ills. 227–30). The wall-paintings which make up this cycle, and which have now been firmly attributed to the Master of the Leitmeritz (Litoměřice) Panels, were executed above the plinth, which was itself decorated with precious stones. The St. Wenceslas Chapel, which was built for Charles IV by Peter Parler, was consecrated to St. John the Evangelist and St. Wenceslas in 1367, and subsequently played an important part in the coronation of the Bohemian kings. On the day of his coronation each new king presented himself in the chapel with his dignitaries, where he donned his ceremonial vestments before proceeding to the high altar in the cathedral proper. The Crown of St. Wenceslas was also carried from the chapel to the cathedral in the course of the ceremony, as were the sacred oils and the blessed sacrament, which were kept in the chapel, the latter in the iron tabernacle of Charles IV. These ancient rituals, which were dear to the heart of every Bohemian, are very important, for unless we bear them in mind, the artistic import of this chapel and its wall-paintings will be lost on us, and we will fail to appreciate its significance as an integral part of European culture and cultural history. But the Master of Leitmeritz was not the first artist to decorate the St. Wenceslas Chapel. Much earlier, in the reign of Charles IV, a number of small format paintings were executed immediately beneath the cornice, where they were offset by decorative panels studded with semi-precious stones. Moreover, there are two sets of wall-paintings from the reign of the Jagellone King Vladislav II (reigned from 1471 to 1516). The first of these, which is on the east wall of the chapel, dates from c. 1470, and the second, the cycle by the Master of Leitmeritz, from c. 1509. Some of the earlier paintings, on the left and right of the statue of St. Wenceslas, have survived whilst traces of others—on the same east wall—were discovered in the early 1960s when restoration work was carried out in the cathedral. In view of their dates, it seems likely that the 1470 paintings were intended to commemorate the corona-tion of King Vladislav (1471) and the 1509 cycle that of Vladislav's son Ludwig (reigned from 1516 to 1526).

In this cycle King Vladislav and his queen, Anna de Foix, are portrayed above the statues of St. Wenceslas and Charles IV, one on either side of the east window. The two figures are set against a background depicting a brocade tapestry surmounted by pointed arch windows, which afford a view of a blue sky slightly overcast by clouds. Above these windows the artist has painted a vaulted ceiling, from whose ribs the coats of arms of the king and queen are suspended. The king wears the Crown of St. Wenceslas and holds the royal orb and sceptre in his hands. His shoulders are adorned by the ermine cape of an elector of the Holy Roman Empire. The queen is dressed in a full-length gown with a train that is hemmed with fur. Beneath her crown she wears a black cloth which reaches to her shoulders, and in her left hand she holds a book. Her right hand rests on her left forearm (a gesture whose significance has yet to be explained).

Whether these are naturalistic portraits of King Vladislav and his queen is a question that has given rise to much discussion. Now, it is a fact that in this painting the king wears a beard, whereas in every other surviving portrait he is clean-shaven, a state of affairs that would seem to preclude a naturalistic interpretation of this work. But in sixteenth-century Bohemia widowers occasionally grew a beard as a mark of respect for their dead wives during the period of mourning, and it has been suggested that this is what the king had done, for his wife had died in 1506, shortly before the St. Wenceslas cycle was undertaken. On the other hand, it has also been argued that Vladislav wished to be painted with a beard because this established a link with St. Wenceslas, who had always been represented as a bearded figure. As far as the queen is concerned, the issue is much clearer. In the first place, Anna had never visited Prague, and was, therefore, not likely to have been known to the artist. And in the second place, the female figure portrayed in the St. Wenceslas Chapel is virtually identical with the female figures in other works by the Master of Leitmeritz.

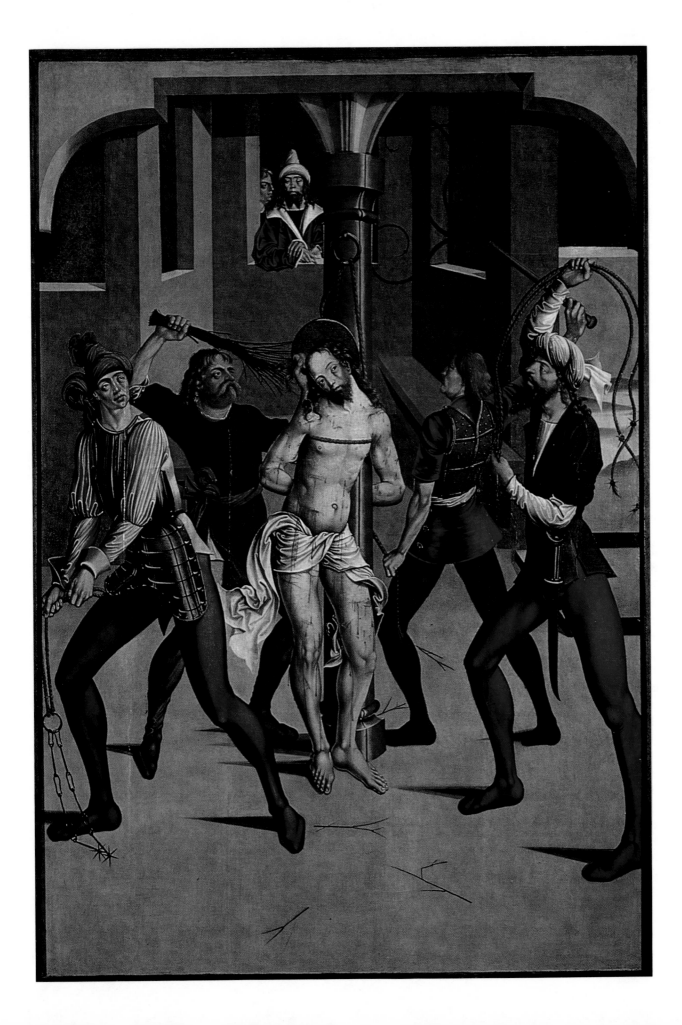

The paintings on the east wall, in which dynastic and historical motifs are dominant, are offset by a single large-format composition on the west wall, reaching from the plinth to the top of the pointed arch, and depicting the legendary visit of Duke Wenceslas of Bohemia to the Imperial Diet in 929 and his appointment as the seventh imperial elector by Henry the Fowler. We see Wenceslas, who has arrived late at the diet, where he is escorted by two angels, being welcomed by the king on a terrace, to whose base the coats of arms of the six other electors are attached. The electors themselves are seated in the throne room, where the only vacant seat is the throne itself. No seat has been provided for the latecomer, and it is evident from the fact that the throne is flanked by two coats of arms, one showing the imperial twin eagles and the other the Bohemian lion, that the king was proposing to place Duke Wenceslas on the throne next to himself. This was a very effective piece of symbolism, for it clearly demonstrated Vladislav's insistence on his own rights as the first elector of the empire, the rank accorded to the kings of Bohemia in the golden bull of Charles IV. In 1486, when Maximilian I was elected King of the Romans, Vladislav had been excluded from the assembly, and since then he had been extremely sensitive about questions of rank.

The most important portraits on the east wall, and the major part of the composition on the west wall, were executed by the Master of Leitmeritz in person.

The remaining ten panels, each of which is subdivided into three horizontal tableaux, depict different scenes from the St. Wenceslas legend, which have been numbered by the celebrated Czech art historian J. Krása. In his commentary Krása has pointed out that the scenes depicted on the walls do not appear to follow one another in a chronological sequence, which would suggest that the sequence adopted was determined by the patrons and not by the artist. Certainly, there is a correlation with the wallpaintings commissioned by Charles IV for Karlštejn Castle, which also depict scenes from the St. Wenceslas legend. These line the staircase leading to the Chapel of the Holy Cross, in which the imperial jewels and the insignia of the Bohemian royal family were kept. Unfortunately, it is not possible, for reasons of space, to describe the pictures in the St. Wenceslas Chapel individually, and I can only refer the reader to the pull-out illustration, where a brief résumé of the different themes is provided. (Ill. 243 should also be studied in this connection.)

I have already indicated that the principal paintings on the east and west walls were executed by the Master of Leitmeritz himself. However, Krása has shown in his detailed study that, as might be expected in such a large-scale project, certain scenes were painted by assistants. But even where parts of the master's design were executed by lesser craftsmen, it is quite apparent that he supervised their work. Some critics maintain that, in addition to assistants, a second master must have contributed to the St. Wenceslas cycle, and they identify him as Leonhard Beck, who—together with Burgkmair and others—worked for Maximilian of Bavaria. This, admittedly, would provide a satisfactory explanation for the presence in the cycle of clear indications of the influence of the Augsburg workshops. In my opinion, however, the work delegated by the Master of Leitmeritz in Prague would have been executed in a much more distinctive manner by a painter of Beck's stature. And in any case, it seems to me that the most obvious source of the Augsburg or, for that matter, Venetian influences that have been identified in the St. Wenceslas cycle is the Master of Leitmeritz himself.

Unfortunately, we know nothing at all about this master save what we have been able to deduce from his works. But Pešina and Krása have attempted to reconstruct the principal stages of his life by tracing his stylistic developments. We meet him for the first time—on this the vast majority of critics are now agreed—in the workshop that was commissioned, doubtless by the king, to produce an altar-piece for the castle chapel in Křivoklát during the closing decade of the fifteenth century. He was responsible for the paintings on the two outer wings of the triptych in this chapel, which is the earliest surviving *Gesamtkunstwerk*, or allied work of art (architecture, sculpture and painting), from Vladislav's reign (Ill. 209). It seems likely that the craftsmen employed in Křivoklát came from the Prague workshops. The Frankfurt architect Hans Spiess, who had been driven from Prague by Benedikt Ried, will doubtless have made the major contribution to the design of the castle chapel. As for the sculptures, there we have to distinguish between the stone carvings, which are, without exception, products of the traditional mason's craft, and the wood carvings, some of which are of very high quality. The stocky, peasant-like figures of the apostles beneath the carved and turreted baldachins call to mind the great Wiener Neustadt apostles, whilst the turreted reredos, which reappears as an ornamental motif in the painting on the east wall of the St. Wenceslas Chapel, is quite inseparable from the architecture. The composition of the paintings on the two outer wings is reminiscent of the Franconian art of the period, although I know of no

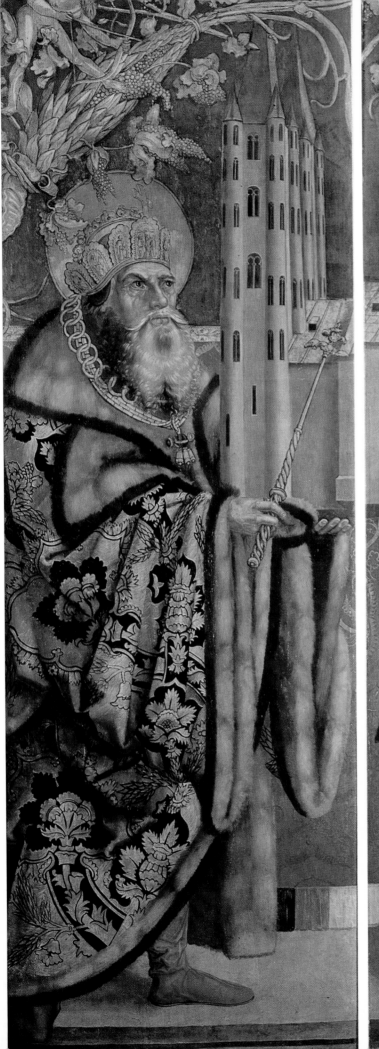
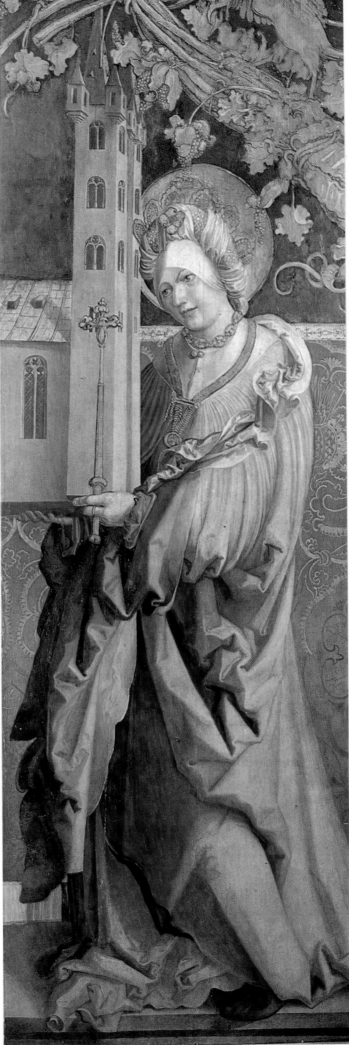

specific works which might have served as models. The altar-piece was probably created by a group of painters and sculptors belonging to a fairly large workshop led by Hans Spiess and presumably based in Prague. After serving his apprenticeship in this workshop the Master of Leitmeritz will have set off on his travels, and during this period he must have seen works by Jörg Breu the Elder and Rueland Frueauf the Elder. Certainly, his major work in the sphere of panel painting, the early sixteenth-century Leitmeritz Altar-piece, bears a close affinity to Rueland Frueauf the Elder's great altar-piece, whose panels are now in Vienna. The Leitmeritz Altar-piece was conceived as a large retable with both fixed and movable wings. Unfortunately, some of the panels have been lost, as has the central section, which was presumably a woodcarving. It seems highly probable that this altar-piece was commissioned from the master by Johann von Wartenberg (c. 1476–1508), who held a number of important royal and imperial offices simultaneously, including that of Prior of St. Vitus's in Prague. Von Wartenberg, who came from one of the foremost aristocratic families in Bohemia, embraced the humanist philosophy when he went to study in Bologna, and this, coupled with his outstanding personal qualities, made him one of the leading men of his generation. In fact, it is quite possible that, in addition to commissioning the altar-piece for Leitmeritz, von Wartenberg also specified its subject matter. We know for sure that the Master of Leitmeritz met von Wartenberg at some point in his career, for there is a panel painting in the National Gallery in Prague that was based on an original portrait of the prior by the master (which may well have been a votive picture). Various other panel paintings executed by the Master of Leitmeritz, or his workshop colleagues, have survived, including those commissioned for the altar-piece in the monastery of Strahov (Ill. 244).

The Master of Leitmeritz had no forebears of any consequence in Bohemia. There was no indigenous tradition dating from the early decades of the century, and it was not until the 1570s that Bohemian artists began to produce works of real merit, such as the St. George Altarpiece (Plate XXIII) and the paintings by the Master of the St. Thomas Altar-piece (Ill. 231), which were very much in line with the new art forms evolved abroad. Just as there are no paintings which point to the existence of major artists in early fifteenth-century Bohemia, so too there is no indication in the extant works of the period —with the possible exception of the Cimelitz Altar-piece— of an early school tradition. From time to time, however,

new panel paintings have come to light which must have been either brought to Bohemia or executed there by foreign artists. The most important of these are the portraits of Emperor Henry and Empress Kunigunde (Plate XXV) by an unknown disciple of Dürer, which have been dated to c. 1510. By virtue of the fact that they have hung in the Maria Schnee Church in Prague for hundreds of years these German works have undergone a kind of naturalization process so that they are now generally regarded as indigenous products.

Unfortunately, the panel paintings of this early period were extremely vulnerable to the ravages of war and iconoclastic fervour, and it must be assumed that many of them were destroyed. Wall paintings are, of course, somewhat less fragile, and—presumably for this reason— rather more of these have survived in Bohemia. Although stylistically these early fifteenth-century works had nothing in common with the paintings in the St. Wenceslas Chapel, thematically they provided the Master of Leitmeritz with relevant source material. The most important of these sources were the great Minters' Chapel at the west end of the south aisle in the Church of St. Barbara in Kutná Hora, and the three south-eastern choir chapels: the Chapel of King Wenceslas IV, the Smíšek Chapel (Ill. 235) and the Haspler Chapel. The characteristic feature of the decorations in these chapels is their heterogeneous iconography. Religious and secular themes, which have no apparent connection with one another, are given equal prominence. Whether this was due to a relaxation of the old religious dogmatism as a result of Utraquist influence is debatable. Suffice it to say that neither in Kutná Hora nor elsewhere have I been able to discover any significant difference between the works commissioned by Catholics and those commissioned by Utraquists. In fact, the only paintings to give a really clear indication of the religious allegiance of their patrons are the portraits of Master John Huss and the scenes from Hussite history in the Smíšek Hymnal (1491/2), and the representation of the mass in Vlnoves, at which John Huss was the celebrant. Incidentally, Kutná Hora was completely Utraquist.

The earliest of the four chapels is the Minters' Chapel, on whose west wall a group of minters are depicted on either side of the window (which was later enlarged). Beneath these large-format figures, whose identity is clearly established by the representation of their guild sign, the artist has painted three scenes from the Passion surmounted by four large-format angels. One of the most striking features of this work is the minter's purse, which

is shown hanging from a hook and appears to stand out from the wall like a sculpture, thus providing a very early example of illusionism. Of the three painted choir chapels in Kutná Hora the Haspler or Minters' Chapel is the most western. There too the paintings contain both religious and secular themes. On the east wall, above the altar, there is a Crucifixion surmounted by a panel that is decorated with ornamental motifs similar to those employed by contemporary artists working in Bohemian fortresses and castles. The remaining walls are given over to paintings of saints, and scenes from the daily life of the Bohemian minters. Above the Kutná Hora coat of arms, which incorporates the Utraquist chalice, there is a large crowned W, the symbol of royal power.

In the adjoining chapel of the Smíšek family, above the altar-piece executed by associates of the Master of the St. George Altar-piece, there is a large-format Crucifixion surmounted by paintings of Octavian and the Tiburtine Sibyl. In the pointed arch of the panel a man is seated before a window partly covered by a tapestry. Like the picture beneath the south window, this wall-painting is completely illusionist in effect. In the painting on the south wall, whose symbolism has yet to be fully explained, the artist has portrayed a group of three men, one of them much older than the others (Ill. 237). It has been suggested that these are Literati, i.e. members of the brotherhood responsible for the singing in the Utraquist service, and that in the painting they are in fact preparing themselves for this office. On the west wall of the chapel the plasticity of a pair of painted niches, which appear to contain books and altar vessels, is greatly enhanced by the presence of a carved niche. Above these three niches we see the coat of arms of Michael Smíšek, who acquired the chapel in 1485. Nine years later, the Smíšek coat of arms was enlarged, which would clearly suggest that the chapel was decorated within this nine year period. The principal paintings on the west wall are a portrayal of Solomon and the Queen of Sheba, which faces the Crucifixion, and a representation of Trojan's Court, which serves as a pendant to the Sibyl. Finally, at the very top of the panel, there is a window with a tapestry, as on the east wall. Whether there was also a matching figure on the west wall can no longer be established.

In the St. Wenceslas Chapel the outstanding feature of the decorative scheme is a large W, which appears in conjunction with the saint's 'love knot' and which, despite its traditional association with King Vladislav (Wladislaw), none the less justifies the name given to this, the last of the three chapels decorated in Kutná Hora in the closing years of the fifteenth century. The south wall of the St. Wenceslas Chapel is quite bare, the whole of the east wall is given over to an enormous St. Christopher, whilst on the west wall, above an illusionist tapestry, a Crucifixion and a painting of Christ having his feet bathed are surmounted by the famous love knot executed in decorative tendrils.

The paintings on the panels of the gallery ceiling were also executed for specific chapels. Thus we find the Wise and Foolish Virgins, the Four Evangelists and Christ with the Utraquist Chalice in front of the Haspler Chapel, Prophets, and Angels making music in front of the Smíšek Chapel; and Christ, St. John and St. Vitus, together with a Bishop and Angels bearing chalices, in front of the St. Wenceslas Chapel.

The decorations in the four chapels at St. Barbara's, Kutná Hora, include a series of late fifteenth-century wall-paintings based on a variety of models, including works by Netherlandish masters like Dirk Bouts and the Master of the Tiburtine Sibyl. The same kind of influences are apparent in the ceiling paintings.

Trying to decide which workshops were involved in the decoration of St. Barbara's is no easy task. Unfortunately, the illustrated manuscripts produced in Kutná Hora at the time are of little help in this connection, for both the Utraquist Smíšek Hymnal and the so-called Kutná Hora Hymnal followed the local traditions, which drew on a wide variety of different styles.

If we look for other Bohemian wall-paintings of the period that are at all comparable to the Kutná Hora series, we find that most of these are not in churches but in castles. I am thinking here, above all, of the wall-paintings in the chapel (Ill. 239) and the Green Room (Ill. 238) of the Castle of Žirovnice, which were executed in 1490 for Wencelik von Vrchovišt, who was presumably a brother of the Kutná Hora patron, Michael Smíšek. Although the paintings at Žirovnice are not all of the same high order of merit as was achieved in Kutná Hora, there may none the less have been some connection between the two projects.

But there were also a number of other projects which could have been linked with Kutná Hora, such as the representation of the Day of Judgement on the gallery of the Church of St. Aegidius in Třeboň, and the paintings in the transept of the Minorite monastery in Jindřichuv Hradec, or those in the chapel and, more especially, the 'Red Tower' of Neuhaus Castle. The wall-paintings in the castle, which were executed shortly after 1497, during the reign of the Catholic Count Henry IV of Neuhaus, are

extremely important because in certain respects they foreshadow the paintings in the St. Wenceslas Chapel. Two other series of wall-paintings dating from the 1490s are to be found in the Green Room of the 'Red Bastion' in the Castle of Švihov and the Green Room (Ill. 240) in the Castle of Blatná. In Blatná twenty-two large escutcheons—most of them belonging to members of the gentry—dominate the room, whose walls and vaulted ceilings are covered with flowing tendrils interspersed with paintings of religious and secular motifs. Another green room was created—shortly before the 1490s—in the Castle Chapel in Zvíkov, where a banqueting hall was decorated with ballroom scenes offset by foliage designs.

Although the Luxembourg tradition exerted little influence on Bohemian painting during the 1400s, a number of high quality sculptures were produced in Bohemia, which still reflected this tradition even in the second half of the century. The most important work from the period around 1460 seems to me to have been the Crucifixion Group (Ills. 232–4) created for the Church of St. Bartholomew in Plzeň. But although the figure of Christ in this group was based on the formal conceptions handed down from the late fourteenth century, both the form and the expression of the attendant figures—Mary and John—were clearly inspired by the works of contemporary sculptors in other parts of Europe. The influence of Jakob Kaschauer on the Plzeň Crucifixion Group is undeniable. So too is the influence of the Suabian Hans Multscher on other Bohemian sculptures of this period. Unfortunately, the decline in the economic, cultural, social and religious life of the country, which set in in the second half of the fifteenth century, led to a lowering of artistic standards in the sculptural sphere, and it was not until the turn of the century that Bohemia began to produce new works of artistic merit. Most of these reveal the influence of German Late Gothic sculptors, such as Tilman Riemenschneider and Gregor Erhart, and most were conceived as components of altar-pieces, like the Pürglitz Altar-piece that I have already discussed.

During this late period we find—especially in southern Bohemia—a kind of eclectic style, whose most important representative came to be known as the Master of the Žebrák Lamentation. This relief (Ill. 246), which contains elements that are reminiscent of the Kefermarkt Altarpiece and which may or may not have been intended as a monument, seems to be a particularly important sculpture. The Crucifixion from the Franciscan Church in Český Krumlov (Ill. 245), which is now in the Aleš Gallery in Hluboká, is probably a later work. This amazingly realistic carving was clearly influenced by the Danubian School. There was another outstanding master, whose nationality is unknown but who worked in Bohemia at this time and whose works were conceived entirely in the Danubian mould. He has come to be known as Master I.P., these being the initials with which he signed his small sculptures. He also produced large-format sculptures, the only surviving examples of which were executed in Bohemia. Master I.P.'s major work is the John the Baptist Altar-piece in the Týn Church in Prague (Ills. 247, 248). The reliefs and the fully modelled Crucifixion group which make up this work are carved from natural fruit tree wood. With his precise but by no means pedantic portrayal of human figures and natural objects Master I.P., who probably first came to Bohemia in the early 1520s, is a perfect exponent of the Danubian style, which was designed to achieve the total integration of man with nature.

The 1520s produced the final peak in the development of Bohemian art under the Jagellones. Subsequently, the creative power of the indigenous schools went into a decline. And yet, to this day, we still encounter occasional Late Gothic works in Bohemia, which defy all attempts at attribution, either to a specific master or even to a general stylistic movement. One such is the highly expressive Madonna (Ill. 249), which forms part of the Baroque high altar of the Church of St. Peter and St. Paul in Blatná and which was probably created in c. 1515, i.e. in the period immediately preceeding the arrival of Master I.P.

List of illustrations

Bohemian painting up to 1450

171 Title page of the Astronomical Tables of King Alfonso X of Castile. 1392. Vienna, National Library.

172 Page from the 'Willehalm' Romance, about 1385–7. Vienna, National Library.

173 King Wenceslas and Sophia of Bavaria. Wenceslas Bible, about 1390–5. Vienna, National Library.

174 Illustration to the 'Willehalm' Romance, about 1385–7. Vienna, National Library.

175 Samson being shaved by Delilah; Samson being blinded by the Philistines. Wenceslas Bible, about 1390–5.

176 The burial of a holy man. Wenceslas Bible, about 1390–5. Vienna National Library.

177 Ruth and Boaz asleep in the field. Wenceslas Bible, about 1390–5. Vienna, National Library.

178 The Finding of Romulus and Remus. Decades of Titus Livius, French, about 1380. The Hague, Royal Library.

179 St. Luke the Evangelist. Bible, 1391. New York, Pierpont Morgan Library.

180 Absalom plotting against David. Wenceslas Bible, about 1390–5. Vienna, National Library.

181 The Visitation. Miscellaneous manuscript of Johann von Jenzenstein, 1396–7. Vatican Library.

182 Adam tilling the earth, Eve and the boy Cain. Bible of Konrad von Vechta, 1403, Antwerp, Plantin-Moretus Museum.

183 Four Prince Electors. Golden Bull, 1400. Vienna, National Library.

184 God speaking to the Israelites from a cloud of fire. Bible of Konrad von Vechta, 1403. Antwerp, Plantin-Moretus Museum.

185 The Prophet Ahias dividing his garment into twelve parts. Bible of Konrad von Vechta, 1403. Antwerp, Plantin-Moretus Museum.

186 The Crucifixion. Missal of Shinko von Hasenburg, 1409. Vienna National Library.

187 Madonna from Jindřichův Hradec (Neuhaus). About 1400–10. Prague, National Gallery.

188 The Death of the Virgin. Altar-piece from Roudnice (Raudnitz), 1410–15. Prague, National Gallery.

189 Jael slaying Sisera. Bible of Konrad von Vechta, 1403. Antwerp, Plantin-Moretus Museum.

190 The Covenant of David and Jonathan. Bible of Konrad von Vechta, 1403. Plantin-Moretus Museum.

191 The zodiacal sign of Pisces. Prague Missal, about 1405–10. Vienna, National Library.

192 Prophet. Korczek Bible, about 1403–5. Vienna, National Library.

193 Antonius, Donatus, Zachaeus, Claudius and their companions. About 1410, so-called Dietrichstein Martyrologium. Gerona, (Spain), Diocesan Museum.

194 Pentecost. Choir book fragment from Sedlec, about 1414. Budapest, Museum of Fine Arts.

194a The Crucifixion. About 1410–15. Berlin-Dahlem, Stiftung Preussischer Kulturbesitz, Gemäldegalerie.

195 The Martyrdom of Theodosia; the Burial of Mary of Egypt; Enagrius and Benignus. About 1410, so-called Dietrichstein Martyrologium. Gerona (Spain) Diocesan Museum.

196 The zodiacal sign of Virgo. Prague Missal, about 1405–10. Vienna, National Library.

197 The Nativity. Boskovic Bible, about 1415–20. Olomouc (Olmütz), University Library.

198 Madonna with Angels and Saints in the Enclosed Garden. About 1415–20. Innsbruck, Museum Ferdinandeum.

199 The Carrying of the Cross. Panel of the altar-piece from Rajhrad (Raigern), about 1415–20. Brno (Brünn), Moravian Gallery.

199a The Martyrdom of St. Catherine, outer panel of the Namešt altar-piece. About 1430–5. Brno (Brünn), Moravian Gallery.

Late Gothic architecture

200 Prague, Týn Church, west façade. Gable 1463, north tower 1466, south tower completed 1511.

201 Kutná Hora (Kuttenberg), St. Barbara's Church, choir vaulting (1489–99) by Matthias Rajsek.

202 Prague, Týn Church, canopy over the tomb of Bishop Lucianus, by Matthias Rajsek, 1493.

203 Prague, Hradčany Castle, Horsemen's Staircase, by Benedikt Ried, about 1500.

204 Prague, Hradčany Castle, wing of King Ludwig, vaulting of the Bohemian Chancellery, about 1505.

205 Prague, Hradčany Castle, Vladislav Hall (1493–1502) by Benedikt Ried.

206 Kutná Hora (Kuttenberg), St. Barbara's Church from the north-east.

207 Kutná Hora (Kuttenberg), St. Barbara's Church, nave, by Benedikt Ried, begun 1512, completed 1548.

208 Rábí Castle. Outer fortifications by Benedikt Ried, about 1500–20.

209 Křivoklat (Pürglitz) Castle, chapel, about 1489, probably by Hans Spiess.

210 Tábor, Town Hall, built by Wenzel Rosskopf, 1515–16.

211 Bechyně (Bechin) Castle, ground floor, about 1510.

212 Prachatice (Prachatitz), Pisek Gate, 1493, and St. James's Church, completed 1505–13.

213 Prachatice (Prachatitz), St. James's Church, view from the north aisle, vaulting 1490–1513.

214 Chvalšiny (Kalsching), St. Magdalen's Church, corbel of the nave vaulting, about 1520.

215 Chvalšiny (Kalsching), St. Magdalen's Church, nave vaulting, about 1520.

216 Chvalšiny (Kalsching), St. Magdalen's Church, view from the north-east.

217 Český Krumlov (Krumau), oriel-window, Deanery, 1514–20.

218 Český Krumlov (Krumau), oriel-window, Castle, about 1513.

219 Dolní Dvořiště (Unterhaid), St. Giles's Church, nave, early sixteenth century.

220 Most (Brüx), Church of the Assumption, pendant boss in west gallery, about 1532.

221 Most (Brüx), Church of the Assumption, south side of the vault in the west chapel.

222 Most (Brüx), Church of the Assumption, 1517–44, from a design by Jacob Heilmann.

223 Ústí nad Labem (Aussig), Church of the Assumption, nave vaulting, 1500–25.

224 Soběslav (Sobieslau), Church of St. Peter and St. Paul, nave vaulting after 1493.

Late Gothic painting and sculpture

Colour plates

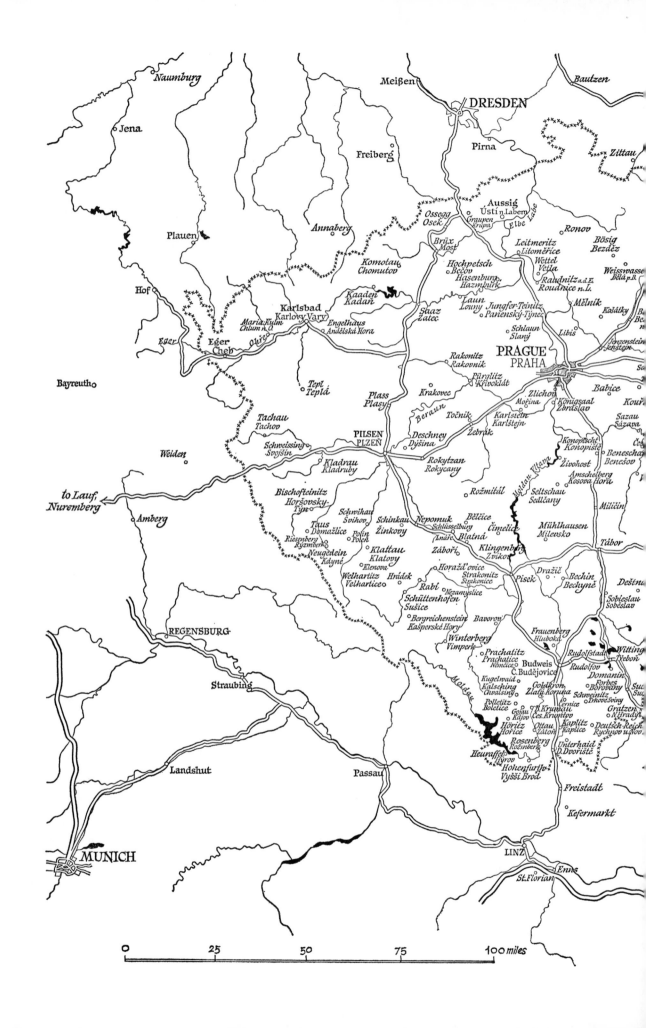

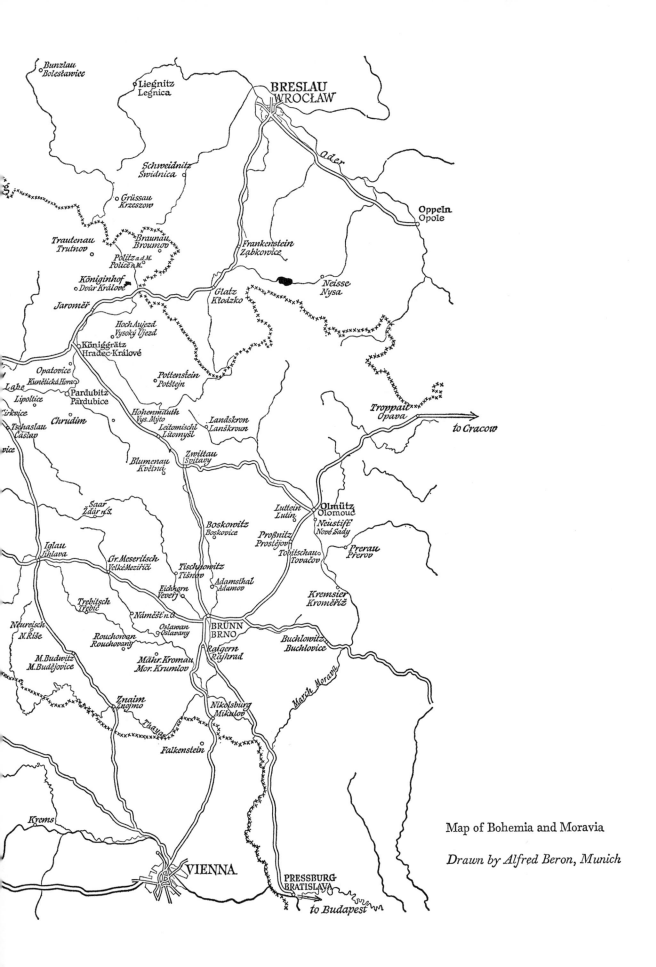

Map of Bohemia and Moravia

Drawn by Alfred Beron, Munich

Bibliography

1. Social developments in Bohemia during the Gothic Period

F. Seibt, 'Bohemica: Probleme und Literatur seit 1945' in *Sonderheft 4 der Historischen Zeitschrift* (Munich, 1970)

—'Die Zeit der Luxemburger und der hussitischen Revolution' in *Handbuch der Geschichte der böhmischen Länder* I (Stuttgart, 1967; pp. 348–568)

2. Gothic architecture in the period before the Hussite Wars

Bachmann E, 'Peter Parler' in *Göttinger Arbeitskreis 25* (Kitzingen, 1952)

—'Vorstufen parlerischer Wölbformen' in *Zeitschrift f. Sudetendeutsche Geschichte* II, 1938

—'Zu einer Analyse des Prager Veitsdomes' in *Zeitschrift f. Sudetendeutsche Geschichte* II, 1938

Bony J, 'The Resistance to Chartres in Early Thirteenth Century Architecture' in *Journal of the British Archaeological Association*, XX–XXI, 1957/58

Branner R, *La Cathédrale de Bourges et sa Place dans l'Architecture Gothique* (Paris 1962)

Clasen K. H, *Deutsche Gewölbe der Spätgotik* (Berlin, 1958)

Dějepis výtvarného umění v Cechách. I. dil: Středověk (History of the Fine Arts in Bohemia. First Part: Middle Ages) Edited by Z. Wirth (Prague, 1931)

Denkstein V, *Matoús F: Südböhmische Gotik* (Prague, 1955)

Donin R. K, *Die Bettelordenskirchen in Österreich* (Baden near Vienna, 1935)

Evans J, 'English Art: 1307-1461' in *The Oxford History of English Art* Vol. 5 (Oxford, 1949)

Götz W, *Zentralbau und Zentralbautendenz in der gotischen Architektur* (Berlin, 1968)

Grueber B, 'Die Hochgotik im deutschen Kirchenbau' in *Marburger Jahrbuch* VII, 1937

— *Die Kunst des Mittelalters in Böhmen* (Vienna, 1877)

Hyzler J, 'Obnova bývalého kláštera bl. Anežky v Praze' (The Restoration of the Former Convent of the Blessed Agnes in Prague) in *Památkova péce 24* (1964) and 26 (1966)

Keviczky A, 'Najstarši časy a romanska architekture' (Early and Romanesque Architecture) in *Architektura na Slovensko* (Pressburg, 1958)

Kletzl O, *Peter Parler: Der Dombaumeister zu Prag* (Leipzig, 1940)

Konow H, *Die Baukunst der Bettelorden am Oberrhein* (Berlin, 1954)

Kotrba V, 'Kaple svatováclavská v prasžké katedrále' (The Chapel of St. Wenceslas in St. Vitus's Cathedral in Prague) in *Umění 7/8*, 1959/60

Krautheimer R, *Die Kirchen der Bettelorden in Deutschland* (Cologne, 1925)

Kubicek A, *Betlémská kaple* (The Bethlehem Chapel) (Prague, 1953)

Kühn K, 'Zur Baugeschichte der Karlshofer Stiftskirche in Prag' in *Mitt. d. Ver. f. Geschichte d. Deutschen in Böhmen 69*, 1931

Lamperez y Romea V, *Historia de la arquitectura christiana española in la estad media* (Madrid, 1930)

Lefèvre Pontalis E, Les nefs sans fenêtres dans les églises romanes et gothiques' in *Bull. Mon.*, 1922

Libal D, *Architektura gotická: Architektura v ceském národním dědictvi* (Gothic Architecture: The Bohemian Heritage (Prague, 1961

—'Gotická architektura v Čechách a na Moravě' (Gothic Architecture in Bohemia and Moravia) in *Cesta K Umění* III/I

Martin A. R. *Franciscan Architecture in England* (Manchester, 1957)

Mencl V, *Česká architektura doby Lucemburské* (Bohemian Architecture from the Time of the Luxembourg Rulers) (Prague, 1948)

Menclová D and V, 'Ceský hrad v dobé

václavové' (The Bohemian Castle in the Time of Wenceslas) in *Umění 14*, 1942/3

Münzerová Z, 'Klášter blahosl. Anežky na starém městé pražském' in *Archeologické Památky* (The Convent of the Blessed Agnes in the Old City of Prague). Nos II/III, 1932

Neuwirth J, *Die Wochenrechnungen und der Betrieb des Prager Dombaus in den Jahren 1372/78* (Prague, 1890)

Neuwirth J, *Geschichte der bildenden Kunst in Böhmen vom Tode Wenzels III. bis zu den Hussitenkriegen* (Prague, 1893)

Poche E, *Dominikánský kostel sv. Kříže v Jihlavě* (The Dominican Church of the Holy Cross in Iglau) in *Čas. spol. přátel starož* Vol. 32

Podlaha A and Hilbert K, 'Metropolitní chrám Sv. Víta v Praze' (The Archiepiscopal Cathedral of St. Vitus in Prague) in *Soupis Památek Historických a Uměleckých* (Prague, 1906)

Rhein A, 'Les voûtes des déambulatoires' in *Bull. Mon.*, 1932

Roosval J, *Den gotlandske Ciceronen* (Stockholm, 1926)

Schadendorf W, 'Wien, Prag und Halle' in *Hamburger mittel- und ostdeutsche Forschungen* III, 1961

Schürer O, *Romanische Doppelkapellen* (Marburg, 1929)

Swoboda K. M, *Peter Parler* (Vienna, 1940) *idem* and Bachmann E, *Parler-Studien* (Brno and Leipzig, 1939)

Wagner-Rieger R, 'Architektur der Gotik in Österreich' in *Gotik in Österreich* (Exhibition Catalogue; Krems, 1967)

Wenzel A, 'Die Baugeschichte der Klosterkirche zu Trebitsch' in *Marburger Jahrbuch 5*, 1929

Zadnikar M, *Romanská architektura na Slovenském* (Romanesque Architecture in Slovenia) (Ljubljana, 1959)

3. Bohemian sculpture up to the Hussite Wars

Bachmann H, *Gotische Plastik in Böhmen und Mähren vor Peter Parler* (Brno, Munich and Vienna, 1943)

—'Martin und Georg von Klausenburg' in *Neue Deutsche Biographie* (Berlin, 1953 *et seq*)

Bräutigam G, 'Gmünd-Prag-Nürnberg' in *Jahrbuch der Berliner Museen* III, 1961

Demus O, 'Der Meister der Michaeler Plastik' in *Österreichische Zeitschrift für Kunst und Denkmalpflege* 7, 1953

Grossmann D, 'Die Schöne Madonna von Krumau und Österreich' in *Österreichische Zeitschrift für Kunst und Denkmalpflege* 14, 1960

—'Salzburgs Anteil an den Schönen Madonnen' in *Schöne Madonnen: 1350–1450* (Exhibition Catalogue; Salzburg, 1965)

Kletzl O, 'Zur Parlerplastik' in *Wallraf-Richartz-Jahrbuch: 1933–34*

Kosegarten A, 'Zur Plastik der Fürstenportale am Wiener Stephansdom' in *Wiener Jahrbuch für Kunstgeschichte 1965*

Kotrba V, 'Kaple svatováclavská v prázské catedrále' (The Wenceslas Chapel in St. Vitus's Cathedral in Prague) in *Umění* 7–8, 1959–60

Kutal A, Ceske gotické socharství: 1350–1450 (Bohemian Gothic Sculpture) (Prague, 1962)

—'K problému horizontálních piet' (The Problem of the Horizontal Pietà) in *Umění* 11, 1963

Liess R, 'Vesperbilder um 1400' in *Alte und moderne Kunst* (1963)

Martin K, *Die Nürnberger Steinplastik im 14. Jahrhundert* (Berlin, 1927)

Swoboda K. M, *Peter Parler* (Vienna, 1940)

Ziomecka A, *Śląska rzezba gotycka* (Silesian Gothic Wood Sculpture) (Catalogue; Breslau, 1968)

4. Bohemian painting up to 1450

Illuminované Rukopisy (Illuminated Manuscripts) (Exhibition Catalogue published by the Library of the National Museum in Prague; Prague, 1965)

Moravská Křizní Malba XI až XVI Století (Moravian Book Illumination from the XI to the XVI Century) (Exhibition Catalogue published by the Strahov Library; Prague, 1955)

Naródní Galerie v Praze: Ceské Umění Gotické (The National Gallery in Prague: Bohemian Gothic Art; Prague, 1964)

Burger F, *Die deutsche Malerei vom ausgehenden Mittelalter bis zum Ende der Renaissance* (Berlin, 1917)

Cibulka J, 'Ceské stejnodeskové polyptychy z let 1350–1450' (Bohemian Polyptychs from the Years 1350–1450) in *Umění* 11, 1963

Dějepis výtvarného umění v Čechách. I. dil: Středovek (History of the Fine Arts in Bohemia. First Part: Middle Ages) Edited by Z. Wirth (Prague, 1931)

Drobna Z, *Die gotische Zeichnung in Böhmen* (Prague, 1956)

—*Les Trésors de la broderie religieuse en Tchécoslovaquie* (Prague, 1950)

Dvoráková V, Krása J, Merhautová A and Stejskal K, *Gothic Mural Painting in Bohemia and Moravia 1300–1378* (London, 1964)

Dvoráková V and Mencovál D, *Karlštejn* (Prague, 1965)

Ernst R, *Beiträge zur Tafelmalerei Böhmens im XIV. und am Anfang des XV. Jahrhunderts: Forsch. z. Kunstgeschichte Böhmens VI.* (Prague, 1912)

Friedl A, *Magister Theodoricus: Das Problem seiner malerischen Form* (Prague, 1956)

Frinta M. S, 'The Master of the Gerona Martyrology and Bohemian Illumination' in *The Art Bulletin* 46, 1964

Gotische Malerei in Böhmen: Tafelmalerei 1350–1450 Edited by the Institute of Art History at Prague University under the direction of A. Matejček (Prague, 1939)

Krása J, *Die Handschriften König Wenzels IV* (Vienna, 1971)

Krofta J, *Mistr Brevíře Jana ze Středy* (The Master of the Breviary of Johann of Neumarkt) (Prague, 1940)

Kutal A, 'The Brunswick Sketchbook and the Czech Art of the Eighties of the 14th Century' in *Sborník prací fil. fak. Brněnské University* 10, 1961

Matejcek A and Myslivec J, 'České madony gotické byzantinských typu' (Bohemian Gothic Madonnas of the Byzantine Type) in *Památky archaeologické* N.S. 4/5 (40), 1934/35

Matejcek A and Pesina J, *Czech Gothic Painting 1350–1450* (Prague, 1950)

Pächt O, 'A Bohemian Martyrology' in *The Burlington Magazine* 73, 1938/II

Pešina J, 'Obraz krajiny v česke knižni malbé kolem r. 1400' (Landscape in Bohemian Book Illumination about 1400) in *Umění* 13, 1965

Pešina J and Homolka J, 'K problematice evropského umění kolem roku 1400' (On some problems of European Art about 1400) in *Umění* 11, 1963

Petas F and Paul A, *Das Jüngste Gericht: Mittelalterliches Mosaik am Prager Veitsdom* (Prague, 1958)

Poche E and Krofta J, *Na Slovanech* (The Emmaus Monastery) Prague, 1956

Podlaha A, *Die Bibliothek des Metropolitankapitels: Topographie der histor. u. Kunstdenkmale i. Kgr. Bohmen II/2* (Prague, 1904)

Schlosser J von, 'Die Bilderhandschriften König Wenzels' in *Jahrbuch d. Kunsthist. Sammlungen des A. H. Kaiserhauses* 14, 1893

Stange A, *Deutsche Malerei der Gotik* (Berlin, 1934 *et seq*)

Stejskal K, 'O malířích nástěnných maleb kláštera na Slovanech' (On the Painters of the Frescoes in the Emmaus Monastery) in *Umění* 15 1967

Stockhausen H. A von, 'Der erste Entwurf zum Strassburger Glockengeschoss und seine künstlerischen Grundlagen' in *Marburger Jahrbuch f. Kunstwissenschaft* 11/12, 1941

5. Late Gothic architecture

Büchner J, *Die spätgotische Wandpfeilerkirche in Bayern und Österreich* (Passau, 1964)

Die Kunst der Donauschule: 1490–1540 (Exhibition Catalogue containing articles by G. Fehr and R. Feuchtmüller; St. Florian and Linz, 1965)

Fehr G, *Benedikt Ried: Ein Baumeister zwischen Gotik und Renaissance* (Munich, 1961)

Fischer F, *Der spätgotische Kirchenbau am Mittelrhein* (Heidelberg, 1962)

Jihočeská Pozdní Gotika (Exhibition Catalogue containing an article by V. Kotrba; Hluboká and Frauenberg, 1965)

Kotrba V, 'Baukunst und Baumeister der Spätgotik am Prager Hof' in *Zeitschrift für Kunstgeschichte*, 1968

Lůžek B, *Stavitelé chrámu sv. Mikuláše v Lounech* (The Architects of the Church of St. Nicholas in Laun) (Laun, 1968)

Milobedzki A, 'Zamok W Mokrsku Górnym i niektóre problemy malopolskiej

architektury XV i XVI wieku' (The Castle in Mokrsko Gorne and some Problems of Polish Architecture in the XV and XVI Centuries) in *Buletyn Historii Sztuky* XXI, 1959

Samánková E, 'Review of Fehr's book on B. Ried' in *Umění* XI/4, 1963, pp 311 ff

—*Architektura české renezance* (Bohemian Renaissance Architecture) (Prague, 1962)

6. Late Gothic painting and sculpture

Homolka J, 'Riemenschneiderová socha biskupa ze Zelené Hory' (Riemenschneider's Figure of a Bishop from Grünberg) in *Umění* 8, 1960

—*Z Díla Ulricha Creutze: 1516–ok.1530* (From the Work of Ulrich Kreutz 1516–c.1530) (Exhibition Catalogue; Teplitz and Leitmeritz, 1966)

Kotrba V, 'Kaple svatováclavska v praszké katedrále' (The Wenceslas Chapel in St. Vitus's Cathedral in Prague) in *Umění* 7/8, 1959/60

Krasa J, 'K výsledkům některých významných restaurátorských akcí r. 1961' (On the Results of Some Important Restorations of 1961) in *Umění* 10, 1962

—'Nástěnně malby žirovnické zelené svétnice' (The Wall Paintings of the Green Room in Zirovnice) in *Umění* 12, 1964

—'Renesanční nástěnná výzdoba kaple svatováclavské v chrámu Sv. Víta v Praze' (The Renaissance Wall Paintings in the Wenceslas Chapel of St. Vitus's Cathedral in Prague), in *Umění*, 6, 1957

Kropácek J, 'Marginalie dílu mistra Oplakávaní ze Žebráka' (Marginals on the Work of the Master of the Lamentation in Žebrák) in *Jihoceská pozdní gotika: 1450–1530* (Exhibition Catalogue; Hluboká, 1965)

—'Ukřižovaný z byvalého dominikánského Kláštera v Českých Budějovicích' (The Crucifix from the Former Dominican Monastery in Böhmisch Budweis) in *Umění* 8, 1960

—'Zur Meister-IP-Problematik' in *Werden und Wandlung: Studien zur Kunst der Donauschule* (Linz, 1967)

Kutal A, České gotické sochařství: 1350–1450 (Bohemian Gothic Sculpture 1350–1450) (Prague, 1962)

Pešina J, 'Malířska výzdoba Smíškovské kaple v kostele sv. Barbory v Kutné Hore' (The Decoration of the Smisek Chapel in the Church of St. Barbara at Kutna Hora) in *Umění* XII, 1939/40

—*Mistr Litomerický* (The Master of Leitmeritz) (Prague, 1958)

—'Paralipomena k dějinám českého malířstvi pozdní gotiky a renexance. Osm kapitol o opravách k české malbe deskové 1450–1550' (Paralipomena to the History of Late Gothic and Renaissance Painting in Bohemia. Eight Chapters on Bohemian Panel Painting 1450–1550) in *Umění* 15, 1967

—*Tafelmalerei der Spätgotik und der Renaissance in Böhmen: 1450–1550* (Prague, 1958)

Sipová-Vacková J, K ideové koncepci renesančních nástěnných maleb ve svatováclavské kapli pražské katedrály (On the Programmatic Concept of the Renaissance Wall Paintings in the Wenceslas Chapel of St. Vitus's Cathedral in Prague) (Manuscript)

Acknowledgements

Kunsthistorisches Institut der Universität Wien: 79, 109, 130, 132, 133, 139, 141, 169, 170, 171, 172, 174, 194[a]

Statní ústav památkové péče, Prague: 78, 81, 90, 107, 110, 113, 114, 115, 116, 117, 118, 119, 120, 121, 122, 124, 125, 126, 127, 128, 129, 131, 135, 142, 146, 149, 167

Ceskoslovenská akademie věd, Ústav pro theorii a dejiny umění, Prague 1: 82, 130, 142, 143, 197

Bildarchiv Foto Marburg. Marburg/Lahn: 96, 98, 136, 137, 138, 144, 148, 152

Bodleian Library, Oxford: 83

Walter Steinkopf, Berlin: 85, 87

Alinari, Florence: 86, 101

Museum of Fine Arts, Boston: 94

Philip Hofer, Houghton Library, Harvard University, Cambridge, Mass.: 97

Deutsche Fotothek, Dresden: 102

Pierpont Morgan Library, N.Y.: 106, 179

Universitätsbibliothek Strasbourg: 108

Deutscher Verein für Kunstwissenschaft: 111

Jiři Josefik, Prague: 123

Johnson Collection, Philadelphia: 128, 134

Schlesisches Museum, Wroclaw: 140

Eugen Kusch: 153

Royal Commission on Historical Monuments, London: 154

Věra Frömlová, Prague, National Gallery: 160

Museum of Fine Arts, Budapest: 194

MAS, Barcelona: 193, 195

Musée Plantin Moretus, Antwerp: 182

ACL, Brussels: 184, 185, 189, 190

Vatican Library: 181

Koniklijke Bibliotheek, The Hague: 178

National Gallery, Prague: 164

British Museum, London: 168

Stiftsbibliothek Stams, Tirol: 167

Österreichische Nationalbibliothek, Vienna: 173, 176, 177, 183, 192, 196

Klaus Gallas, Munich, drew the ground-plans on pp. 12, 14, 17, 19, 20, 21, 22, 25, 70, 71, 74, 75

Index

Numbers in italics refer to the plates

93

Social developments in Bohemia during the Gothic period

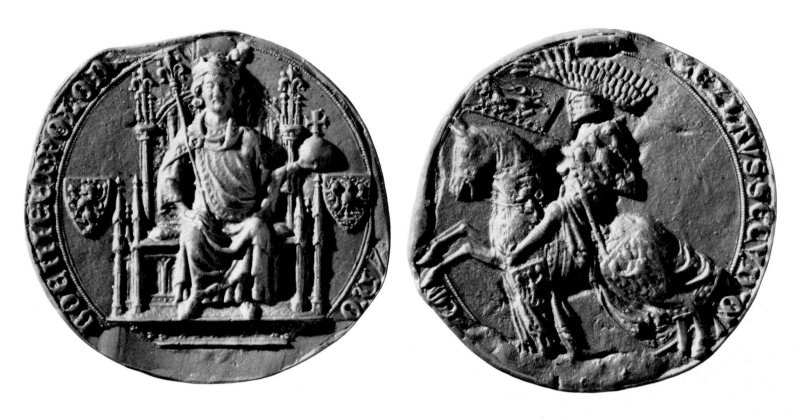

1 Wenceslas II, King of Bohemia and Poland (1278-1305). Seal impression

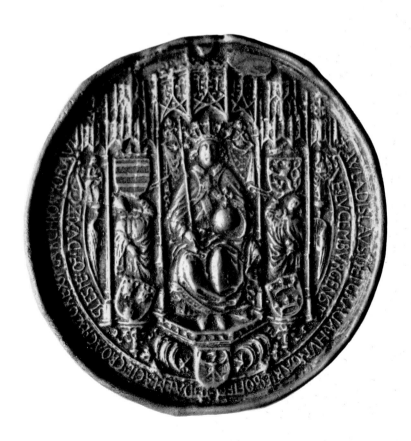

2 Vladislav II, King of Bohemia and Hungary (1471-1516). Seal impression

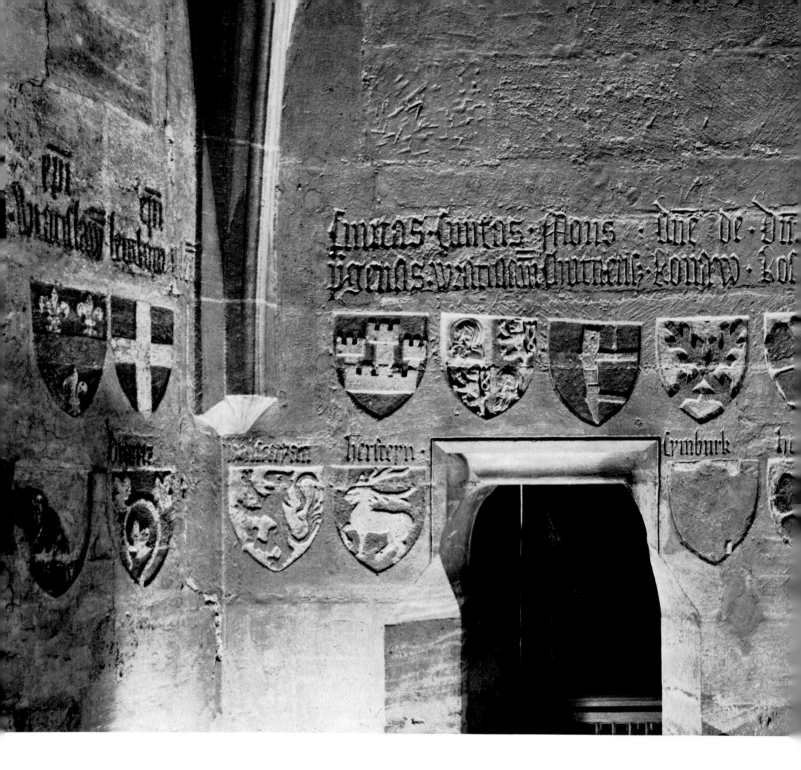

3 Coats of arms in the hall of the Castle of King Wenceslas at Lauf an der Pegnitz (Bavaria)

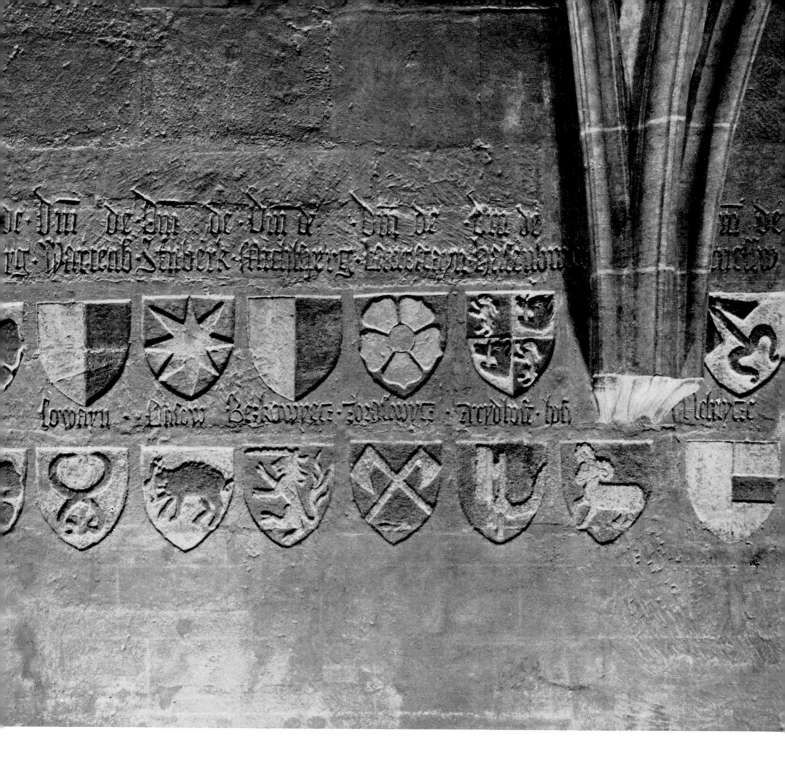

longitudinal wall, top row: the arms of the cities of Prague, Wroclaw (Breslau) and Kutná Hora (Kuttenberg), and of the lords of Ronow, Rosenberg, Wartenberg, Sternberg, Michelsberg, Landstein, Hasenburg and Beneschau

bottom row: the arms of the lords of Waldstein, Hirschstein, Zimburg, Amschelberg, Kováň, Onšov, Beškovec, Zbraslawic, Ředhošt, Hoswracin and Melnitz

left wall, top row: the arms of the bishoprics of Wroclaw (Breslau) and Litomyšl (Leitomischl)

bottom row: the arms of Preczlaus of Pogarell, bishop of Breslau, and Johann of Dražic, bishop of Prague

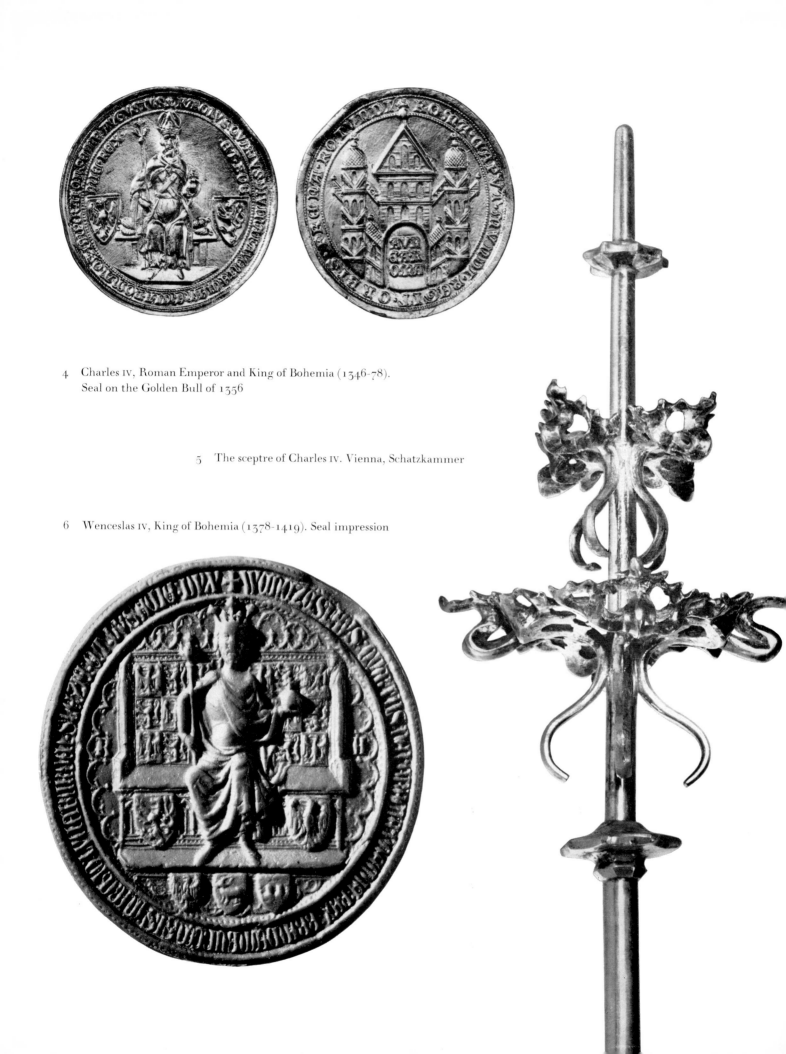

4 Charles IV, Roman Emperor and King of Bohemia (1346-78).
 Seal on the Golden Bull of 1356

5 The sceptre of Charles IV. Vienna, Schatzkammer

6 Wenceslas IV, King of Bohemia (1378-1419). Seal impression

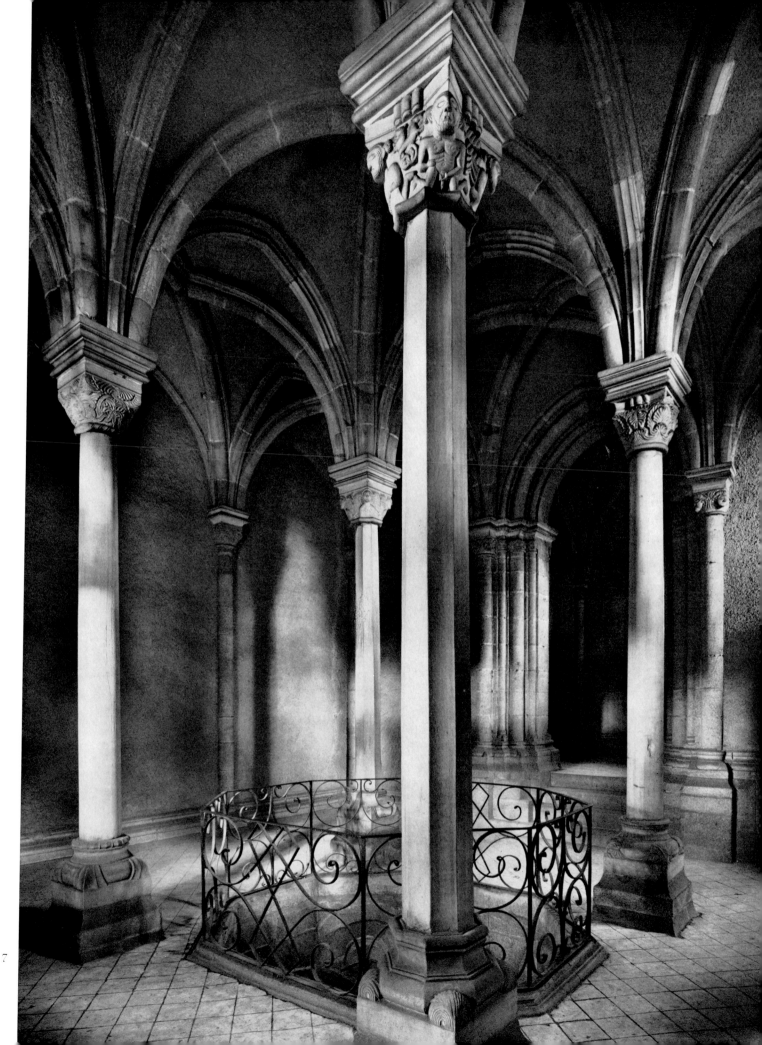

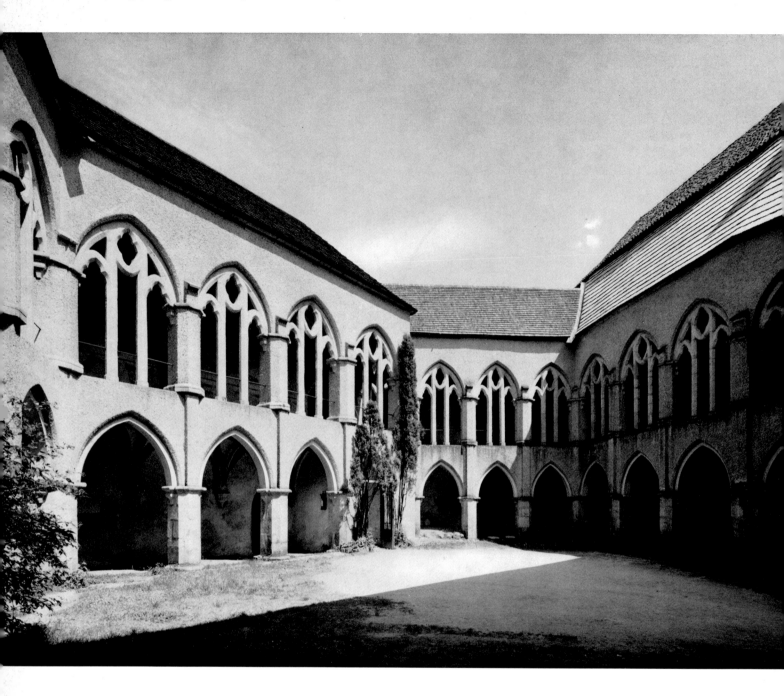

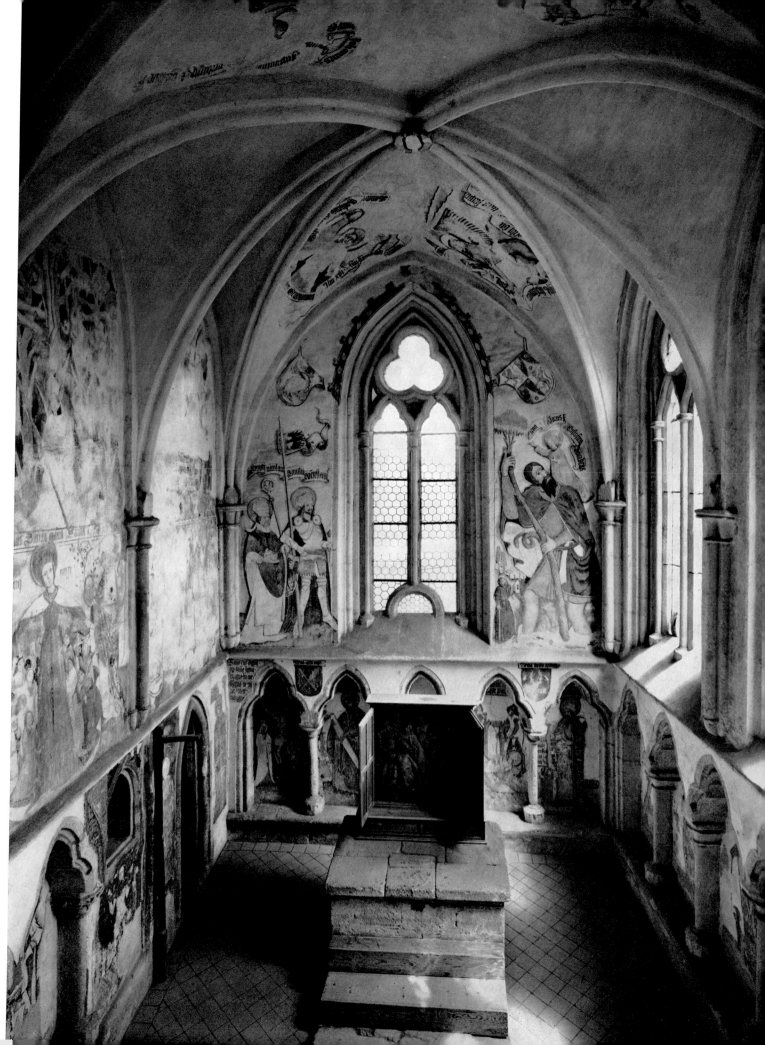

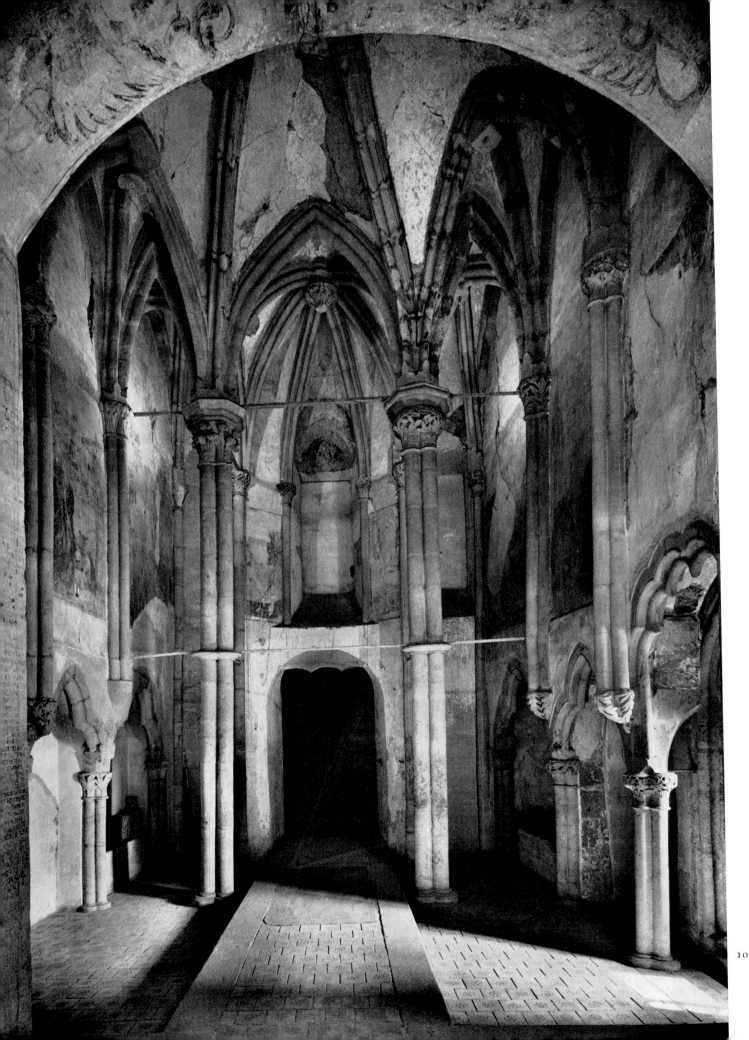

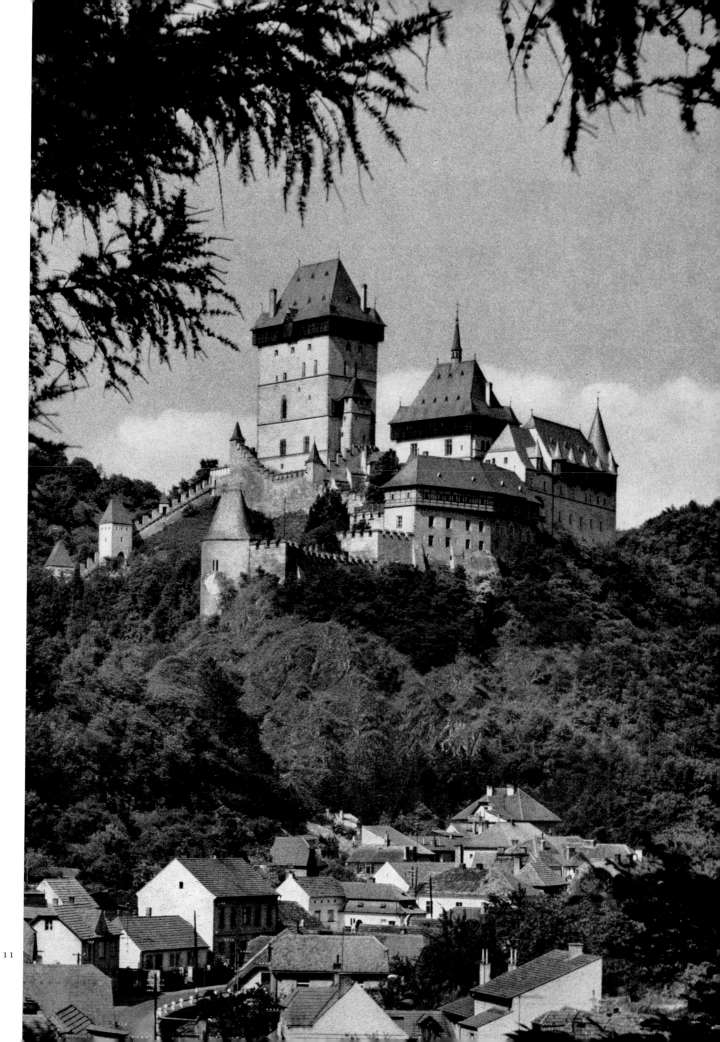

11

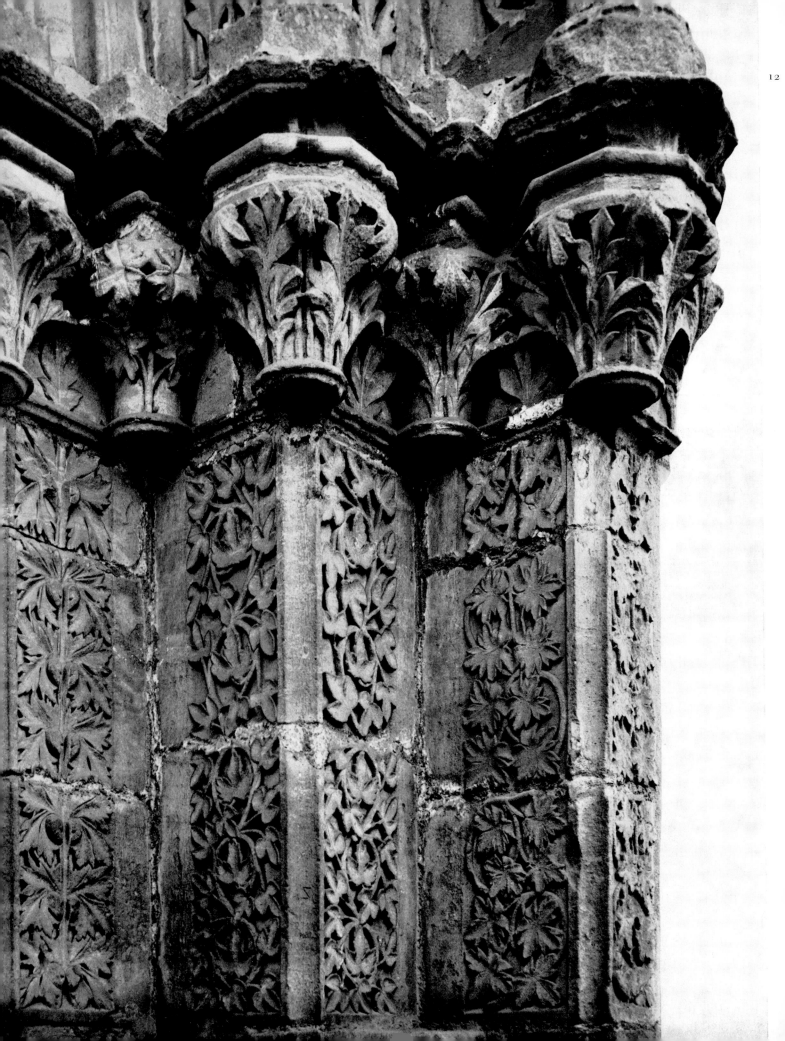

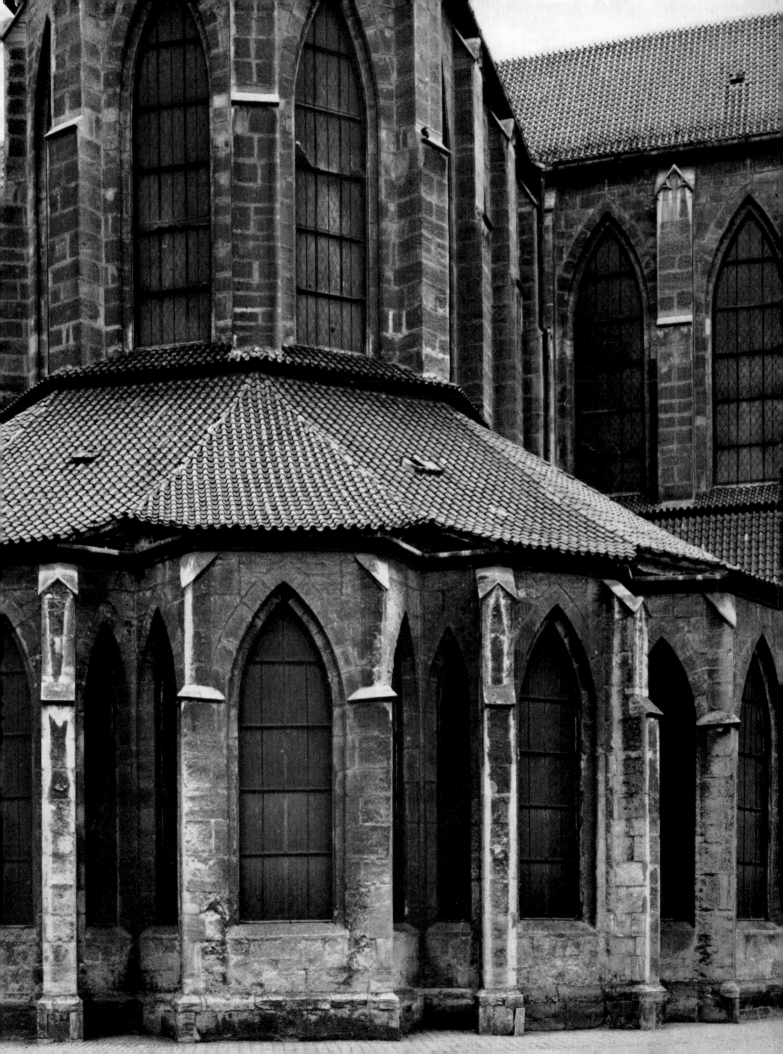

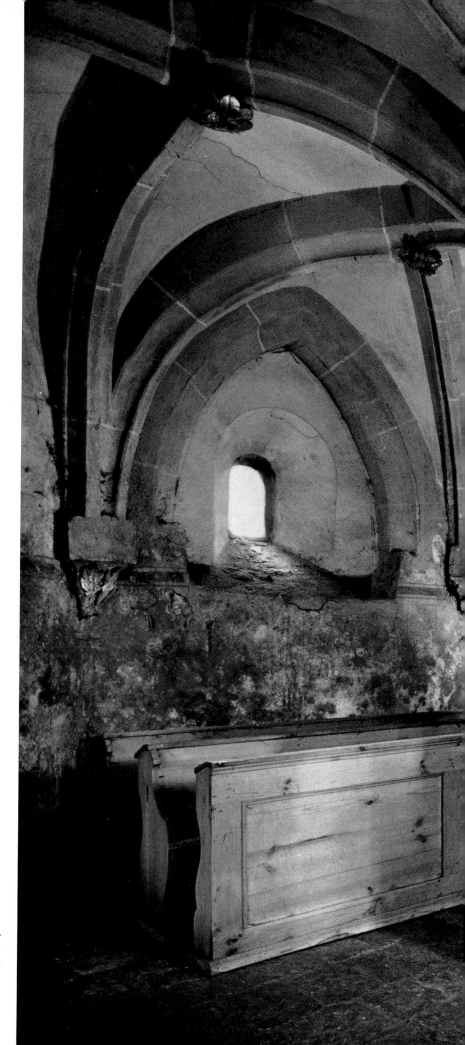

14
Kouřím, St. Stephen's Church,
crypt. About 1270-80

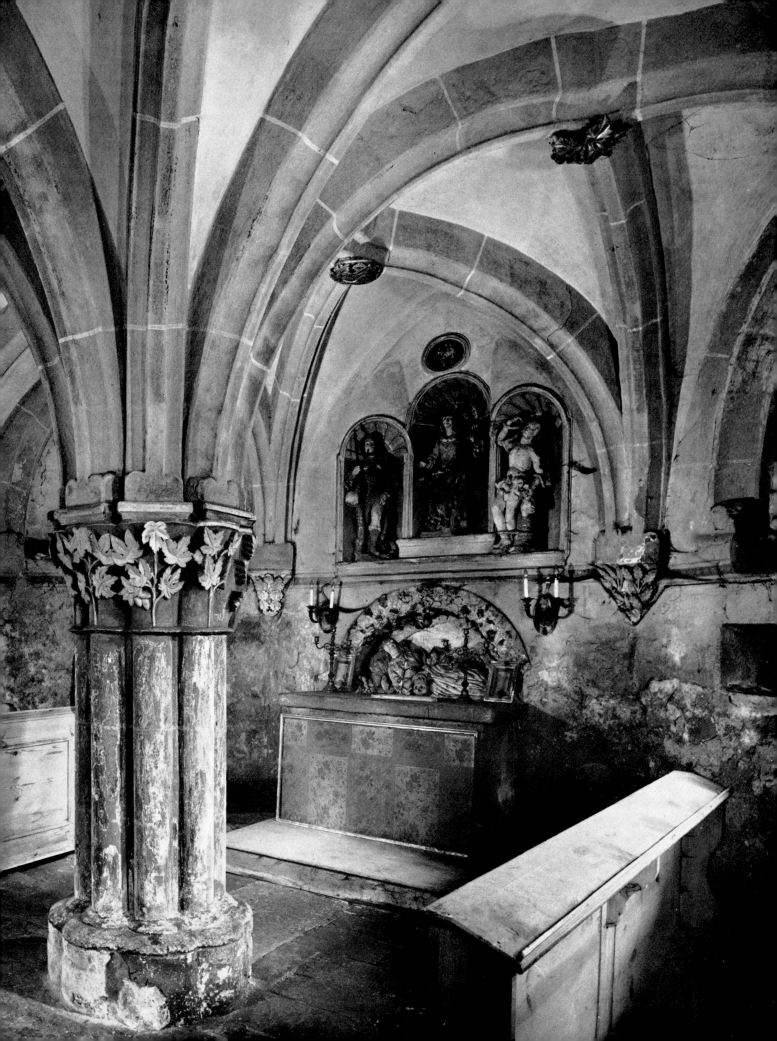

16 Prague, St. Agnes's Convent, chapel of Our Saviour, detail of the triumphal arch. About 128

15 Prague, St. Agnes's Convent of the Poor Clares, so-called chapter-house. After 1250

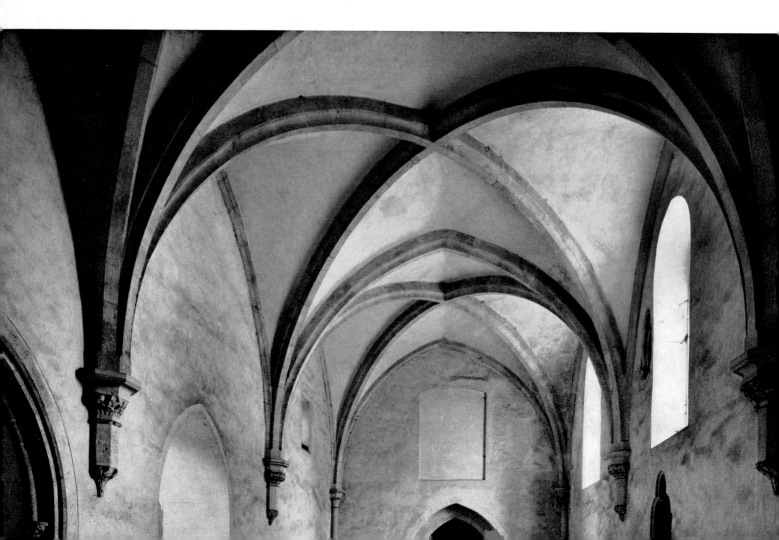

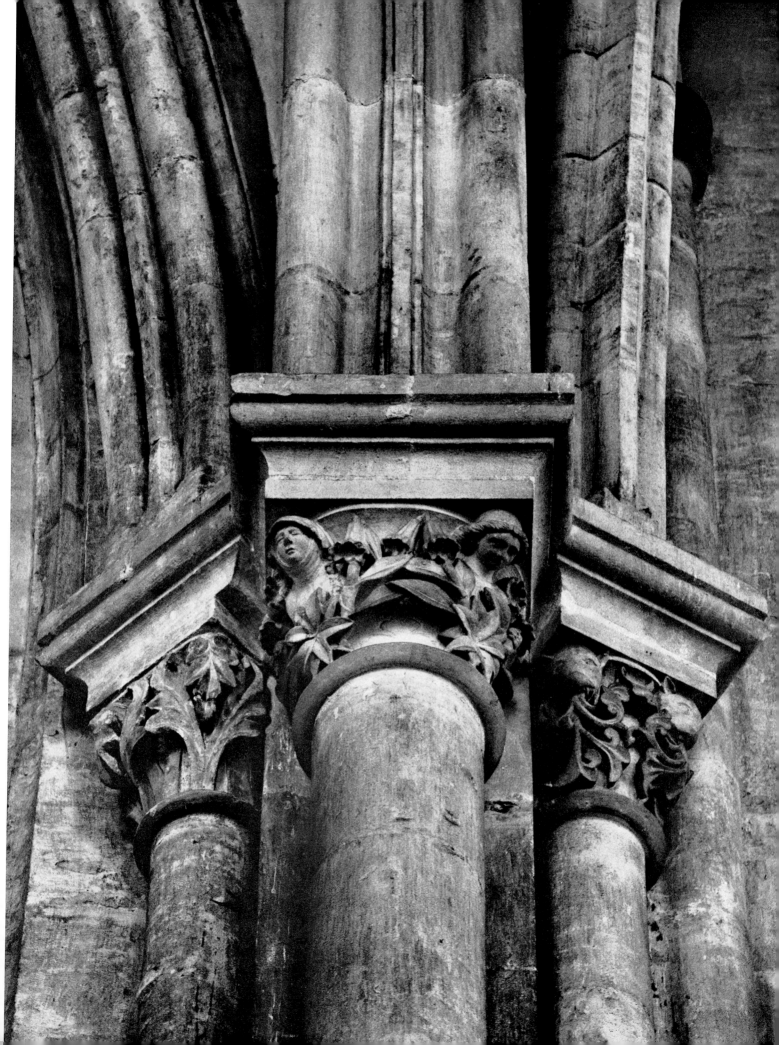

18
Vyšši Brod (Hohenfurth)
Cistercian Monastery
chapter-house. After 128

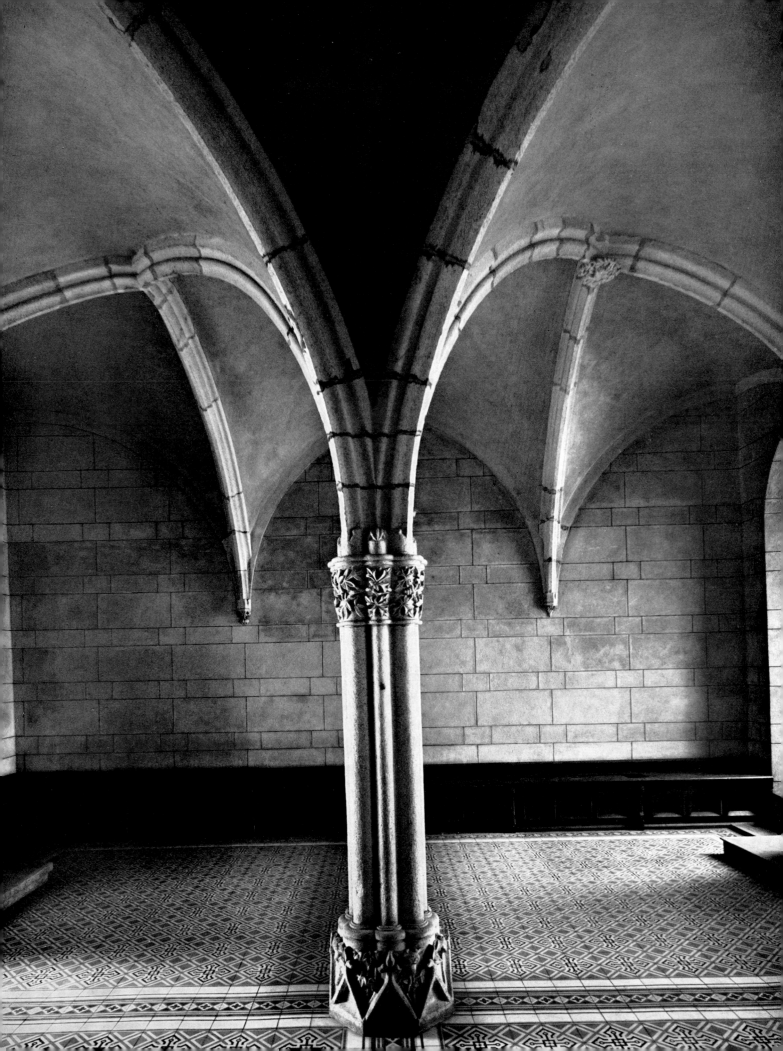

19 Kolin, St. Bartholomew's Cathedral, nave. After 1261

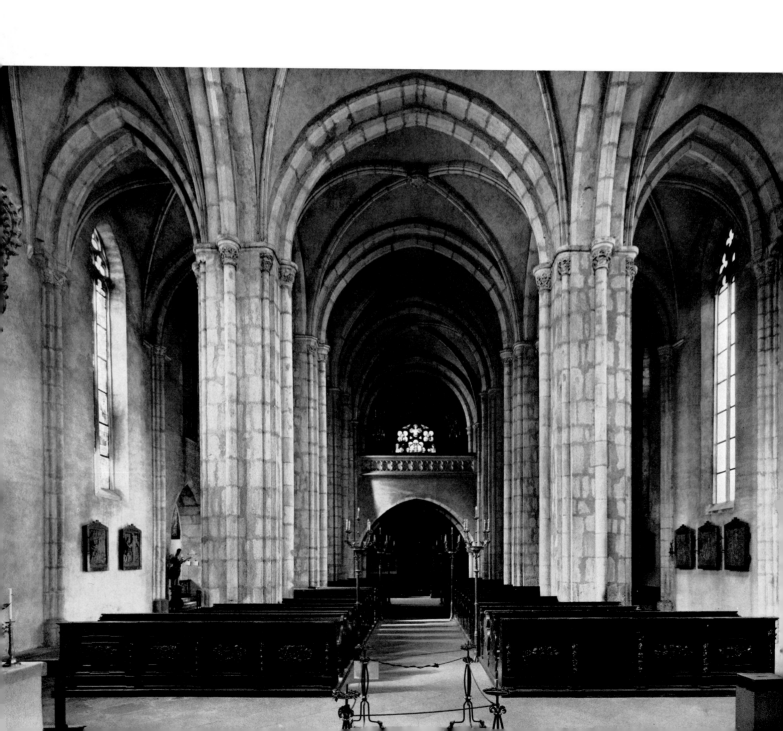

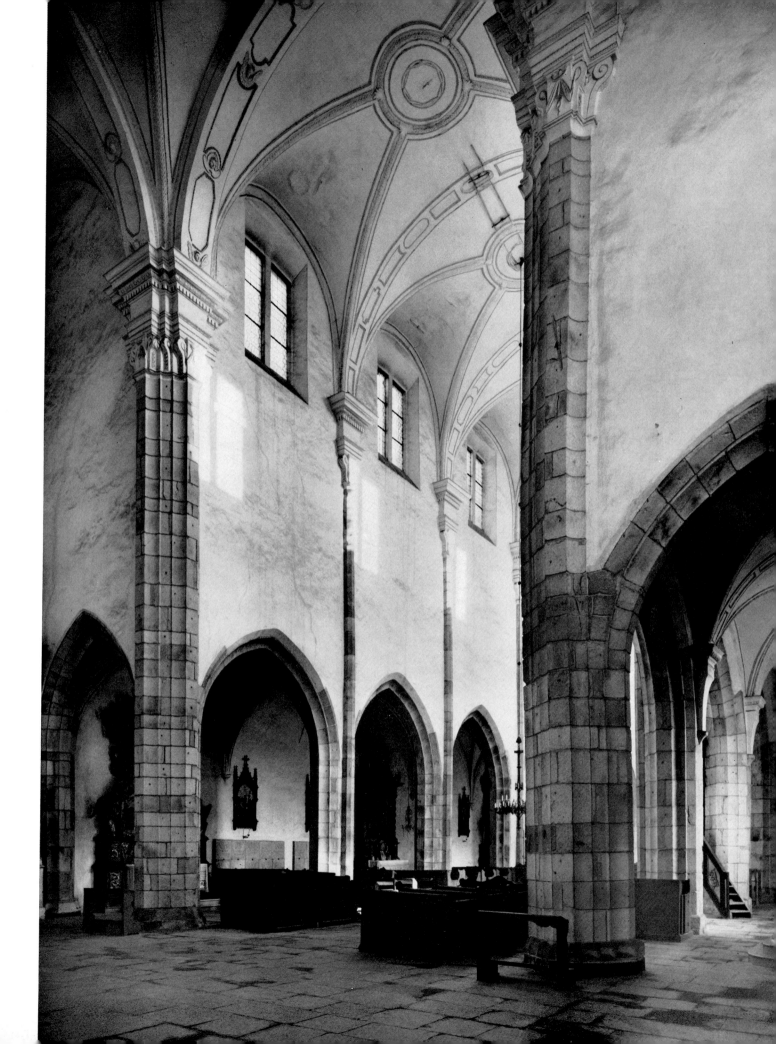

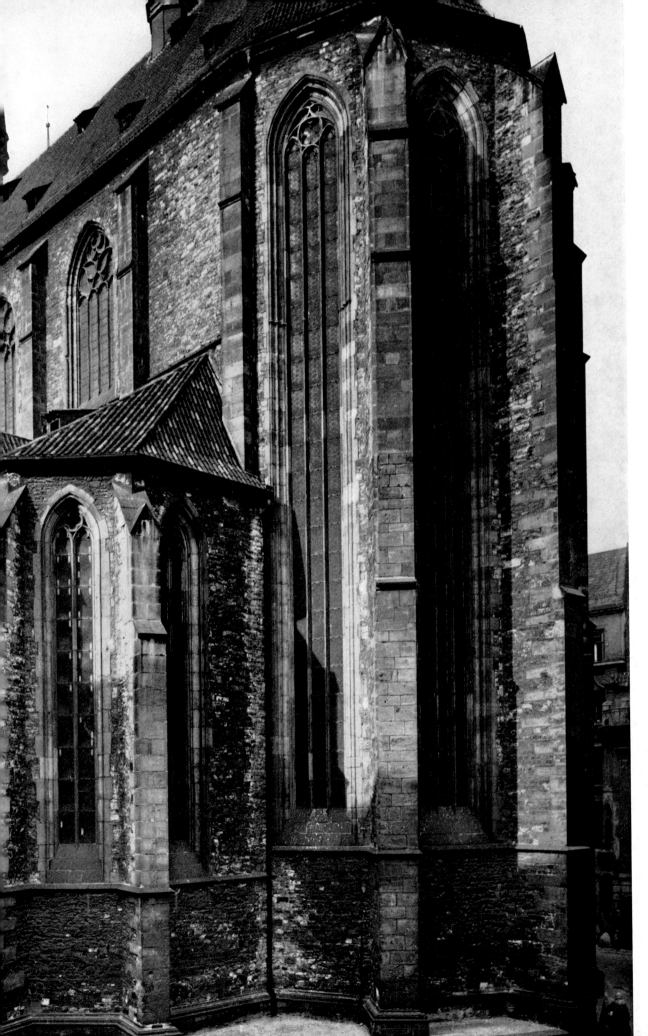

21
Prague, Týn Church,
east end.
About 1360-70

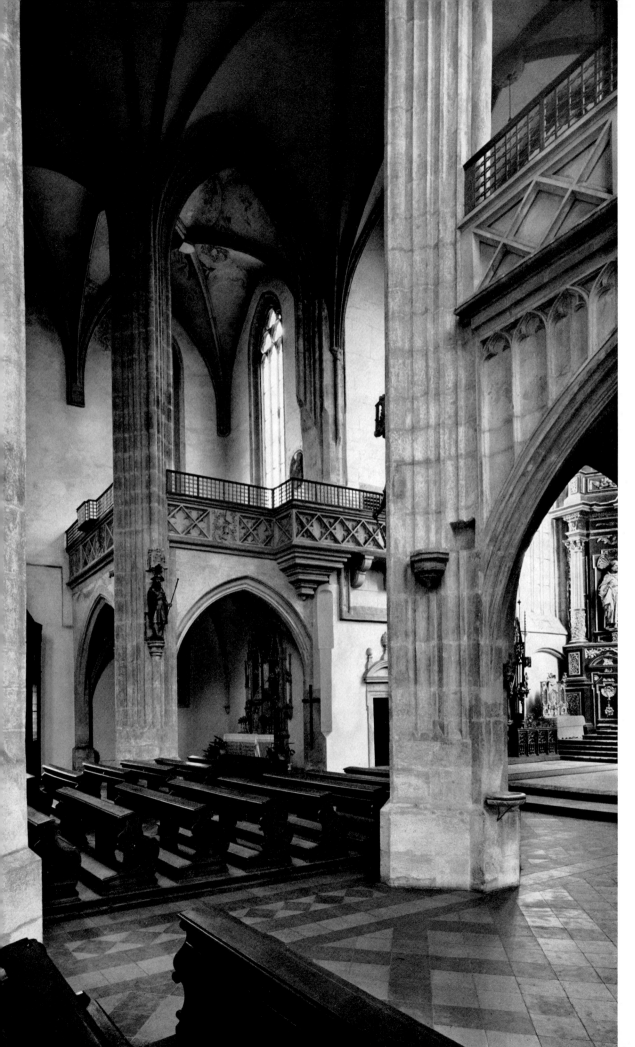

22
Kutná Hora
(Kuttenberg),
St. James's Church,
crossing.
1330-80

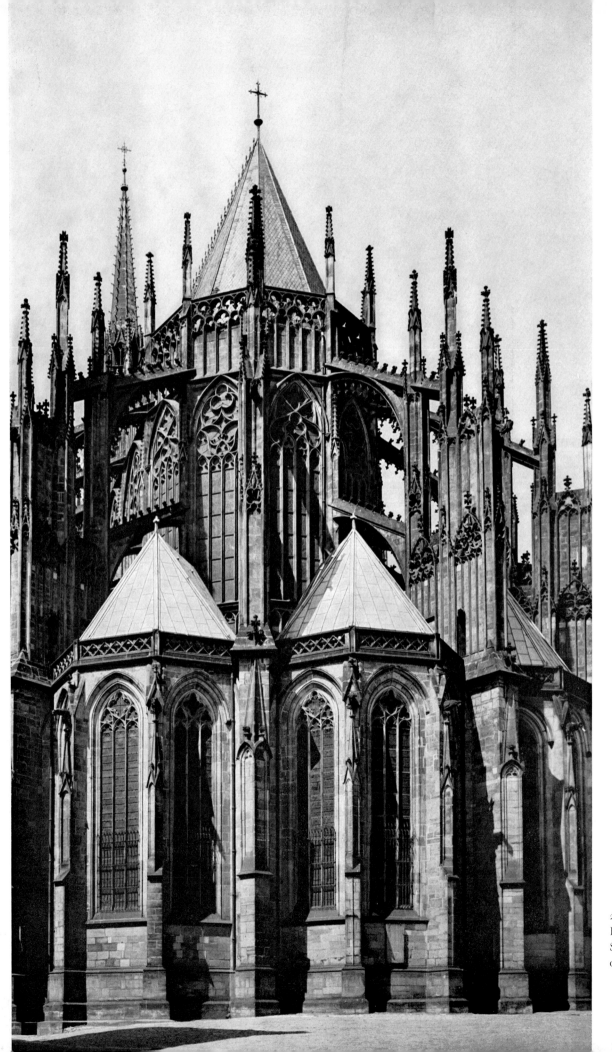

23
Prague,
St. Vitus's Cathedral,
choir, 1344-85

24
Prague,
St. Vitus's,
choir buttresses.
Before 1385

25
Prague,
St. Vitus's,
choir interior.
Before 1385
→
26
Prague,
St. Vitus's,
fan tracery
in the choir.
Before 1385

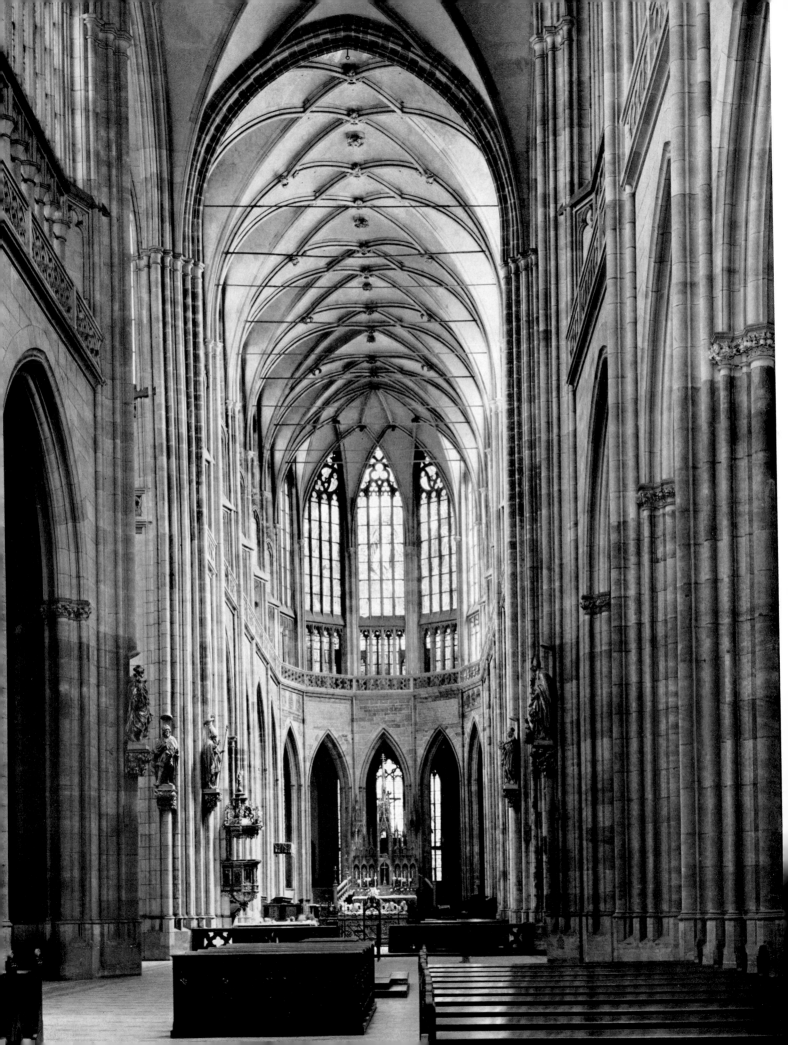

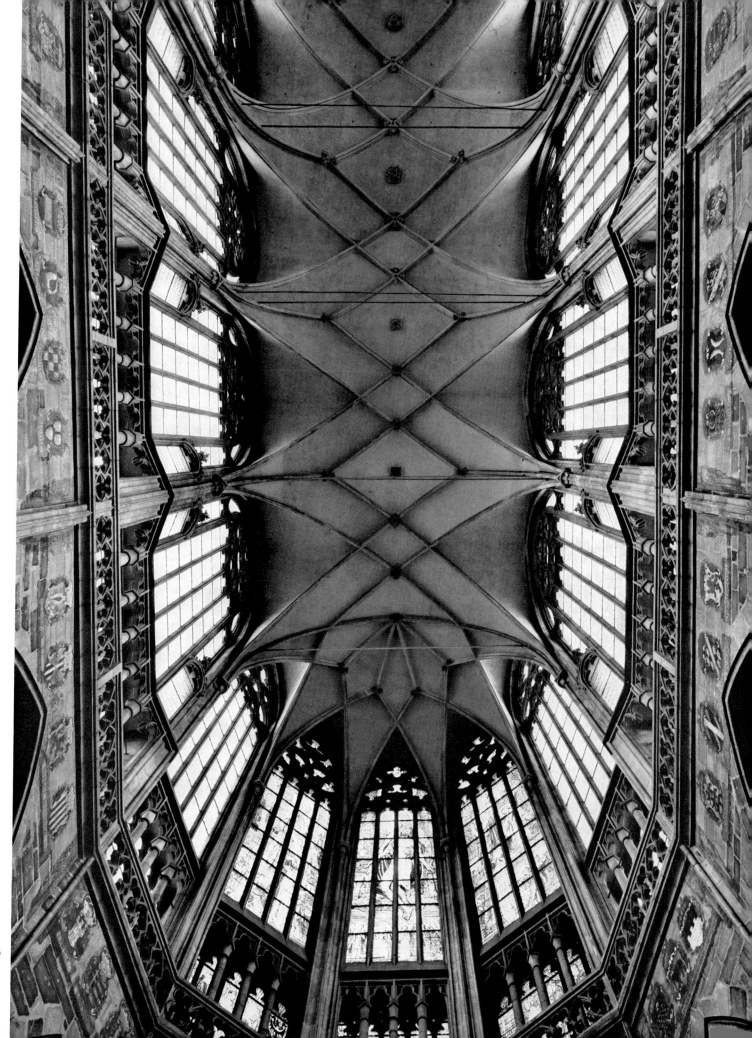

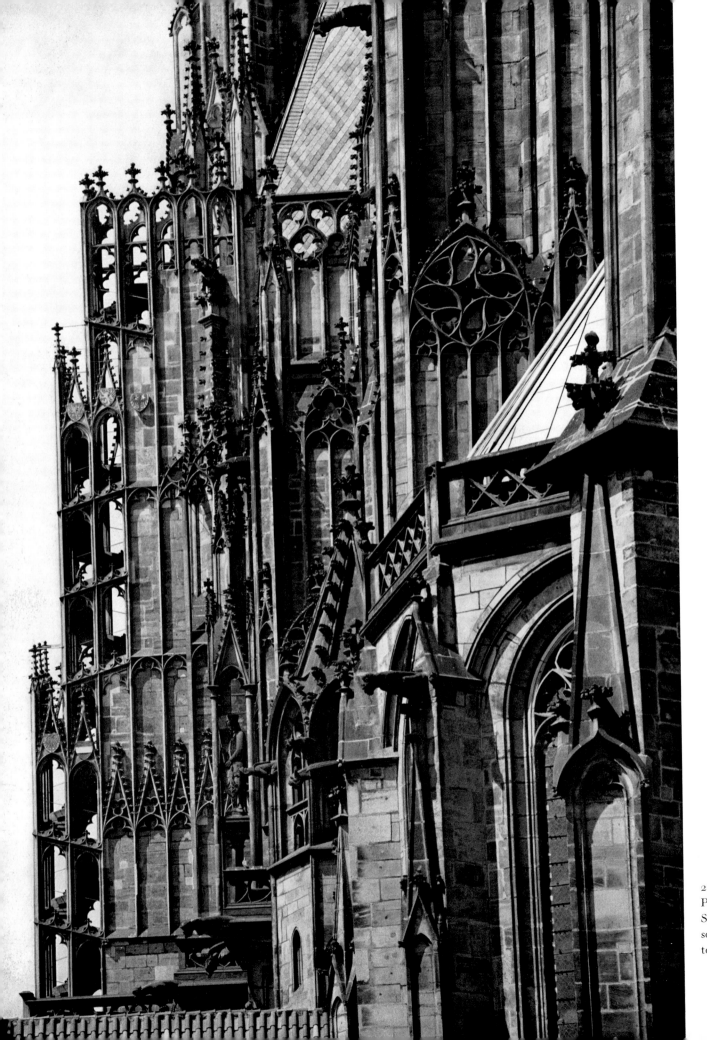

2[
Prague[
Old Tow[
Bridge Tower[
fan tracer[
in th[
gateway[
Before 137[

27
Prague,
St. Vitus's,
south transept,
tower.

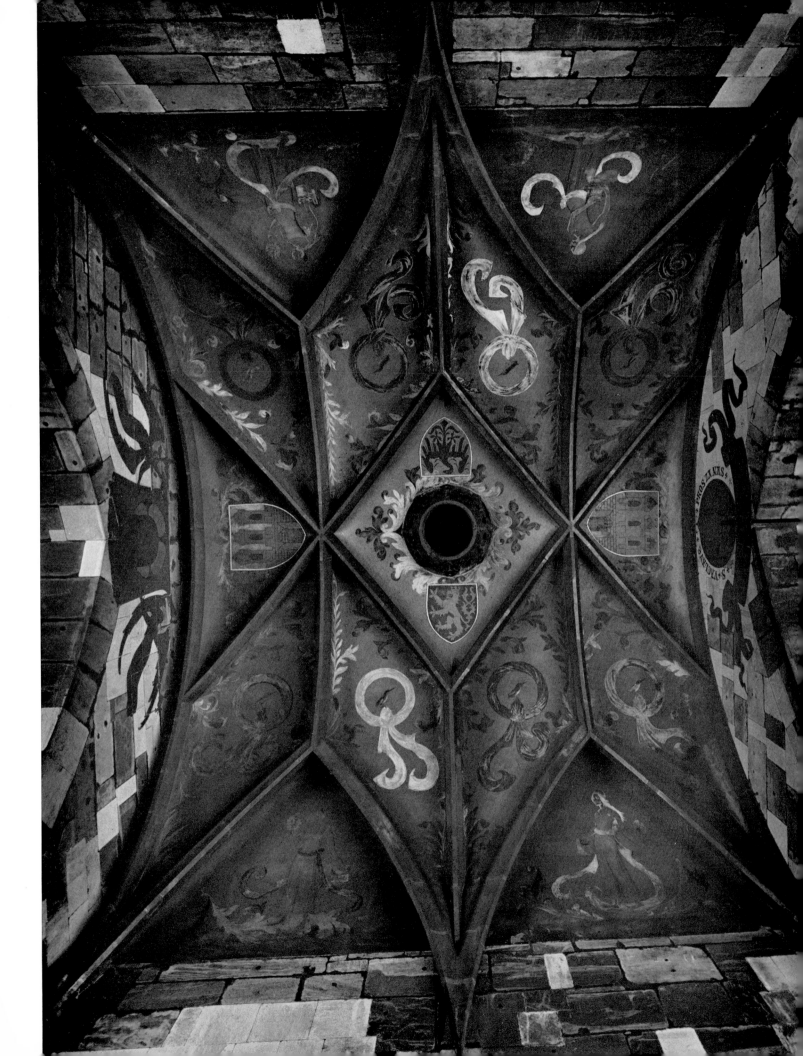

29
Prague, St. Vitus's Cathedral,
south porch (Hostium Magnum),
detail. About 1366-7

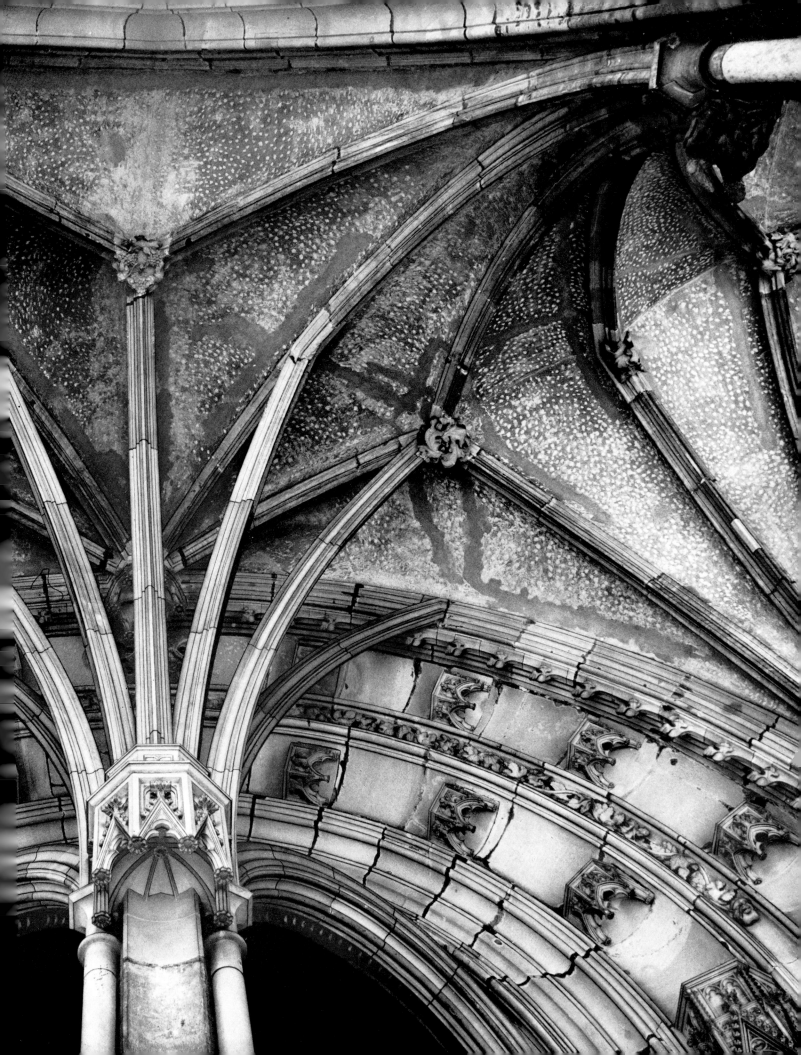

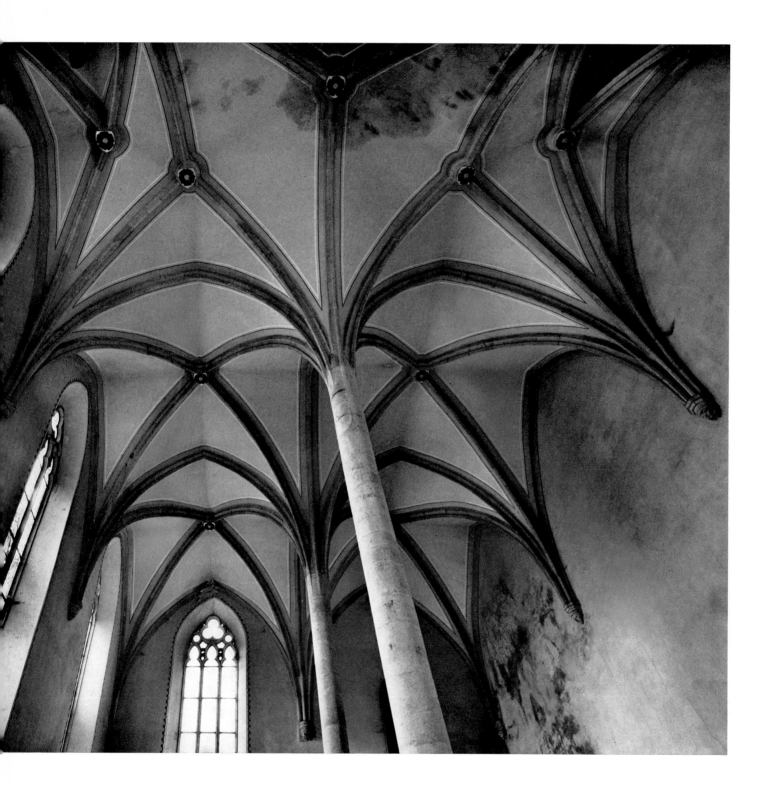

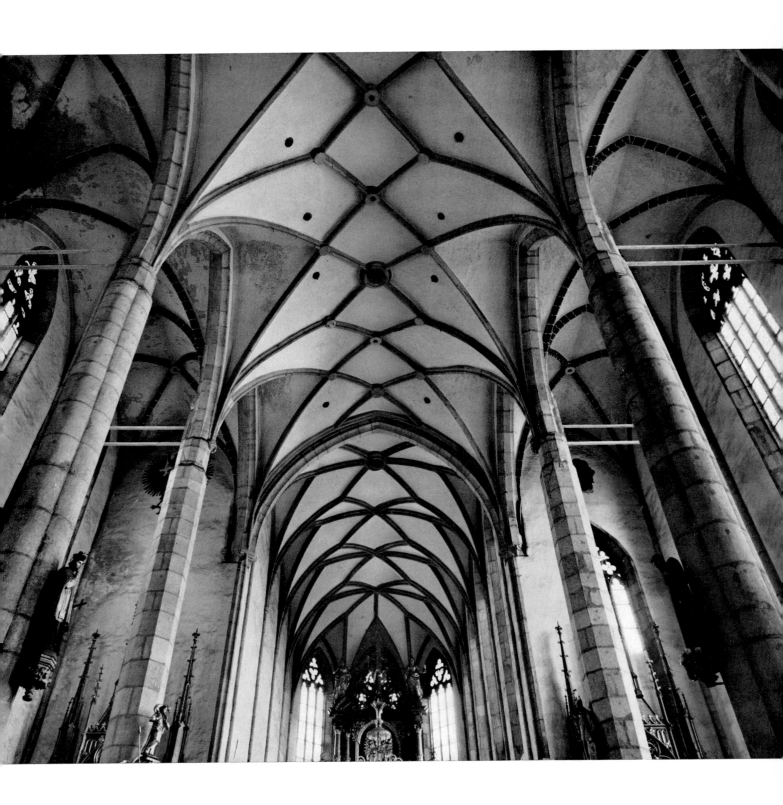

32 Kutná Hora (Kuttenberg), 'Wälsch' chapel. About 1400

33 Prague, Servite Church of St. Mary 'na slupi'

→

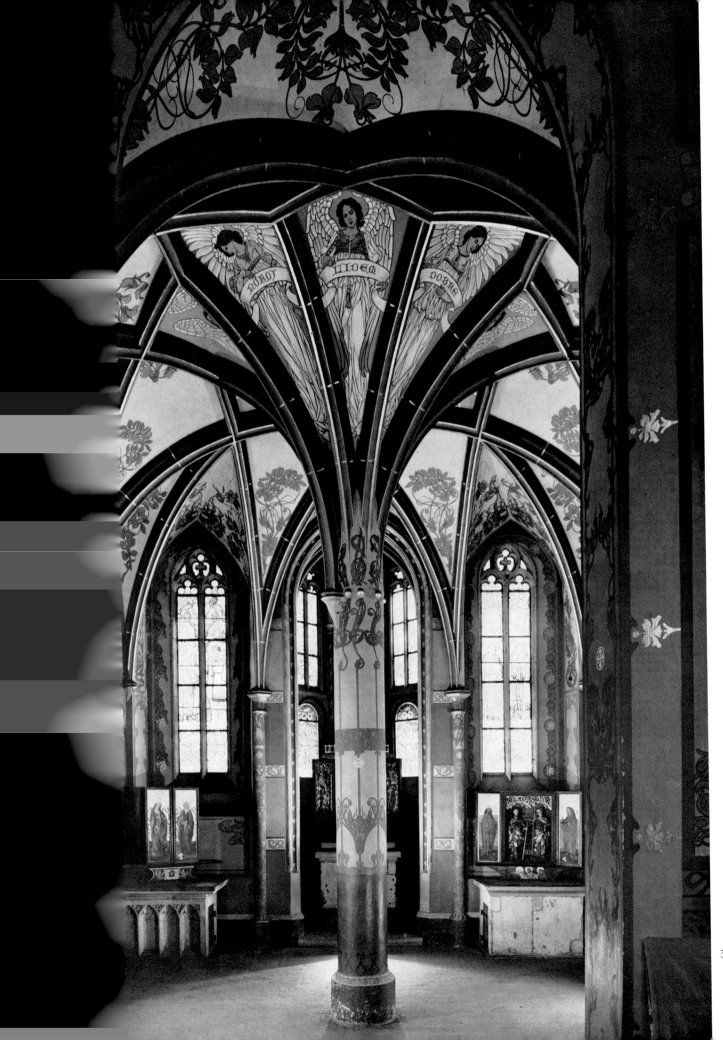

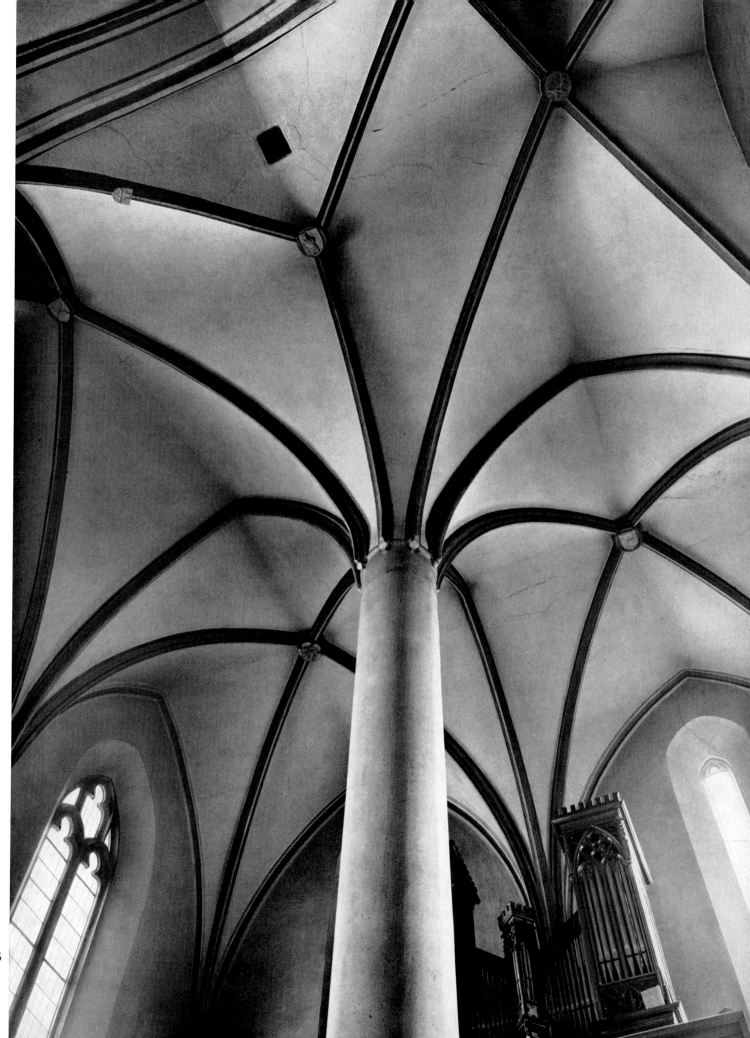

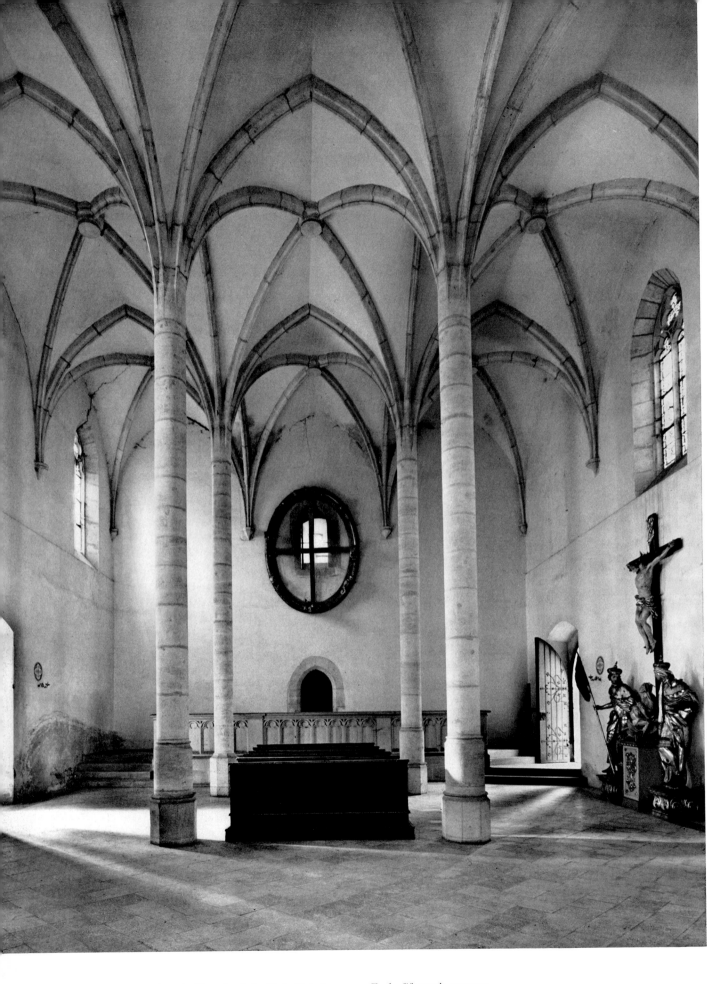

34 Kutná Hora (Kuttenberg), Church of the Holy Trinity, nave. Early fifteenth century

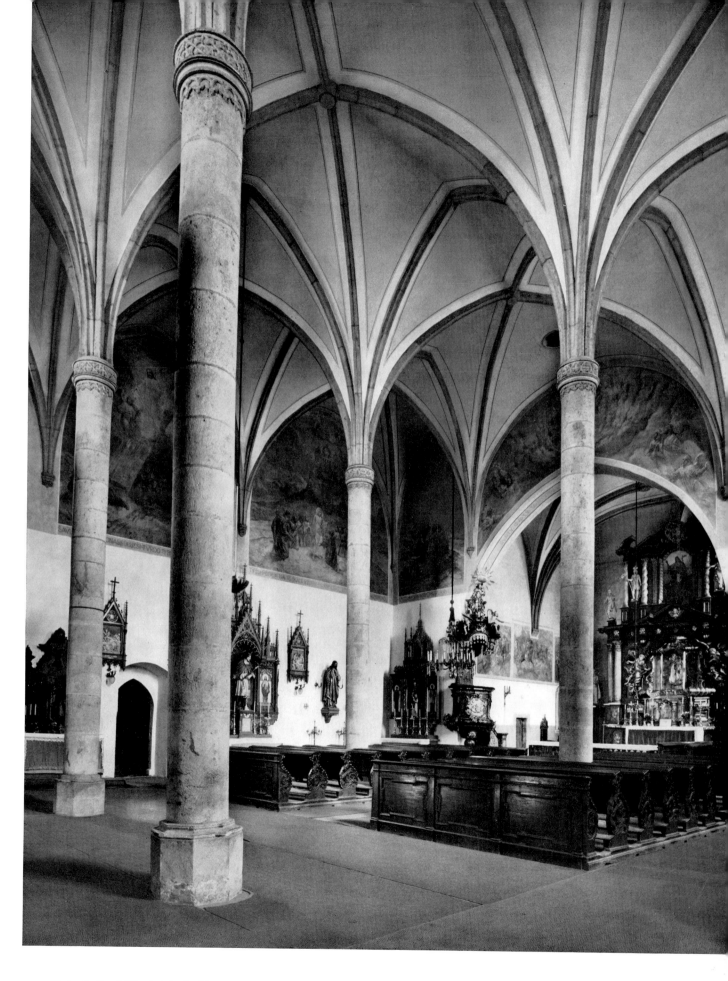

35 Dvůr Králové (Königinhof), Church of St. John the Baptist, nave. Early fifteenth century

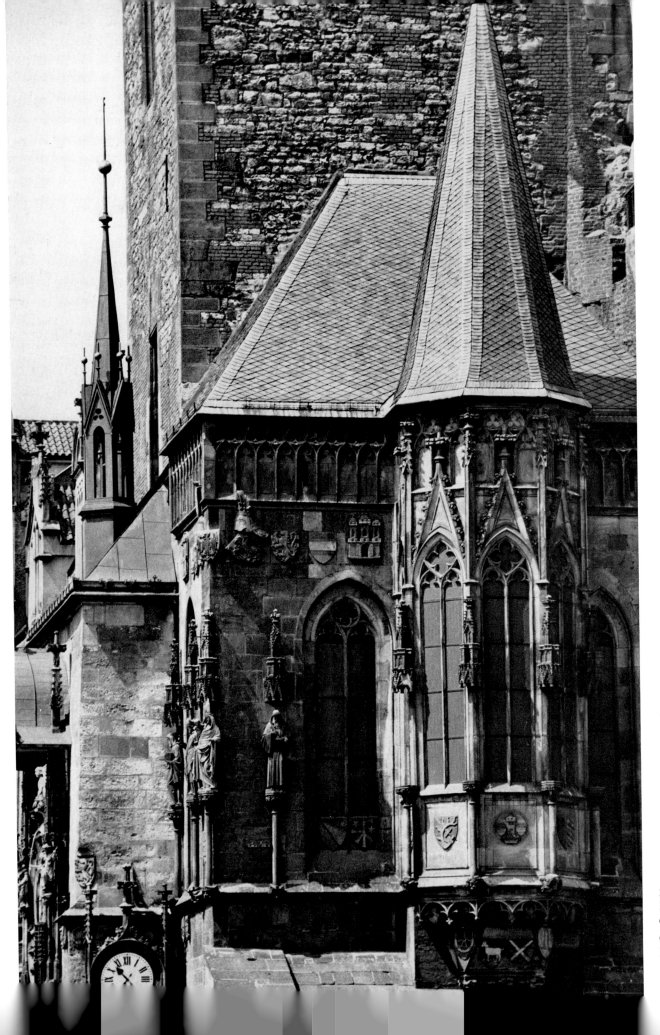

36
Prague,
Old Town Hall,
oriel-window.
Before 1381

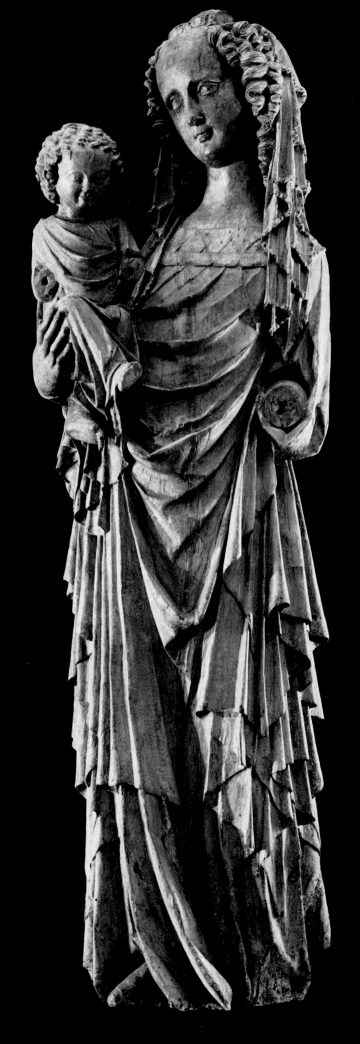

37
Madonna from Michle.
Wood, about 1340.
Prague,
National Gallery

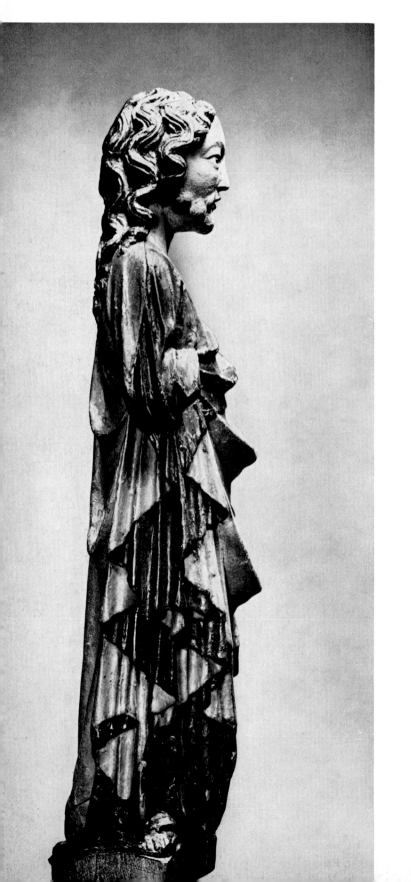

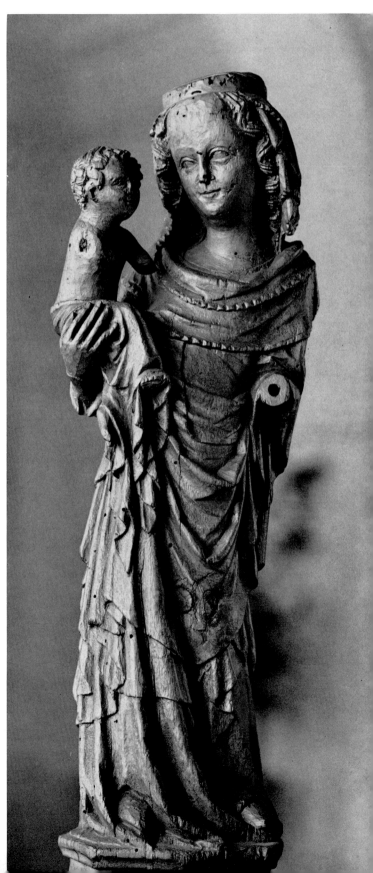

38
Apostle from Veveří (Eichhorn).
Wood, after 1340.
Brno (Brünn),
private collection

39
Madonna from Dyšina (Deschney).
Wood, about 1350,
Plzeň (Pilsen), Museum

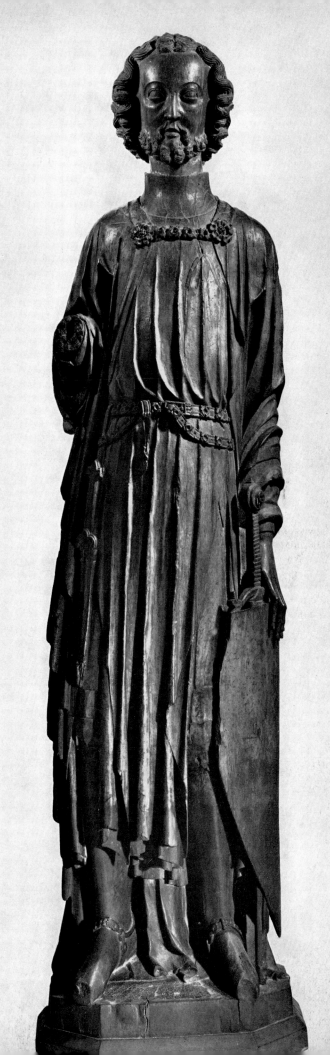

40
St. Florian
from St. Florian's Monastery near Linz.
Wood, about 1340

42 Crucifix from Moravský Krumlov (Mährisch-
Kromau).
Wood, about 1350. Brno (Brünn),
Moravian Gallery

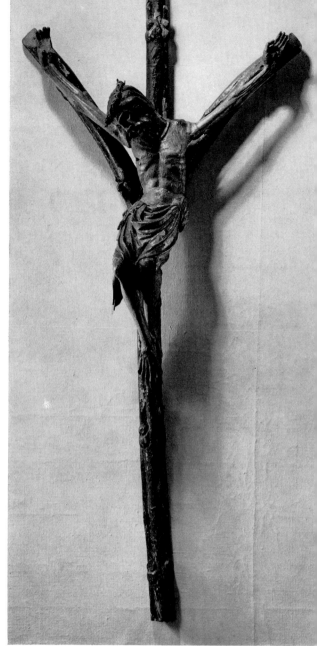

41 Crucifix from the Barnabite Monastery on the Hradčany,
Prague. Wood, about 1350, Prague, National Gallery

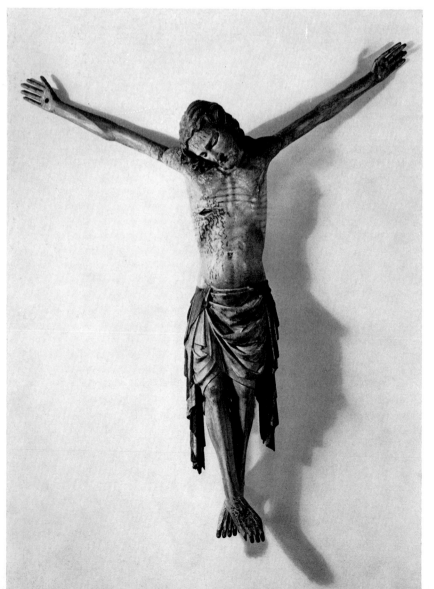

43
Madonna from Strakonice (Strakonitz).
Wood, after 1330.
Prague, National Gallery

44
Madonna from Rudolfov (Rudolfstadt).
Wood, about 1340.
Hluboká (Frauenberg), Aleš Gallery

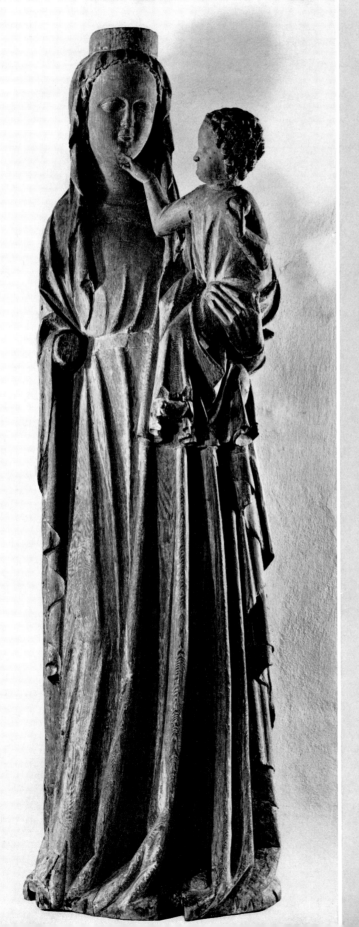
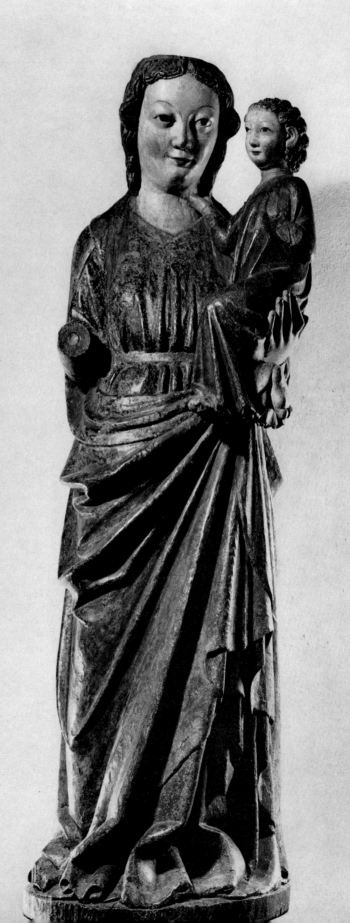

45 46

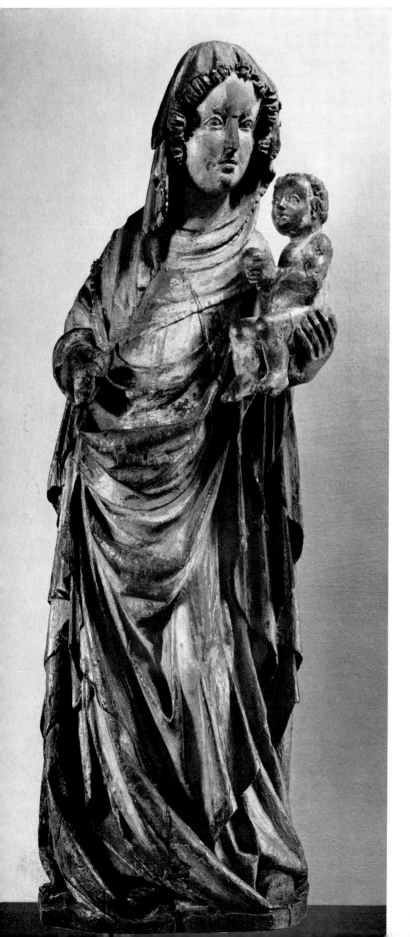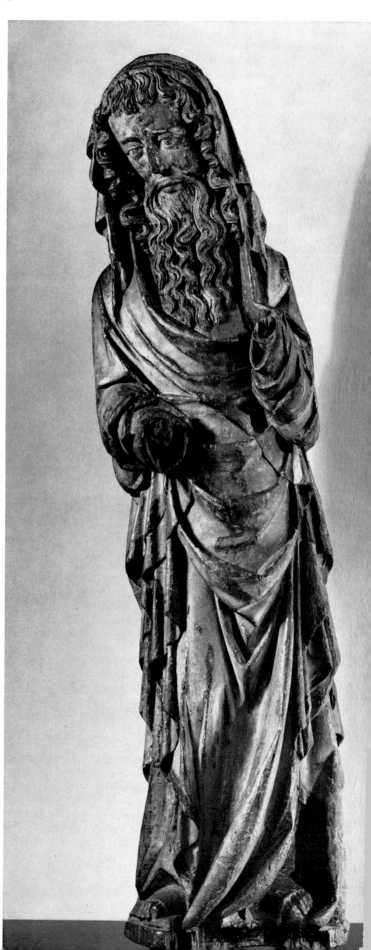

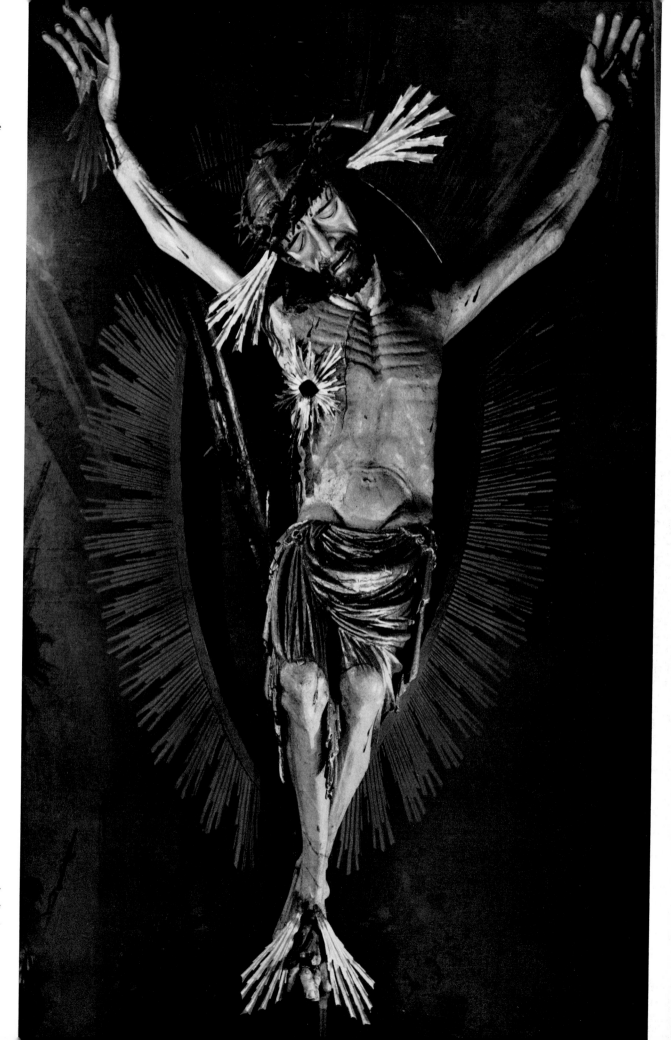

45-46
Madonna and apostle
from
St. James's Church,
Brno (Brünn).
Wood, about 1370.
Brno,
Moravian Gallery

47
Crucifix in the
Dominican Church
in Jihlava (Iglau).
Wood, after 1330.
hlava, Jesuit Church

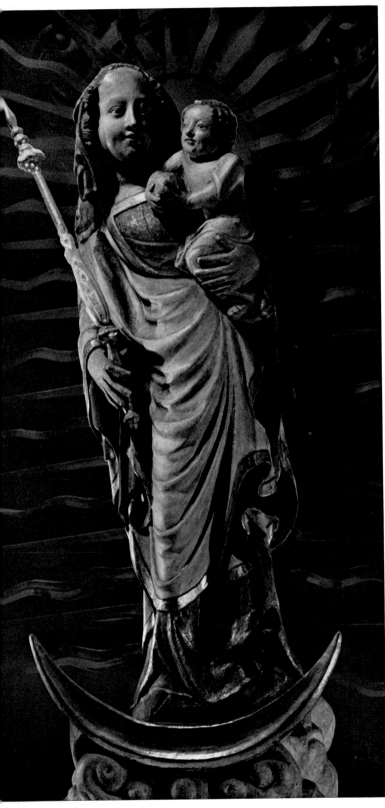

48

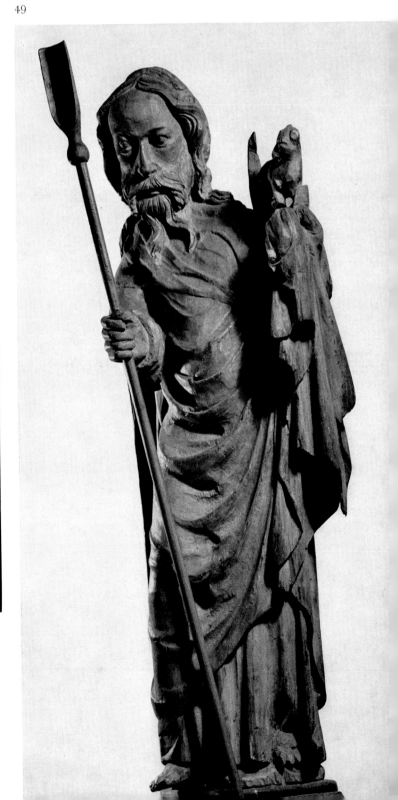

49

48 Madonna in the Parish Church in Broumov (Braunau).
Wood, about 1370

49 St. John the Baptist. Cheb (Eger), Municipal Museum.
Wood, about 1370

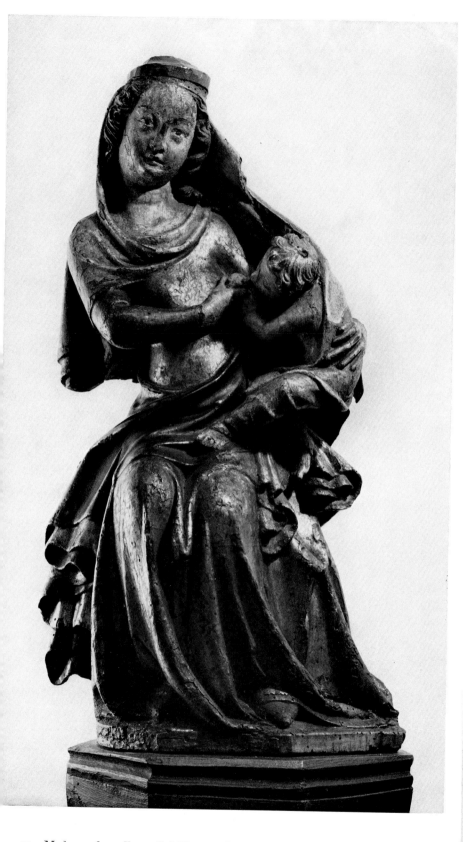

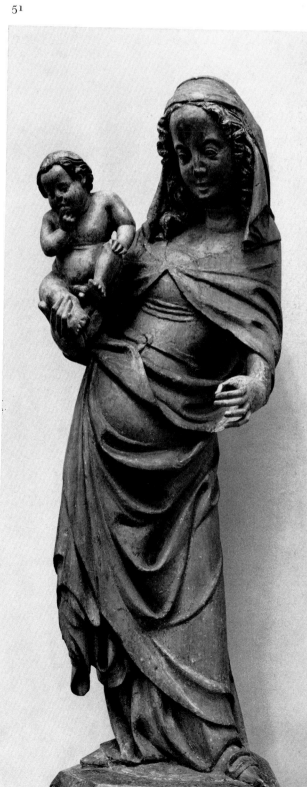

50 Madonna from Konopiště (Konopischt). Wood, 1370-80.
 Prague, National Gallery

51 Madonna from Zahražany (Saras). Wood, 1370-80.
 Prague, National Gallery

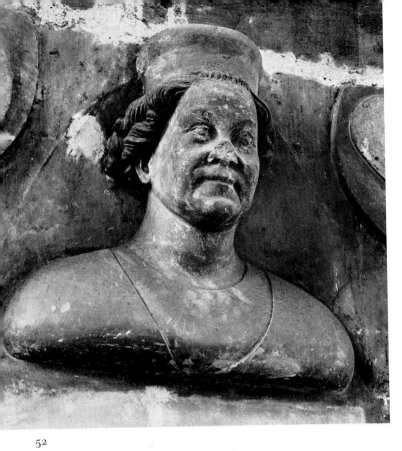

52

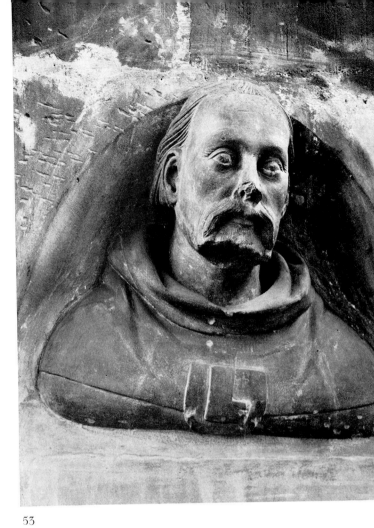

53

54

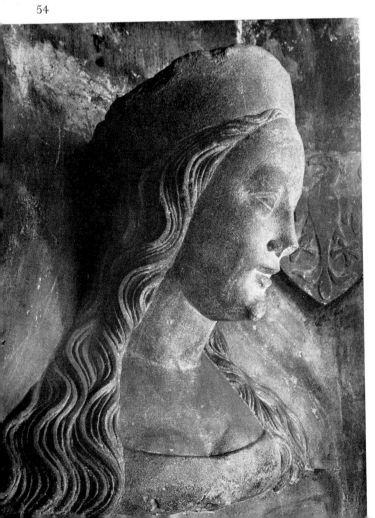

55

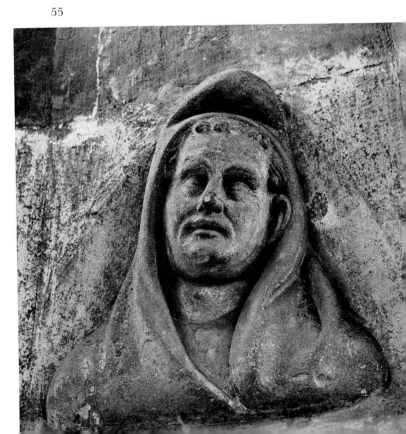

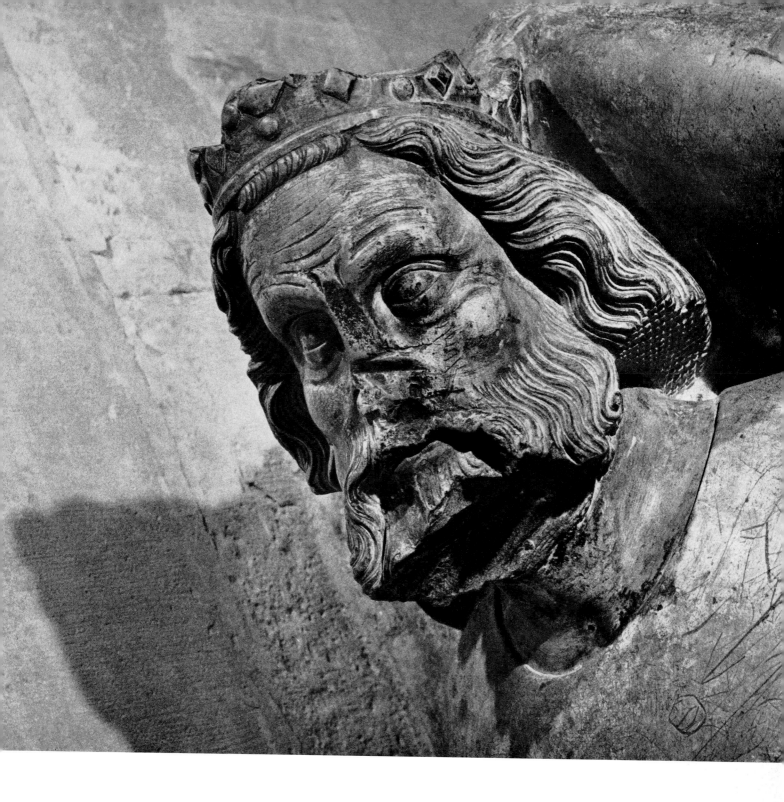

52-55
Sandstone busts in the lower triforium of St. Vitus's Cathedral, Prague

52 Benesch of Weitmühl, 1378-9

53 Peter Parler, 1378-9

54 Anna of Schweidnitz, wife of Charles IV, before 1378

55 Nikolaus Holubec, 1378-9

56 King Otakar I. Limestone head on his tomb,
 1377. Prague, St. Vitus's Cathedral, choir polygon

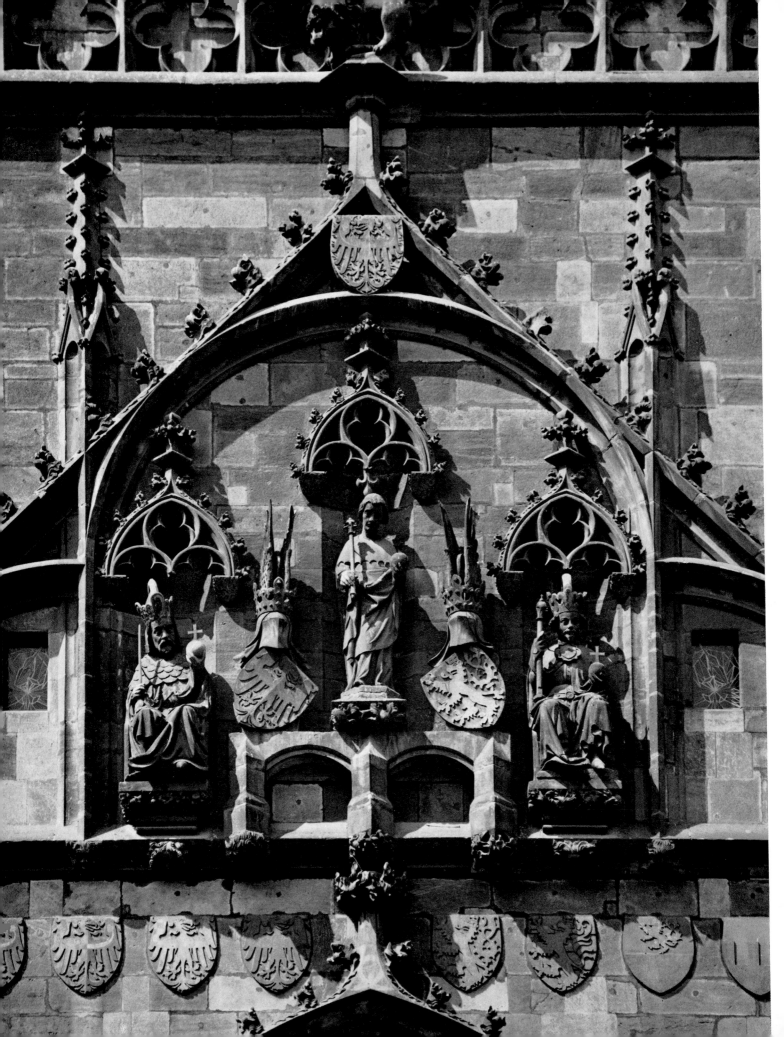

57 Statues of King Charles IV, King Wenceslas IV and St. Vitus on the east façade of the Old Town Bridge Tower in Prague. Sandstone, after 1380

58 Equestrian statue of St. George. Bronze, 1373. Prague, Hradčany Castle, third courtyard

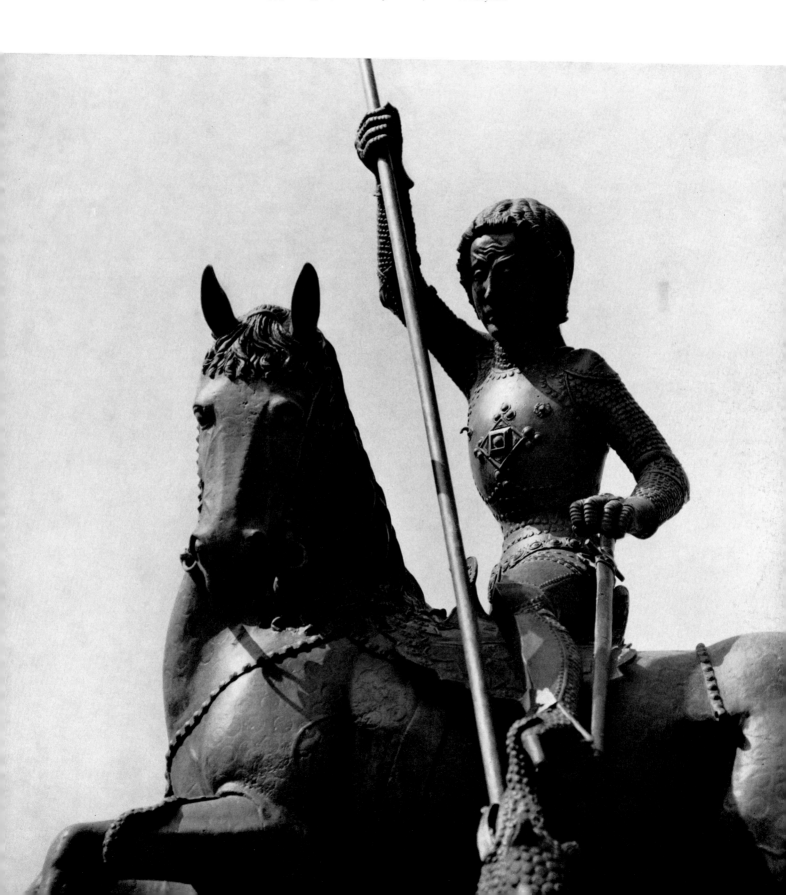

59 Madonna from the Old Town Hall in Prague. Sandstone, 1381.
Prague, National Gallery

60 Madonna in the Parish Church in Žebrák. Wood, 1380-90

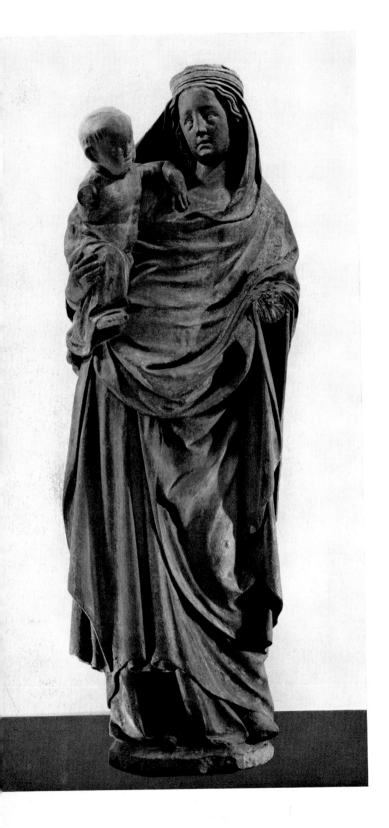

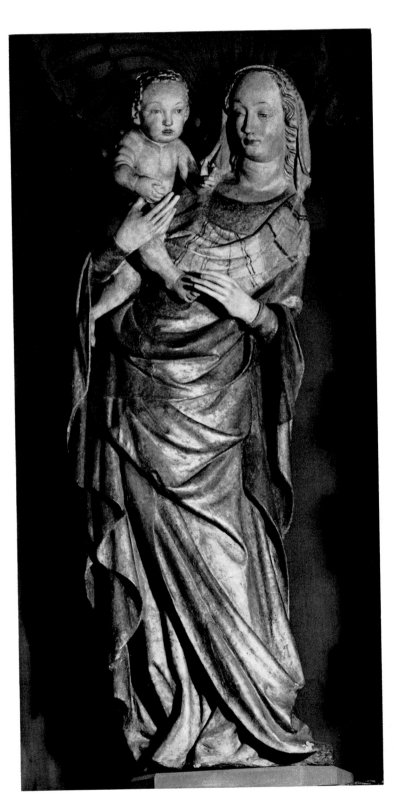

61
Bust of a Saint from Dolní Vltavice (Untermoldau).
Wood, 1380-90. Hluboká (Frauenberg), Aleš Gallery

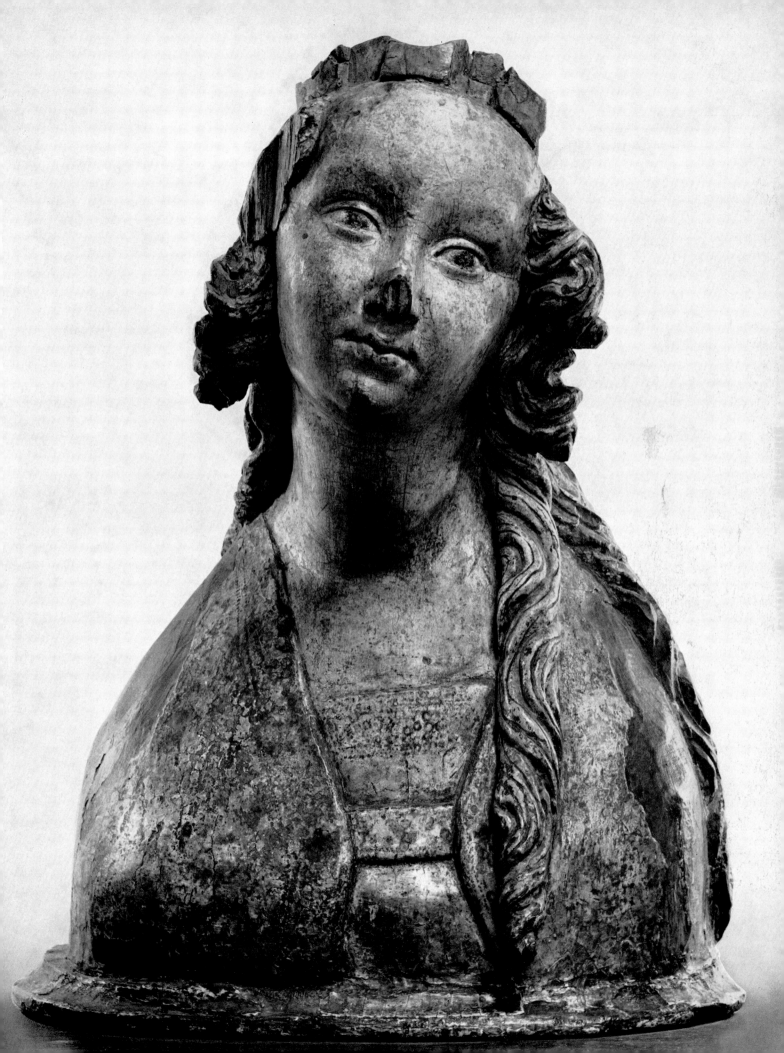

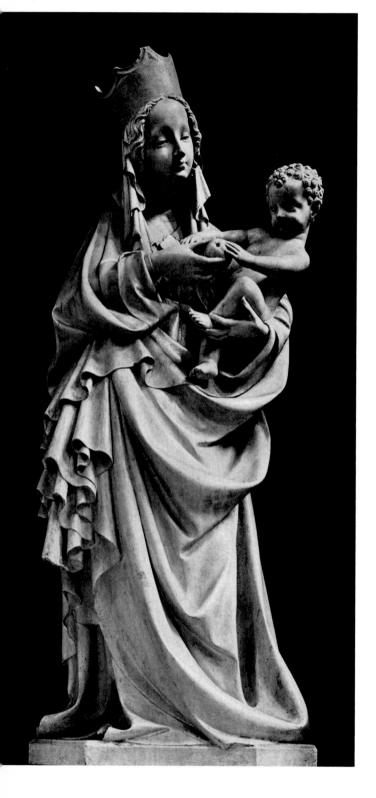

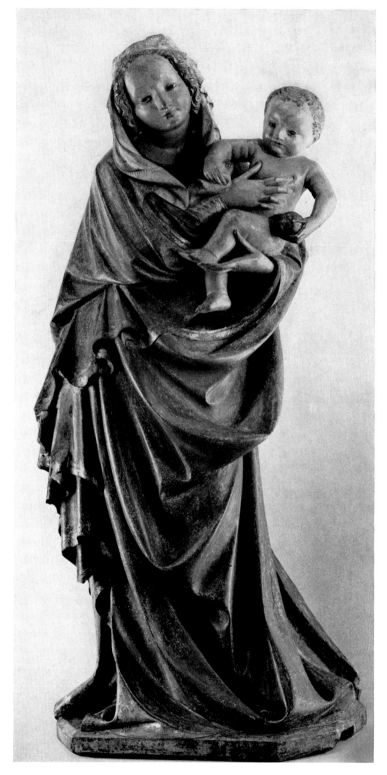

62 Madonna from St. John's Church, Thorn.
 Limestone, about 1400. Lost

63 Madonna from Babitz. Stone, after 1400.
 Sternberg Castle

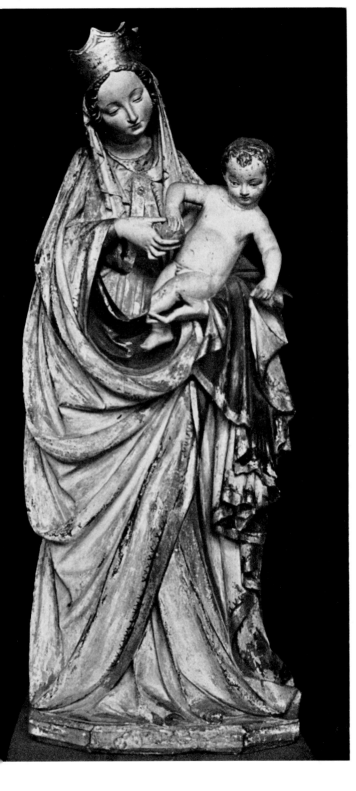

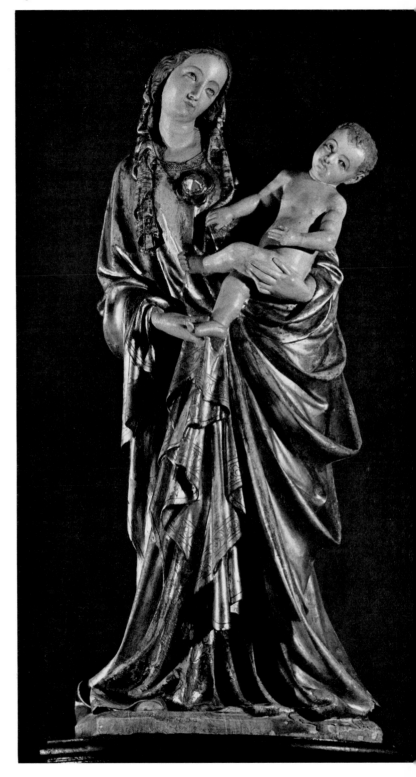

4 Madonna from the Church of St. Elizabeth, Wroclaw (Breslau).
 Limestone, about 1400. Warsaw, National Museum

5 Madonna in the Augustinian Church in Třeboň (Wittingau).
 Stone, about 1410.

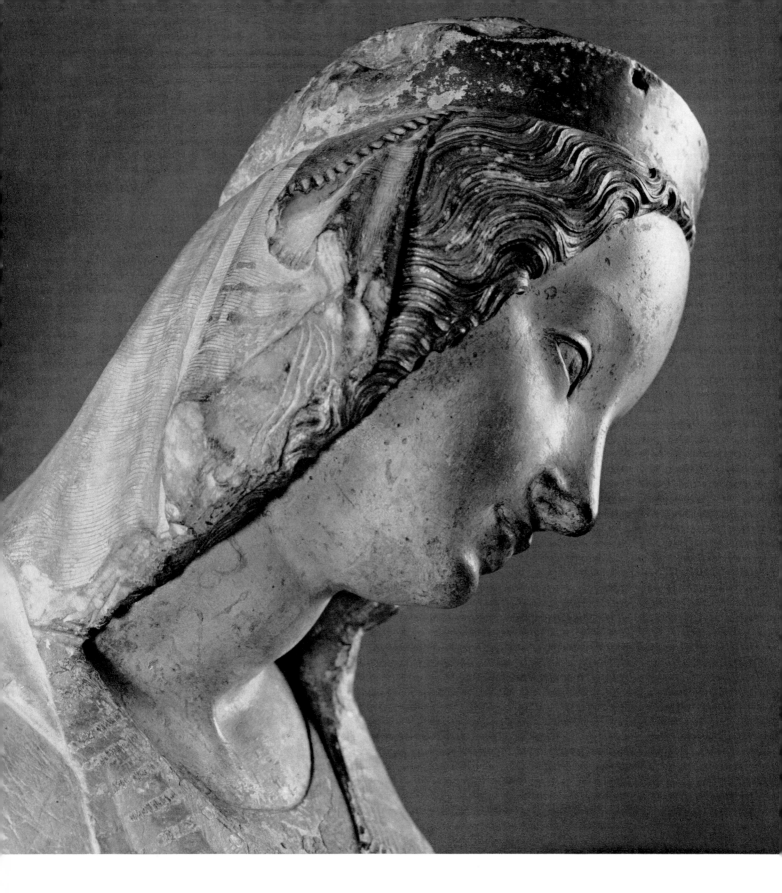

66–67 Madonna from Krumau. Limestone, about 1400. Vienna, Kunsthistorisches Museum

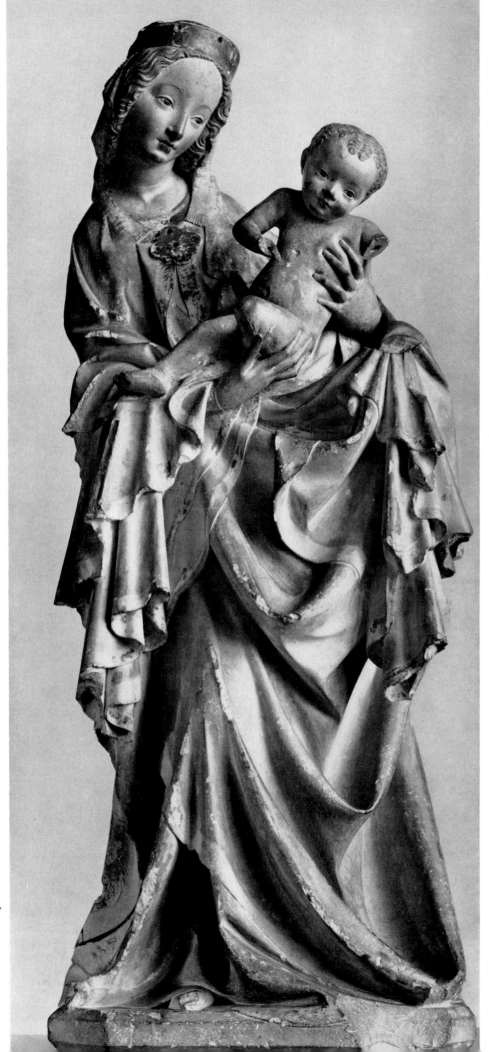

67

68 Madonna from Hallstatt. Stone, 1410,
 Prague, National Gallery

69 Madonna in St. Bartholomew's Church, Plzeň (Pilsen).
 Stone, 1395

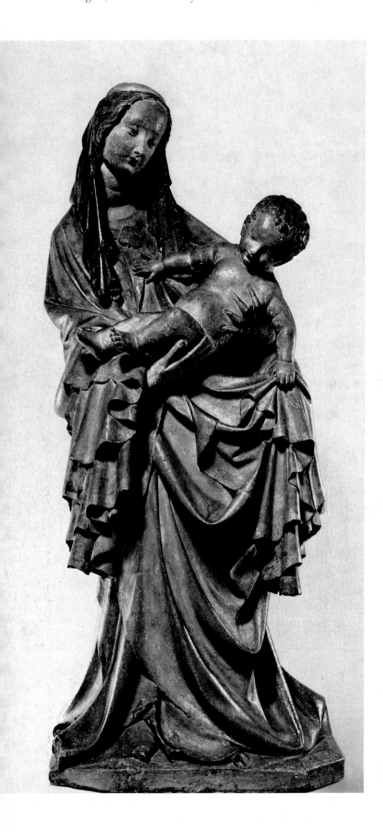

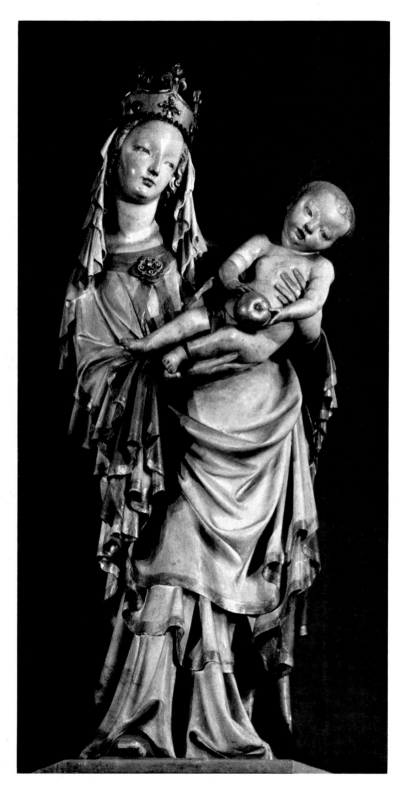

St. Catherine, in St. James's Church, Jihlava (Iglau),
Limestone, about 1400

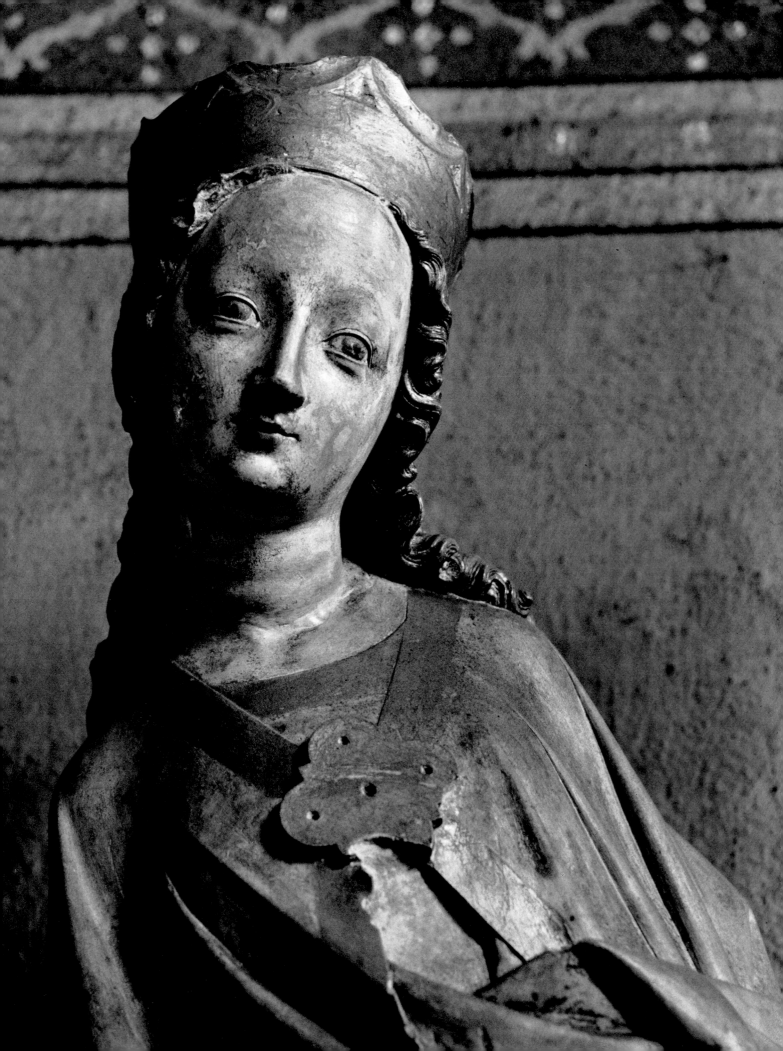

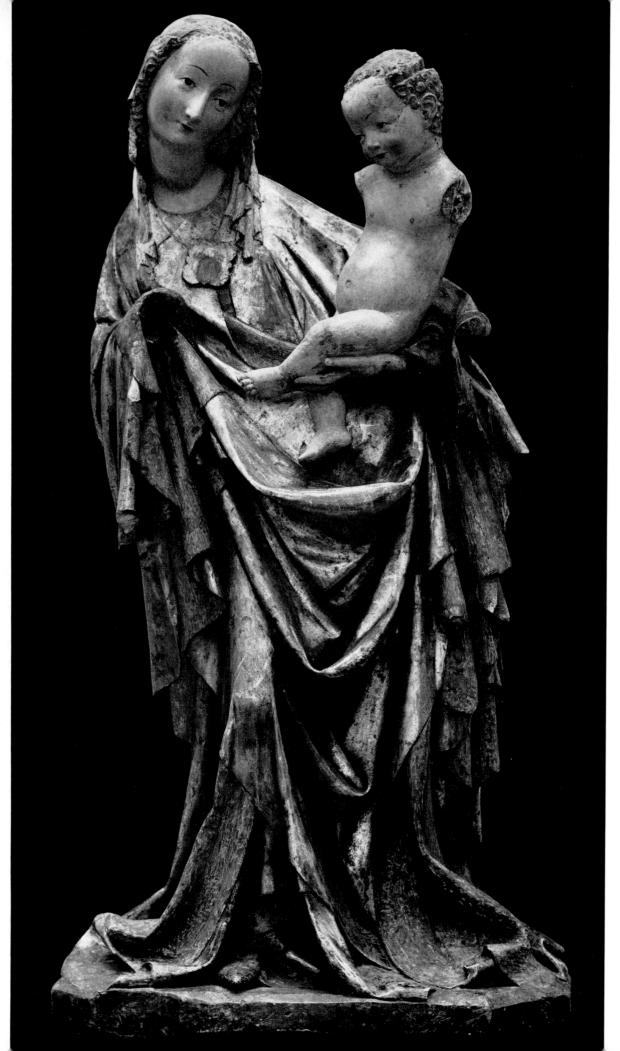

71
Madonna
in the Parish Church
in Vimperk (Winterber
Stone, 1410

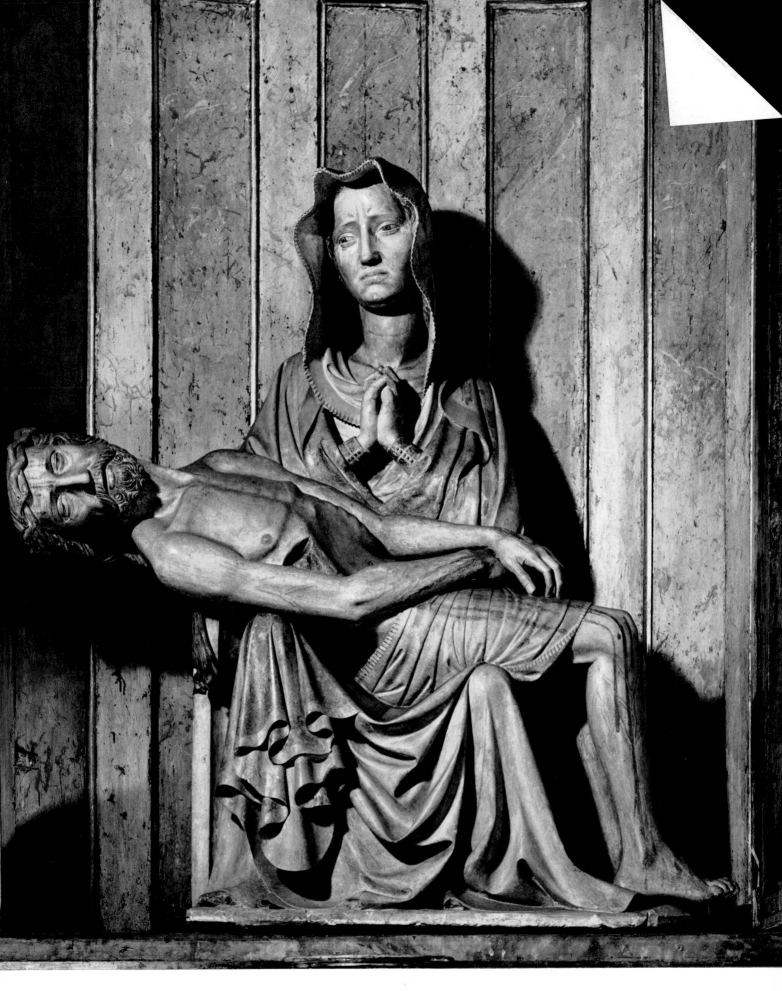

72 Pietà in St. Thomas's Church in Brno (Brünn). Limestone, 1380-90

73 Pietà from Lutín. Limestone, about 1390. Sternberg Castle

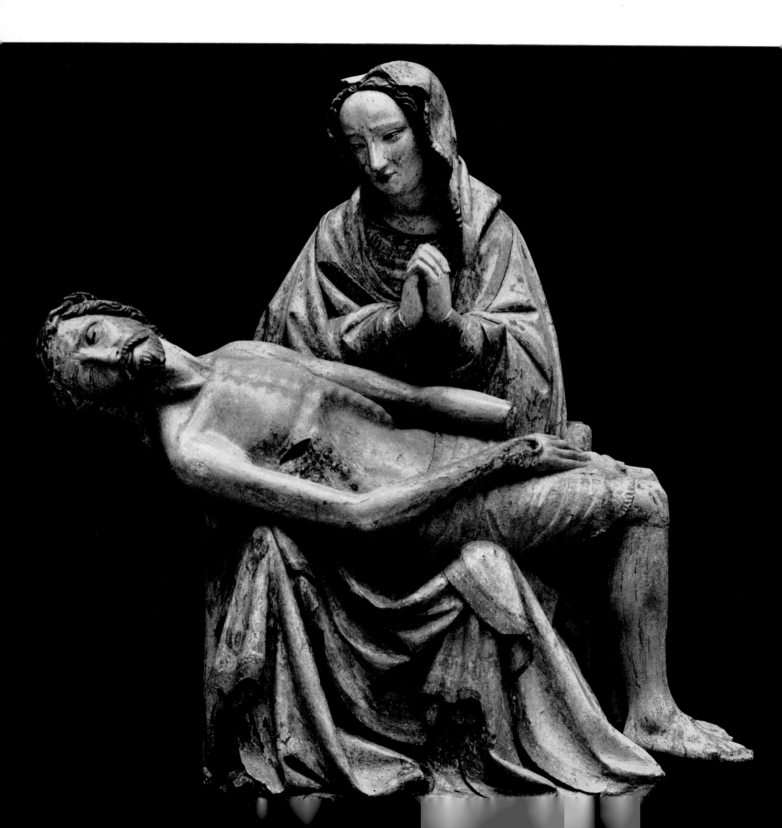

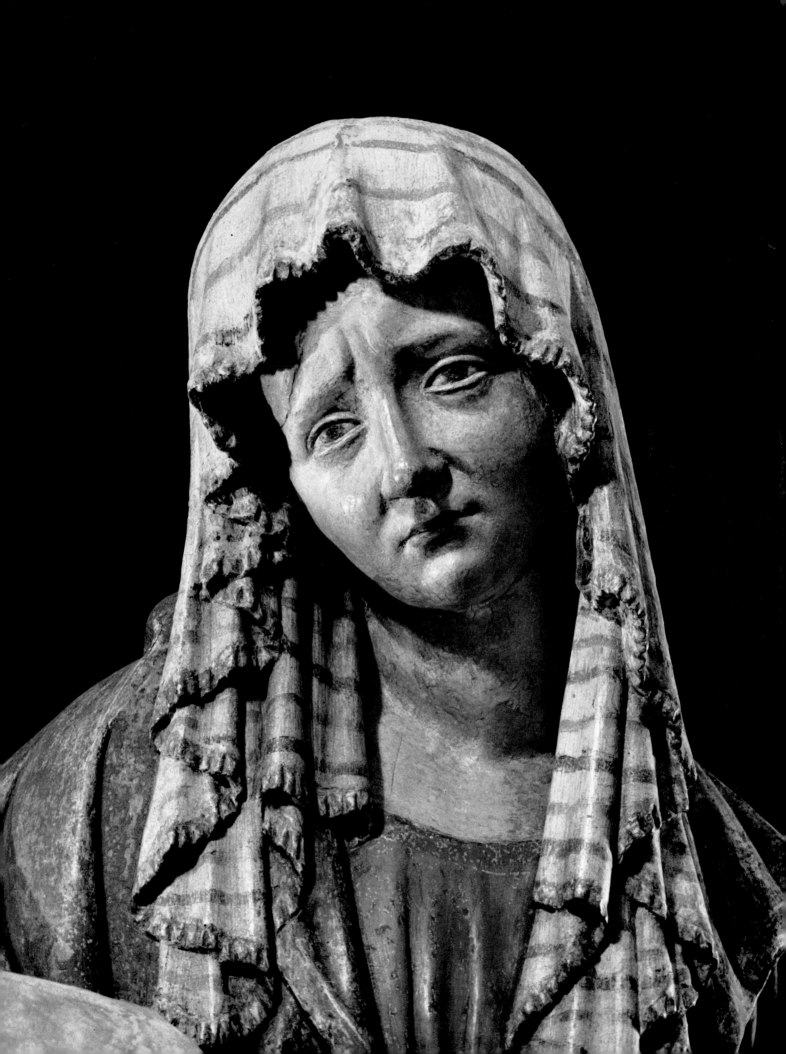

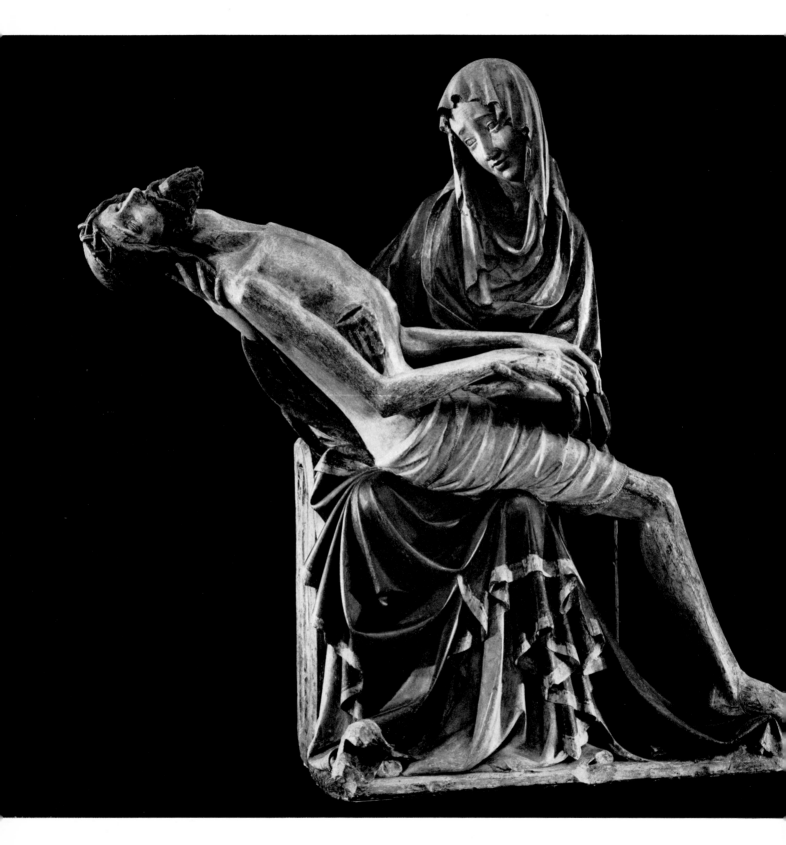

75 Pietà in St. Ignatius' Church, Jihlava (Iglau). Stone, about 1410

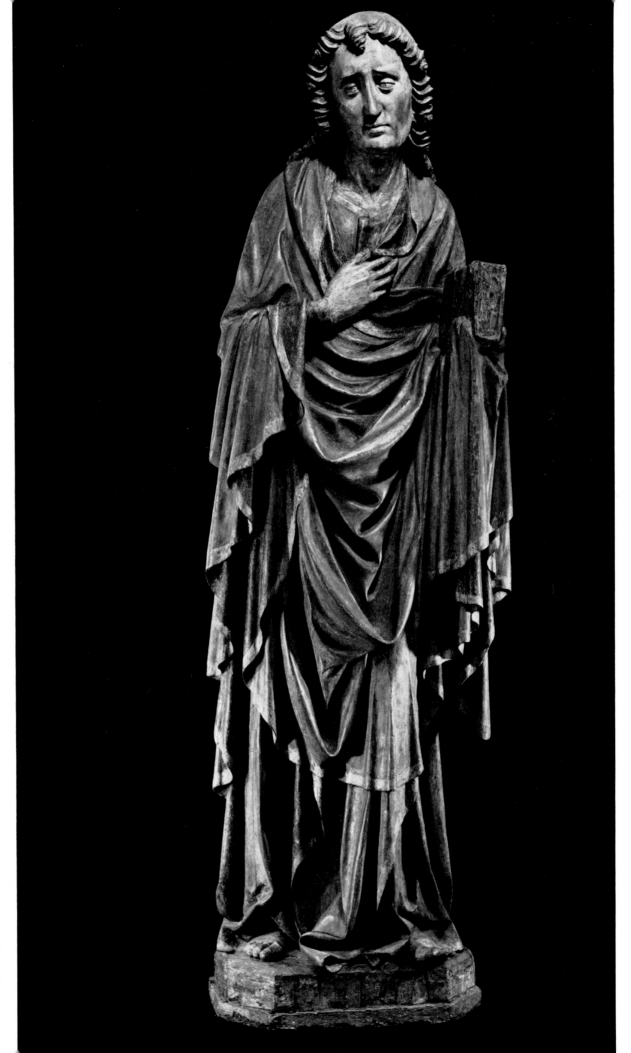

76
John the Evangelist,
Crucifixion group
in the Týn Church,
Prague. Wood, 1420-30

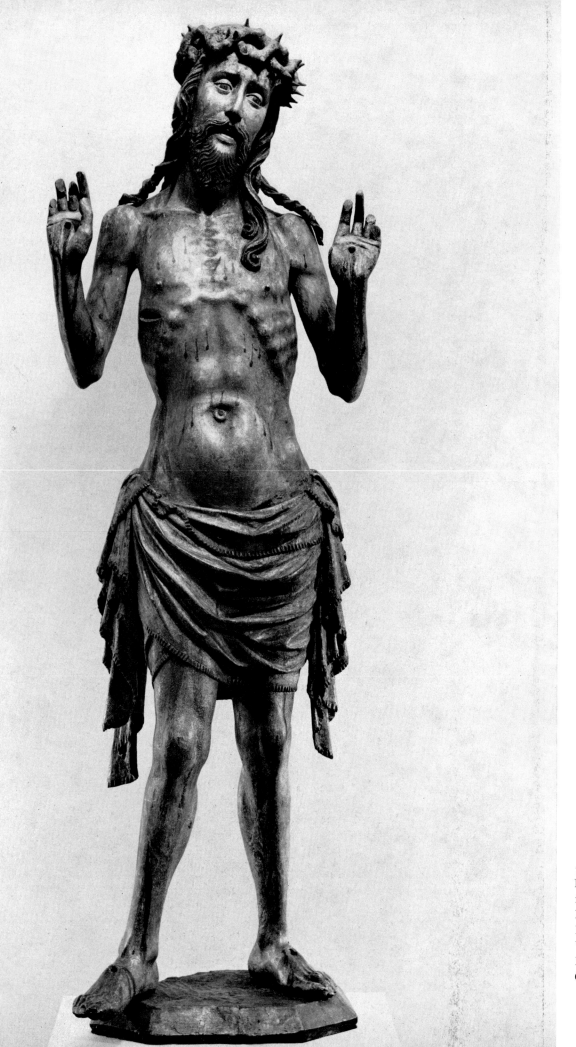

77
Man of Sorrows,
from the
New Town Hall,
Prague.
Wood, 1510-20.
Prague,
City Museum

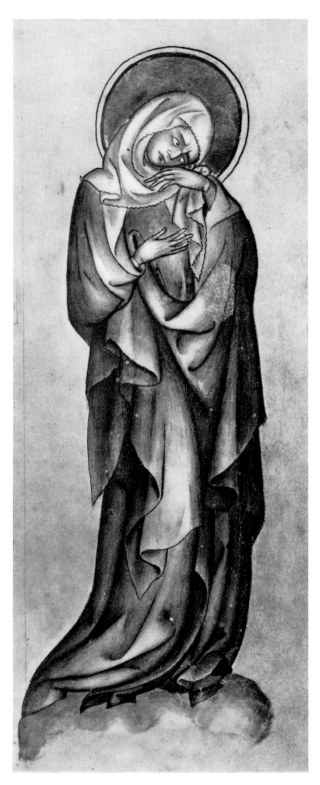

78 The Mourning Virgin. Passional of St. Kunigunde,
 about 1320. Prague, University Library

79 Madonna, Liber Viaticus, about 1355-60.
 Prague, National Museum

82 Samson pulling down the house of the Philistines. Velislav Bible, about 1345-50. Prague, University Library

83 Madonna Enthroned, with Angels and two nuns.
Sermologium of the Diocese of Constance, about 1340.
Oxford, Bodleian Library

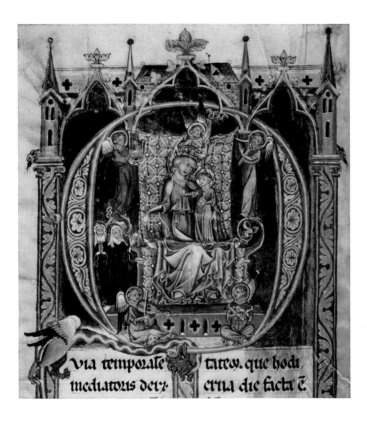

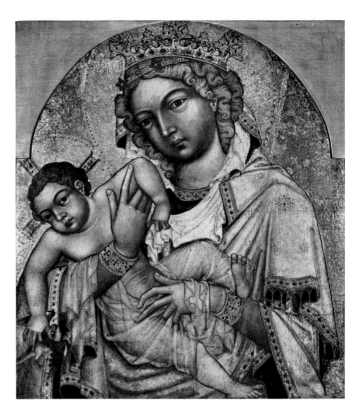

84 Madonna from the Strahov Monastery, Prague. About 1350.
Prague, National Gallery

86 St. Ansanius.
Detail from the Maestà
by Simone Martini. 1315.
Siena, Palazzo Pubblico

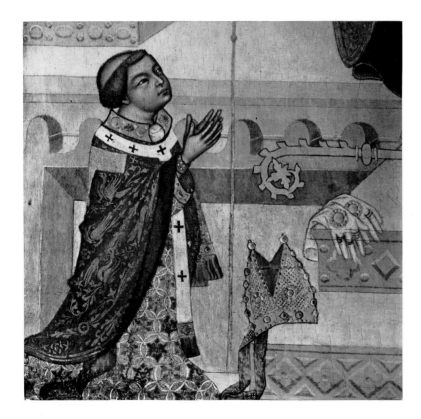

85 Archbishop Ernst of Pardubice. *Detail of Plate 87*

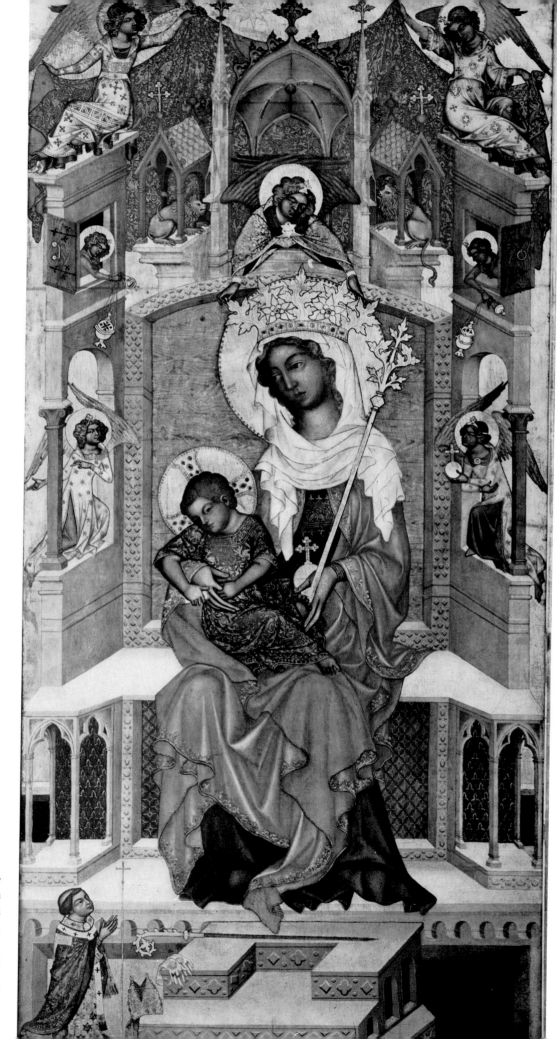

87
Madonna Enthroned with Angels
and Archbishop Ernst
of Pardubice,
from Kłodzko (Glatz).
Berlin, Stiftung
Preussischer Kulturbesitz,
Gemäldegalerie

ae gracia plena vns tecu

89

90

88
The Annunciation,
from Vyšší Brod (Hohenfurth).
About 1350-5.
Prague, National Gallery

89
King David.
Breviary from Rajhrad
(Raigern), 1342.
Brno (Brünn),
University Library

90
The Foundation
of the Kreuzherren Monastery.
Kreuzherren Breviary, 1356.
Prague, University Library

91
Madonna from Veveří
(Eichhorn). About 1350.
Prague, National Gallery

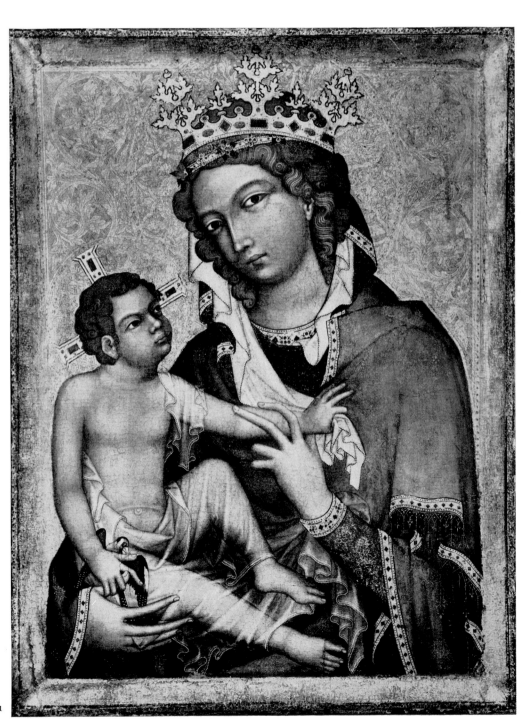

91

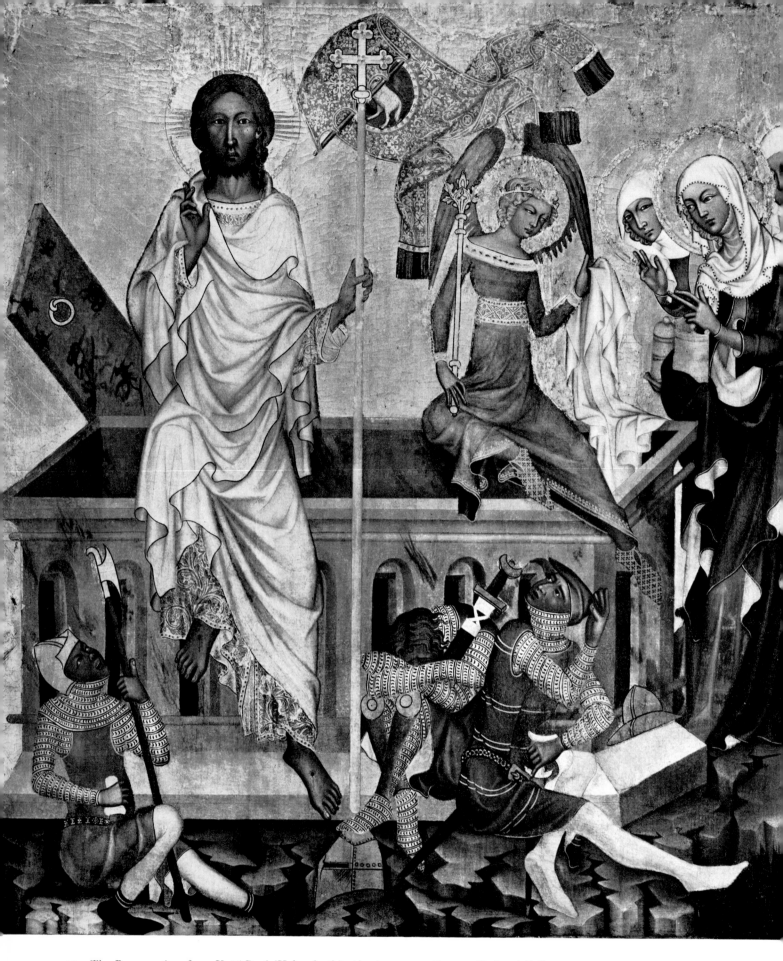

92 The Resurrection, from Vyšší Brod (Hohenfurth). About 1350-55. Prague, National Gallery

93

94

93
Prophet. Missal of the Provost Nicholas,
about 1357-60. Brno (Brünn), City Archives

94
The Death of the Virgin, from Košátky.
Detail. About 1345. Boston, Mass., Museum
of Fine Arts

95
Pentecost, from Vyšší Brod (Hohenfurth).
Detail. About 1350-5. Prague, National Gallery

95

96

96
Abraham on his way to
sacrifice Isaac,
leaving the two young men
with the ass. Bible of Jean de Sy,
after 1356. Paris,
Bibliothèque Nationale

97
King David.
North Italian Psalter,
about 1340. Cambridge, Mass.,
Houghton Library,
Hofer Collection

98
Roman soldiers. Miniature
by Niccolò da Bologna, 1373,
in Lucanus, *De bello Pharsalico*.
Milan, Biblioteca Trivulziana

97

98

99
The Nativity and the Annunciation to the Shepherds.
Liber Viaticus, about 1355-60.
Prague, National Museum

101
Head of a Saint. Detail
from the Maestà by Lippo Memmi. 1317
San Gimignano, Palazzo Comunale

100 The Crucifixion. Missal of Provost Nicholas, about 1357-60. Brno (Brünn), City Archives

102

The Coronation of the Virgin. Centre part of the antependium from Pirna, about 1345-50. Meissen, State Gallery

103 The Presentation in the Temple. Laus Mariae, about 1360. Prague, National Museum

104 The Annunciation. Laus Mariae, about 1360. Prague, National Museum

105
Anna von Schweidnitz. About 1357-8.
Overdoor of St. Catherine's Chapel,
Karlštejn Castle

106
The Death of the Virgin. Morgan Diptych, about 1355-60.
New York, Pierpont Morgan Library

107 King Peter of Cyprus. About 1357-8.
South wall of the Lady Chapel,
Karlštejn Castle

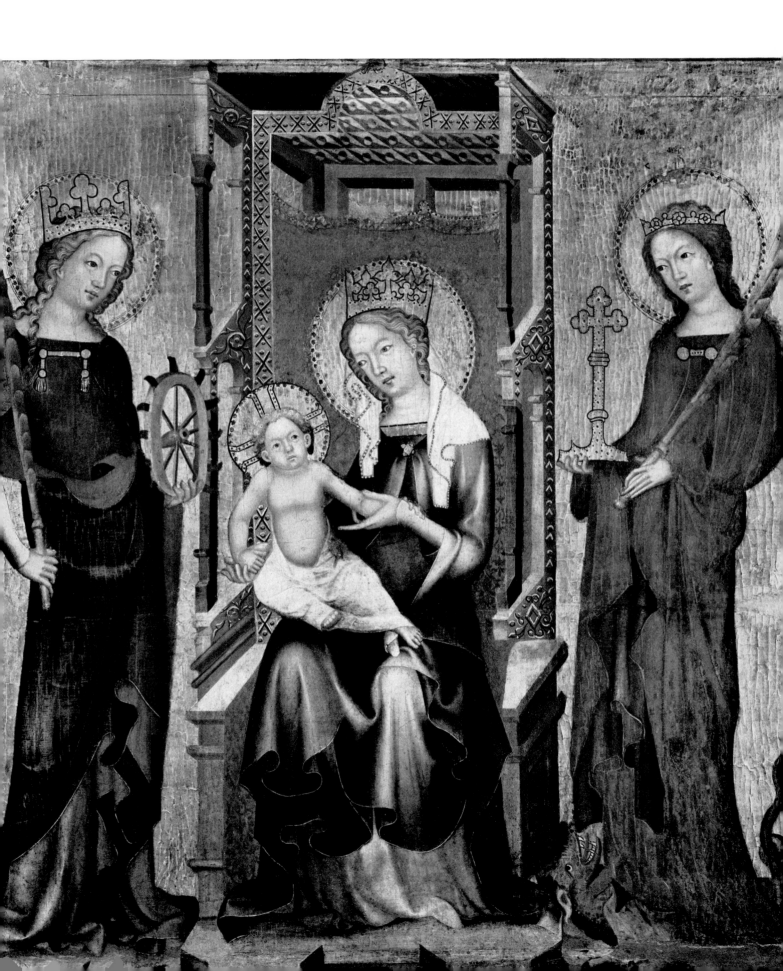

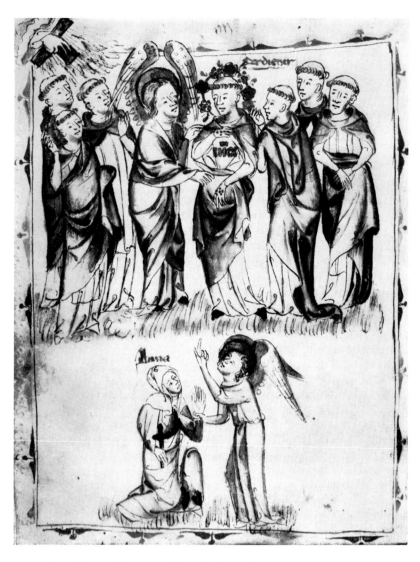

109 The Vision of St. Anne. Heinrich Suso's Exemplar,
South-West Germany,
about 1365. Strasbourg, University Library

110 The Expulsion from Paradise. About 1355-6.
Fresco from the fourth bay of the cloisters,
Emmaus Monastery, Prague

111
Priest giving Holy Communion.
Legenda Aurea, Alsace, 1362.
Munich,
Bavarian State Library

112
St. Stephen. About 1355-60.
Nave window in the
Dominican Church in Colmar,
Alsace

111

112

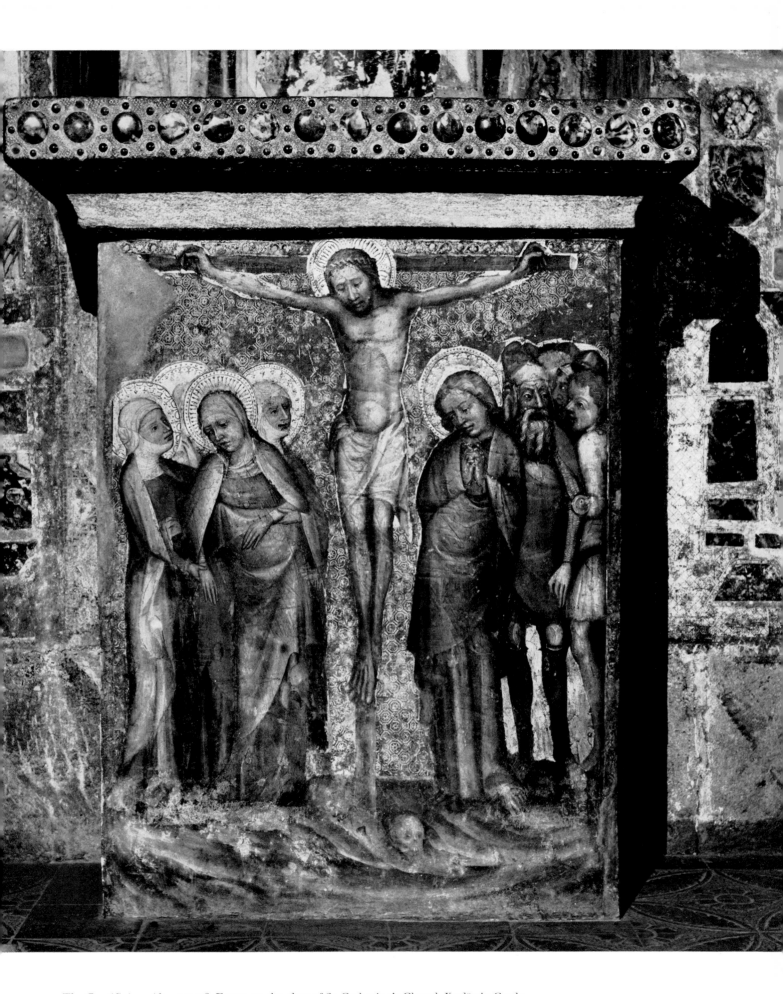

113　The Crucifixion. About 1356. Fresco on the altar of St. Catherine's Chapel, Karlštejn Castle

114

115

116

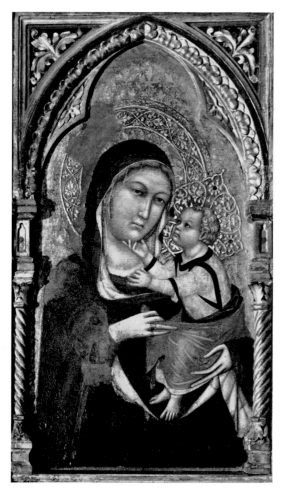

117

114-119 From Karlštejn Castle:

114 Mourning woman. *Detail from Plate 113*

115 Warrior. About 1360-2.
East wall of the Lady Chapel

116 The Woman clothed with the sun.
Detail of Plate 118

117 Madonna. Left wing of a diptych
by Tommaso da Modena, about 1357 (?)

118 The Woman clothed with the sun
fleeing from the seven-headed dragon.
About 1360-2.
West wall of the Lady Chapel

119 Head of the Madonna. About 1356.
Altar niche, St. Catherine's Chapel

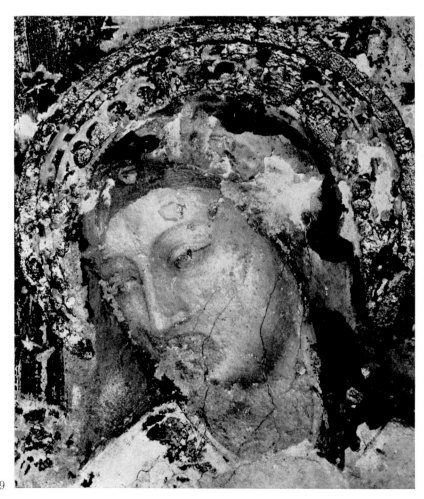

119

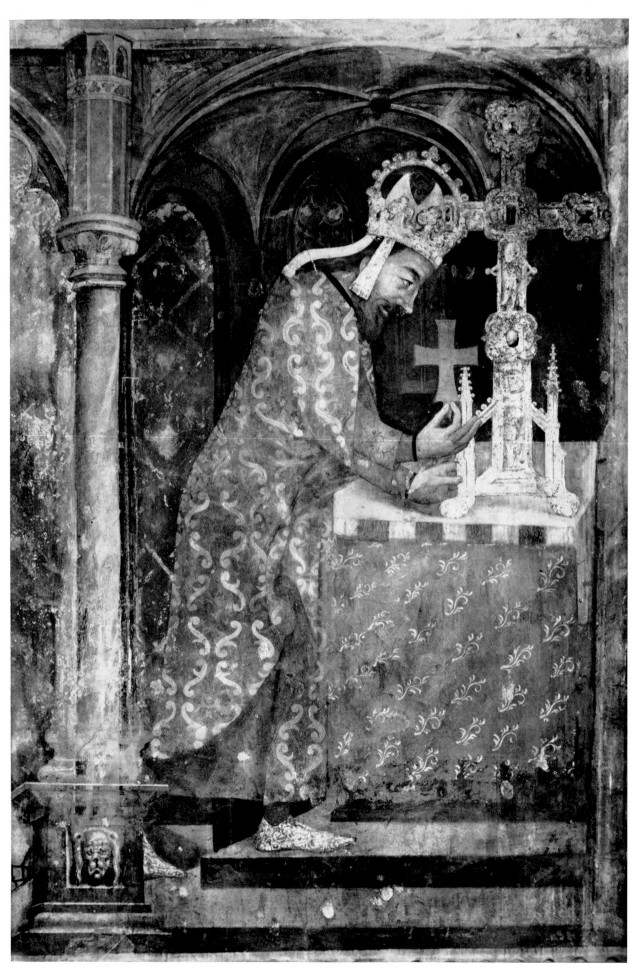

120
Emperor Charles IV
placing a relic into
a Reliquary
of the Cross.
About 1357-8.
South wall
of the Lady Chapel,
Karlštejn Castle

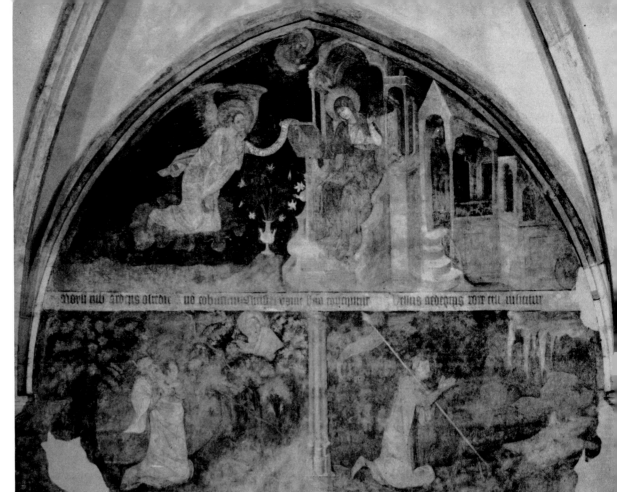

121
The Annunciation;
Moses and the Burning Bush;
two stories from
the Old Testament.
About 1355-60.
Fresco from the 7th bay,
cloisters, Emmaus Monastery,
Prague

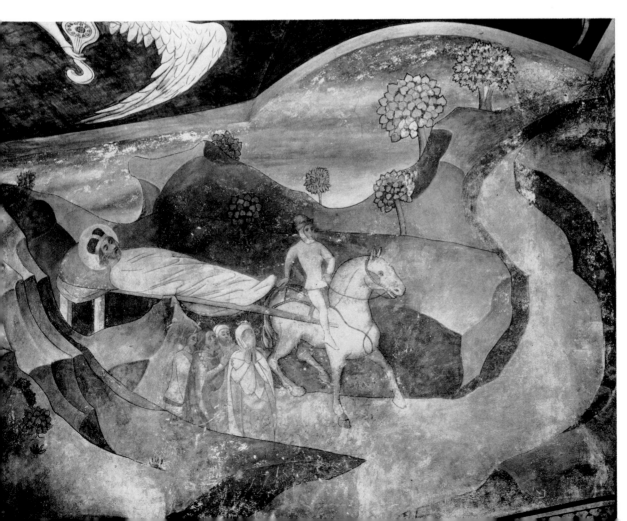

122
St. Wenceslas' body
being taken to Prague.
Soon after 1360.
Main tower staircase,
Karlštejn Castle

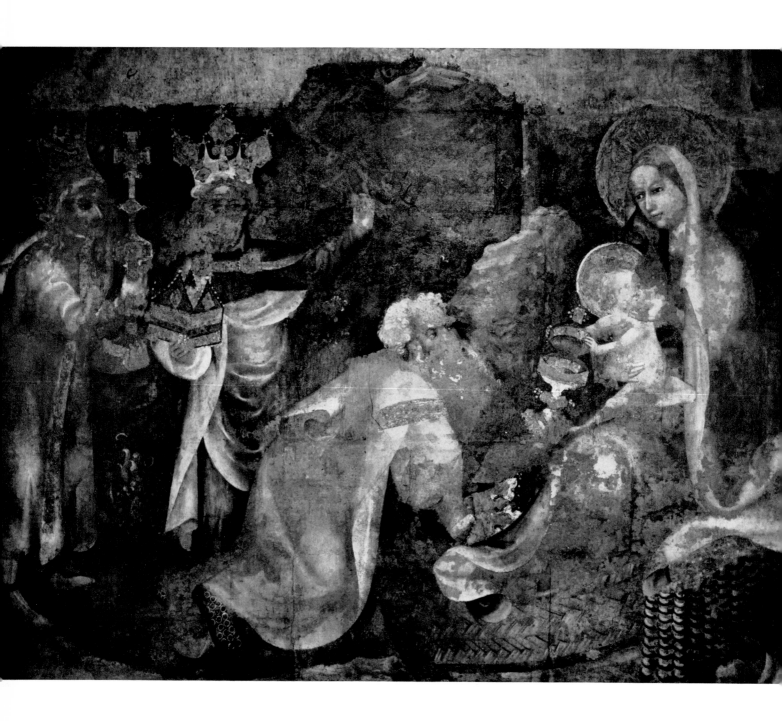

123 The Adoration of the Magi. Fresco, about 1365. Saxon Chapel of St. Vitus's Cathedral, Prague

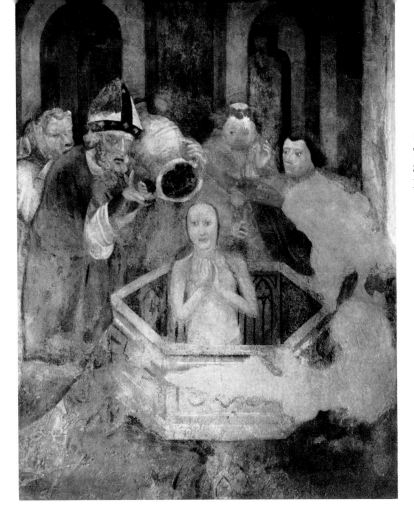

124
The Baptism of St. Ludmilla. Shortly after 1360.
Staircase of the main tower,
Karlštejn Castle

125 The Adoration of the Magi. About 1360. Chapel of the Holy Cross, Karlštejn Castle

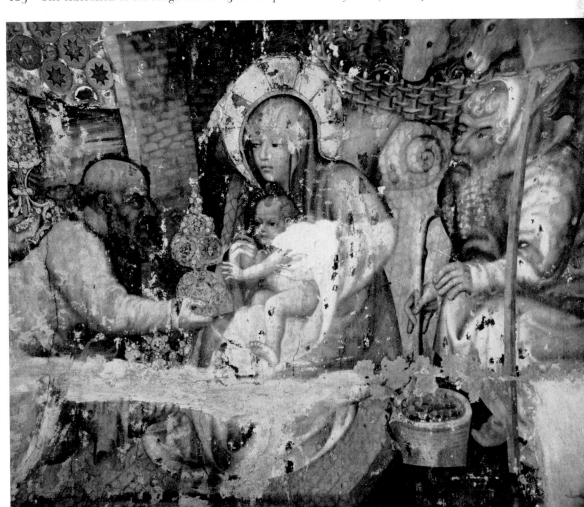

126 The Israelites eating manna. About 1358-60.
Fresco from the fourteenth bay of the cloisters, Emmaus Monastery, Prague

127
Job struck with ulcers.
Illuminated Bible, about 1360.
Prague, Library of the Metropolitan Chapter

12
The twenty-four ancients adoring the Lamb
About 1360. Chapel of the Holy Cross
Karlštejn Cast

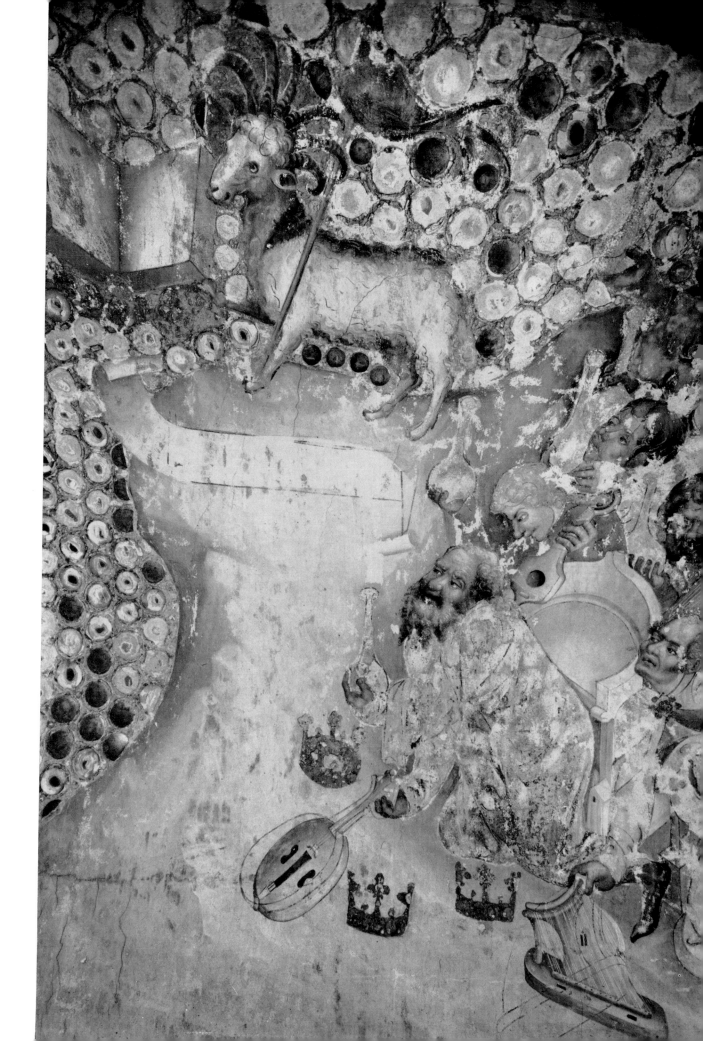

129

130

131

132

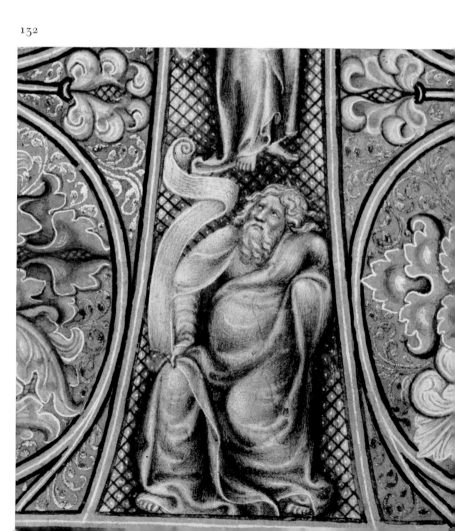

133

134

135 St. Peter. Preliminary drawing for a wall-painting in the Chapel of the Holy Cross, Karlštejn Castle

129
Prophet. Liber Viaticus,
about 1355-60.
Prague, National Museum

130
St. Peter.
Antiphonary from the
Chapter-house
of Vyšehrad, about 1360.
Monastery Library, Vorau

131
Moses before the
Burning Bush.
About 1358-60.
Detail of Plate 121

132
Prophet. Gospel Book
of Johann von Troppau,
1368, Vienna, Nat. Lib.

133
St. Peter. About 1360.
Fresco from the 16th bay
of the cloisters,
Emmaus Monastery, Prague

134
St. Jerome. Detail
from a Sienese diptych,
1350-75. Philadelphia,
Johnson Collection

136
Moses receiving the Law on Mount Sinai.
Brno (Brünn) Municipal Statutes,
shortly after 1355.
Brno, State Archives

137
The Crucifixion of St. Andrew.
Antiphonary from Vyšehrad, about 1360.
Monastery Library, Vorau

138
Illuminated border decoration.
World Chronicle
from Benediktbeuren, 1350-75.
Munich, Bavarian State Library

139 The Creation of Eve. Antiphonary from the Chapter House of Vyšehrad, about 1360. Monastery Library, Vorau

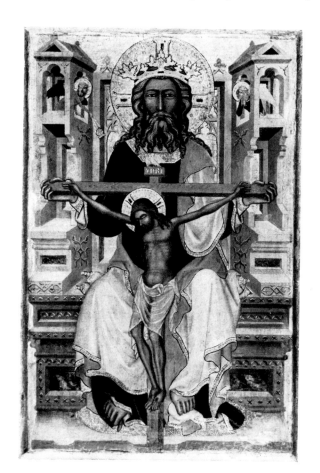

140 The Throne of Mercy. About 1350.
Wroclaw (Breslau), Silesian Museum

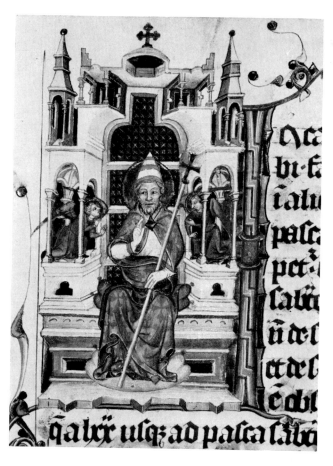

141 The Throne of St. Peter (Cathedra Petri).
About 1360. Monastery Library, Vorau

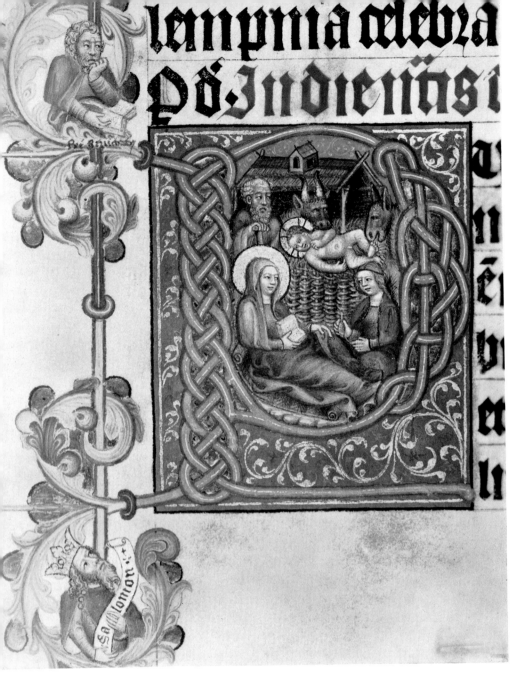

142 The Nativity. Missal of Johann von Neumarkt, about 1365.
Prague, Library of the Metropolitan Chapter

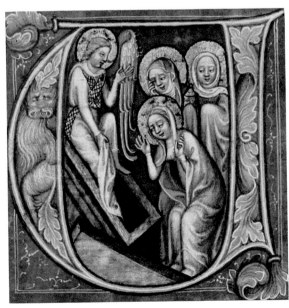

143
The Three Marys at the Sepulchre.
Gospel-Book of Johann von Troppau, 1368.
Vienna, National Library

144
Prophet. Kuneš Bible, 1389.
Prague, Nostitz Library

145
Jacob's Dream. Liber Viaticus,
about 1355-60.
Prague, National Museum

146 The Blessing of the Candles. Liber Pontificalis
of Albert von Sternberg. Prague, Strahov Library

147 The Coronation of a King. Liber Pontificalis
of Albert von Sternberg. Prague, Strahov Library

148 A temptation scene. Thomas von Štítný, Six Books of Faith,
1376. Prague, University Library

149 Madonna. Bible, 1385.
Olomouc (Olmütz), State Archives

Archbishop Jan Očko of Vlašim kneeling between St. Vitus and St. Adalbe
Detail of a votive picture, 1371-5. Prague, National Gall

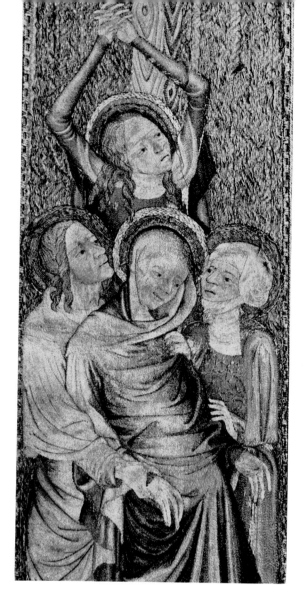

152 St. John and the Mourning Women at the foot of the Cross.
Embroidered Chasuble, about 1390.
Brno (Brünn), Museum of Arts and Crafts

153 The Presentation in the Temple.
From an altar-piece by Melchior Broederlam, 1393-9.
Dijon, Musée des Beaux-Arts

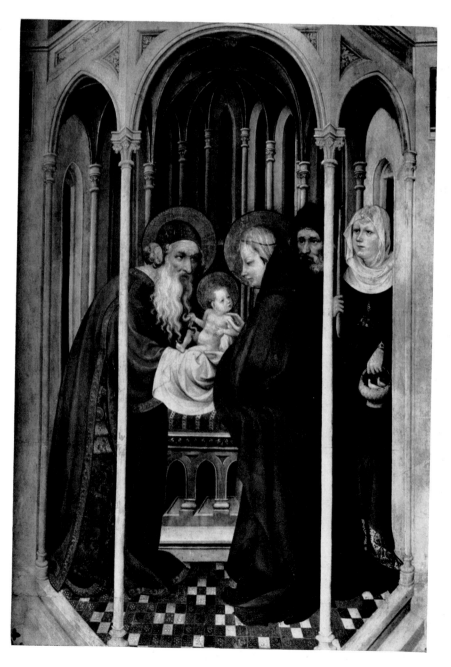

151 St. Catherine, St. Mary Magdalen
and St. Margaret.
Panel of the Wittingau altar-piece,
about 1385-90. Prague, National Gallery

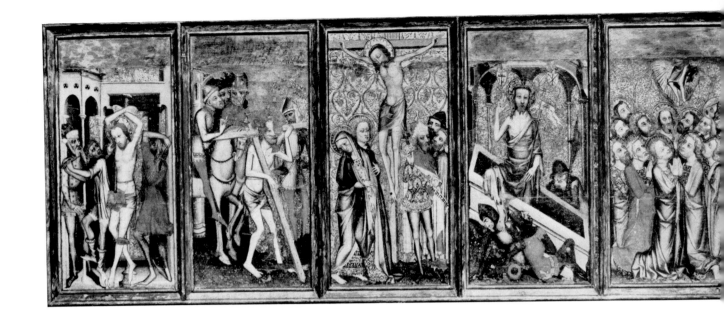

154
Polyptych with five scenes from the
Passion:
The Flagellation, the Carrying of the Cross,
The Crucifixion, The Resurrection,
The Ascension.
English, about 1380-5.
Norwich, Cathedral

155
Soldier at the Sepulchre.
Detail from the Resurrection panel
of the Wittingau altar-piece,
about 1385-90. Prague, National Gallery

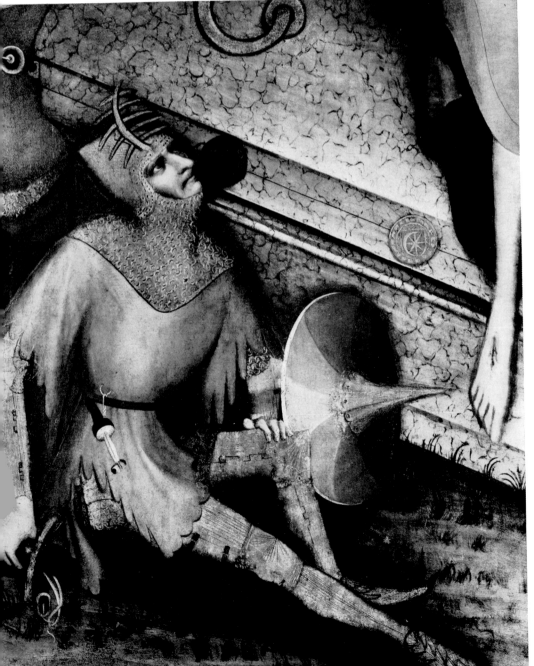

156
The Crucifixion, from St. Barbara
About 1385. Prague, National Gallery

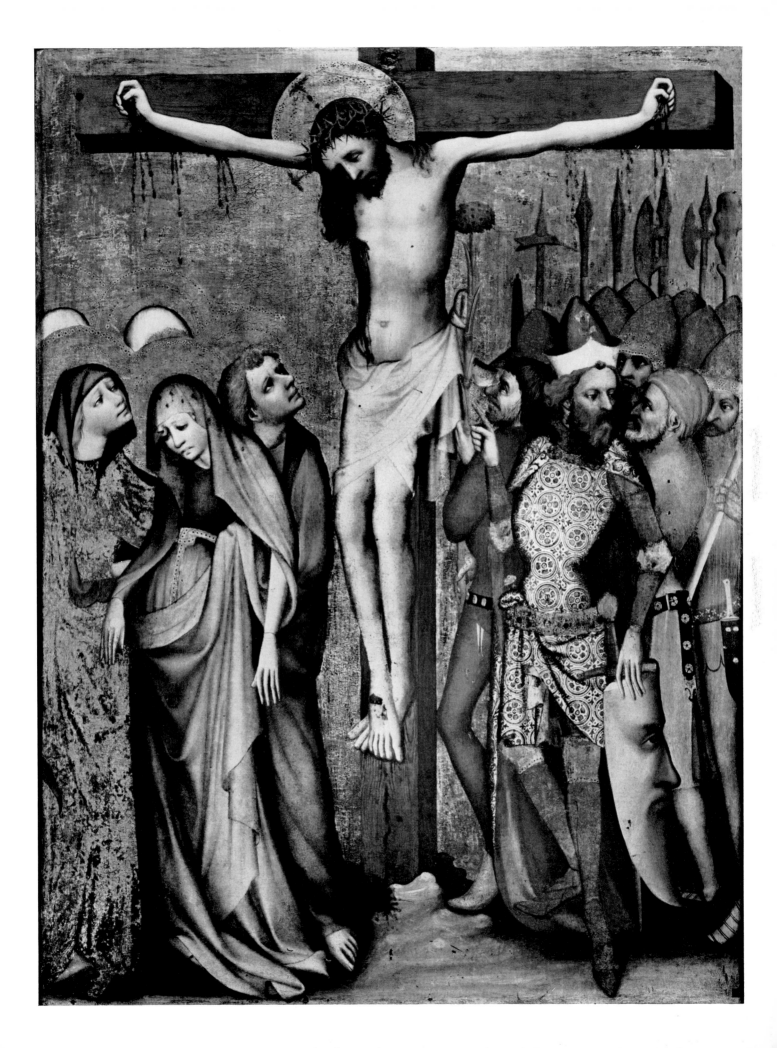

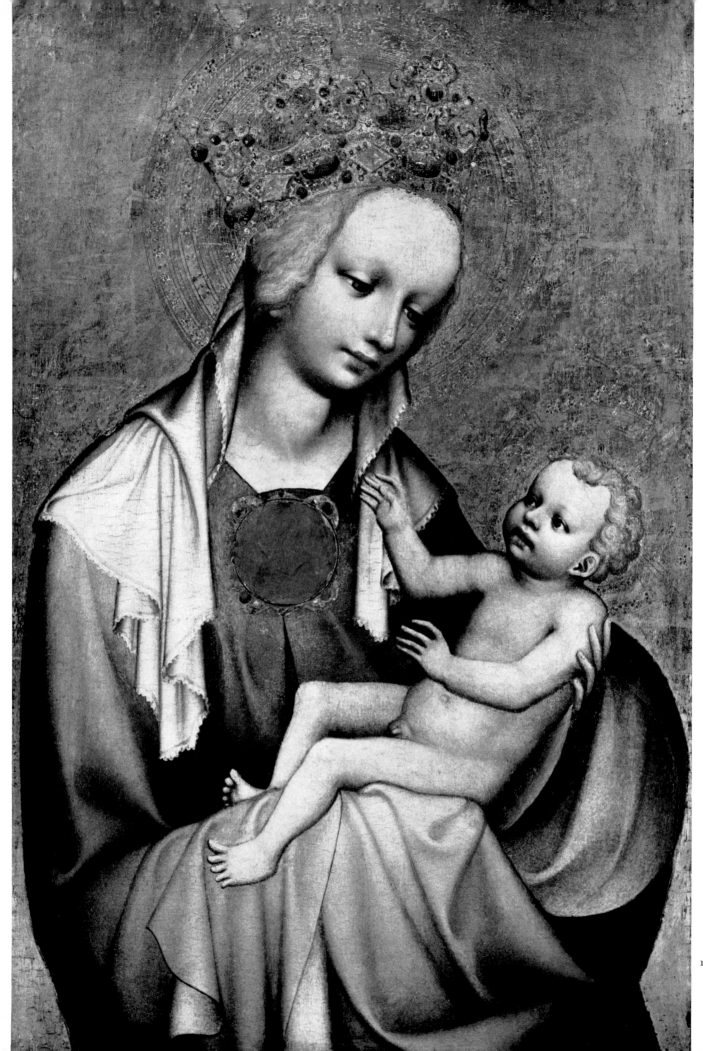

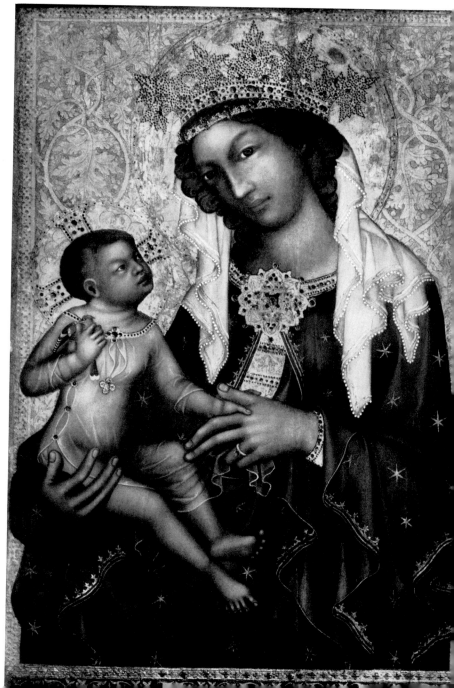

158 St. Catherine. *Detail of Plate 151*

159 Madonna. About. 1355-60. Zbraslav (Königsaal), former Cistercian Church

157 Madonna
from Roudnice nad Labem (Raudnitz).
About 1390. Prague, National Gallery

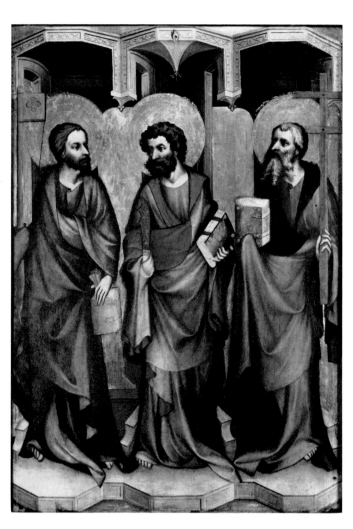

160 The Apostles James Minor, Bartholomew and Philip.
Panel of the Wittingau altar-piece, about 1385-90.
Prague, National Gallery

162
St. Christopher.
From the fragment of an altar-piece, about 1395.
Cirkvice, Parish Church

163
St. Philip. *Detail of Plate 160*

164
An Apostle. From the Capuchin Monastery,
about 1400-10. Prague, National Gallery

165
St. Thomas. From the Jeřeň Epitaph, 1395.
Prague, National Gallery

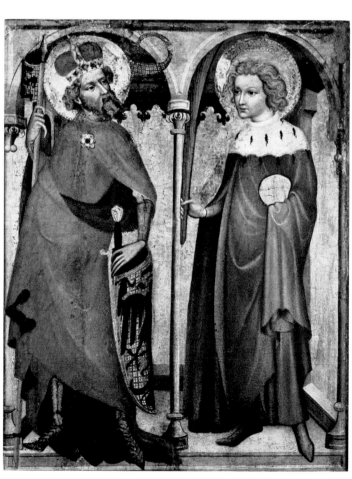

161
St. Wenceslas and St. Vitus.
Panel of the altar-piece from Dubeček, about 1405.
Prague, National Gallery

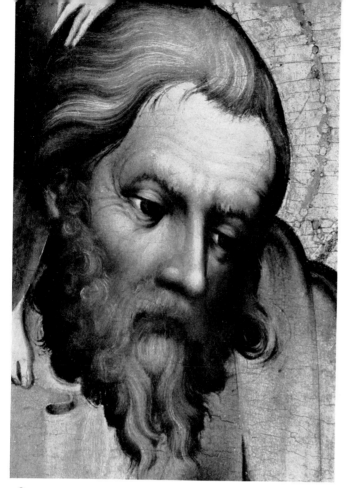

162

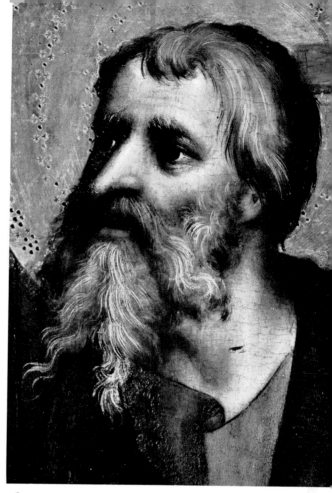

163

164

165

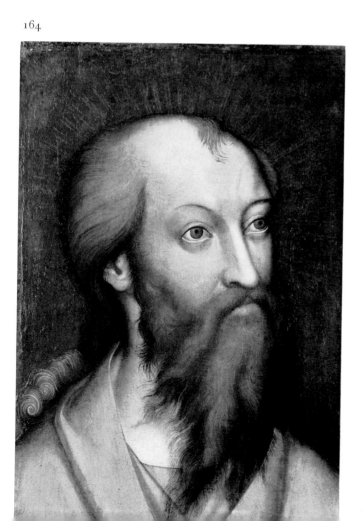

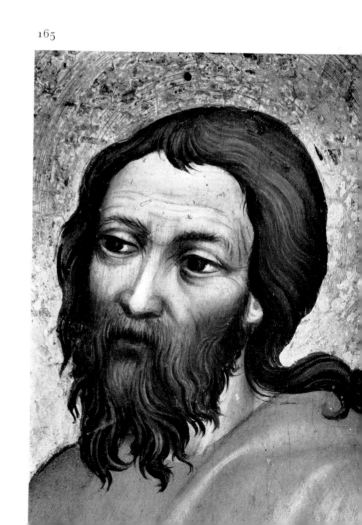

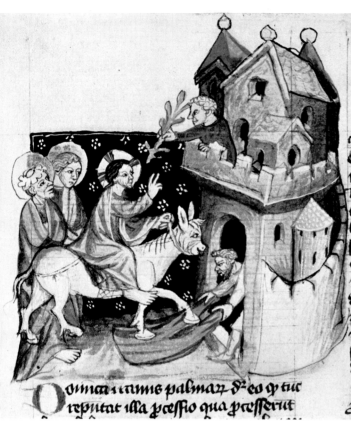

rus no z lucas addit a
Est aut bethania villu
montj olyucti qñ stadi
beda Ambro vio con
te veniō olyucti ut nā
lim ītice plantaieit q
sursū e vlm Jhūr mō
qui ties facie ut plan
possint dicā Ego sū o
dm Sequit̄ me
plos dicēs illis vbi ĵ
vrbim mittit discipli ĵ
siste z vno duo odiuat
septat botz deā sta
opus z̄stiam zduo mo
z̄ ferit z̄duobz̄ sōtib
de li fretib̄ azilab

Oomica ī rāme palmar dᵒ eo q̄ tūc
repurtat illa pᵉssio qua pᵉssᵉmt

166
Christ's Entry into Jerusalem.
Sanctorale Bernardi Quidonis, about 1390.
Prague, National Museum

167 A fortified town. Cosmas, Bohemian Chronicle, about 1395. Prague, National Museum

169 An Apostle. Initial
in a miscellaneous manuscript, about 1385.
Stams (Tyrol), Abbey Library

68 Madonna standing on the moon.
Meditatio de humanitate Christi,
Nürnberg, 1380. London, British Museum

170
Illustration to the 'Willehalm' Romance,
about 1385-7. Vienna, National Library

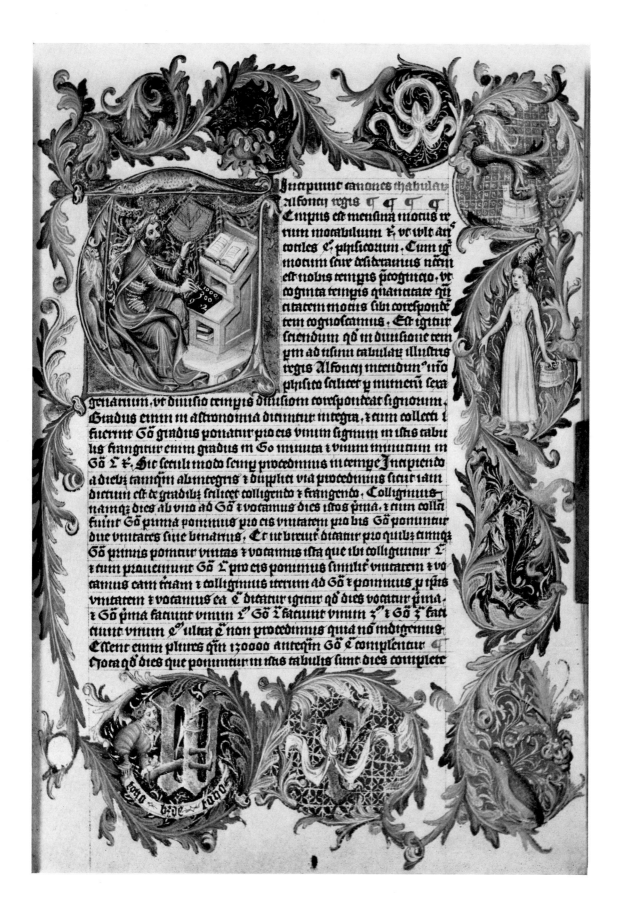

171 Title page of the Astronomical Tables of King Alfonso X of Castile. 1392.
Vienna, National Library

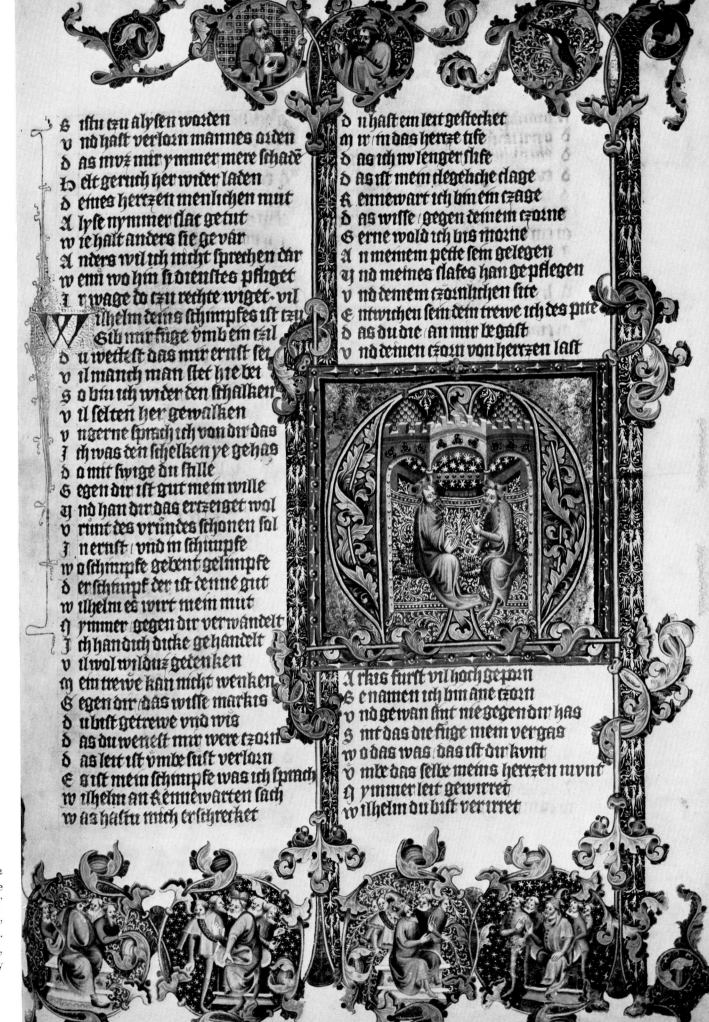

s iftu tzu alyfen worden
v nd haft verlorn mannes orden
d as muz mir ymmer mere fchade
h elt geruch her wider laden
d eines hertzen menlichen mut
A lyfe nymmer flac getut
w ie halt anders fie gevar
A nders wil ich nicht fprechen dar
w enn wo hin fi dienftes pfliget
J r wage do tzu rechte wiget· vil
ilhelm dein fchimpfes ift tzu
Gib mir fuge vmb ein tzil
d u weiteft das mir ernft fei
v il manch man ftet hie bei
s o bin ich wider den fchalken
v il felten her gewalken
v ngerne fprach ich von dir das
J ch was den fchelken ye gehas
d a mit fwige du ftille
G egen dir ift gut mein wille
y nd han dir das ertzeiget wol
v riunt des vrinndes fchonen fol
J n ernft· vnd in fchimpfe
w o fchimpfe gebent gelimpfe
d er fchimpf der ift denne gut
w ilhelm es wirt mein mut
y mmer gegen dir verwandelt
J ch han dich dicke gehandelt
v il wol wilduz gedenken
y ein treue kan nicht wenken
G egen dir/das wiffe markis
d u bift getrewe vnd wis
d as du weiieft mir were tzorn
d as leit ift vmbe fuft verlorn
E s ift mein fchimpfe was ich fprach
w ilhelm an kennewarten fach
w as haftu mich erfchrecket

d u haft ein leit geftecket
m ir/in das hertze tiefe
d as ich nu lenger fliefe
d as ift mein clegeliche clage
k ennewart ich bin ein tzage
d as wiffe/gegen deinem tzorne
G erne wold ich bis morne
A n meinem pette fein gelegen
y nd meines flafes han gepflegen
v nd deinem tzornlichen fite
E ntwichen fein dein treue ich des pite
d as du die/an mir legaft
v nd deinem tzorn von hertzen laft

A rkis furft vil hoch geporn
s e namen ich bin ane tzorn
v nd gewan fint nie gegen dir has
s int das die fuge mein vergas
w o das was/das ift dir kunt
v mir das felbe meins hertzen munt
y mmer leit gewirret
w ilhelm du bift verirret

172
Page from the
'Willehalm'
Romance,
about 1385-7.
Vienna,
National Library

173 King Wenceslas and Sophia of Bavaria.
Wenceslas Bible, about 1390-5. Vienna, National Library

174 Illustration to the 'Willehalm' Romance, about 1385-7.
Vienna, National Library

175 Samson being shaved by Delilah; Samson being blinded
by the Philistines. Wenceslas Bible, about 1390-5.

176 The burial of a holy man. Wenceslas Bible, about 1390-5.
Vienna, National Library

177 Ruth and Boaz asleep in the field.
Wenceslas Bible, about 1390-5.
Vienna, National Library

178
The Finding of Romulus and Remus.
Decades of Titus Livius, French, about 1380.
The Hague, Royal Library

179 St. Luke the Evangelist. Bible, 1391.
New York, Pierpont Morgan Library

180 Absalom plotting against David. Wenceslas Bible,
about 1390-5. Vienna, National Library

181 The Visitation.
Miscellaneous manuscript of Johann von Jenzenstein,
1396-7. Vatican Library

182 Adam tilling the earth, Eve and the boy Cain.
Bible of Konrad von Vechta, 1403,
Antwerp, Plantin-Moretus Museum

183 Four Prince Electors. Golden Bull, 1400. Vienna, National Library

184 God speaking to the Israelites from a cloud of fire.
Bible of Konrad von Vechta, 1403.
Antwerp, Plantin-Moretus Museum

185 The Prophet Ahias dividing his garment
into twelve parts. Bible of Konrad von Vechta, 1403.
Antwerp, Plantin-Moretus Museum

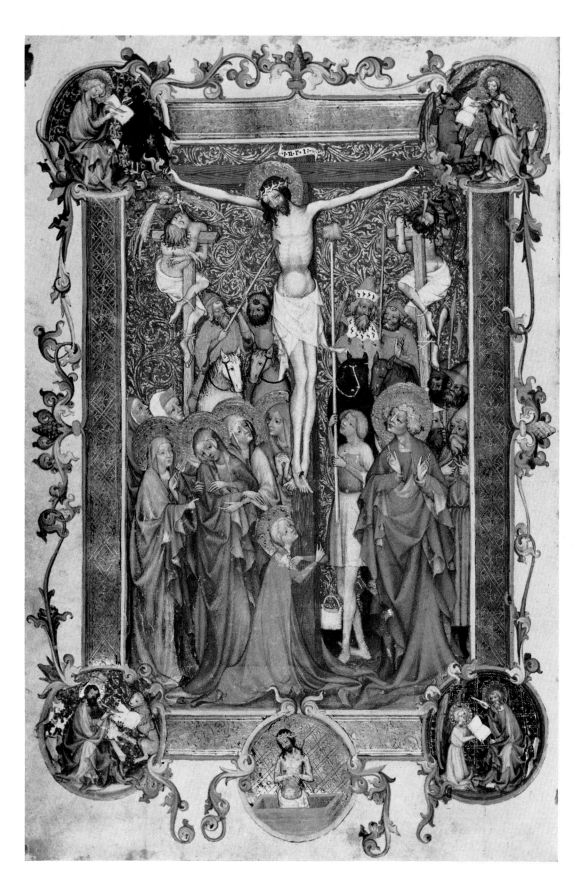

186 The Crucifixion. Missal of Sbinko von Hasenburg, 1409. Vienna, National Library

187 Madonna from Jindřichův Hradec (Neuhaus). About 1400-10.
Prague, National Gallery

188 The Death of the Virgin. Altar-piece from Roudnice (Raudnitz), 1410-15.
Prague, National Gallery

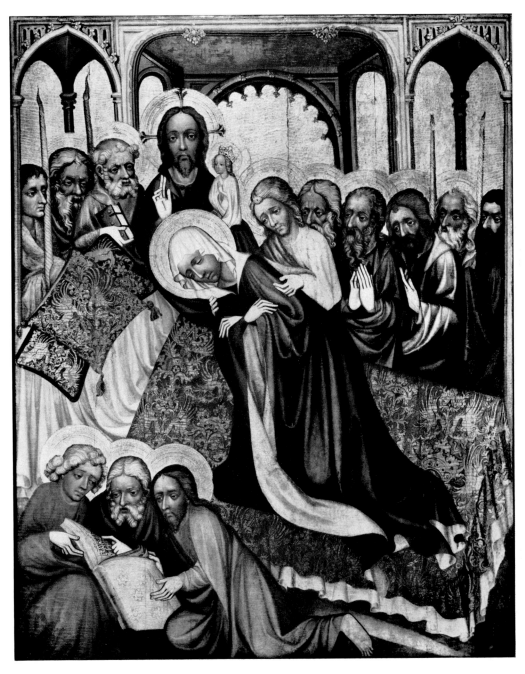

189 Jael slaying Sisera. Bible of Konrad von Vechta, 1403. Antwerp, Plantin-Moretus Museum

190 The Covenant of David and Jonathan. Bible of Konrad von Vechta, 1403. Antwerp, Plantin-Moretus Museum

191 The zodiacal sign of Pisces. Prague Missal, about 1405-10. Vienna, National Library

192
Prophet. Korczek Bible, about 1403-05. Vienna, National Library

193
ntonius, Donatus, Zachaeus,
udius and their companions.
About 1410, so-called
Dietrichstein Martyrologium.
Gerona (Spain),
Diocesan Museum

194
Pentecost.
Choir book fragment
from Sedlec, about 1414.
dapest, Museum of Fine Arts

194a
e Crucifixion. About 1410-15.
Berlin-Dahlem,
Stiftung Preussischer
Kulturbesitz, Gemäldegalerie

193

194

194a

195
The Martyrdom of Theodosia;
the Burial of Mary of Egypt;
Enagrius and Benignus.
About 1410, so-called
Dietrichstein Martyrologium.
Gerona (Spain),
Diocesan Museum

196 The zodiacal sign of Virgo. Prague Missal,
 about 1405-10. Vienna, National Library

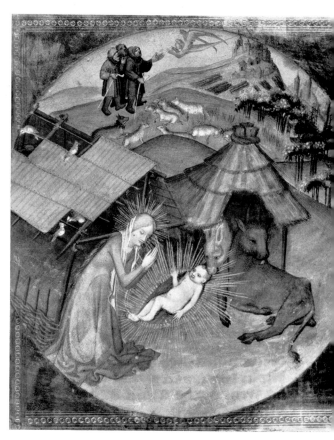

197
The Nativity. Boskovic Bible, about 1415-20.
Olomouc (Olmütz), University Library

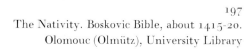

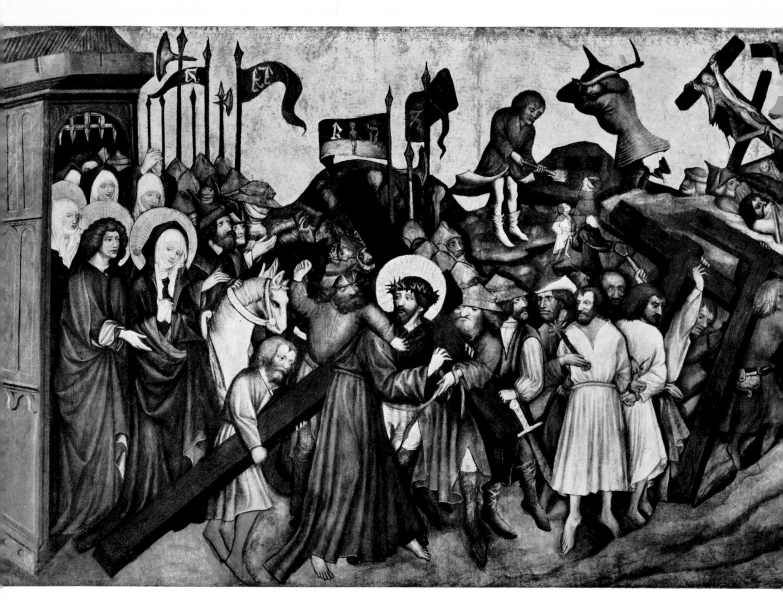

199　The Carrying of the Cross. Panel of the altar-piece from Rajhrad (Raigern), about 1415-20. Brno (Brünn), Moravian Gallery

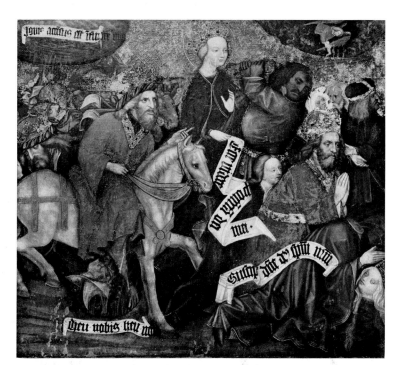

199a
The Martyrdom of St. Catherine,
outer panel of the Namešt altar-piece.
About 1430-5.
Brno (Brünn), Moravian Gallery

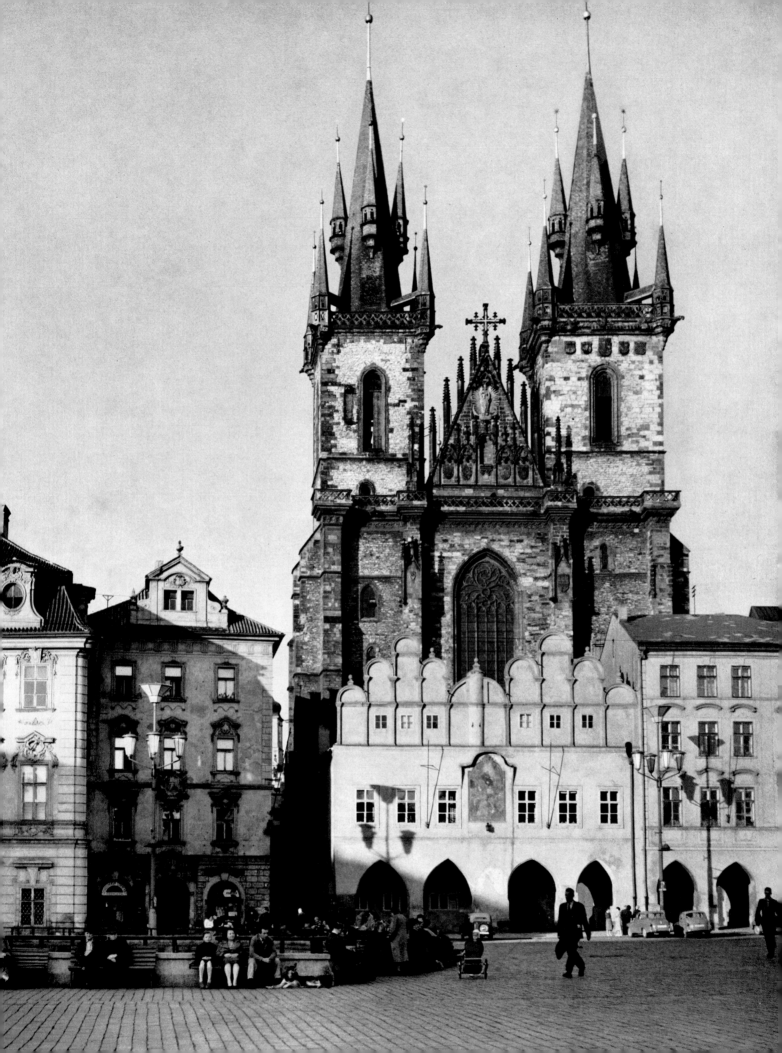

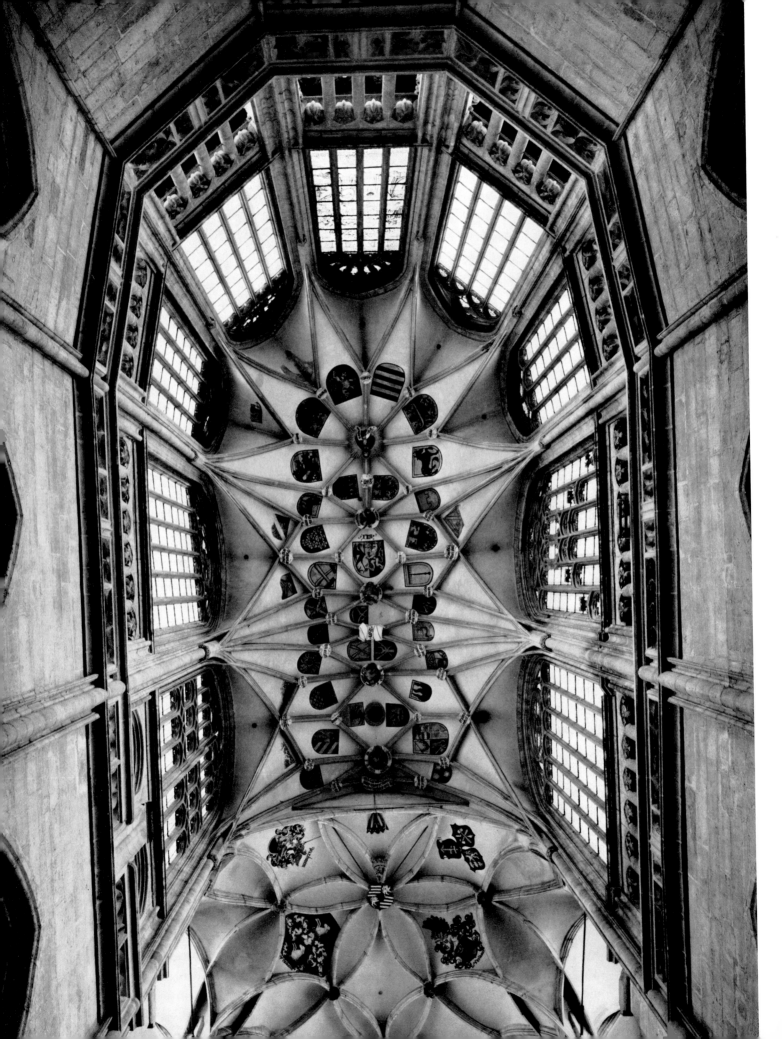

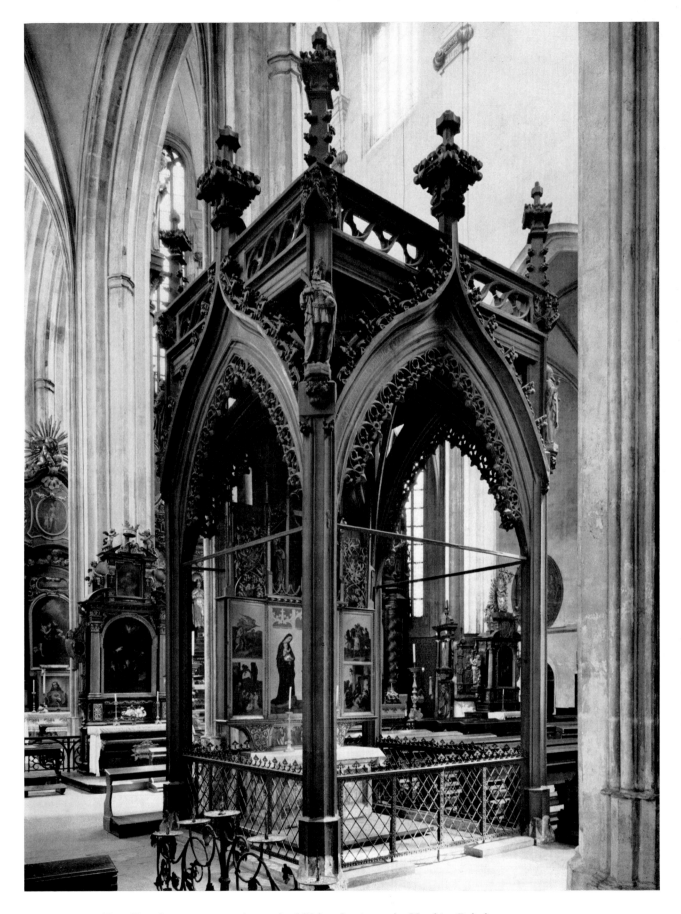

202 Prague, Týn Church, canopy over the tomb of Bishop Lucianus, by Matthias Rajsek, 1493

203
Prague, Hradčany Castle,
Horsemen's Staircase, by Benedikt Ried, about 1500

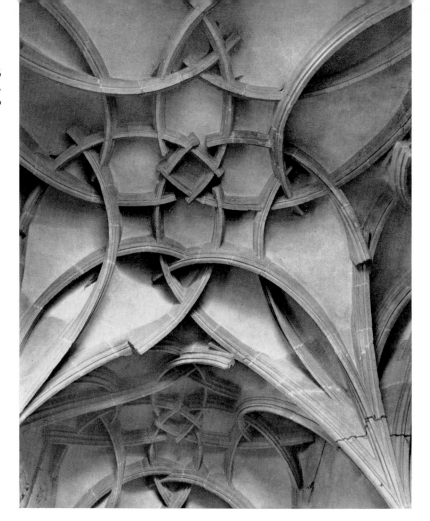

204
Prague, Hradčany Castle, wing of King Ludwig,
vaulting of the Bohemian Chancellery, about 1505

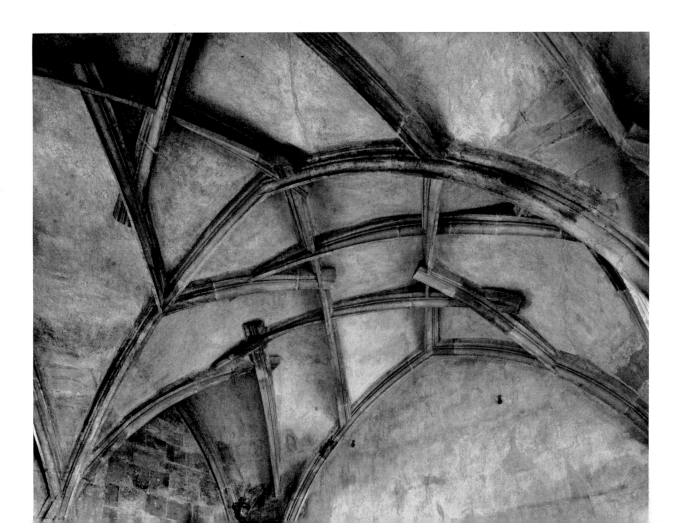

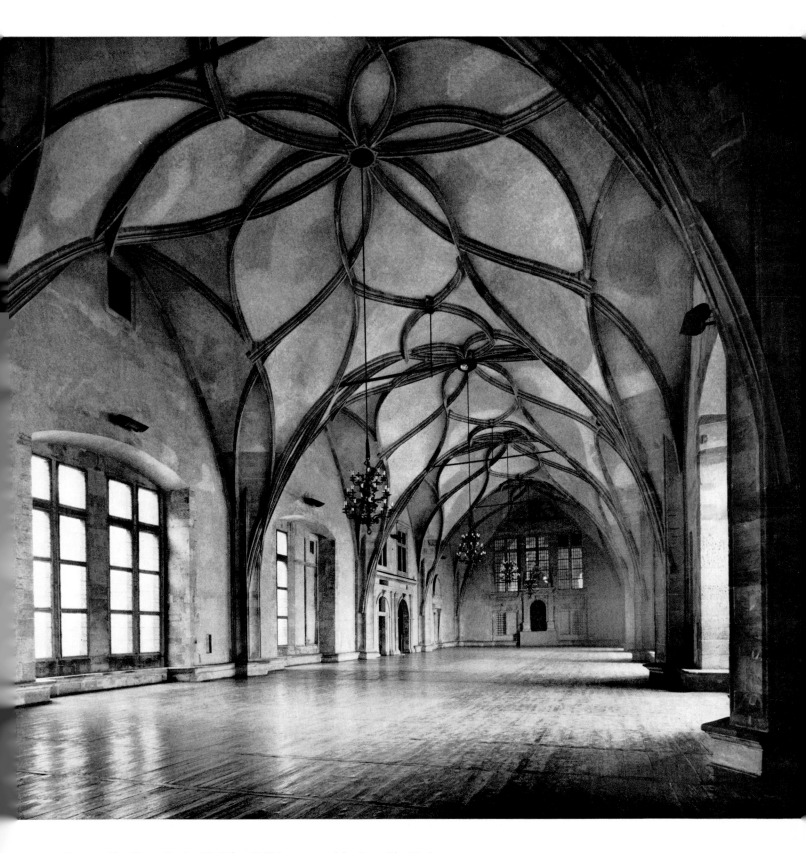

205 Prague, Hradčany Castle, Vladislav Hall (1493-1502) by Benedikt Ried

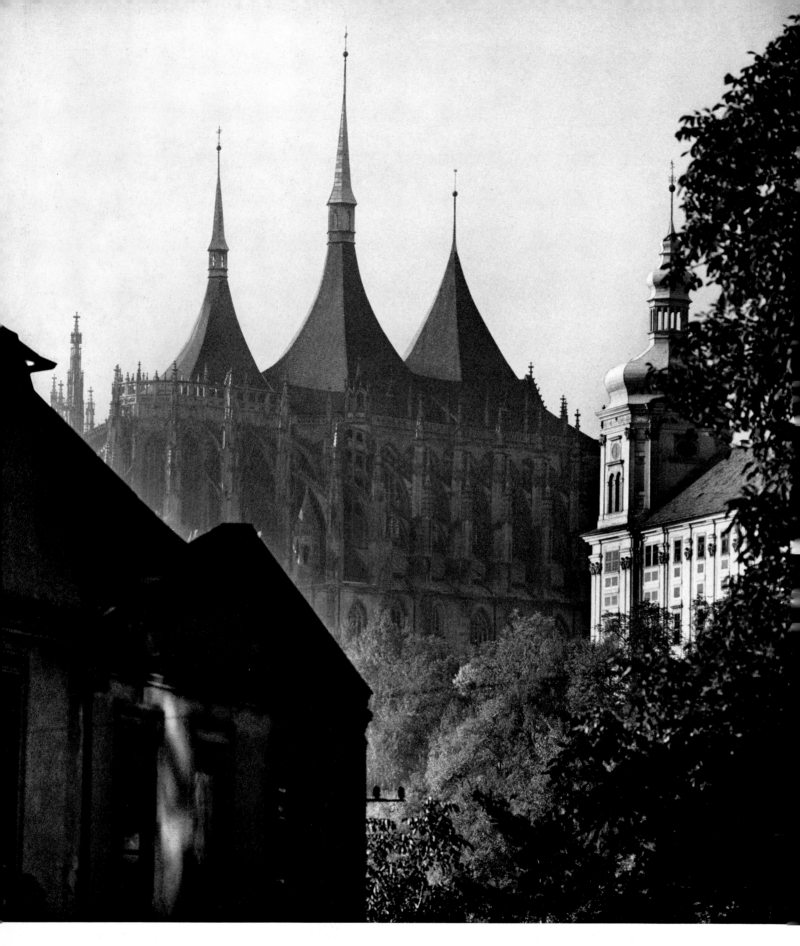

206 Kutná Hora (Kuttenberg), St. Barbara's Church from the north-east

Kutná Hora (Kuttenberg), St. Barbara's Church, nave, by Benedikt Ried, begun 1512, completed 154

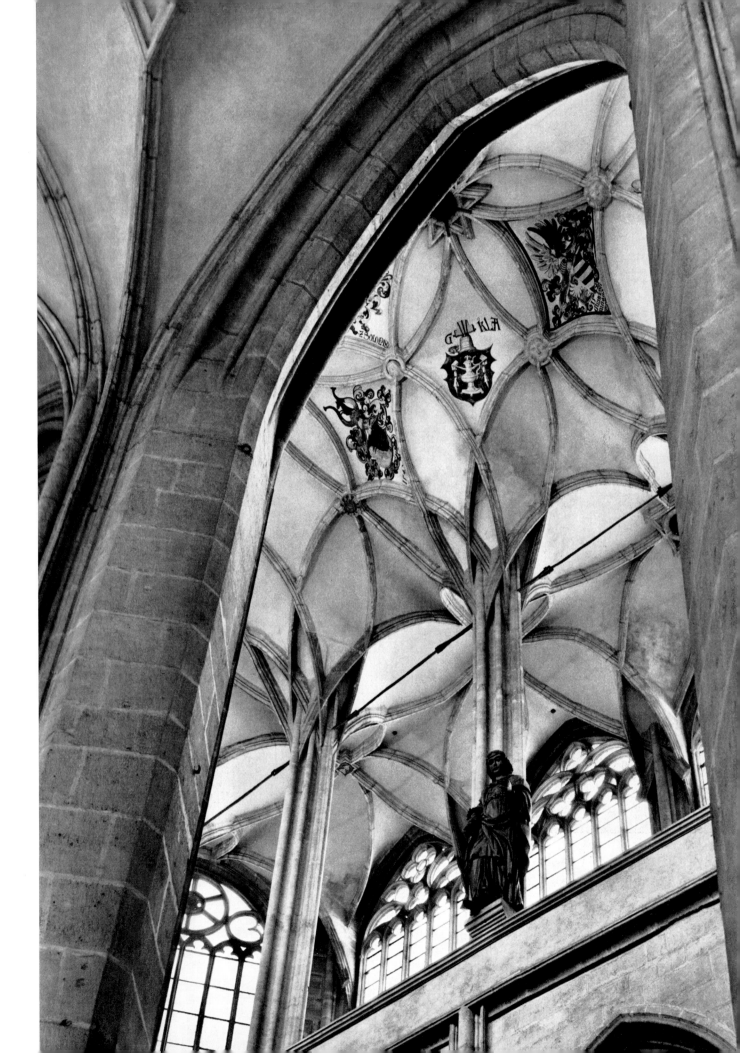

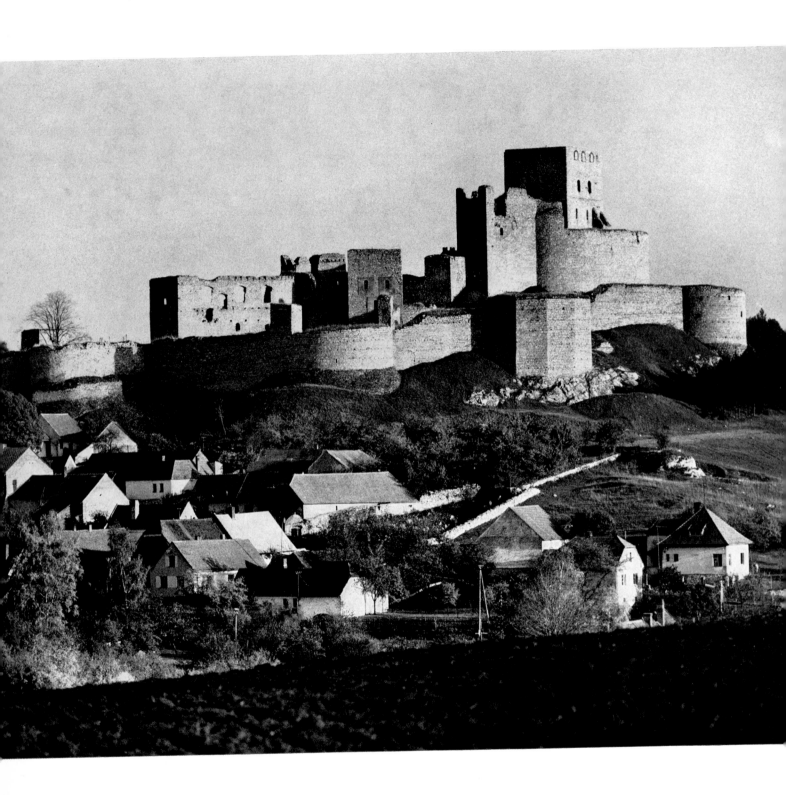

Křivoklát (Pürglitz) Castle, chapel, about 1489, probably by Hans Spie

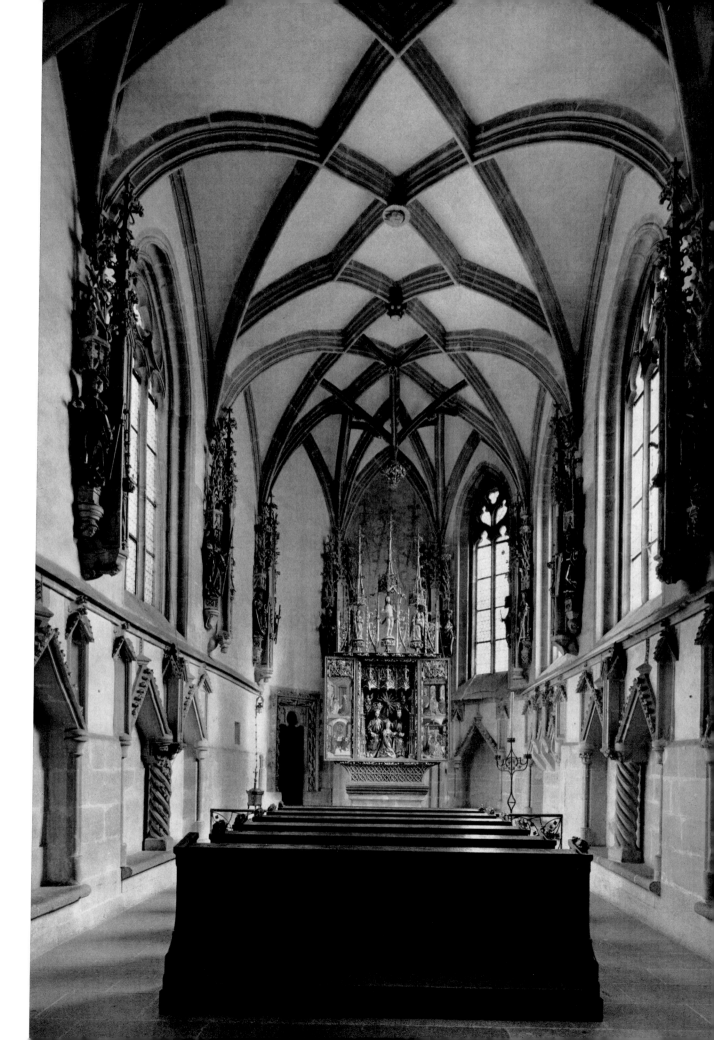

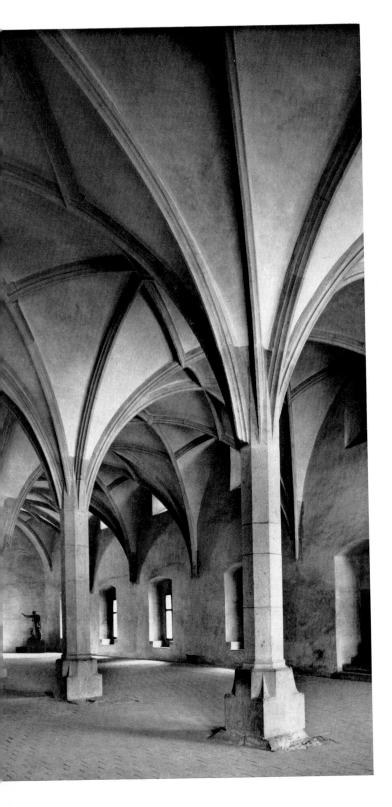

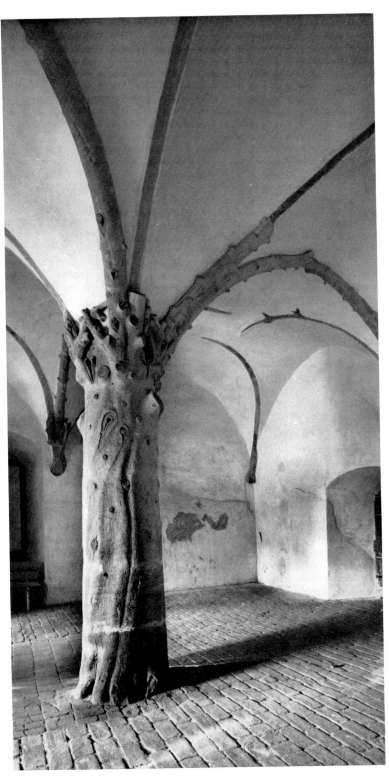

210 Tábor, Town Hall, built by Wenzel Rosskopf, 1515-6

211 Bechyně (Bechin), Castle, ground floor, about 1510

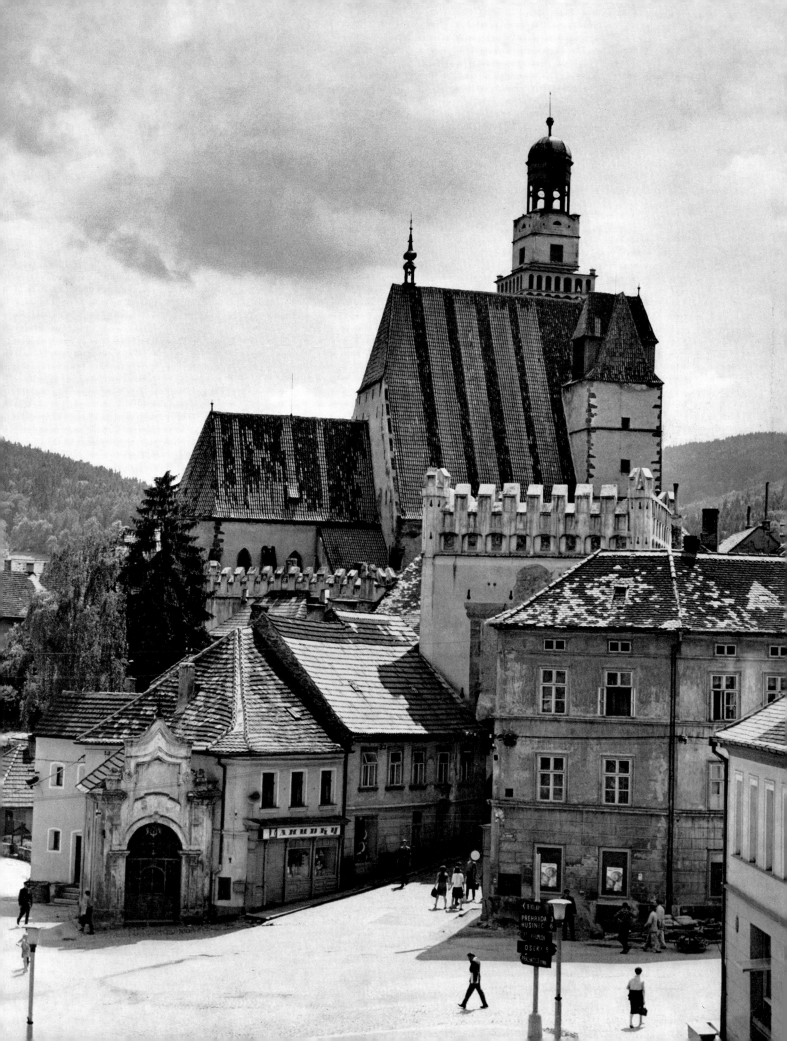

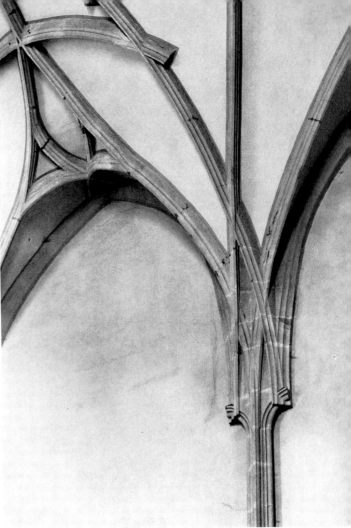

213 Prachatice (Prachatitz), St. James' Church,
 view from the north aisle,
 vaulting 1490-1513

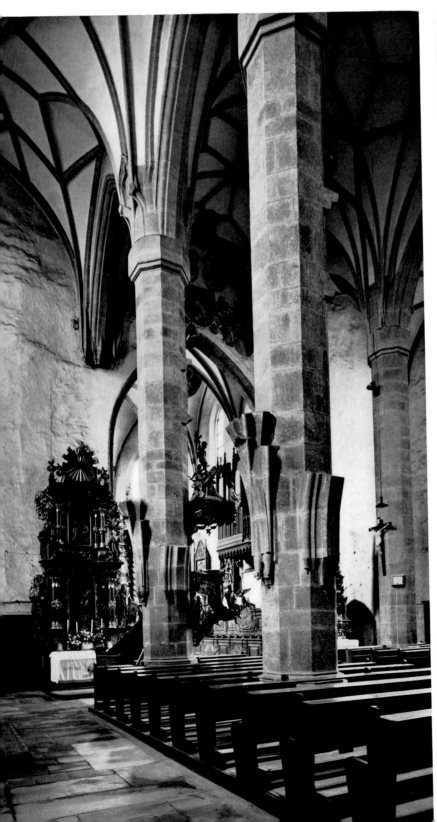

214 Chvalšiny (Kalsching), St. Magdalen's Church,
 corbel of the nave vaulting, about 1520

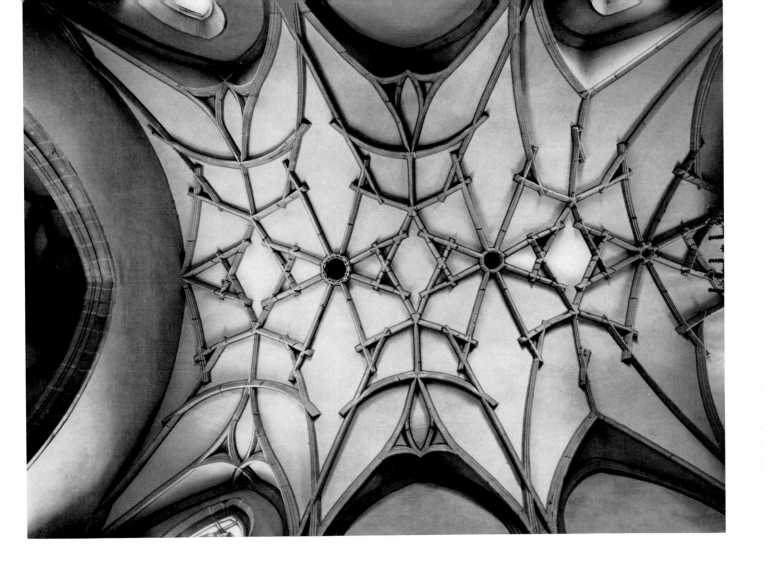

215
Chvalšiny (Kalsching), St. Magdalen's Church,
nave vaulting, about 1520

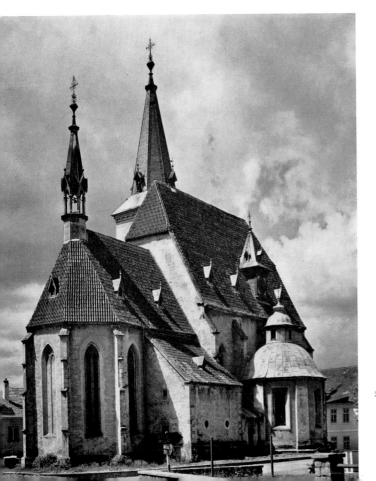

216 Chvalšiny (Kalsching), St. Magdalen's Church,
view from the north-east

217 Český Krumlov (Krumau), oriel-window,
 Deanery, 1514-20

218 Český Krumlov (Krumau), oriel-window,
 Castle, about 1513

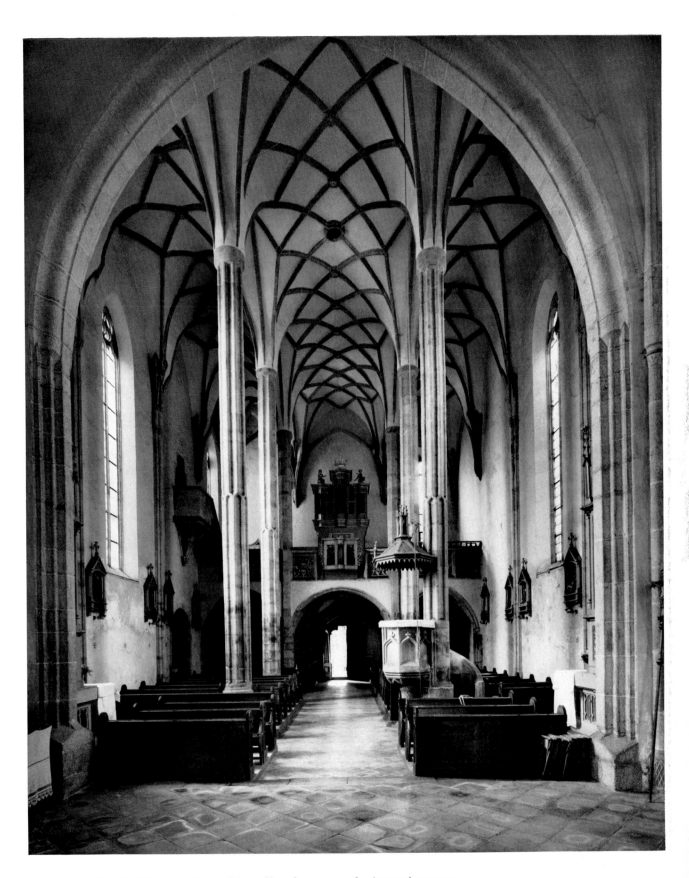

219 Dolní Dvořiště (Unterhaid), St. Giles's Church, nave, early sixteenth century

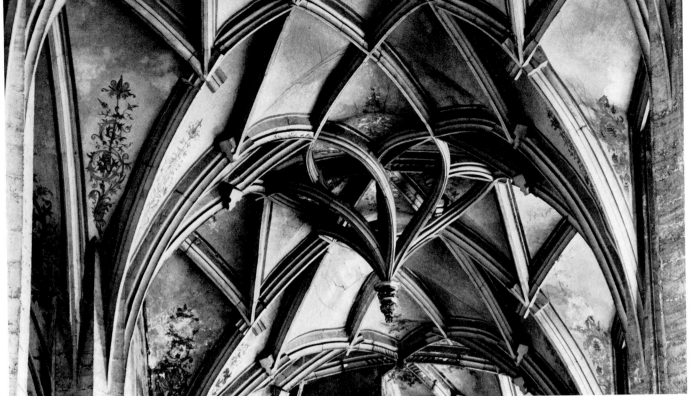

220

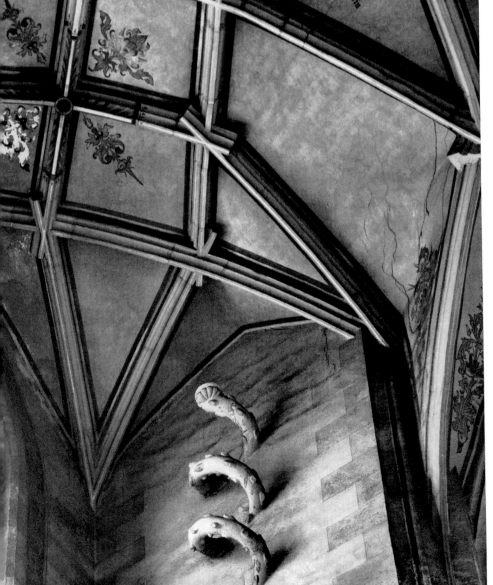

221

220
Most (Brüx), Church of the Assumption,
pendant boss in west Gallery, about 1532

221
Most (Brüx), Church of the Assumption,
south side of the vault in the west chapel

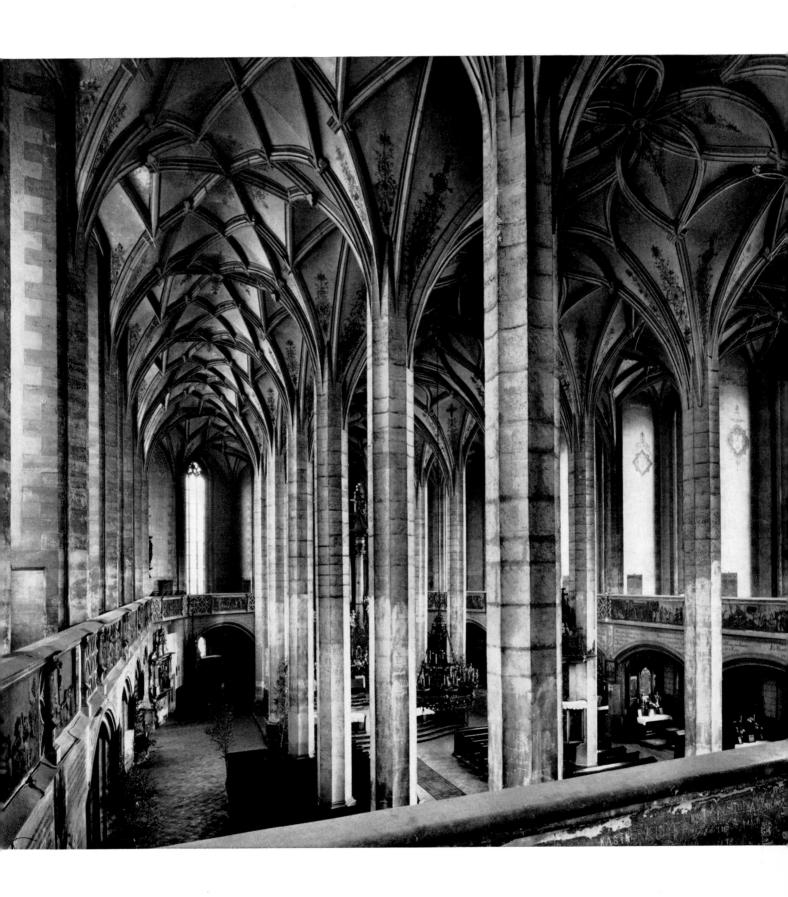

222 Most (Brüx), Church of the Assumption, 1517-44, from a design by Jacob Heilmann

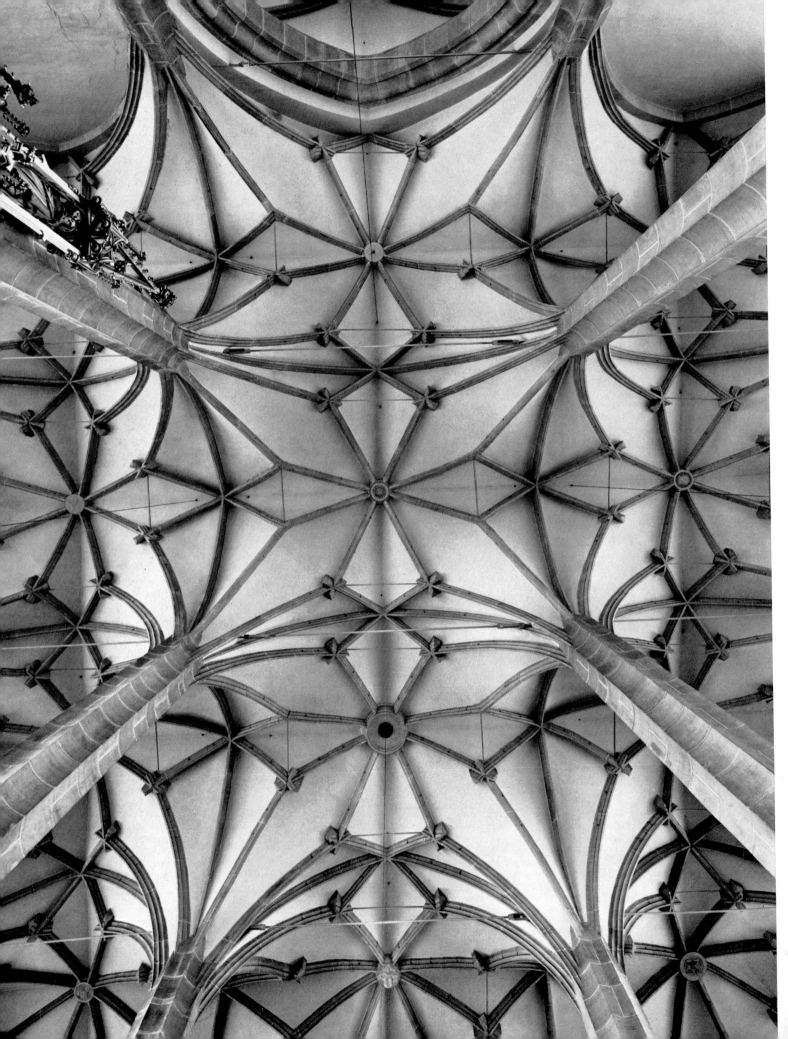

224

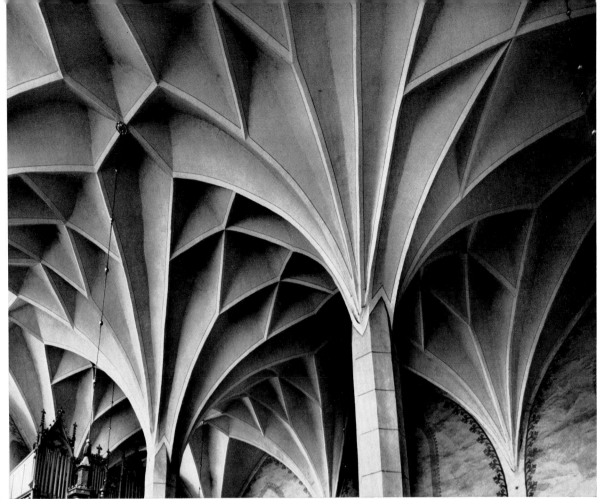

226

Bechyně (Bechin), Church of the Assumption, nave vaulting, early sixteenth century
→

225

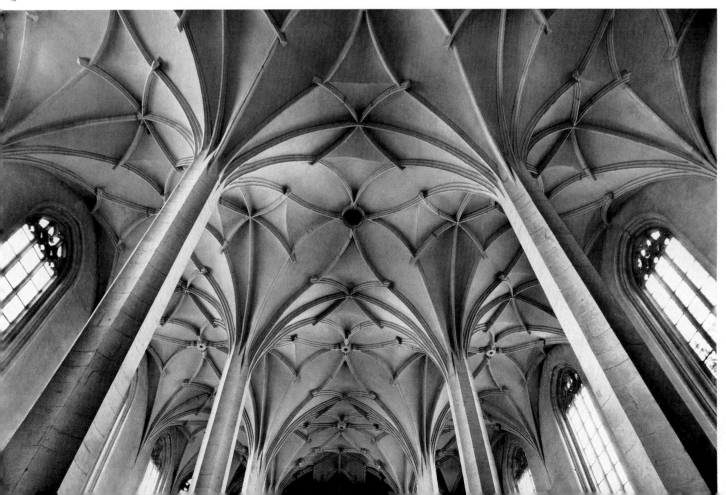

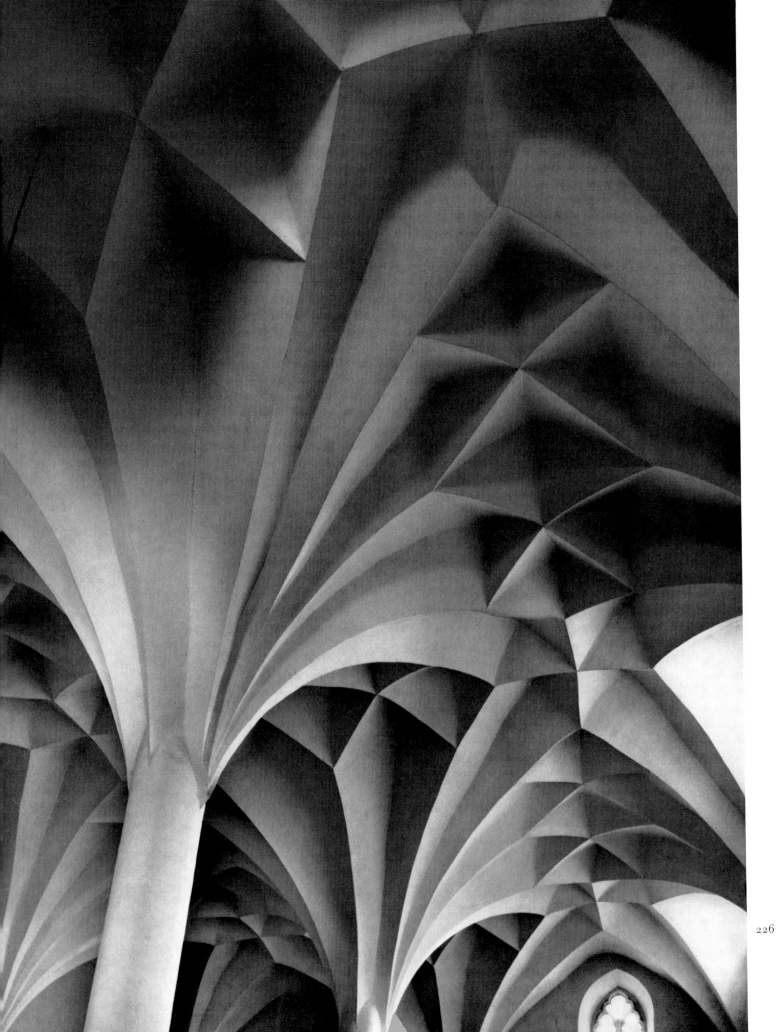

227–230 The Chapel of St. Wenceslas in St. Vitus's Cathedral, Prague

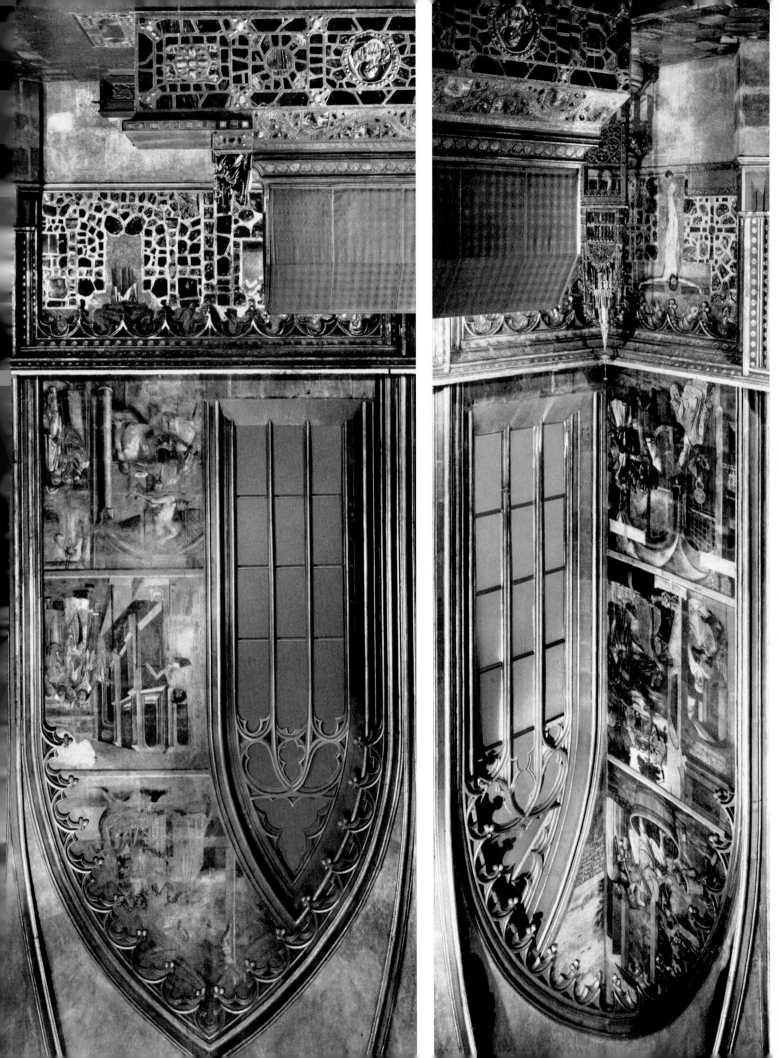

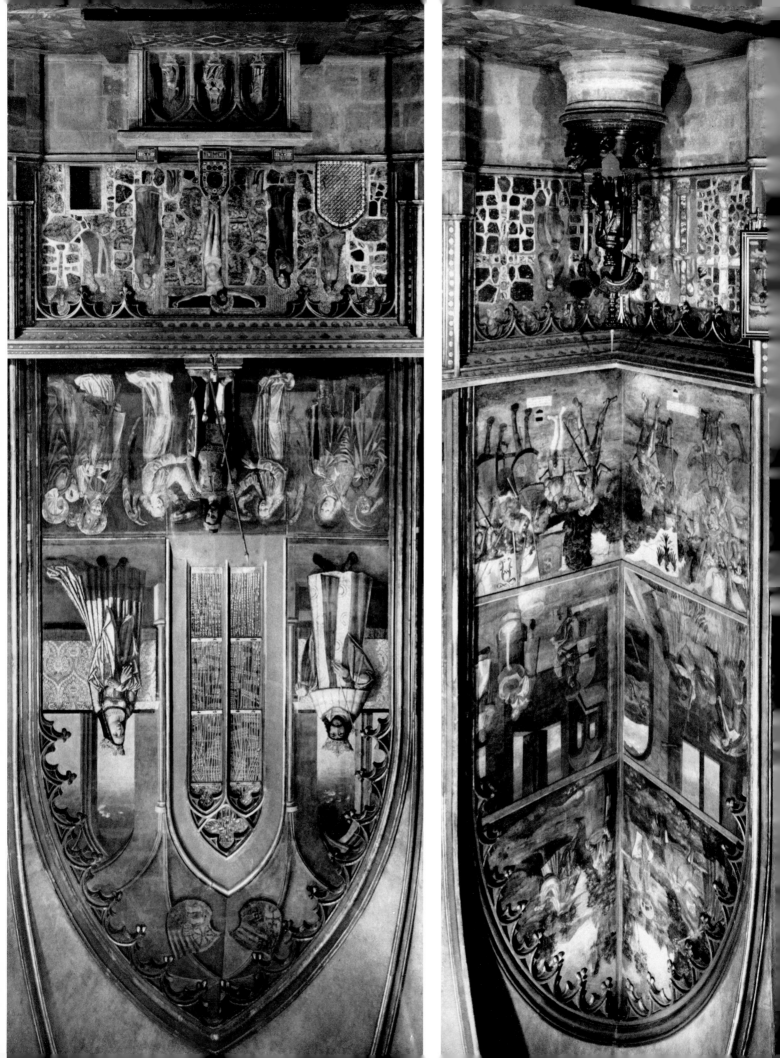

The pictorial programme of the Chapel of St. Wenceslas

The Arabic numbers (according to J. Krása) follow in general the legend of the Saint. Roman numbers refer to the wall-paintings in the lowest register.

THE LEGEND OF ST. WENCESLAS

1 The Saint ransoms heathen children
2 He baptizes the heathen children
3 He fells a gallows
4 He visits prisoners
5 He frees prisoners
6 He feeds a wayfarer
7 He digs a grave
8 He serves at Mass
9 He brings timber to a widow and is accused by foresters
10 He advises his servant Podiven to follow his footsteps in the snow
11 He toils in the fields
12 He sows corn
13 He harvests and threshes corn
14 He bakes bread for the Eucharist
15 He presses grape-juice
16 He arrives at the Imperial Diet
17 He is greeted by King Henry
18 The Meeting of the Electors
19 The Saint receives the relic of St. Vitus's arm from King Henry
20 The relic is placed in a chest
21 The duel with Radslav is arranged
22 The submission of Radslav

23 The Saint is greeted by his brother Boleslav at Alt-Bunzlau
24 The banquet at Alt-Bunzlau
25 The Saint is murdered by Boleslav
26 A miracle taking place during the translation of the Saint's body
27 Podiven kills the Saint's murderer and is hanged
28 Christ appearing to King Eric of Denmark
29 King Eric inspects a church consecrated to Saint Wenceslas
30 King Wladislav II and his wife, Anna de Foix: above, their coats of arms
31 Statue of St. Wenceslas by Peter Parler, flanked by two angels and the national patron saints: at the left, Sigismund and Vitus, at the right, Adalbert and Ludmilla

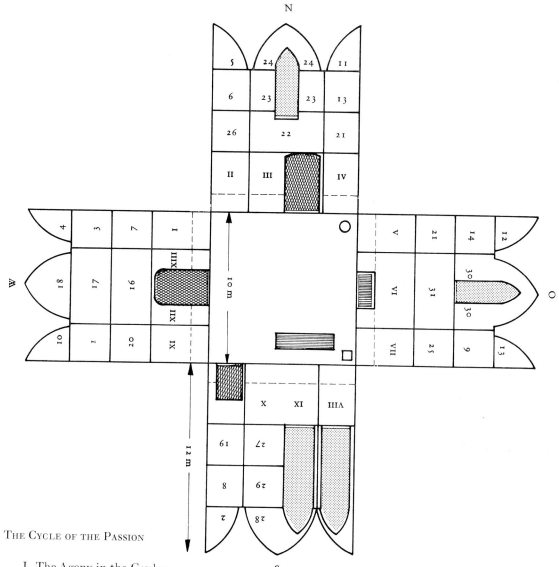

THE CYCLE OF THE PASSION

 I The Agony in the Garden
 II The Betrayal of Judas
 III Christ before Caiaphas
 IV Christ at the Column
 V Christ Enthroned, Crowned with Thorns
 VI Christ on the Cross, with the Virgin and St. John,
 on the left, Emperor Charles IV, on the right,
 an Empress (Elizabeth of Pomerania?),
 at the foot of the Cross two crowned women
 VII Christ on the Cross
 VIII Christ in the Sepulchre
 IX The Resurrection
 X The Ascension
 XI Pentecost
 XII St. Paul
 XIII St. Peter

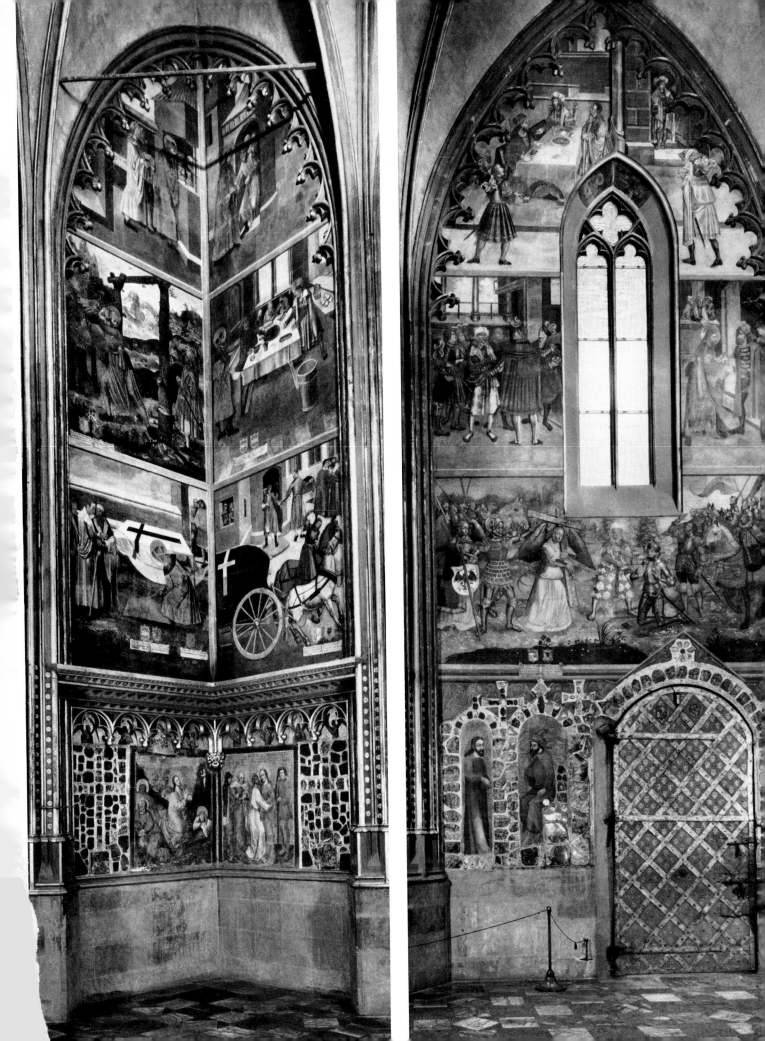

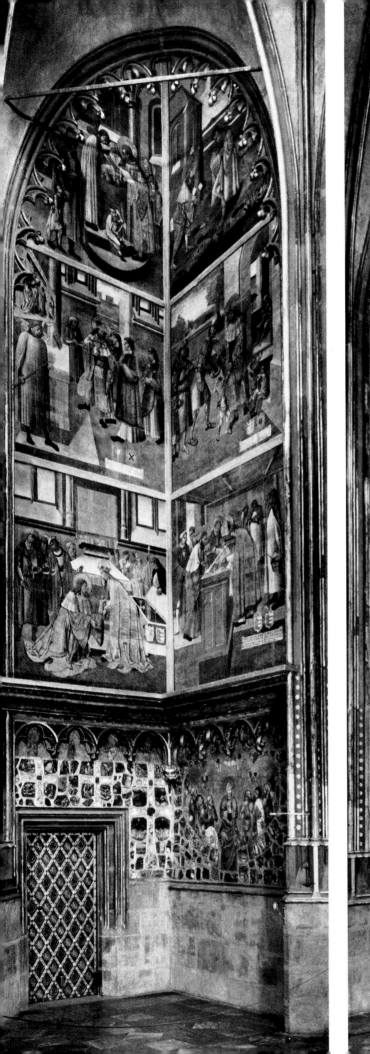
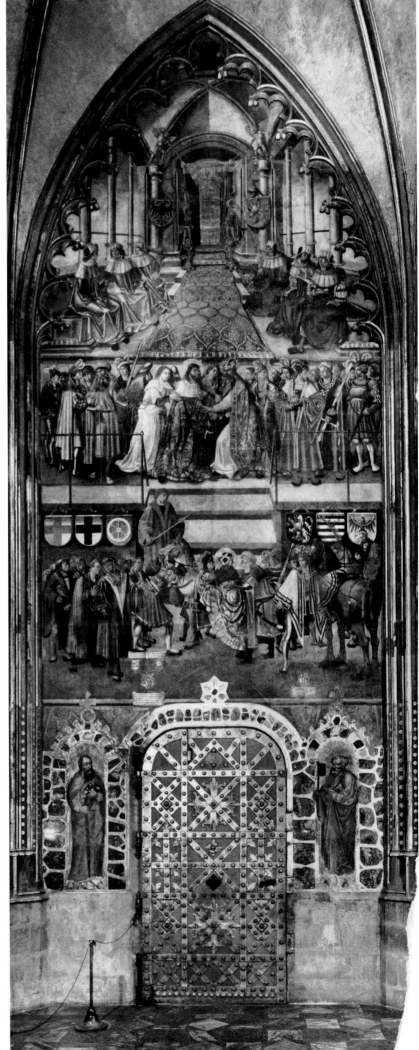

Late Gothic painting and sculpture

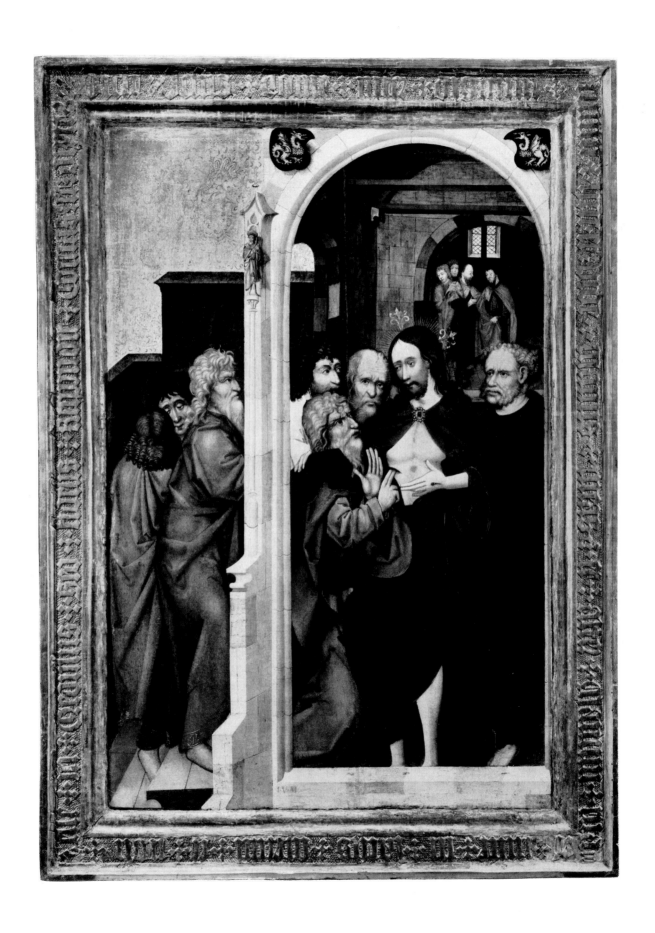

231 Master of the Thomas altar-piece: Christ appearing to St. Thomas. About 1475. Prague, National Gallery

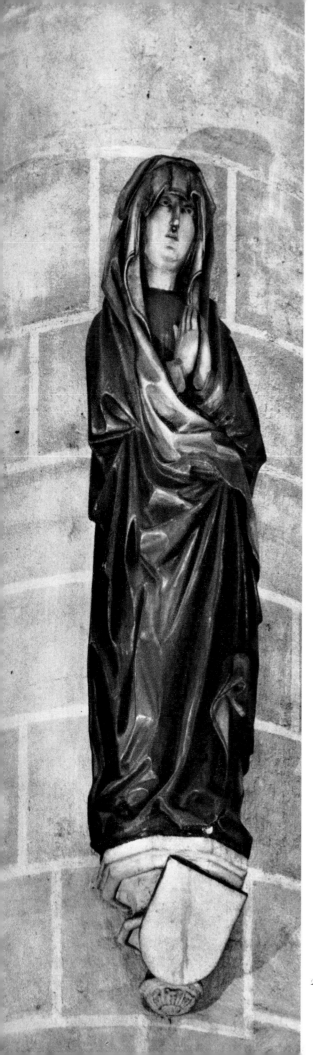

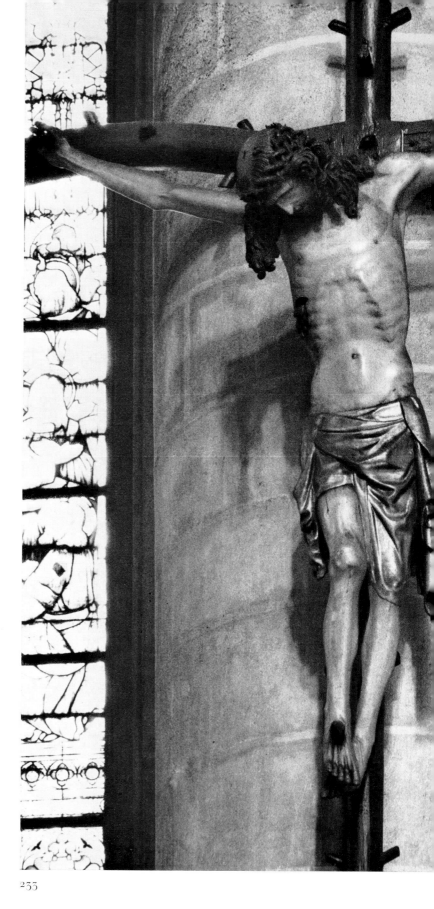

233

232-234 Christ on the Cross, mourning Virgin and St. John.
About 1460. Plzeň (Pilsen), St. Bartholomew's Church

232

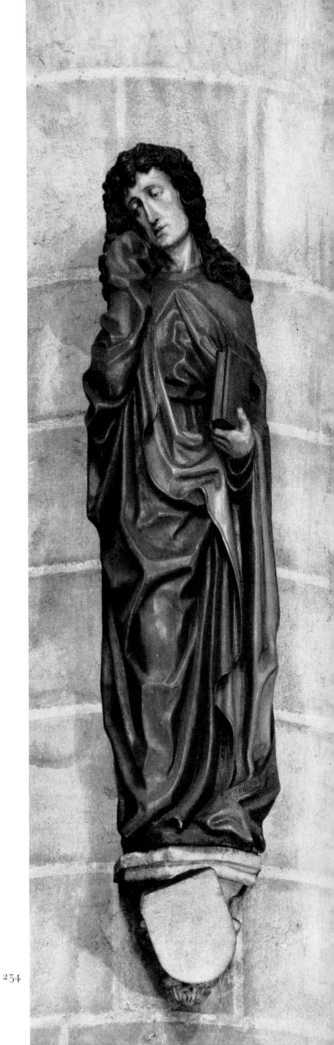

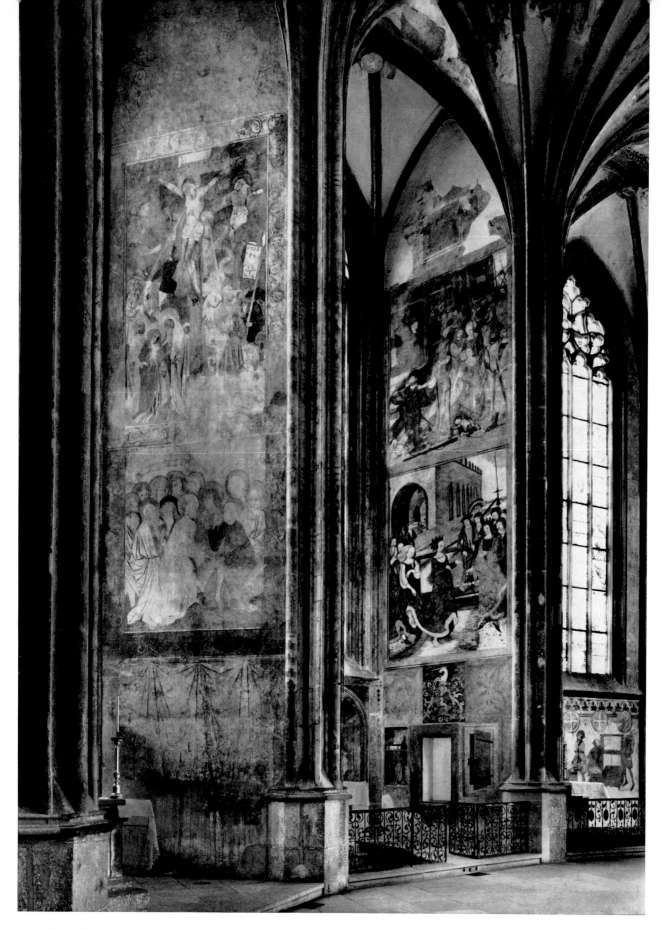

235 View from the choir towards the Chapel of Wenceslas IV and the Smíšek Chapel. Wall-paintings about 1490

Vaulting in the choir gallery 236

Smíšek Chapel, portrait group of the so-called Literati, about 1490 237

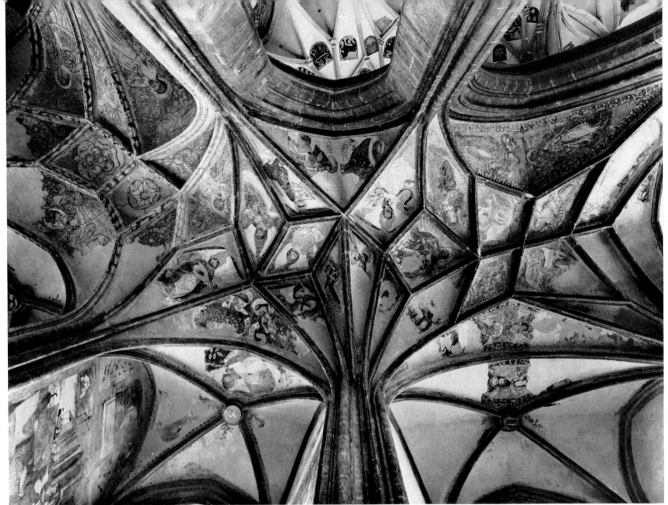

236

237

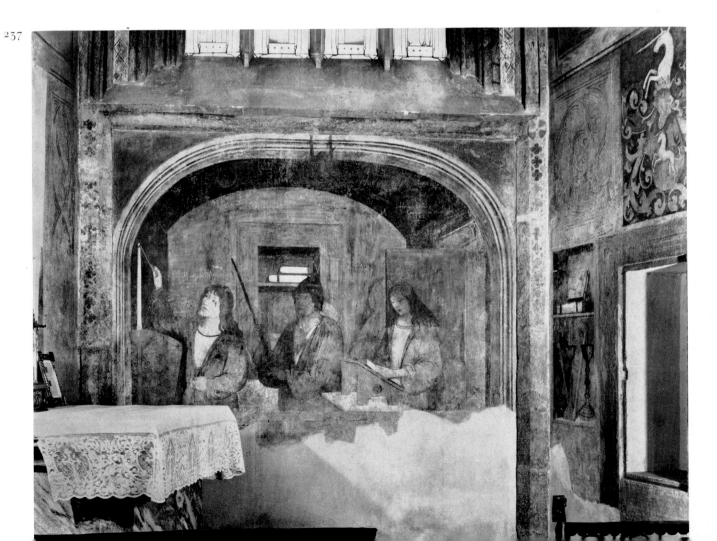

238

239

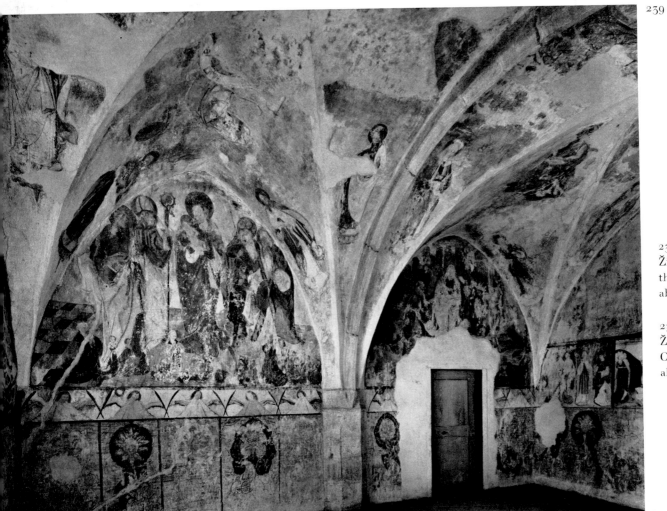

238
Žirovnice Castle,
the Green Room,
about 1490

239
Žirovnice Castle,
Chapel,
about 1490

24
Blatná Castl
the Green Roon
about 149

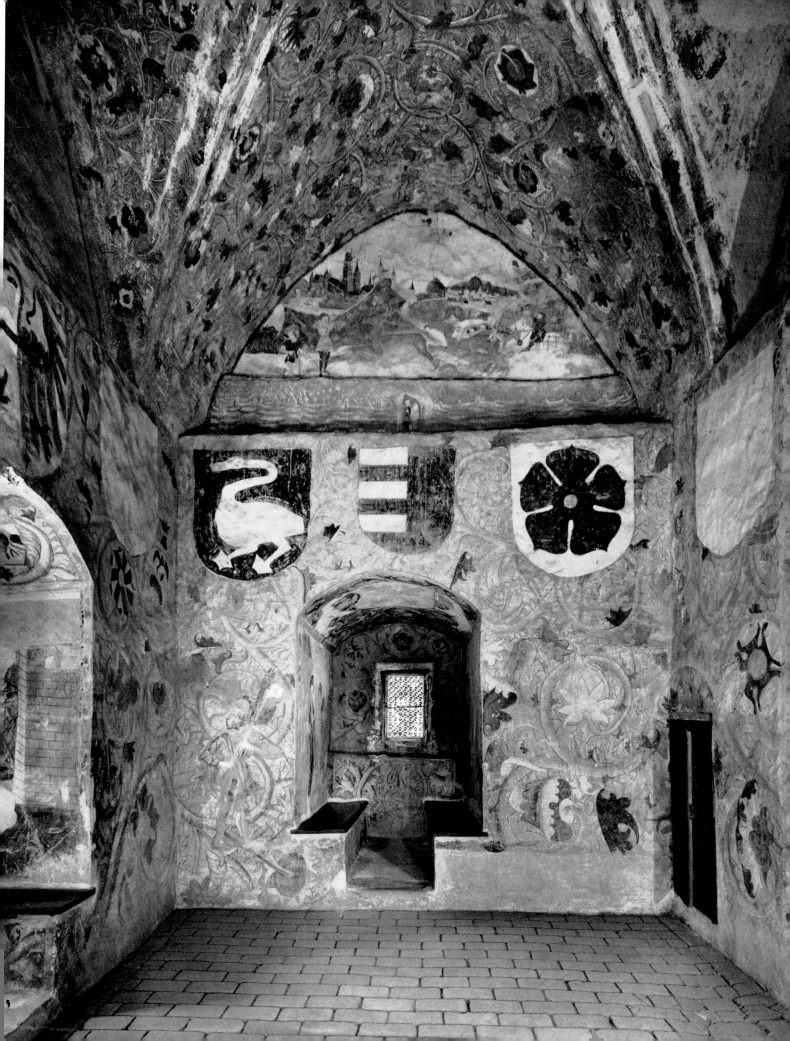

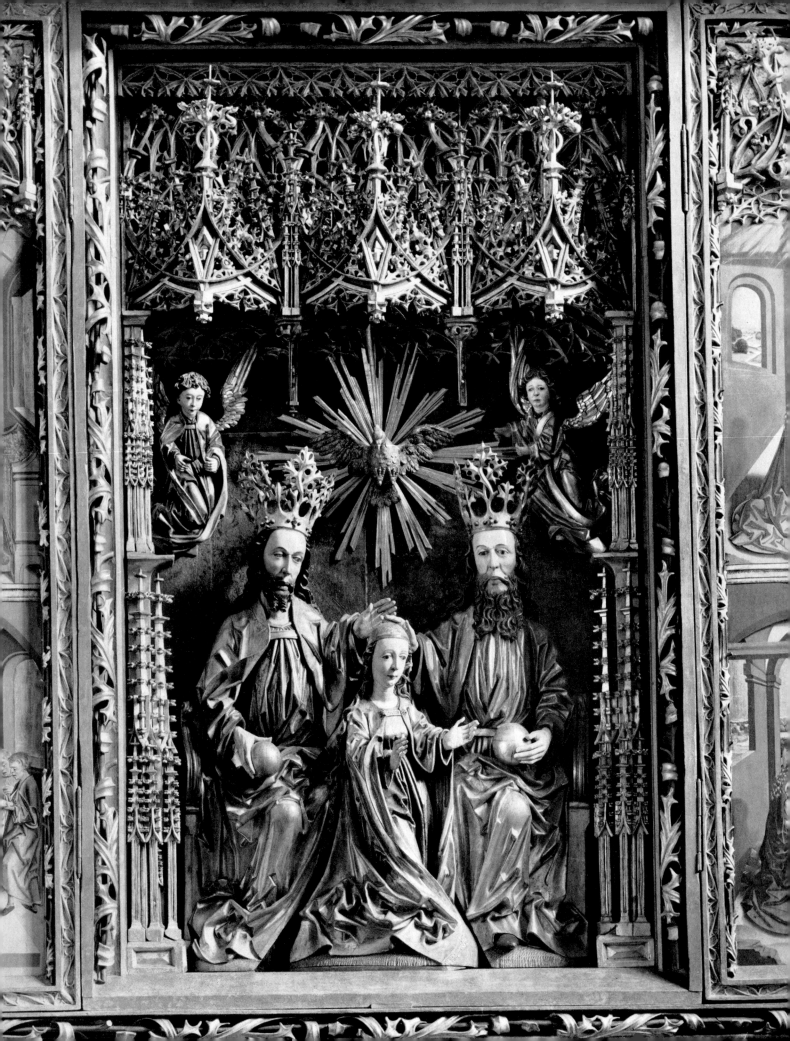

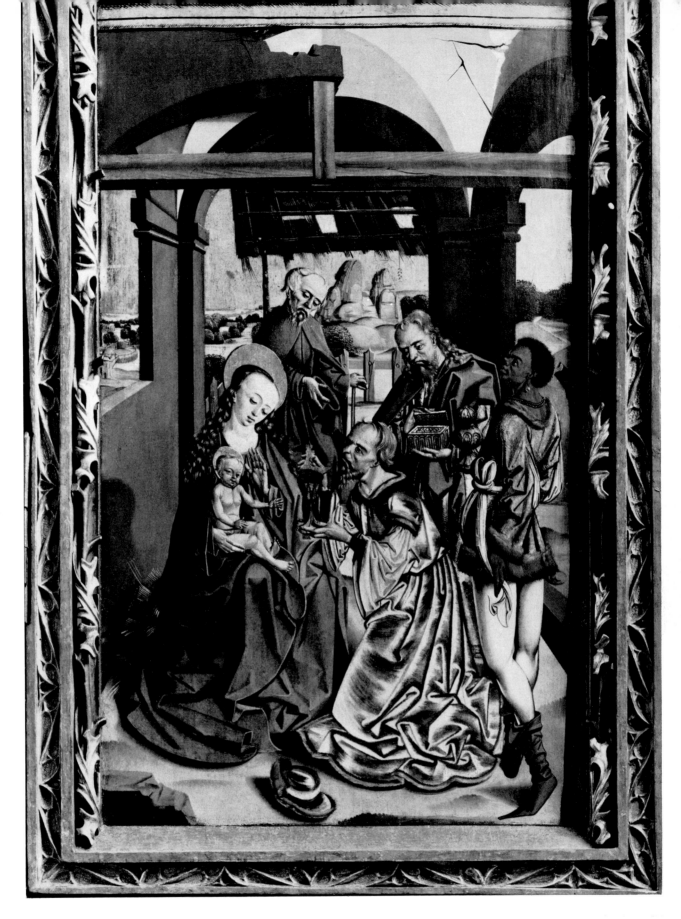

242 The Adoration of the Magi. Righthand wing of the altar-piece, about 1495. Křivoklát (Pürglitz), Castle, chapel

41 Křivoklát (Pürglitz) Castle, chapel. The Coronation of the Virgin, carved centre panel of altar-piece, about 1495

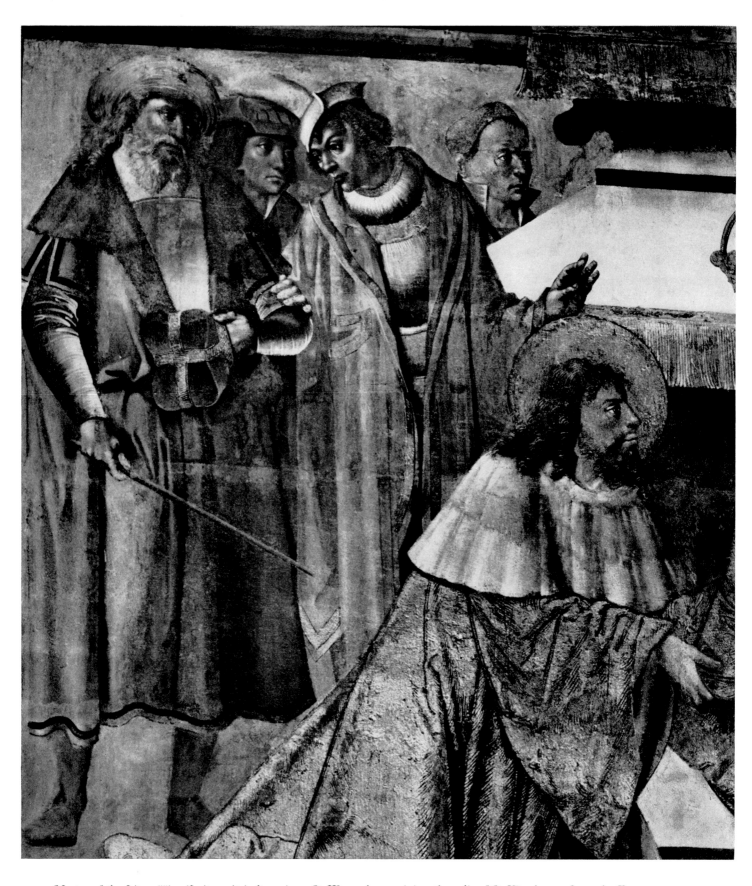

243 Master of the Litoměřice (Leitmeritz) altar-piece; St. Wenceslas receiving the relic of St. Vitus's arm from the Emperor.
Detail. Prague, St. Vitus's Cathedral, Wenceslas Chapel

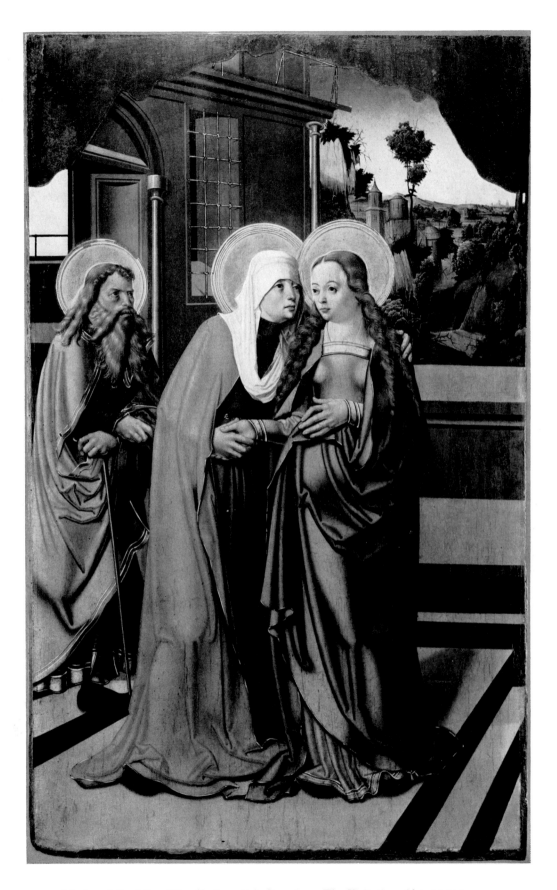

244 Master of the Litoměřice (Leitmeritz) altar-piece: The Visitation. About 1510.
Prague, National Gallery

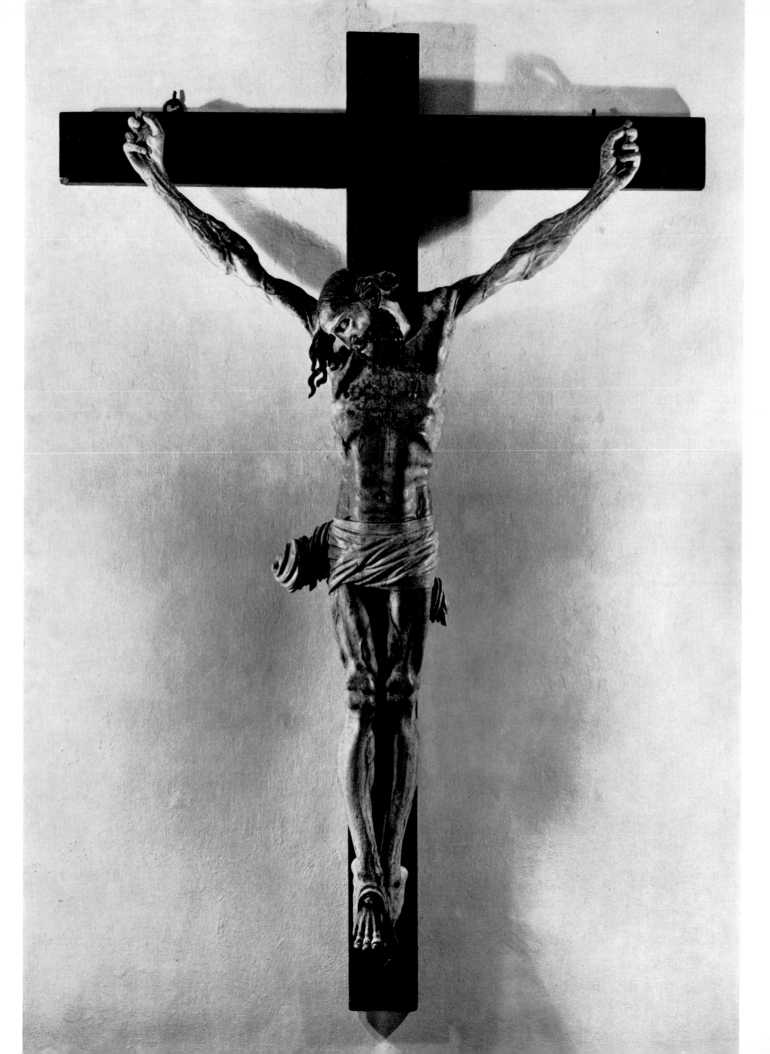

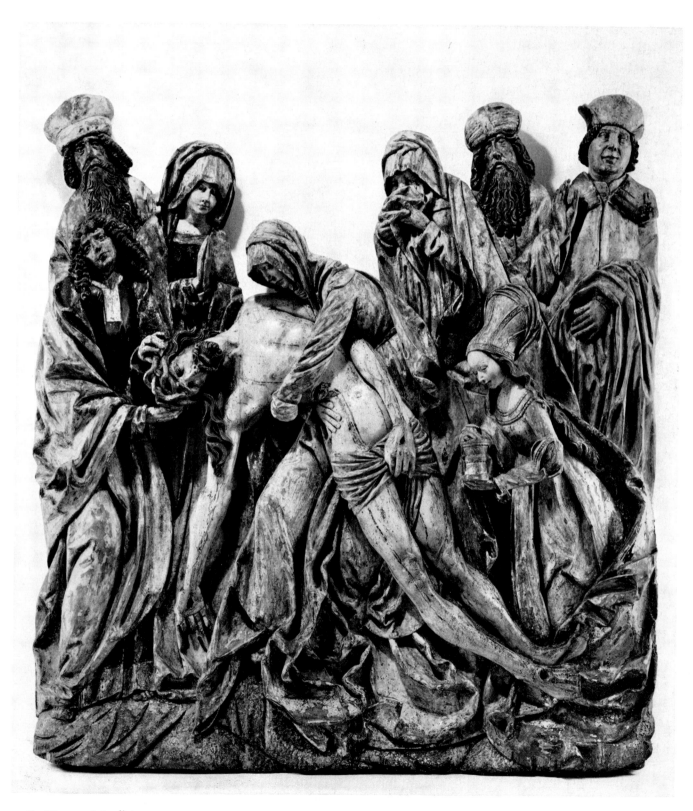

246 Master of the Žebrák Lamentation: The Lamentation for Christ. About 1505. Prague, National Gallery

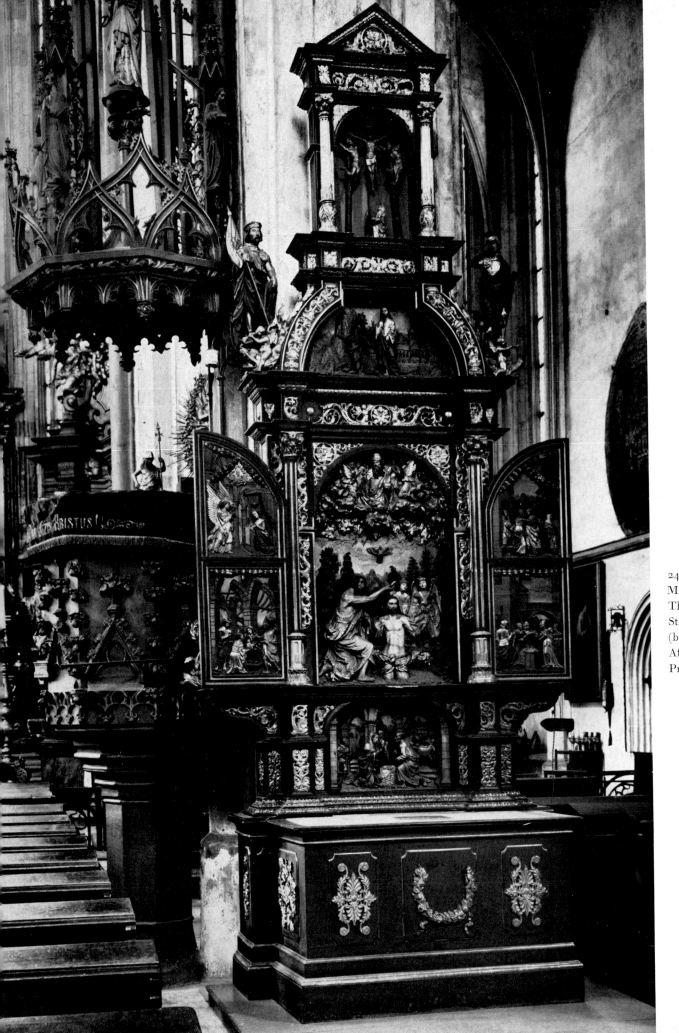

247
Master IP:
The altar-piece of
St. John the Baptist
(before restoration).
After 1520.
Prague, Týn Church

248
Master IP:
The Baptism
of Christ
(after restoration).
Detail of Plate 247

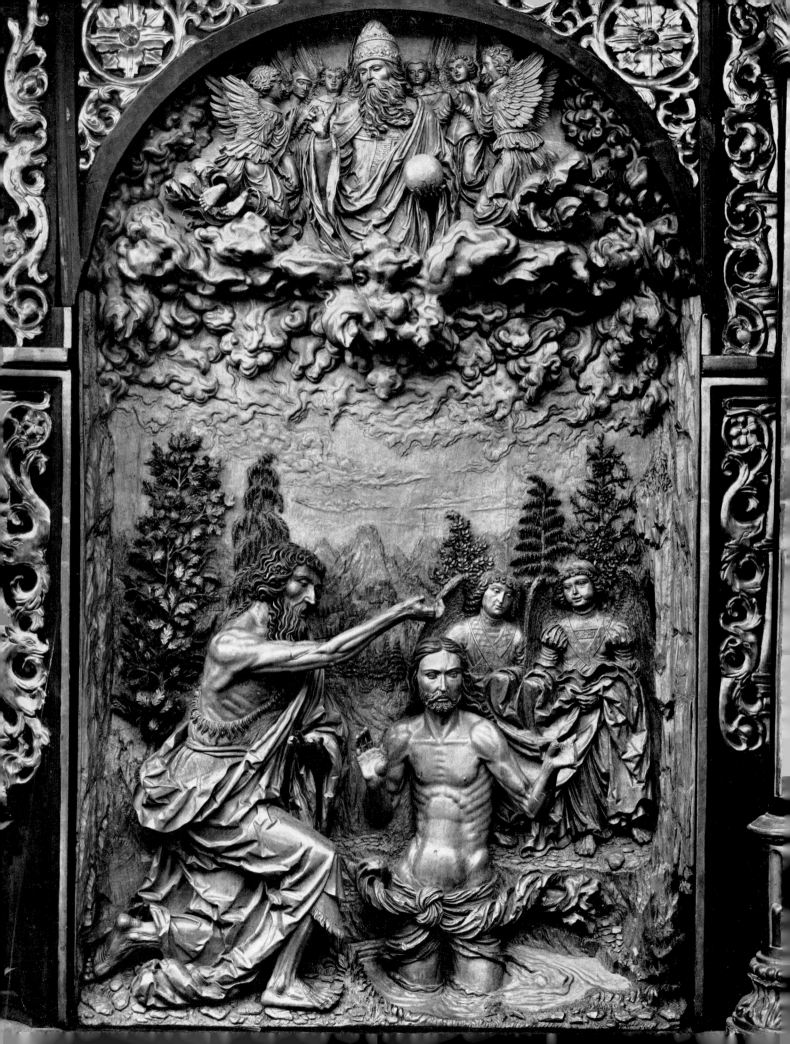

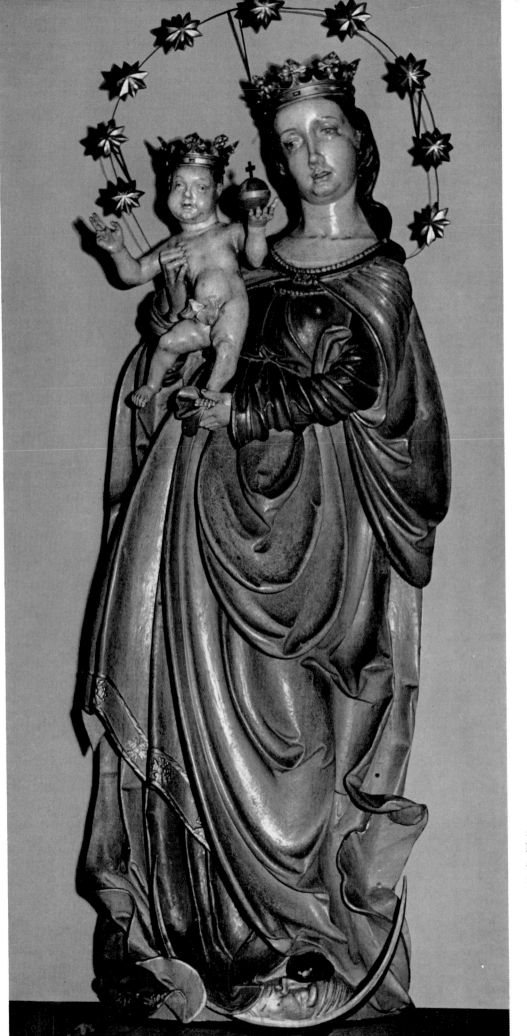

249
Madonna from the high
altar of the Parish Church
in Blatná, about 1515.

Gothic art in Bohemia

B

TE DUE